ART

AN INTRODUCTION

Second Edition

ART

AN INTRODUCTION

Second Edition

Dale G. Cleaver
University of Tennessee

 HARCOURT BRACE JOVANOVICH, INC.

New York / Chicago / San Francisco / Atlanta

Cover photo: VICTOR VASARELY, *YMPO,* 1970. Acrylic on canvas, 67″ x 99$\frac{1}{2}$″. Galerie
Denise René, New York.

Picture credits and copyright acknowledgments on p. 356.

ISBN: 0-15-503431-6

Library of Congress Catalog Card Number: 74-182343

Printed in the United States of America

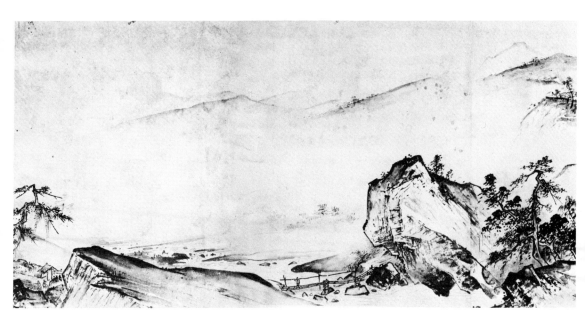

PART ONE
The Principles of Art

To understand the art of our own time or that of other eras, it is necessary first to consider the nature of art and some of the principles by which it operates. Art has continually outgrown the definitions imposed upon it; but, for our purposes, a work of art might be defined as an object created or selected for its capacity to express and stimulate experience within a discipline. The experience may range from the pity evoked by the face of a starving child to a revelation of order in architecture. The discipline may vary from the strictest geometrical organization to a spontaneous irregularity that approaches the accidental; yet discipline provides for order, completeness, and intensity.

ART

AN INTRODUCTION

Second Edition

Contents

I wish once again to thank my artist-colleagues in the Art Department of the University of Tennessee for suggestions leading to improvements in the section on techniques. I would also like to express my thanks to the many responsive teachers of art history across the country for their interest and comments, many of which proved very helpful in revising this book. Although there are too many to thank individually, I am especially grateful to Professors A. William Clark, Farleigh Dickinson University, Gail Hammond, University of Tennessee, and Rachael Young, also of the University of Tennessee. They kindly read the entire manuscript while it was in preparation and had made many valuable suggestions.

<div align="right">Dale G. Cleaver</div>

Preface

The second edition of *Art: An Introduction,* like the first, is based on a dual approach to art. Part I discusses the elements of form, design, technique, iconography, and esthetics. Part II presents a historical survey in which these elements are utilized for stylistic analysis in discussions of painting, sculpture, and architecture.

Also as in the previous edition, this book offers generally accepted interpretations of the historically important periods, styles, and artists of Western culture. However, this edition departs from its predecessor in two significant respects. Approximately three times as many works of art are reproduced in this book as in the earlier one. Moreover, the reproductions are now integrated with the text and can be easily referred to in following the discussions. Secondly, the current text has been strengthened by the addition of new chapters on Near Eastern, Aegean, and Etruscan art as well as by the subdivision of the last two chapters into more manageable units.

Of necessity the writing is highly condensed. Only the most important traditions and media of Western art have been included. The result is a core text that can serve as a structural basis for courses of varying aims and orientations. Now as before, the book is intended to be used in conjunction with other material. To this end, selective bibliographies are provided at the end of each chapter. Many of the works cited here contain additional examples of the periods and artists covered. *Art: An Introduction* can also be supplemented by materials on such specialized subjects as primitive and oriental art, photography, and various fields of design.

HSIA KUEI, detail from *River Scenes*,
Sung Dynasty. Collection of the
National Palace Museum, Taipei,
Taiwan.

The basis for the visual arts is visual and tactile experience, but not all visual and tactile experiences are art; the difference lies in human purpose. The artist arranges an experience for us by selecting and manipulating, within the limits of a discipline, such elements as line, shape, mass, value, texture, and color. The painter or sculptor may use these elements to represent well-known objects from the everyday world and to suggest feelings about them, or he may create an entirely new world for our contemplation. The architect is equally concerned with these elements, although he is rarely inclined to depict objects in his art and must usually consider utilitarian functions such as shelter and useful space. Whatever his field, the artist creates by choosing and composing the basic elements, and the word COMPOSITION is often used to denote a work of art. The individual objects or parts within the work of art are frequently called FORMS, but the word FORM is also used for the total character or structure of a composition. Thus we call the study of how visual and tactile elements function in art FORMAL ANALYSIS.

Chapter 1

Visual and Tactile Elements in Art

Line

Line may be thought of as the path of a moving point, as the edge of a flat shape, as the axis (dominant direction) of a shape, or as the contour of a solid object. Line may be of even or modulated (varied) thickness; and the range of personality it may express is wide: quick, slow, or still; nervous, majestic, or rigid. It can suggest mass, texture, light, and shadow; it can emphasize form or create mood.

In Picasso's pencil drawing of Dr. Claribel Cone (Fig. 1-1), the lines overlap and are modulated to suggest the roundness and heaviness of the body, but they become light and rippling to depict the ruffles of lace. In contrast, the drypoint, *Self-Portrait with Graver*, by Beckmann (Fig. 1-2) expresses a nervous, tense personality through its jerky, restless lines and their contrasting angles. Beckmann used *crosshatching* (superimposed sets of parallel lines) for the shadows that define the mass of the head.

Delacroix's painting (Fig. 17-9) evokes line with short, curving brush strokes that occasionally establish

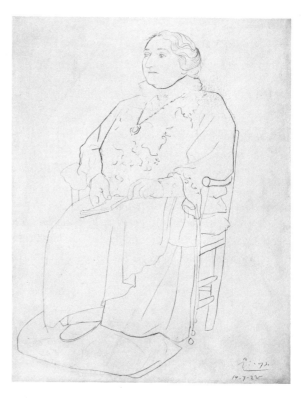

1-1
PABLO PICASSO, *Dr. Claribel Cone*, 1922. Pencil on paper, 25³⁄₁₆" × 19½". Cone Collection, Baltimore Museum of Art.

4

the contour of an object but more often blur the separations between the parts, move from the edges into the mass of the forms, and heighten the frenzied activity depicted. In the Chinese scroll painted by Hsia Kuei (pp. 2–3), vast scale is suggested by the contrast between clusters of precise linear details and areas left relatively empty. Men, plants, and surface textures are almost microscopic in a world of towering peaks and infinite, mist-filled space.

Line in sculpture may be seen as the edge of a form considered in silhouette, as incisions in the surface of the mass, or as the general directional thrust of a form. In all three types of line, the horseman carved by a Dogan tribesman of Africa (Fig. 1-3) has tense, straight sections enlivened by abrupt changes of direction. On the other hand, *The Assumption of the Virgin* by Cosmas and Egid Asam (Fig. 1–27) has a Delacroix-like activity in its complex twisting and curling edges.

In architecture, line may emphasize rigid simplicity and sharply defined edges, as in Santa Maria delle Carceri (Fig. 1-16). In contrast to the simple balance of vertical and horizontal lines in this church, a powerful

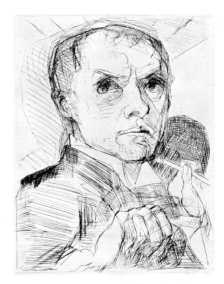

1-2 MAX BECKMANN, *Self-Portrait with Graver*, 1917. Drypoint, 11¾″ × 9⅜″. Museum of Modern Art, New York (gift of Edgar Kaufman, Jr.).

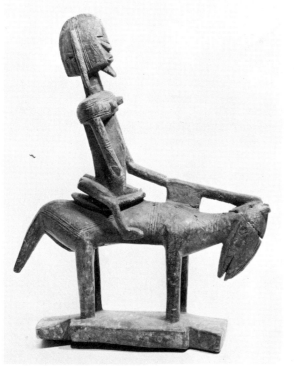

1-3 DOGON TRIBESMAN, *Horseman*, late nineteenth century (?). Wood, 14¾″ high. The Katherine White Resnick Collection, Cleveland Museum of Art.

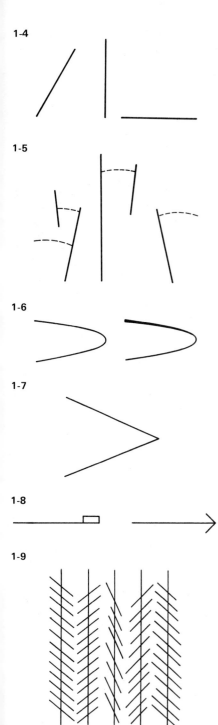

1-4

1-5

1-6

1-7

1-8

1-9

(a)

upward thrust is provided by the dominant vertical lines of Amiens Cathedral (Fig. 1-29).

MOTION IN LINE

To suggest or emphasize movement, as in the painting by Delacroix or in Amiens Cathedral, line may be used in at least two ways: It may represent or suggest things that we know are capable of motion, such as rippling waves, or it may imply motion by its form or by its relation to other lines. Our experience of gravity causes us to feel that vertical and horizontal lines are stable, whereas unsupported diagonal lines often seem to move in the direction in which they are leaning (Fig. 1-4). Grouped lines may suggest tensions between each other by the degree to which they seem to require or to provide mutual support (Fig. 1-5), an effect often utilized by Cézanne (see Fig. 17-15). Curving lines tend to move in the direction of their greatest thrust; modulating the thickness of a line can accentuate this effect (Figs. 1-6 and 18-1). An angle often seems to point toward its apex (Fig. 1-7), and a line may suggest motion by drawing the viewer's attention toward one end (Figs. 1-8 and 13-45). The dynamic effect lines may have on each other is dramatically illustrated by several classic diagrams. The vertical lines in Figure 1-9a are actually parallel but appear otherwise because of the pushing forces of the diagonals. The horizontal lines in Figure 1-9b are of equal length but appear different because of the expanding and contracting qualities of the diagonals, whereas the verticals in Figure 1-9c seem to push the two diagonals out of alignment. These effects may be exploited deliberately or instinctively by the artist, architect, or designer.

LINE AND SPACE

The depth in Masaccio's *Tribute Money* (Fig. 1-10) is achieved partly by *linear perspective*, one means of

(b)

(c)

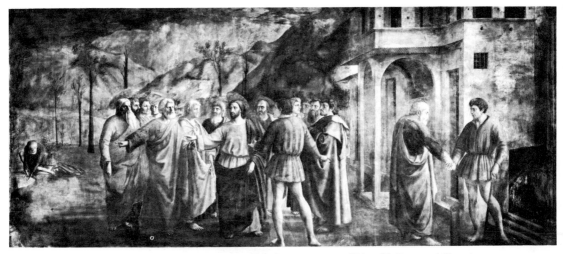

1-10 MASACCIO, *The Tribute Money*, c. 1425. Fresco, approx. 20′ × 8′. Brancacci Chapel, Santa Maria del Carmine, Florence.

creating the illusion of depth on a flat surface. To our eyes, parallel lines in a plane pointing into space appear to converge at a *vanishing point* (V. P.) on the horizon established by our eye level, or on a line perpendicular to the horizon (Figs. 1-11 and 1-12). Frequently, however, intervening objects hide the horizon. In Figure 1-11, the converging lines of Masaccio's building have been extended until they meet, thus revealing the vanishing point, the hidden horizon, and the eye level chosen for us by the artist. Masaccio used linear perspective also to emphasize the major figure in the composition, Jesus, by placing the vanishing point right behind his head. In choosing the eye level and hence the horizon, the artist may give us an ordinary view (Fig. 1-11), a worm's-eye view (Fig. 1-12), or a view from above (Fig. 1-13). When all converging lines focus on a single vanishing point, as in the Masaccio, we call it a *one-point perspective* system (Fig. 1-11). It is often desirable to have more than one vanishing point, as in Figures 1-12 and 1-13; an appropriate term is *multiple-point perspective*. The artist is not bound to restrict himself to a particular system. The various types of perspective—and there are others, which have not been mentioned here—are only devices that the artist may or may not wish to use. He may deliberately use two or more different eye levels in the same painting in order to emphasize certain objects or to create for the viewer an unusual experience of space.

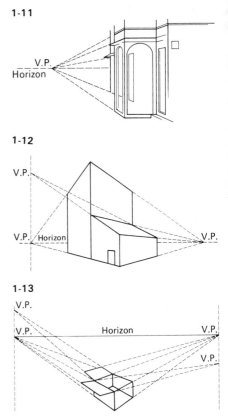

1-11

1-12

1-13

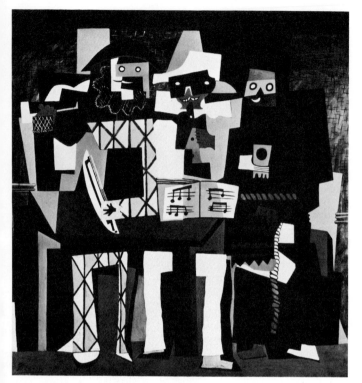

1-14
PABLO PICASSO, *The Three Musicians*, 1921. Oil on canvas, approx. 7' × 6'. Philadelphia Museum of Art.

1-15

Shape

A *shape* is an area or a plane with distinguishable boundaries. If we think of shape as having length and width only, then it is a more limited term than *form* and is distinguishable from *mass*, which requires depth as a third dimension (although it is possible to ignore the third dimension of a mass and consider it as a shape if we view it one surface at a time or see it in silhouette). Shape, like line, may have many personalities: rigid, flexible, precise, uncertain, calm, active, awkward, or graceful.

Picasso's *Three Musicians* (Fig. 1-14) has shapes that tip, slide, bend suddenly, break up, and interweave in a staccato fashion; the total effect is one of great activity. In the *Decorative Figure on an Ornamental Background* (Plate 5), Matisse placed a massive, rigidly contoured figure in an environment of shapes that blossom expansively within loose-framing lines (Fig. 1-15). It is the room that is agitated; the woman seems motionless. This unusual effect comes partly from the orientation

of the figure along vertical and horizontal lines, which seem stable compared with the diagonals of the floor and the irregular curves on the wall.

As we have seen, it is often necessary to ignore the third dimension when considering shape in sculpture and architecture. Although Egyptian sculpture derives much of its character from mass, it is helpful to consider the nature of shape in *Menkure and His Queen* (Fig. 7-8). The clearly delineated shapes present vertical and horizontal elements locked into a static, timeless rigidity. In contrast, the forms of the Asam composition (Fig. 1-27), if considered as shapes, have the restlessness of dried leaves in a wind. Similarly, the simple rigid shapes, organized by line, of Santa Maria delle Carceri (Fig. 1-16) contrast with the lilting and constantly interrupted shapes of San Carlo alle Quattro Fontane (Fig. 15-13), where multiplicity and changes of direction suggest flexibility and even metamorphosis.

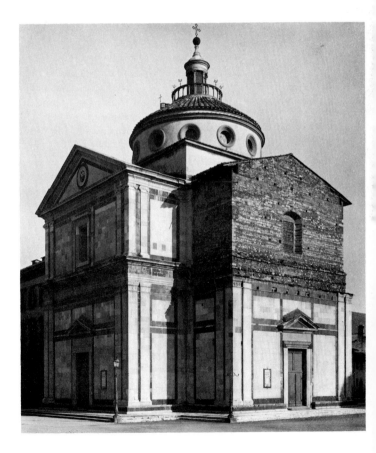

1-16
GIULIANO DA SANGALLO,
Santa Maria delle Carceri,
Prato, Italy, 1485–92.

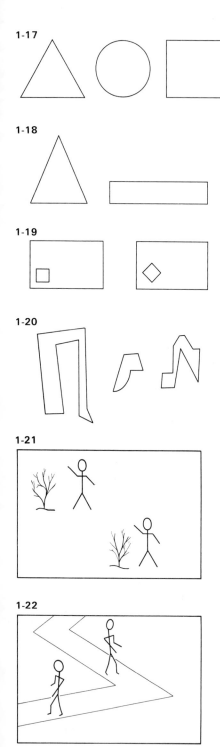

1-17

1-18

1-19

1-20

1-21

1-22

MOTION IN SHAPES

Static shapes maintain a rigid equilibrium within themselves and with their environment (Fig. 1-17). Shapes become more dynamic as they draw our attention in a specific direction. The triangle in Figure 1-18 pushes upward more than to the sides. The rectangle is relatively stable, but because of its width our attention is drawn along a horizontal axis. Even the stability of the square may be disturbed if we move it out of alignment with a stable environment (Fig. 1-19). Less regular shapes can suggest much more activity; Figure 1-20 shows several of the shapes in Picasso's *Three Musicians* (Fig. 1-14). Their liveliness comes from irregularly expanding and contracting parts that draw our attention in several directions.

SHAPE AND SPACE

The illusion of depth on a flat surface may be produced simply by overlapping shapes, as in the Picasso painting and the landscape by Hsia Kuei on pages 2–3. Even the position of shapes on the picture surface can suggest space. In Figure 1-21 the upper figure appears to be farther away even though the two figures are equal in size. The assumption is easily made that the figures are standing on a plane that extends to an unseen horizon outside the picture. Diagonal lines or parallels that do not converge may strengthen the effect of depth (Fig. 1-22), but the illusion of space is strongest when linear perspective is employed. A size difference between similar or recognizable shapes may suggest distance between them because the effect implies linear perspective, as with the figures or the trees in Ghiberti's relief (Fig. 14-12).

Mass

Mass, or three-dimensional solidity, is used directly in architecture and sculpture but must be created by illusion in painting and drawing. The artist can produce the effect of thickness or roundness with highlights and shadows, as in Masaccio's *Tribute Money* (Fig. 1-10); with lines describing some forms pushing in front of others, as in Picasso's drawing of Dr. Claribel Cone (Fig. 1-1); with lines delineating the various sides of a three-dimensional object, either with linear perspective, as in Masaccio's *Tribute Money*, or without it, as in Davis'

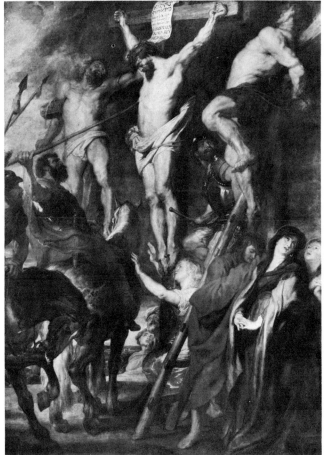

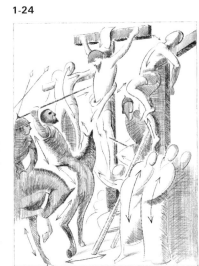

1-23
PETER PAUL RUBENS, *Coup de Lance (The Crucifixion)*, 1620. Oil on canvas, 14' × 10'. Koninklijk Museum voor Schone Kunsten, Antwerp.

1-24

Something on the Eight Ball (Fig. 18-15); and with colors that advance or recede (see p. 19) to pull some parts of an object forward. Mass may express dynamic power, as in Rubens' *Coup de Lance* (*The Crucifixion*, Fig. 1-23), where the vast bulk, foreground placement, and twisting forms emphasize the dramatic violence of the subject (Fig. 1-24). Rembrandt reinforced the quiet equilibrium of his *Supper at Emmaus* (Plate 3) by aligning and framing the figure masses with the stable architectural forms and the rigid edges of the painting (Fig. 1-25).

Sculpture may emphasize or deny mass. The term *closed form* is used for sculpture, painting, or architecture that stresses impenetrable mass. The figures of *Menkure and His Queen* (Fig. 7-8) have simplified anatomical forms with broad surfaces of blocklike permanence. The mass is not opened up between the two

1-25

figures or between their legs or their arms and their bodies. For more *open form* and more violent push-pull tensions, consider the Asam sculpture (Fig. 1-27). Some sculptors deny the importance of mass. Gabo, for example, prefers transparent plastics that seem to give order to space without displacing it, as in *Linear Construction* (Fig. 18-25).

Architecture usually employs mass to define interior space, and the character of architectural mass ranges from the quiet symmetry of Santa Maria delle Carceri (Figs. 1-16 and 14-21) to the swooping, turning liveliness of Notre-Dame-du-Haut (Figs. 18-42 and 18-43). In the Seagram Building (Fig. 18-41), glass and steel reduce the mass to thin, transparent, membrane walls.

Value

Variations in lightness and darkness, called variations in *value*, are used to define shapes, to suggest line, to create the illusion of mass and space on a flat surface, to emphasize certain parts, and to express feeling. Value changes define shapes in Picasso's *Three Musicians* (Fig. 1-14). In Rubens' *Coup de Lance* (Fig. 1-23), he *modeled* (molded) solids with light and shadow, focused attention on Christ by floodlighting, and reinforced the dramatic quality of the scene with bold contrasts in value. Holbein clarified details and space relations with light and shadow in his *Ambassadors* (Fig. 14-42); but Rembrandt, in the *Supper at Emmaus* (Plate 3), obscured much of the detail in deep shadow, sacrificing clarity for an effect of soft glowing atmosphere and quiet drama. The light and shadow used to model form, as in the works by Rubens and Rembrandt, are often called by the Italian term *chiaroscuro*. Leonardo da Vinci, a pioneer in the use of chiaroscuro, often used *reflected light* to separate shaded surfaces. In Figure 1-26, the jaw of the pointing angel acquires solidity and moves out from the neck because the shaded area of the jaw receives reflected light from the lower neck and shoulder.

In sculpture and architecture, value contrasts are produced by different degrees of projection and recession in the masses and by use of different materials and colors, as in *The Assumption of the Virgin* (Fig. 1-27), where the contrasts of colors and of light and dark stone work with the light and shadow produced by bold recessions and deep hollows in the figure groups. The opposition of light and shadow is intensified by win-

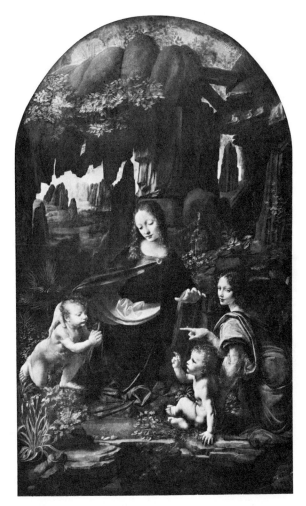

1-26
LEONARDO DA VINCI, *The Madonna of the Rocks, c.* 1485. Oil on wood panel, approx. 6' × 4'. Louvre, Paris.

dows directly overhead. Value contrasts dramatize the event and acquire Christian content—the Virgin ascends toward the light, which symbolizes God. In Frank Lloyd Wright's Robie House (Fig. 18-35), the hovering horizontals, which suggest shelter and align themselves sympathetically with the ground surface, are stressed by the value contrasts of brick and concrete and by highlights and shadows of projecting and receding parts.

VALUE RELATIONS

Our perception of the value, as well as of the size and color, of a given form may be affected by its environment through the principle of *simultaneous contrast.* Of

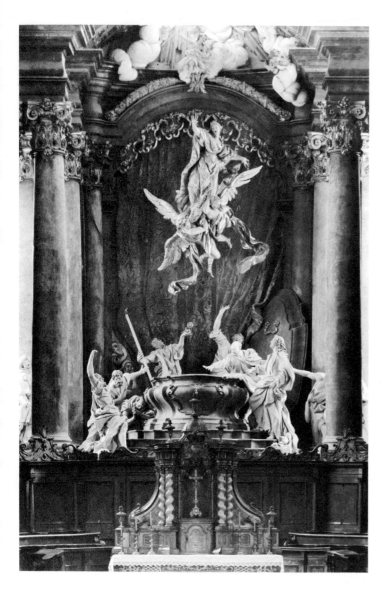

1-27
COSMAS DAMIAN and
EGID QUIRIN ASAM,
*The Assumption of the
Virgin,* 1718–25. High
altar, monastery church
at Rohr, Bavaria.

the two circles of equal white in Figure 1-28a, the top
one appears lighter because of its strong contrast with
its surroundings. In Figure 1-28b, the white circle tends
to appear larger because light areas seem to radiate and
expand against darker backgrounds or surroundings. In
the *Coup de Lance* (Fig. 1-23), such effects help create
the monumentality of the figure of Jesus, the glowing
flesh of Mary Magdalene at the foot of the cross, and
the malevolent eye of the warrior who thrusts the lance
into the side of Jesus.

VALUE CONTRAST AND SPACE

Value contrast can be used in painting to create the illusion of space by defining mass, which implies the space necessary to contain it; by separating planes or edges; and by sharpening or softening details. The illusion of deep space in the Chinese landscape (pp. 2–3) is achieved partly through a carefully adjusted sequence of overlapping masses and planes separated not only by line but also by value contrasts that become softer from foreground to background. *Aerial perspective* (or *atmospheric perspective*) is the term for the softening of value contrasts and details and the muting of colors to give the effect of distance. Aerial perspective is used by Giorgione in his *Pastoral Concert* (Plate 2) and by Masaccio in his *Tribute Money* (Fig. 1-10).

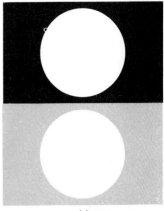

(a)

Texture

Texture is the quality of a surface: smooth, rough, slick, grainy, soft, or hard. In painting, it may apply both to the texture of the paint itself and to the textures that are depicted. The painter, the sculptor, and the architect frequently use texture for variety, focus, or unity. In Holbein's *Ambassadors* (Fig. 14-42), the smooth surface of the paint helps give unity to the work even while the painting gives the illusion of a great variety of textures in the different objects depicted. Delacroix was less interested in depicting a variety of textures in his *Lion Hunt* (Fig. 17-9). He used the rough texture of the paint in undisguised brush strokes to stress the violence of the action and to unify the variety of shapes. In Gabo's *Linear Construction* (Fig. 18-25), space is articulated mainly by nylon strings that produce the illusion of grooved—that is, textured—surfaces. The Asam sculpture (Fig. 1-27) has a multiplicity of textures that increases the complexity of the composition but also helps to separate the figures from their setting. From a distance, the thousands of sculptured details on the surface of Amiens Cathedral (Fig. 1-29) give the cathedral a bristling roughness of texture that has great variety. The countless perforations in the stone façade accentuate the soaring lightness of the structure. Notre-Dame-du-Haut (Fig. 18-42), with its more asymmetrical form, attains some of its unity and massive strength from its relatively uninterrupted surfaces and the overall texture of the concrete.

Textural variation may be used in painting to give the illusion of space. The softening of focus in aerial

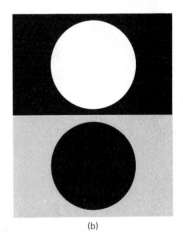

(b)

1-28

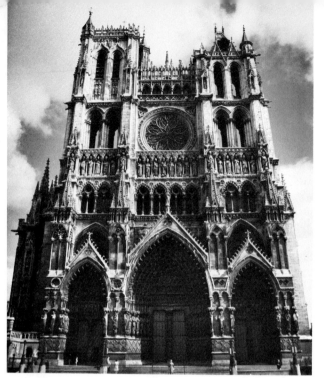

1-29
Robert De Luzarches, Amiens
Cathedral, thirteenth century
with later additions.

perspective involves the softening of textural qualities—
not only the depicted textures but the actual texture
of the paint. In sculpture and architecture, spatial effects
may be emphasized by using bold textures in the fore-
ground and softer ones for more distant surfaces.

Color

Color is one of the artist's principal means of achieving
variety, emphasis, and unity; of creating the effects of
mass and space; and of expressing feelings. In Gior-
gione's *Pastoral Concert* (Plate 2), the focal color of the
red hat is set against the cool light green of the distant
meadow; the contrast of warm and cool colors works
with the contrast of values and aerial perspective to
create depth, and the total effect of serenity and ele-
gance comes partly from the opulent but quiet colors.
Monet was fascinated by the shimmer of light and color
on the stone façade of Rouen Cathedral (Plate 4). Vi-
brating contrasts of blue and orange dance backward
and forward in accord with their brightness and warmth,
denying the mass of the stone and producing a luminous
vision. The colors in Matisse's *Decorative Figure on an
Ornamental Background* (Plate 5) are heavier and more
earthy, but they provide a rich and lively variety as they

change in modulations of reds, browns, blues, yellows, and greens.

Color in sculpture and architecture may come from the natural color of the materials or from paint, glaze, or chemical treatment (see Chapter 4). Color may complicate the form, or it may stress the point of central importance and even act as the axis of balance. Color can separate the various parts of a composition or pull the parts together by giving them a common characteristic. Architecture may be united with a landscape through the use of native wood or rock that repeats the colors of the setting, or the building may be separated from its environment by the use of "foreign" colors.

THE NATURE OF COLOR

Sunlight, or white light, contains the elements of all colors in such a mixture that each color is canceled. White light can be broken into its component colors by projecting it through a prism. An object is seen as a particular color because it absorbs some elements of white light and reflects others. That is, an apple is red when it reflects those elements of light that we have named red and absorbs the others.

The basic color that the artist chooses to give an object is called its *local color.* The artist may emphasize local colors, stress their modifications, or subordinate them to a general effect. The local red of an apple may be modified by reflections from a green tablecloth or by light coming through yellow curtains. By partly subduing local colors, Rembrandt achieved the overall effect of brown-gold light that characterizes many of his works, such as the *Supper at Emmaus* (Plate 3). Matisse, in contrast, retained more local colors (Plate 5).

The word *color* refers to a combination of *hue, saturation,* and *value. Hue* is the property that distinguishes one color from another, the property that enables us to name the color. Three hues are especially important because, in theory, they can be mixed to produce all the others. These are called the *primary colors.* Although there is some disagreement among scientists, for our purposes we may say that the primary colors in pigments are red, yellow, and blue. (In light, certain hues of red, green, and blue function as primaries.) The convenient arrangement called a color wheel (Plate 8) places between each two primary colors the color made by mixing them. Thus orange, green, and violet are

called *secondary colors.* Mixing of primaries and secondaries produces additional colors; the mixing could go on indefinitely. Colors directly opposite each other on the wheel are called *complementaries.* Complementary colors dull or neutralize each other when mixed together. A small amount of green added to red will dull the red. A larger amount of green will convert the red to brown, and a very careful adding of still more green will usually turn the brown to neutral gray. The proportions required of red and green will depend on the purity of the hues employed; since absolutely pure hues do not exist in pigments, the theoretical relationships described here are flexible in practice. Complementary colors placed side by side usually intensify each other, depending on the sizes of the areas of color and the distance of the observer. This characteristic is basic to the intensity and spatial effect of Monet's blues and oranges (Plate 4) and the focal and spatial effects of the red hat in the Giorgione (Plate 2).

Saturation refers to the purity or vividness of a color. A strong red is said to be of high saturation. It is possible to lower the saturation of a color by adding its complement, by diluting it with white, or by darkening it with black.

The *value* of a color is its darkness or lightness. Colors at full saturation can be assigned positions on a value scale ranging from white to black. A bright yellow, for example, would have the value equivalent of light gray, whereas a red would be darker in value. Colors that are greatly diluted with white are called *tints;* colors rendered darker by the addition of black or a complement are called *shades.*

THE EFFECTS OF COLOR

For the greatest possible control over his medium, the artist must consider the effects of simultaneous contrast in colors. A neutral gray or white placed near a strong color will seem to acquire some of the complementary of the color. This effect also occurs with combinations of colors; for example, red next to yellow will assume a touch of yellow's complement, violet; the yellow will appear to have a tinge of red's complement, green.

Certain colors (yellow, red, orange, and often violet) are considered *warm,* while others (greens and blues) are considered *cool.* This classification is largely based on our association of certain colors with light and heat. Contrasts of warm and cool colors can be especially intense.

For some color phenomena, we do not have adequate experimental data to draw precise conclusions. The considerable variation in response to colors is apparently due to both physiological and emotional differences in observers. Warm colors may make an object seem larger, while cool colors often seem to diminish its size, but value and saturation differences can be manipulated to reverse this effect. For many observers, certain warm colors, especially when light and highly saturated, seem to advance toward the eyes, cool colors often seem to recede. The individual observer's color preferences, however, appear to be important in causing certain colors rather than others to advance. The old rule that warm colors always advance and cool colors always recede is not valid in all cases.

In a given culture, certain colors may be commonly understood as being expressive of particular feelings; we may speak of "seeing red" or "feeling blue." The artist may utilize this expressive potential, but it may not work for an observer from another culture.

Some theorists and researchers have attempted to equate colors with sounds or with tastes (*synesthesia*), but the results have been inconclusive.

Suggestions for Further Study

Albers, Josef. *Interaction of Color.* New Haven, Conn.: Yale University Press, 1963.

Ball, Victoria. "The Aesthetics of Color: A Review of Fifty Years of Experimentation." *Journal of Aesthetics and Art Criticism,* Vol. 23, No. 4 (Summer 1965), pp. 441–52.

Birren, Faber. *Color, Form, and Space.* New York: Reinhold, 1961.

Hanes, Randall M. "The Long and Short of Color Distance." *Architectural Record,* Vol. 127, Pt. 2 (April 1960), pp. 254–56 and 348.

Jacobsen, Egbert. *Basic Color: An Interpretation of the Ostwald Color System.* Chicago: Theobald, 1948.

Luckiesh, M. *Visual Illusions, Their Causes, Characteristics, and Applications.* Republication of the original edition of 1922, with a new introduction by William H. Ittelson. New York: Dover, 1965.

Munsell, Alexander E. O. *Munsell Book of Color, Defining, Explaining, and Illustrating the Fundamental Characteristics of Color.* Baltimore: Munsell Color Company, 1929.

Norling, Ernest R. *Perspective Made Easy.* New York: Macmillan, 1939.

Sargent, Walter. *The Enjoyment and Use of Color,* rev. ed. New York: Dover, 1964.

White, Gwen. *Perspective: A Guide for Artists, Architects, and Designers.* London: Batsford; New York: Watson-Guptill, 1968.

Functions of Design

Among the many sources of satisfaction that works of art offer are the experiences of order and variety. An artist may work consciously or unconsciously to create such experiences. Design is his organization or composition of the visual and tactile elements in a work of art. He may employ *rhythm*, a recurrence of variations—often in the form of accents and intervals—that have enough similarity to establish continuity and order. Rhythm may be extended indefinitely; it does not require limits. *Balance*, the equilibrium of opposing forces, does involve limits and provides self-sufficiency and unity. Balance may be *axial*, that is, organized on either side of an actual or implied axis that acts as a fulcrum (Fig. 2-1), or *central*, that is, radiating from or converging upon an actual or implied central point (Fig. 2-2). Axial balance may be *obvious* (symmetrical), having very similar or identical elements on either side of the axis (Fig. 2-1a, b, c), or it may be *occult* (asymmetrical), having an equilibrium of elements that are dissimilar in size or shape (Fig. 2-1d, e). Central balance

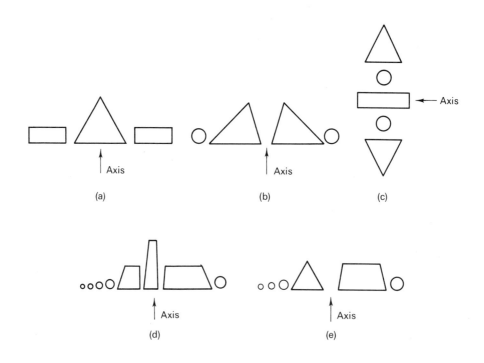

2-1 Types of axial balance: a, b, and c are in obvious axial balance; d and e are in occult axial balance.

(a)

(b)

(c)

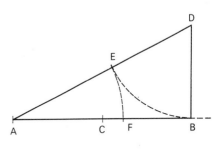
(d)

2-2 Types of central balance.

may also be obvious with similar elements in equilibrium around a center (Fig. 2-2a, b), or occult, using dissimilar elements (Fig. 2-2c, d). Axial balance and central balance usually become three-dimensional in sculpture, in architecture, and in painting that has the illusion of depth.

Different kinds of rhythm and balance, or the lack of them, can evoke strong reactions in the viewer of a work of art. Such reactions are in part due to the process of *empathy*, by which we identify with an object and tend to respond to it sympathetically. A statue of a man in an unbalanced or awkward pose may cause a sense of physical discomfort. Empathy is especially strong with images of our own species, but it also occurs in response to designs using forms that do not refer to nature.

Both rhythm and balance involve *proportion*, the size relationship of parts. It is partly because of proportion that some schemes of rhythm and balance are more satisfying than others. Throughout history, numerous theories have been proposed as bases for satisfying proportions. One of the most famous is that of the *Golden Mean*, whose mathematical ratio cannot be simply stated, though its proportions are easily found by using geometry (Fig. 2-3).

2-3
The Golden Mean. To divide line AB by the Golden Mean, first bisect the line (point C). At B, erect a perpendicular equal in length to AC. Complete the triangle ABD, and on the hypotenuse, AD, locate point E so that DE equals BD. Then locate point F on line AB so that AF equals AE. Line AB is divided by point F according to the proportions of the Golden Mean.

Repetition and Variation on a Theme

Several basic devices are used to achieve order and variety in art. One of these is repetition, the most elementary means of establishing order. We instinctively assume a relationship between similar or identical things. In the visual arts, repetition may appear in line, shape, mass, value, space, color, size, or even directional emphasis. At Moissac (Fig. 2-4), the sculptor used repetition to build an extremely symmetrical composition, or, more precisely, one of obvious axial balance. Such ritualistic formal order adds dignity to the subject. In Matisse's *Decorative Figure* (Plate 5), the scalloped shapes on the wall provide a theme or motif that is repeated with variations in the mirror, the plant, and the floor designs. Even the sturdy figure of the woman

2-4 *The Apocalyptic Christ,* twelfth century. 18'8'' wide, abbey church of St. Pierre at Moissac, France.

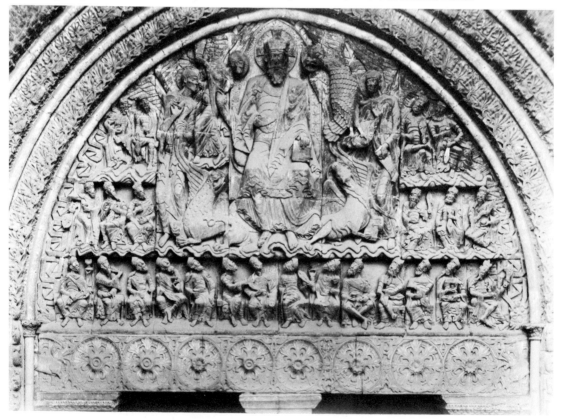

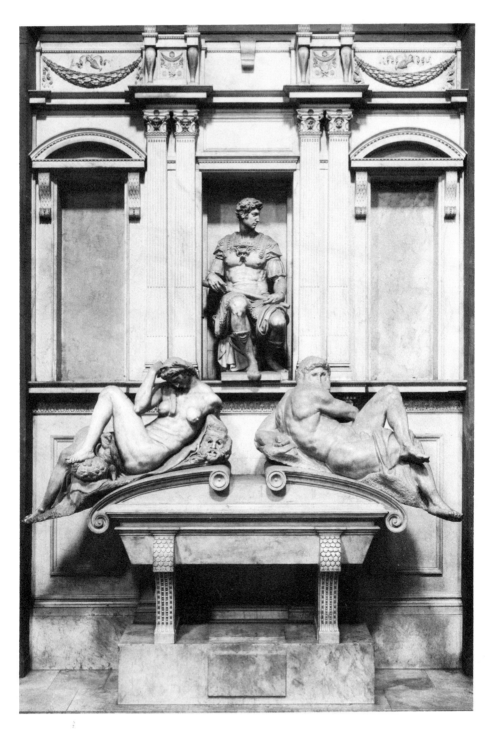

2-5 MICHELANGELO BUONARROTI, Tomb of Giuliano de' Medici, 1524–34. Marble, central figure approx. 6' high. New Sacristy, San Lorenzo, Florence.

is *modulated,* or modified, by curved drapery around the hips to conform to the other curved shapes. The rippling alternation of concave-convex shapes gives rhythmic vitality to the scene. Objects are further related by colors, such as the browns, greens, and yellows that are repeated with variations. Unlike the Moissac sculpture, Matisse's painting employs an occult axial balance. The figure is opposed by the potted plant and the diagonal floor lines, and the implied axis is a vertical line running through the knees of the figure to the bowl of fruit in the foreground.

In contrast, an obvious axial balance may employ repetition to unify opposing elements and to provide focus. For example, in Michelangelo's Tomb of Giuliano de' Medici (Fig. 2-5), the concave curves of the reclining figures are countered by the convex curve of the sarcophagus (Fig. 2-6). Within the obvious axial balance, symmetrical repetition of alternating curves leads our attention to the figure of Giuliano, who is given added importance by the buildup of repeated architectural forms.

The columns of the Parthenon (Fig. 9-10) create a rhythmic repetition of masses and spaces that adds variety to the rectangular building and enriches its symmetry. Subtle variation in the intercolumnar spaces helps to prevent monotony. The horizontals of the platform on which the temple sits are contrasted with repeated verticals in the columns and are echoed by horizontals in the roof, making an almost static balance with very sharply defined limits. In Amiens Cathedral (Fig. 1-29), a profusion of repeated vertical and horizontal elements frames variations on the theme of the pointed arch. The arches, in turn, frame circular or *foliated* (scalloped) openings and occasional standing figures. Complexity makes the compositional limits fuzzy, but order is achieved by repetition and variations on themes within the obvious axial balance.

Contrast

Contrast is basic to variation and important for visual interest. Contrast can be used to clarify or modify form, to create mass and space, to suggest activity, to provide balance, to express feeling, and to focus attention. The lively, aggressive personality of Picasso's *Three Musicians* (Fig. 1-14) depends on contrasts in color, in value, and in shape. Contrast of direction gives the African sculpture (Fig. 1-3) its tense equilibrium, while contrasts

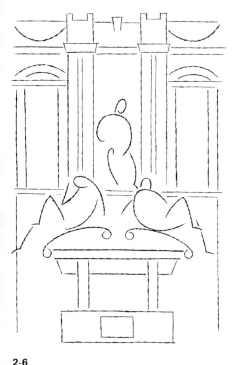

2-6

of texture, value, and color emphasize the horizontals of brick and concrete masses in the Robie House (Fig. 18-35).

Gradation and Climax

Gradation is smooth or step-by-step development that usually suggests direction and builds to a climax. Any of the visual and tactile elements may be treated in this way. In the *Supper at Emmaus* (Plate 3), Rembrandt developed a gentle gradation from shadow toward a climax of light that emphasizes Jesus. The Asam brothers used gradation and climax in light, in the pyramidal buildup of figure groups, and in the architectural setting (Fig. 1-27). At Amiens Cathedral (Fig. 1-29), the gradation in the size of the three main doors emphasizes the center one. Each entrance, in turn, is the focus of a funnel-like gradation of arches of decreasing size.

Suggestions for Further Study

Arnheim, Rudolf. *Art and Visual Perception: A Psychology of the Creative Eye.* Berkeley: University of California Press, 1954.

Gombrich, E. H. *Art and Illusion: A Study in the Psychology of Pictorial Representation.* New York: Pantheon Books, 1960.

Kepes, György. *The Language of Vision.* Chicago: Theobald, 1944.

Lowry, Bates. *The Visual Experience: An Introduction to Art.* Englewood Cliffs, N.J.: Prentice-Hall; New York: Abrams, 1961.

Moholy-Nagy, László. *Vision in Motion.* Chicago: Theobald, 1947.

Norberg-Schulz, Christian. *Intentions in Architecture.* Cambridge, Mass.: M.I.T. Press, 1965.

Pepper, Stephen C. *Principles of Art Appreciation.* New York: Harcourt Brace Jovanovich, 1949.

Pope, Arthur. *The Language of Drawing and Painting.* Cambridge, Mass.: Harvard University Press, 1949.

Scott, Robert G. *Design Fundamentals.* New York, Toronto, and London: McGraw-Hill, 1951.

Seiberling, Frank. *Looking into Art.* New York: Holt, Rinehart and Winston, 1959.

Zevi, Bruno. *Architecture as Space: How to Look at Architecture.* Edited by Joseph Barry, translated by Milton Gendel. New York: Horizon Press, 1957.

Chapter 3

Subject Matter

Subject matter is most simply defined as the recognizable objects depicted by the artist; yet subject matter acquires meaning on different levels and can be employed in different degrees.

Levels of Meaning in Subject Matter

Factual meaning in subject matter is established through identification of objects. Understanding the significance of the subject matter, however, frequently involves more than recognizing the objects. An inventory of the subject matter in Jan van Eyck's portrait of the Arnolfinis (Plate 1), for example, does not explain why the couple is so formally posed in the privacy of a bedroom; nor does a description of objects in Raphael's *Madonna of the Meadow* (Fig. 3-1) convey its content to a person unfamiliar with Christian scripture. Factual meaning is often supplemented or supplanted by meaning on other levels.

CONVENTIONAL MEANING

Certain objects, actions, and even colors acquire special meaning for a particular culture. In our culture, for example, the cross stands for Christianity, red suggests life or danger, and white is associated with purity. To understand the conventional or generally accepted symbolism of other cultures or historical periods, it is often necessary to do research. In the Van Eyck portrait, a number of symbols would be missed by the casual observer today. The painting is a testament to the marriage vow. The lone candle symbolizes the all-seeing Christ; the fruit on the window sill refers to the state of innocence before the Fall of Man; the mirror and the crystal beads are symbols of purity; the wooden shoes recall the command of God to Moses on Mt. Sinai to take off his shoes when he stood on holy ground; the dog stands for marital fidelity; and the back of the chair by the bed is carved in the image of St. Margaret, the patron saint of childbirth. The study of such conventional symbols is called *iconography*.

Some of the most pervasive symbols in Western art derive from the Christian tradition. The following are only a few of the hundreds of symbols used in Christian religious art, and for these only the more frequent meanings are included. The iconography of other cultures will be considered in the historical chapters in Part II.

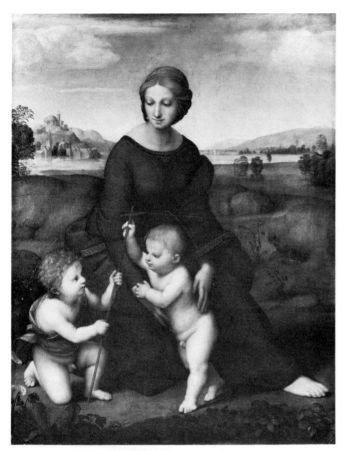

3-1
RAPHAEL SANZIO, *Madonna of the Meadow*, 1505. Panel, approx. 4' × 3'. Kunsthistorisches Museum, Vienna.

APPLE Tree of Knowledge in the Garden of Eden, hence evil. An apple held by Jesus or Mary means salvation from sin.

CARNATION Red means pure love; pink stands for marriage.

CAT Laziness, lust.

CHALICE Last Supper. A chalice with serpent identifies St. John the Evangelist. A chalice with wafer identifies St. Barbara. A broken chalice indicates St. Donatus.

COLUMBINE Holy Ghost.

CROSS The Latin cross (tall post with short crosspiece) refers to Jesus; the Greek cross (equal arms) stands for the Christian Church; an X-shaped cross refers to St. Andrew the Apostle.

DOVE Holy Ghost, peace, purity.

EAGLE St. John the Evangelist. Resurrection. Generosity.

EGG Resurrection, source of life.

EWER AND BASIN Purity, cleanliness.

FISH Christ, since the five letters for the Greek word for *fish* form the initials of the words: "Jesus Christ, God's Son, Savior."

FOUNTAIN Mary, seen as the "fountain of living waters" (Song of Solomon 4:12ff. and Psalms 36:9) because she was the mother of Christ the Savior. Medieval and Renaissance Christian art often interpreted Old Testament passages as predictions of New Testament events.

GARDEN, ENCLOSED Mary. A symbol of the Immaculate Conception of Mary (Song of Solomon 4:12).

GLOBE Earthly or spiritual power, held by God, Jesus, or a monarch.

GRAIN Body of Jesus (bread in Holy Communion).

GRAPES OR GRAPEVINE Christ as the "true vine" of which his followers are the branches (John 15:1, 5, 8). Blood of Jesus (wine in Holy Communion).

GRIDIRON St. Lawrence, who was martyred on a grid over a fire.

HALO Saintliness. A round halo is most common. A triangular halo reflects the Trinity; a square halo refers to living persons.

HAMMER Instrument of the Passion, used in the Crucifixion.

INRI The initials of the Latin words for *Jesus of Nazareth, King of the Jews*, which appear on the Cross of Jesus.

IRIS Sorrow and purity of Mary. The bladelike leaf is associated with a sword and alludes to the suffering of Mary.

KEY St. Peter, a reference to Christ's charge to Peter of the keys of the kingdom of heaven (Matthew 16:19).

LADDER Instrument of the Passion, used in the Crucifixion.

LAMB Jesus, the sacrificial lamb of God. The sinner saved by Jesus the Good Shepherd. St. John the Baptist. St. Agnes. St. Clement.

LAMP Wisdom.

LIGHT Christ.

LILY Purity, Mary.

LION Jesus. St. Mark the Evangelist. St. Jerome. Majesty.

MANDORLA Almond-shaped radiation of light surrounding the whole body of Jesus or Mary and signifying divinity.

MOON Mary, who is identified as the woman with the moon under her feet (Revelations 12:1).

NAILS Instruments of the Passion.

OINTMENT BOX Mary Magdalene, a reference to her anointing of Christ.

OLIVE Peace.

OX OR BULL St. Luke the Evangelist. The Jewish Nation. Patience.

PALM Victory.

PEACOCK Vanity. Immortality, because of the ancient belief that the flesh of the peacock does not decay.

PILLAR Instrument of the Passion (the pillar to which Christ was tied while he was whipped).

RIVERS The four rivers of Paradise, thought to flow from the same rock, symbolize the four Gospels, which had their source in Jesus.

ROSE Red for martyrdom, white for purity.

SCALES Equality and justice. The Archangel Michael is often shown with scales for the weighing of souls.

SCOURGE Instrument of the Passion.

SHIP The Christian Church, referring to the ark of Noah and the Church as means of salvation.

SKULL The vanity of earthly life (often shown with St. Jerome). A skull at the foot of the Cross refers to Adam and indicates the Cross as a means of salvation from man's original sin.

SPEAR Instrument of the Passion.

SPONGE Instrument of the Passion.

STAR Divine guidance, as in the journey of the Magi. One star is also the symbol of Mary. Twelve stars stand for the Apostles or for the twelve tribes of Israel.

SUN Mary (Revelations 12:1).

SWORD A symbol of martyrdom by the sword, often shown with St. Paul, St. Peter, St. Justina, St. Agnes, and many others.

THORNS Sin, grief. Instrument of the Passion (Christ's crown of thorns).

TOWER Identifies St. Barbara, who was confined in a tower.

WATER OR A WELL Purification, baptism, rebirth.

WHALE A symbol of the Devil or of the story of Jonah.

WHEEL Identifies St. Catherine, who was tortured on a wheel.

XP The Greek letters *Chi* and *Rho*, the first two letters in the Greek word for Christ. They are often superimposed: ☧

A society often modifies its iconography according to changes in prevailing tendencies in thought. The study of factors causing changes in iconography and

the interpretation of such changes within the history of thought is called *iconology*.

SUBJECTIVE MEANING

The individual artist may consciously or unconsciously employ a private symbolism based on an association of certain objects, actions, or colors with past experiences, a temporary state of mind, or an adopted world view. Likewise, the observer tends to interpret art according to his own associations, and over this interpretive activity the artist never has complete control. In a sense, therefore, a work of art is re-created anew each time it is experienced by an observer. Dali (Fig. 3-2) paints objects in such a way as to encourage a wide range of individual interpretation. So did Kandinsky (Fig. 18-1), who felt that painting should make its appeal on the same nonrepresentational basis as music. Mondrian (Fig. 3-3) argued that recognizable objects were impurities that distracted the observer from the essential quality in art: a unique equilibrium of line and color. Thus his work can be described as the most "subjectless," that is, the least encouraging to associational meaning.

3-2 SALVADOR DALI, *The Persistence of Memory*, 1931. Oil on canvas, 9½″ × 13″. Museum of Modern Art, New York.

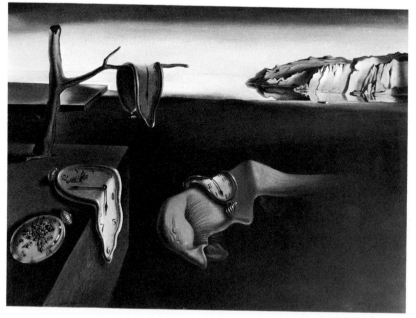

Degrees of Subject Matter

Writers on art generally employ three terms to classify works according to degree of subject matter. These categories overlap somewhat, but the terms are worthwhile if they are used cautiously. *Representational* art has clearly recognizable objects (Fig. 17-7); *abstract* art has a basis in identifiable objects (Fig. 1-14); and *nonobjective* art has no direct reference to such objects, that is, no subject matter (Fig. 3-3). These terms may be applied from either the artist's or the observer's standpoint, with possible disagreement. The artist may work so abstractly that the observer finds no apparent subject matter and assumes the painting to be nonobjective; conversely, the artist may work nonobjectively, but the observer may see recognizable objects in the work and consider it to be abstract. It is important to recall that recognizing objects in representational or abstract art is not necessarily grasping its content. Content in both representational and abstract art is an interaction of subject matter with the interpretive qualities of the visual and tactile elements. In fact, subject matter may acquire meaning on different levels if it is present in any degree.

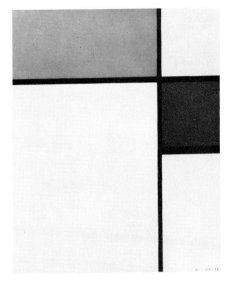

3-3
PIET MONDRIAN, *Composition with Blue and Yellow,* 1932. Oil on canvas, 16¼" × 13". A. E. Gallatin Collection, Philadelphia Museum of Art.

Suggestions for Further Study

Ferguson, George. *Signs and Symbols in Christian Art.* New York: Oxford University Press, 1961.

Gilson, Étienne. *Painting and Reality.* New York: Meridian Books, 1959.

Ogden, C. K., and I. A. Richards. *The Meaning of Meaning.* New York: Harcourt Brace Jovanovich, 1959.

Panofsky, Erwin. *Gothic Architecture and Scholasticism.* New York: Meridian Books, 1957.

————. *Meaning in the Visual Arts: Papers in and on Art History.* Garden City, N.Y.: Doubleday, 1955.

————. *Studies in Iconology: Humanistic Themes in the Art of the Renaissance.* New York: Oxford University Press, 1939.

————, and Dora Panofsky. *Pandora's Box: The Changing Aspects of a Mythical Symbol,* rev. ed. New York: Pantheon Books, 1962.

Pierce, James Smith. *From Abacus to Zeus: A Handbook of Art History.* Englewood Cliffs, N.J.: Prentice-Hall, 1968.

Chapter 4

Techniques

The content of a work of art depends in varying degrees on its visual and tactile elements, which in turn depend on the materials and techniques used. A particular material, along with the technique appropriate to it, is often called the *medium* (plural, *media*) *of expression.* We can better understand a composition if we know something of the problems and possibilities inherent in the medium. Today artists often combine many media in one work; the result is often referred to as *mixed media.*

Drawing

Though generally identified with line, drawing is a term used so broadly that it often overlaps the realm of painting. A drawing may be a *study,* an investigation of a certain detail of what may become a more extensive work; it may be a *sketch,* the quick notation of the general organization and effect of a composition; or it may be a *cartoon,* a full-size composition meant to be transferred to another surface for a finished work.

In *pencil drawing,* a wide range of values is possible with *leads* (graphite) of differing hardness. Hard lead on a smooth surface is good for a precise light line, such as that in Picasso's drawing of Dr. Claribel Cone (Fig. 1-1); soft lead applied to a rough surface gives a dark line with grainy texture. If the lead is sharpened to a wedge shape, it can be twisted to create a line with considerable modulation.

In *ink drawing,* great variety is possible through the use of colored inks, colored papers, inks of differing degrees of opacity, and different pen points. Formerly pens were made by splitting quills or reeds; nowadays pen points of many shapes and sizes are available in steel. Modulation in line depends on the point's width and on its flexibility, which governs the spreading of the split point. Today pens with felt-tip points add to the range of possibilities.

Charcoal varies in hardness; it can be used directly for crisp lines, or it can be rubbed to produce soft grays. Large areas can be covered quickly in a variety of values characteristic of painting. Charcoal does not adhere well. Soft paper with considerable *tooth* (texture) takes it best, and smearing is minimized if the drawing is sprayed with a *fixative* (thin varnish).

Chalk and *pastel* are made of powdered pigments (coloring matter) mixed with glue and formed into

sticks. *Crayon* is made of pigment mixed with wax; it adheres well but does not lend itself to rubbing for soft gradations. Pastels and chalks are more powdery because of their weak glue binder. They have the advantages and disadvantages of charcoal and require a fixative.

Brush drawing—application of ink or watercolor with a brush—is often used in combination with pen-and-ink or pencil. In *dry brush drawing*, ink or watercolor is used dryly, permitting great detail and easy correction. In *wash drawing*, watercolor or ink diluted with water is used for flowing transparent washes, and correction is more difficult. In brush drawing of both types, usually only one or two colors are used. The color limitation differentiates brush drawing from watercolor painting.

Printmaking

A *print* is a work of art produced by a duplicating process. It is considered an original rather than a reproduction because the artist works toward the print as the end product. For this reason the print has been called a multiple original. Many artists perform the whole process themselves; some prepare the printing surface and have special printers make the prints; still others create the composition only and have specialists transfer it to a printing surface and make the prints. In any case, the artist must understand the printing process to be used if he is to exploit its possibilities effectively. The total number of prints is called an *edition*. After the edition is printed, the printing surface is usually destroyed or *canceled* (x'd out with lines). The edition is thus limited, and the prints are more valuable to collectors. Today the artist frequently signs each print in pencil on the margin and uses a fraction to indicate the place of that particular print in the total edition; the number 6/45 would mean the sixth print in an edition of forty-five. Trial prints made during the preparation of the printing surface are called *artist's proofs*. Different stages of the composition (often indicated by artist's proofs but sometimes carried out even during the printing of the edition) are called *states*. A composition may have one or many states. An artist might make a number of prints of a landscape and then decide to add a cloud in the sky. Prints without the

cloud would be first-state; prints with the cloud would be second-state.

The many processes used in printmaking may be grouped in four broad categories, although the contemporary tendency to mix techniques within each of these general groups sometimes makes it difficult for the observer to know how a print was produced.

RELIEF PROCESSES

In a *relief process*, the artist cuts away parts of the printing surface. The parts of the surface left raised (*in relief*) are inked, and the ink is then transferred to paper.

For *woodcuts*, a piece of wood is cut or gouged to leave the design in relief. Prints may be made with a press or by placing paper over the inked block, and rubbing it with a spoon or other smooth instrument. Color woodcut prints traditionally are made with a separate block for each color. Careful *registration* is necessary to ensure that each color is printed exactly in the proper area. Transparent colors may be overlapped to produce additional colors, and colored paper may be used. Woodcut lends itself to bold lines and large areas of light and dark. Sometimes the grain of the wood or the texture of the paper will be evident in the print.

In *wood engraving*, a hard end-grain (grain at right angles to the surface) block is used, allowing easy cutting in any direction. *Burins* (cutting tools) of various shapes and sizes are employed, and great detail is possible.

For *linoleum cuts*, linoleum mounted on a wood block is cut in the same manner as a woodcut. The surface is soft, and there is no wood grain to exploit. Like a woodcut, the linoleum cut does not encourage great detail.

In a *metal cut*, metal is cut away with engraving tools, or the surface is lowered with punches; or the design may be drawn with acid-resistant material and the rest of the plate eaten (*etched*) with acid, leaving the design in relief.

INTAGLIO PROCESSES

In *intaglio processes*, the low parts, rather than the relief parts, of the printing surface carry the ink. The lines of the design are cut or eaten into a metal plate (usually copper). Ink is forced into these lines, and the surface

of the plate is wiped clean. A high-pressure press forces dampened paper against the surface and into the depressed lines. Often the dried ink can be felt standing in relief on the surface of the finished print. Unless the plate is larger than the print paper, the pressure of the press mashes the paper down around the edges of the plate and makes an indented *plate mark*, which may later be cut away. Since the pressure of the press slowly breaks down the edges or ridges between the intaglio lines, the size of an edition is limited (unless the copper plate is electroplated with a firmer metal), and early prints in an edition are generally valued more highly than later ones. As in the relief processes, a separate plate is employed for each color.

The sunken lines that hold the ink in an intaglio plate may be produced in several ways. In the *drypoint* process, a sharp point is used to scratch lines into the soft copper plate. Tiny ruffles of displaced metal (*burr*) pile up along the sides of each scratch. The ink held by the burr creates slightly fuzzy lines that can be used very effectively by the artist (Fig. 1-2). The burr quickly wears off, however, and drypoint editions are small.

For *metal engraving*, burins are used to cut out the metal, rather than to push it aside as in drypoint (a drypoint plate with the burr worn off produces the same effect as an engraved plate). Great sharpness and precision are possible. Engraving is often used in combination with etching.

In the process of *etching*, a copper plate is coated with acid-resistant material (*ground*) through which the lines of the design are easily drawn. The plate is then immersed in acid, which eats into the metal wherever lines have been scratched through the ground. Thus the artist does not fight the resistance of the metal, and lines are produced more easily than in drypoint or engraving. Some lines may be etched a longer time than others to obtain greater depth; these hold more ink and provide greater darkness of line in the print. Etched lines are generally softer and freer than engraved lines. In *soft ground etching*, the ground is so soft that lines drawn on a paper placed on the plate pick up the ground when the paper is pulled away from the plate. The plate is then etched. Fabrics and other materials may be pressed into the soft ground and lifted off. The ground is pulled away where the texture of the material pressed into it, and the texture of the material can then be etched into the plate. *Aquatint etching* produces soft sandy or speckled areas. It is done by sifting resin powder onto a heated plate. The resin melts partially and sticks to

the plate. Acid attacks the metal exposed between the resin particles and produces thousands of tiny pits that hold ink and create speckled areas on the print. The evenness and darkness of the aquatint will depend on the amount of resin sifted onto the plate, the size of the resin particles, and the length of time the plate is exposed to acid. Although resin is sifted over the whole plate, the aquatint effect is limited to chosen areas by *stopping out* other areas with acid-resistant varnish.

PLANOGRAPHIC PROCESSES

As the name implies, these methods print with a level rather than a raised or lowered surface.

The *monotype* process produces only a single print. Inks or paints are brushed, dripped, or rubbed on a smooth glass or metal plate. A paper is laid over the plate and rubbed. Wide varieties of superimposed colors and textures are possible with this procedure.

For *lithography*, the printing surface is traditionally fine-grained limestone, but in commercial lithography metal plates are used. The drawing is done with grease-containing crayons, pencils, or inks; the surface is then treated chemically to make it reject ink except where the greasy substance has established the drawing. Printing is done with a special press.

STENCIL PROCESSES

One of the most important stencil processes is *silk-screen*, often called *serigraphy*. Many methods are used. Basically, the idea is to fill or cover the pores of the silk (stretched on a frame), leaving them open only in the shape of the design. Colored inks are then rolled or scraped across the silk and penetrate to form a print of the design on paper or cloth underneath.

Painting

Oil paint, watercolor, crayon, and pastel can all be made from the same pigment. The differentiating factor is the *binder* (the substance that holds the color particles together and makes them adhere to a surface). The word "paint" is normally applied to media that are used in liquid or paste form. The immediate surface that receives the paint is called the *ground* (an entirely different meaning, obviously, from an etching ground). For watercolor, the ground is usually the surface of the paper.

For many paints applied to wood or canvas, intervening substances such as *sizing* and *priming* must be applied to limit the absorption of the base material. Then the panel or canvas becomes the *support*, and the preparatory coating becomes the ground. Paint may be applied in a single layer (*alla prima*) or in many layers. Transparent layers are called *washes* in watercolor and *glazes* in oil paint. Opaque color can be rubbed or dragged loosely over previous colors to modify them without obscuring them, a process called *scumbling*. Paint applied very thickly is called *impasto*.

TEMPERA PAINTING

In *tempera* painting, the binder is an emulsion (a mixture of oil and water) that may include casein, glue, gum, egg, or egg and oil. The advantages of tempera are its quick drying ability, its potential for precise detail, its resistance to yellowing and darkening with age, its relative insolubility when dry, and—for some types of tempera—the convenience of taking a water thinner. The disadvantages are the brittleness of some tempera formulas, the difficulty in blending it smoothly, some change in color and value as it dries, and the impossibility of creating impasto textures.

WATERCOLOR PAINTING

The binder in watercolor is an aqueous solution of gum. For whites, transparent watercolor depends on the whiteness of the paper, and colors are lightened by thinning with water. The quality of the paper is very important because yellowing can spoil the colors as well as the whites. Advantages of watercolor are the cheapness and lightness of the materials, the quickness with which large areas can be covered with washes, the rapid drying time, and the lively sparkle of transparent washes over the white ground. Disadvantages of transparent watercolor are the difficulty of correction, the change in value during drying, and the necessity of working from light to dark. Opaque watercolor, or *gouache*, sacrifices transparency and quick washes for greater ease of correction and the possibility of using light colors over dark ones.

OIL PAINTING

The most common binder in oil paints is linseed oil. Most supports (wood, canvas, or synthetic materials)

require a ground of oil or synthetic primer. For glazing purposes, complex thinning mixtures are used to increase transparency, to add flexibility, or to speed drying. The advantages of oil paint are its permanence and durability, its range of textural effects from light scumble to heavy impasto, the ease with which it can be manipulated and corrected, and the fact that colors do not change in drying.

FRESCO PAINTING

True fresco, or *buon fresco,* is done with pigments combined with just a water "binder." The ground is wet lime plaster, usually on a wall. The paint becomes part of the ground and is very permanent. The mat, or dull, surface of fresco allows the painting to be seen easily from all angles without disturbing reflections. *Fresco-secco* is painting on a dry plaster surface, and a variety of media—tempera is common—may be used.

ENCAUSTIC PAINTING

The binder used in *encaustic* painting is refined beeswax with additives. Paints are mixed on a heated *palette* (mixing surface) and applied quickly to a rigid surface, usually a wood panel; in classical antiquity, encaustic was sometimes used on sculpture. A heat source (today, an electric coil) is then passed over the surface to "burn in " the wax. The inconvenience of heating is compensated for by the extraordinary range of effects from transparency to impasto, the quick drying time, and the permanence of the colors.

OTHER MEDIA

Casein paints, with a casein glue binder, harden to a water-resistant but brittle surface, requiring a rigid support. They have the conveniences of taking a water thinner, drying rapidly, and producing a mat finish, which does not create annoying light reflections as does a shiny surface. Modern science has developed synthetic binders such as acrylic resin and polyvinyl acetate that are also fast-drying and have a mat finish. With some such paints, water can be used for thinning and the dried surface is water-resistant. Heavy impasto is not possible with many of these paints unless they are combined with pastes or paints that have been specifically developed for impasto effects.

Stained Glass

Designs or pictures in colored translucent glass became especially important in the Medieval period. The basic color of each piece of glass came from chemicals, mainly metallic oxides, added in a molten state. The glass was blown to produce sheets from which pieces were cut for the design. Details were painted on the surface with a mixture of powdered glass and lead or iron oxides and fused by firing.

Sculpture

Sculpture may be freestanding or in relief (projecting from a background). Relief sculpture may be *high relief,* such as Ghiberti's *Sacrifice of Isaac* (Fig. 14-12), with high projections from its background, or *low relief,* with forms projecting only slightly.

MODELING AND CASTING

Modeling is an additive process of building up a sculpture from plastic material such as clay or wax. A wire, pipe, or wood *armature* (frame) can be used inside the work to prevent sagging (Fig. 4-1). No tools are necessary for modeling, although wooden spatulas with wire loops at one end are convenient for shaping and cutting. For permanence, natural clay can be *fired* (baked) in a *kiln* (oven), but it then cannot contain an armature, since shrinkage of the clay during firing would cause cracking, nor can it be of vastly different thicknesses. *Ceramic glazes* (a fine clay or glass coating) may be fired on the clay work, making possible a variety of textures and transparent or opaque colors. All fired clay may be called *terra cotta,* but the term refers more precisely to a brown-red unglazed clay.

Another way that clay sculpture may be given permanence is to cast it in plaster. A plaster mold is made while the clay is still wet. The mold is removed and oiled, soaped, or treated in some other way so that new plaster will not stick to it. After the mold has been reassembled and sealed, it is filled with plaster. Small sculptures may be cast solid; larger ones should be hollow. After the plaster has set, the mold is pulled or chipped away. This type of mold is called a *waste mold* because it is usually destroyed to free the cast within; for more than one cast a rubber or gelatin mold

4-1 An armature.

may be used. Plaster may be colored to make it resemble metal or stone.

Both cast plaster and fired clay are breakable; for the greatest permanence in sculpture, the traditional materials are stone and bronze. In the *sand mold* process of bronze casting, *French sand* (a mixture of clay, silica, and alumina) is pressed around a plaster cast of the work to form a mold. The parts of the sand mold are fitted into a *flask* (iron holder), and a core of French sand is made to fill the sand mold except for a one-eighth to one-quarter inch air space all the way around. The core is suspended inside the sand mold and flask by metal rods. Holes are made in the mold so that air can escape as molten bronze is poured into the air space between the core and mold. After the bronze has cooled, the mold is removed and the core is dug out. The hollow bronze cast needs much cleaning up before special workers (*patineurs*) can give the cast its *patina* (color) by acid baths and heat treatment. In the *lost wax* (*cire perdue*) method of bronze casting, the following procedure is one of several that may be used. A gelatin mold and a plaster shell to support it are made from the sculptor's plaster cast of the original clay work. On the inside of the gelatin mold, layers of wax are built up to the desired thickness of the bronze. The gelatin is removed, and the hollow wax replica is filled with a

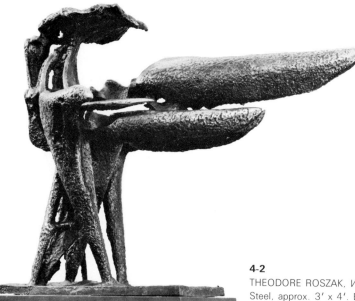

4-2
THEODORE ROSZAK, *Whaler of Nantucket*, 1952.
Steel, approx. 3' x 4'. Edward A. Ayer Collection,
Art Institute of Chicago.

core of heat-resistant material. This material is also used to form a mold around the outside of the wax. Metal rods hold the core inside the mold, and vents are made in the mold to allow the melted wax to drain away when the assembly is heated. The air space left between the core and the mold by the removal of the wax is filled with bronze. The mold and core are taken away, and the finishing process begins.

Today the sculptor may do *direct sand casting* by working negatively, that is, creating the mold directly in a special sand mixture. Iron and aluminum are frequently used for the cast.

Another material common today is *cast stone.* A heavy reinforced plaster or gelatin mold is made from the original clay work, and a mixture of stone dust, pigment, sand, and cement is poured or packed into the mold. Sometimes an armature is included to reinforce the cement. After several days of drying, the mold is pulled or chipped away, and the cast can be finished by filing or carving.

CARVING

The carver must have foresight, since the subtractive process does not allow for addition if too much is cut away. The most common materials, stone and wood, have different kinds of textures and grains that have aesthetic potential for the sculptor. The stone carver uses hammers, picks, drills, and toothed chisels to rough out the form. Chisels and abrasives are used for finishing. The wood carver works with chisels, gouges, files, and sandpaper. Frequently the sculptor does the final work from a smaller preliminary model. A *pointing machine* may be used to transfer the proportions of the model to a larger block.

CONSTRUCTION

Constructed sculpture, of which Gabo's *Linear Construction* (Fig. 18-25) and Roszak's *Whaler of Nantucket* (Fig. 4-2) are examples, has become increasingly important during the twentieth century. The sculptor uses any materials or ready-made objects to build his composition, often soldering or welding them. The strength of metals and plastics has made possible very open forms. Different colors are obtained by the use of different metals, by painting, or by controlled oxidation. *Kinetic sculpture*, or mobile sculpture, utilizes air currents or motors to bring actual movement into the composition.

Architecture

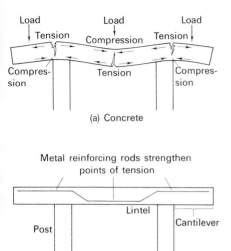

4-3 Post and lintel construction.

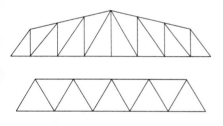

4-4 Trusses.

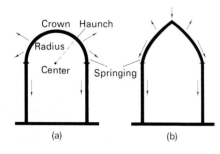

4-5 The dynamics of arches.

The basic diagrams of architectural design are *perspective views, plans,* and *elevations.* A perspective view shows how the building will appear in three dimensions. A plan shows the two-dimensional distribution of interior spaces, walls, windows, and doors. An elevation shows the side of a room or a building without perspective distortion. Other kinds of diagrams, such as *cross sections, longitudinal sections,* and *orthographic projections* are also used to clarify spatial and structural relationships in architecture.

Traditional architectural materials are wood, mud brick, plaster, concrete, stucco, and masonry of stone or fired brick. More recent materials are iron, steel, aluminum, glass, reinforced concrete (ferroconcrete), plywood, and plastics. The strength of reinforced concrete has made it possible for floors, roofs, or ramps to twist, turn, and thrust out into space with very few points of support. Prestressed concrete is particularly strong; here the concrete is allowed to harden around stretched steel cables, or cables are run through the concrete in tubes and anchored under tension at each end. The result is a built-in compression that offsets the weakness of concrete under tension.

POST AND LINTEL

The simplest type of structure is post and lintel, a combination of uprights (*posts*) supporting a crosspiece (*lintel*). Columns, such as those of the Parthenon (Fig. 9-10), often serve as posts. The span between posts is severely limited by the strength of the material in the lintel. In the twentieth century, steel, reinforced concrete, and prestressed concrete have made possible very wide spans (Fig. 4-3). A lintel that extends beyond its supports (Fig. 4-3b) is called a *cantilever.* Lintels are frequently made in the form of *trusses,* very strong but light frameworks made of small pieces fastened together in such a way that they brace each other (Fig. 4-4). Special strength is provided by the perfect rigidity of a triangle.

ARCH

An arch diverts the load—the weight sustained—to the sides as well as down toward the vertical, making possible wider spans than does a post and lintel system in the same material; the arrows in Figure 4-5 show the forces exerted by weight and the tendencies of the

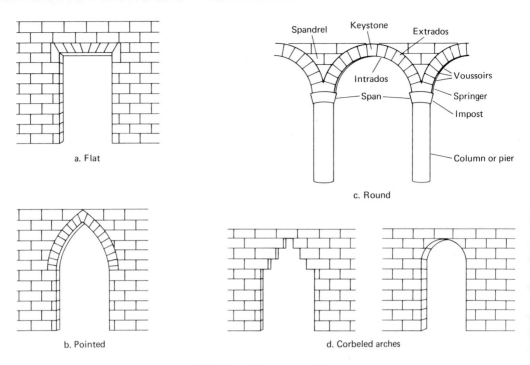

a. Flat

c. Round

Spandrel · Keystone · Extrados · Intrados · Span · Voussoirs · Springer · Impost · Column or pier

b. Pointed

d. Corbeled arches

4-6 Types of masonry arches.

arch to fall in and the walls to buckle out. Until the nineteenth century and the development of steel and ferroconcrete, the most common arch was the masonry arch, a structure of wedge-shaped blocks spanning an opening. True arches have several forms. One, the flat masonry arch (Fig. 4-6a), resembles the post and lintel. The steep sides of a pointed arch divert the load more directly toward the ground (Fig. 4-6b) and require less outside *buttressing* (bracing) than the round arch (Fig. 4-6c). A *corbeled arch* (Fig. 4-6d) is not a true masonry arch; it sacrifices strength to avoid the more precise cutting required in the wedge-shaped blocks of the true arch (Fig. 4-6a, b, c). A masonry arch is supported during the course of its construction by a wooden scaffolding called *centering*.

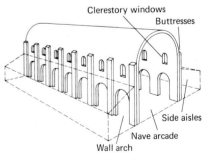

4-7 Tunnel vault.

VAULT AND DOME

Vaulting is arched roofing of stone, brick, or concrete. The *tunnel, barrel,* or *wagon vault* is an extension of a round arch (Fig. 4-7). It requires continuous buttressing along the sides. In Medieval masonry, the common solution to the buttressing problem was thick walls. Windows were infrequent and kept below the level of the *springing* (the beginning of the curve of the arch) to avoid weakening the vault (Fig. 4-8). The inte-

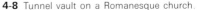

Clerestory windows · Buttresses · Side aisles · Nave arcade · Wall arch

4-8 Tunnel vault on a Romanesque church.

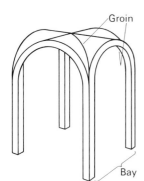

4-10 Cross vault.

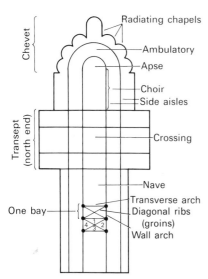

4-11 Robert De Luzarches, plan of Amiens Cathedral.

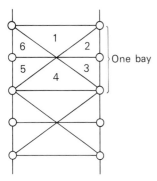

4-12 Plan of a sexpartite vault.

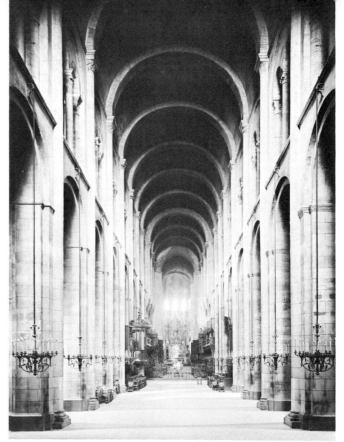

4-9 Interior of St. Sernin, Toulouse, France.

rior view of St. Sernin (Fig. 4-9) shows how Medieval vaults were often divided into *bays* (sections) by *transverse arches* (arches at right angles to the length of the vault that have the appearance and sometimes the function of reinforcements). The bay division was often continued all the way down to the floor by *engaged columns* (columns partially buried in the wall). In Medieval architecture, vaulting is so important that it is often indicated on floor plans. The plan of St. Sernin (Fig. 13-10) shows the transverse arches in dotted lines.

Greater strength and flexibility are obtained if two vaults are crossed at right angles (Fig. 4-10). The *cross vault*, or *groin vault*, focuses the load on four legs and allows the sides to be opened up. The exterior indentations where the vaults meet are the *groins*. On the interior the groins project as ridges. From directly above or below, the groins form an X-shape between the transverse arches and are so indicated on the plans (Fig. 4-11). When the groins are emphasized by moldings or *ribs* on the interior, the vault is called a *ribbed cross*

vault, a series of which can be seen over the nave of Amiens Cathedral (Fig. 13-29). It is thought that in Medieval architecture the ribs were often built first, as a skeleton to shape the vault, and panels of stone were filled in between ribs and side arches. Since the X formed by the ribs divides the vault into four parts, it is called a four-part, or *quadripartite*, vault. Sometimes an additional transverse arch was added in the center of the X, creating a six-part, or *sexpartite*, ribbed cross vault (Fig. 4-12). Figure 4-10 shows the intersecting tunnel vaults, wherein the height of the arches and the ribs is kept level. Semicircular ribs, however, would create a domical form (Fig. 4-13) since the ribs have a much longer diameter than that of the wall arches. The level *crowns* (tops) of the vaults in Figures 4-10 and 4-13b are made possible by depressing the ribs to less than semicircles, but depressed arches are weaker than semicircular ones. A level effect can be achieved without sacrificing strength if the principle of the pointed arch is applied to the vaulting. The pointed ribs and arches are easily adjusted to different heights by varying the degree of pointedness (Fig. 4-13c), as was done at Amiens Cathedral (Fig. 13-29). The pointed ribbed cross vault, like the pointed arch, can be built higher with less buttressing. As the height of Medieval vaults increased, *flying buttresses* (arched segments carrying the thrust from vaults to vertical buttresses) were developed to help bear the load by transferring the thrust of the vaults to buttresses along the outer walls (Fig. 4-14).

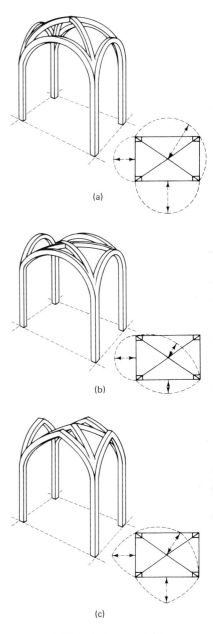

(a)

(b)

(c)

4-13 Ribbed cross vaults.

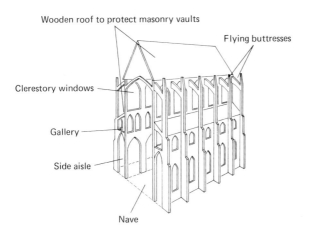

Wooden roof to protect masonry vaults

Flying buttresses

Clerestory windows

Gallery

Side aisle

Nave

4-14 Section of a Gothic cathedral.

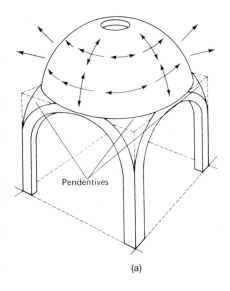

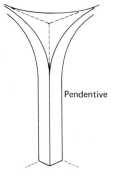

Pendentives

(a)

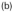

Pendentive

(b)

Squinch

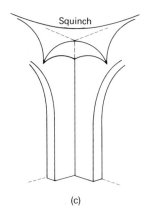

(c)

4-15 The dome and its supports.

Domes may be hemispherical, less than hemispherical (like the depressed arch), or pointed. The problem of buttressing varies accordingly. To hold in the outward buckling tendency, large domes may be made of massive thickness or have circling bands of chain or wood buried in the masonry or concrete (modern domes may be made of ferroconcrete). Unlike the arch, the dome is not weakened by an opening in the crown, because the inward leaning only wedges the circular form more tightly together, and the load forces pushing inward are converted to an outward buckling tendency (Fig. 4-15a). Openings in the sides of a dome, however, tend to destroy the circular system of self-support and require special buttressing. The use of a dome over a square room requires a transition to the round base of the dome. Two solutions have been widely used: the *pendentive* and the *squinch*. The pendentive cuts off or fills in the corners of the square with curved triangular fillets (Fig. 4-15b). The squinch provides a more abrupt transition by arching over the corners to form an octagonal base, which is easily accommodated to the circular dome (Fig. 4-15c).

Two of the more striking forms developed in recent years are the *geodesic dome* and the *hyperbolic paraboloid*. The geodesic dome utilizes the geometry of the tetrahedron to create a light structure of enormous strength (Fig. 4-16). Buoyant spacious effects are possible with the hyperbolic paraboloid, where straight members can be used to construct a curved surface of great strength (Fig. 4-17).

4-16 Geodesic dome.

4-17 Hyperbolic paraboloid.

DRAWING

Collier, Graham. *Form, Space, and Vision: Discovering Design Through Drawing.* Englewood Cliffs, N.J.: Prentice-Hall, 1963.

Kaupelis, Robert. *Learning to Draw: A Creative Approach to Expressive Drawing.* New York: Watson-Guptill, 1966.

Moskowitz, Ira, ed. *Great Drawings of All Time.* 4 vols. New York: Shorewood, 1962.

Nicolaïdes, Kimon. *The Natural Way to Draw.* Boston: Houghton Mifflin, 1941.

PRINTMAKING

Biegeleisen, J. I., and M. A. Cohn. *Silk Screen Techniques.* New York: Dover, 1958.

Brunsdon, John. *The Technique of Etching and Engraving.* London: Batsford; New York: Reinhold, 1965.

Hayter, S. W. *About Prints.* London: Oxford University Press, 1962.

Heller, Jules. *Printmaking Today: An Introduction to the Graphic Arts.* New York: Holt, Rinehart and Winston, 1958.

Ivins, William M., Jr. *How Prints Look: Photographs with a Commentary.* Boston: Beacon Press, 1958.

PAINTING

Doerner, Max. *The Materials of the Artist and Their Use in Painting,* rev. ed. Translated by Eugen Neuhaus. New York: Harcourt Brace Jovanovich, 1949.

Mayer, Ralph. *The Artist's Handbook of Materials and Techniques,* rev. ed. New York: Viking Press, 1957.

SCULPTURE

Clarke, Geoffrey, and Stroud Cornock. *A Sculptor's Manual.* London: Studio Vista; New York: Reinhold, 1968.

Gross, Chaim. *The Techniques of Wood Sculpture.* New York: Arco, 1965.

Hale, Nathan Cabot. *Welded Sculpture.* New York: Watson-Guptill, 1968.

Lynch, John. *Metal Sculpture: New Forms, New Techniques.* New York: Viking Press, 1957.

Norman, P. Edward. *Sculpture in Wood.* New York: Transatlantic Arts, 1966.

Rich, J. C. *The Materials and Methods of Sculpture.* New York: Oxford University Press, 1947.

ARCHITECTURE

Collins, Peter. *Concrete: The Vision of a New Architecture.* London: Faber & Faber, 1959.

Giedion, Sigfried. *Space, Time, and Architecture,* 4th ed. Cambridge, Mass.: Harvard University Press, 1962.

Gropius, Walter. *Scope of Total Architecture* (World Perspectives, Vol. 3). Edited by Ruth N. Anshen. New York: Harper & Row, 1955.

Hamlin, Talbot. *Forms and Functions of Twentieth-Century Architecture.* 4 vols. New York: Columbia University Press, 1952.

Wright, Frank Lloyd. *Frank Lloyd Wright: Writings and Buildings.* Edited by Edgar Kaufmann and Ben Raeburn. New York: Meridian Books, 1960.

Chapter **5**

Problems of Value Judgment

Problems of Objectivity and Subjectivity

Value judgment in art involves factors of varying degrees of subjectivity. The most obvious objective factors seem to miss the point. Physical permanence—that is, the artist's skill in producing a work that does not deteriorate—can be measured easily but is of little value unless the art object is worth preserving. Some objectivity is possible in measuring the artist's skill in depicting recognizable objects when to do so seems relevant to the work, but such mechanical aptitude alone does not guarantee significant content. We may judge with some objectivity the extent to which the artist has exploited the expressive possibilities of his medium; yet he may have deliberately limited the range of colors in his painting, the modulation of line in his drawing, or the variety of texture and color in his architecture. Furthermore, limitations may have been imposed upon him by his time and place. The artist of ancient Egypt did not have the technical knowledge available to the artist of the nineteenth century, but we do not assume that, for this reason, any work produced by a competent nineteenth-century artist is superior to the best work of the older culture. The quality of artistic achievement has not progressed in an ascending spiral, as Western technology has. Clearly, quality means more than technical virtuosity. Art goes beyond the skillful description of facts and feelings to the more subtle and subjective realms of expression and evocation, where the artist requires not just an imitative facility but a special sensitivity to the visual and tactile elements. He may also need sensitivity to human experience, a capacity for empathy, an agile imagination, and an understanding of the symbols or iconography that will be meaningful to his fellow men. Such things would be hard enough to measure even if they were not colored by the interpretation of individual observers, whose capacities to respond may vary widely.

Criteria of formal analysis produce varied judgments because the individual's sensitivity to the visual and tactile elements depends partly on the natural sensitivity of his sensory perceptions and partly on his training. Variations among individuals may therefore lead to disagreement about the total effect of a work of art. The breadth of the observer's experience is important. A person accustomed only to the flowing harmonies of paintings like Raphael's *Madonna of the Meadow*

(Fig. 3-1) might find the relative dissonance and liveliness of Picasso's *Three Musicians* (Fig. 1-14) lacking in unity. The same might be said of the color harmonies in a comparison of Rembrandt and Matisse (Plates 3 and 5). The observer's response also rests on his sensitivity and understanding of human experience. A child might respond with great sensitivity to Rubens' *Coup de Lance* (Fig. 1-23), but more mature experience added to the same sensitivity would deepen the content for him. The observer's response may be very limited if he has no understanding of relevant iconography.

Because of the tremendous stylistic variety encountered in examining even one medium, such as oil painting, and because of the many subjective factors we have described, the major problem in art criticism is to find measurable standards. Most critical statements might be subsumed under the broad demands for *unity, variety,* and *intensity of experience,* qualities we value because they enable us to experience life more completely by developing the sensitivity and subtlety of our perception, imagination, and understanding. Yet it is obvious that no fixed proportion of these three qualities would make an ideal formula for more than one work of art; nor is it easy to agree upon a measurement for such things in a given work of art.

Aesthetic Theories of Value Judgment

Aesthetics, the branch of philosophy that deals with the nature of beauty, has described many different attitudes toward value judgments. These attitudes, which may be conscious or unconscious, may be classed broadly in three overlapping areas.

OBJECTIVISM

The most extreme objective attitude assumes unchanging standards by which absolute judgments can be made for the art of any time and place. An example is the "Neoclassic" art theory of the eighteenth and nineteenth centuries, which held that the painting, sculpture, and architecture of any culture should be measured against Greek or Roman art. Such an attitude tends to reject the art of many cultures and to deny variability in concepts of aesthetic value. A more flexible objective position argues that such qualities as unity,

variety, and intensity—developed in varying degrees and proportions according to the nature of the art object—give the object aesthetic value not only for its own culture but also for others. The capacity of an observer to judge will vary with his sensitivity and understanding, but value resides in the art object itself. Changes in the history of taste therefore do not prove changes in value but only in preference, and preference is not the same as evaluation; a person may prefer one work over another but concede that the second has a higher aesthetic value.

SUBJECTIVISM

Subjective theories consider the judgment of art to be purely personal; each individual uses different criteria or different interpretations of criteria, and all criteria are equally valid. The aesthetic value of an art object rests not in the object but in the response of the observer, who may grant or deny such value to any object.

RELATIVISM

Relativist views hold that value arises from an interaction between spectator and art object. According to the relativist position, there are objective standards that can be valid for the members of a particular culture, but each culture forms its own standards. When an observer judges art from a culture other than his own, he should attempt to escape the prejudices of his own culture and judge the work on the basis of the criteria of the culture that produced it. Historical perspective or cultural differences may enable the outsider to comprehend the standards of a foreign culture more objectively than would its own members. Relativist views make value judgments between art objects from different cultures difficult or undesirable. One aspect of relativism is the attempt to understand the artist's intention and then to judge to what extent he achieved his aim. One may use *internal* evidence (evidence within the art object or other works by the same artist) and *external* evidence (such as statements by the artist about his own work). However, it is conceivable that the work of art might have high aesthetic value even if the artist did not fulfill his intention; conversely, if the intention was fulfilled, we are left with the need for a decision about the aesthetic value of the intent. Which is better, a superficial success or a magnificent failure?

Suggestions for Further Study

Beardsley, Monroe C. *Aesthetics: Problems in the Philosophy of Criticism.* New York: Harcourt Brace Jovanovich, 1958.

————, and Herbert M. Schueller, eds. *Aesthetic Inquiry: Essays on Art Criticism and the Philosophy of Art.* Belmont, Calif.: Dickenson, 1967.

Bell, Clive. *Art.* New York: Putnam, 1958.

Berenson, Bernard. *Aesthetics and History.* Garden City, N.Y.: Doubleday, 1954.

Boas, George. *Wingless Pegasus: A Handbook for Critics.* Baltimore: The Johns Hopkins Press, 1950.

Fry, Roger. *Vision and Design.* New York: Meridian Books, 1956.

Heyl, Bernard. *New Bearings in Esthetics and Art Criticism.* London: Oxford University Press; New Haven, Conn.: Yale University Press, 1943.

Langer, Suzanne. *Feeling and Form: A Theory of Art.* New York: Scribner's, 1953.

Read, Herbert, *The Meaning of Art,* 6th rev. ed. Baltimore: Penguin Books, 1959.

Rosenberg, Jacob. *On Quality in Art: Criteria of Excellence, Past and Present* (Bollingen Series No. 35). Princeton, N.J.: Princeton University Press, 1967.

Venturi, Lionello. *History of Art Criticism.* Translated by Charles Marriott. New York: Dutton, 1936.

Worringer, Wilhelm. *Abstraction and Empathy: A Contribution to the Psychology of Style.* Translated by Michael Bullock. London: Routledge & Kegan Paul, 1953.

Bison, from the cave at Altamira, Spain, *c.* 13,540 B.C. 8¼" long.

PART TWO
The History of Art in Western Culture

The beginnings of art precede written records. The most prolific time for pre-historic art seems to have been the LATE PALEOLITHIC *or* LATE OLD STONE AGE, *which lasted from approximately 30,000* B.C. *to 10,000* B.C. *Particularly in the period between 15,000* B.C. *and 10,000* B.C., *men painted and scratched animals, hunting scenes, and geometric designs on the walls of caves and rock shelters. The artist sometimes painted with charcoal and colored earths with a binder of animal grease, and he sometimes spread the grease on the wall and blew powdered colors against it from a hollow bone tube. Many*

cave paintings have been found in France and northern Spain; some of the most remarkable are in the caves of Altamira in Spain and Lascaux in France. In these works (see opposite page), modulated contours and modeling in light and dark create the illusion of mass in the bodies of bison, horses, and cows. A keen understanding of anatomy is combined by the artist with a sensitive expression of an animal's speed, ferocity, or gentleness. Paleolithic artists did not include landscape backgrounds, and each image or group of images is an isolated scene rather than one episode within the time sequence of a story; human figures were shown infrequently and often simplified, with single lines for torso and limbs. The frequent representation of animals pierced by arrows or spears, the casual overlapping of images, and the frequent location of paintings in almost inaccessible parts of caves all suggest that the making of pictures was a magic ritual to ensure success in the hunt. A purely aesthetic impulse might be evidenced by the geometric designs, but these too could have been motivated or rationalized by the need for magic. Paleolithic artists not only painted but also modeled in soft earth and carved bone, tusk, and antler. Here too, animals and the hunt were the preferred subjects, but we have found female statuettes that may have been intended to increase the fertility of the clan. Some of the characteristics of these paintings and carvings are found in the art of primitive cultures today.

While discoveries of prehistoric art were once difficult to authenticate, it is now possible to be more certain. One method used for dating objects relies on STRATIGRAPHY; an object is dated according to the age of the earth stratum in which it is found. A more precise method is that of CARBON 14 measurement. While it is living, each organic substance maintains a known amount of radioactive carbon 14. After the substance ceases to live, the carbon 14 begins to lose its radioactivity at a constant rate. Thus the amount of radioactivity allows us to determine the age of the organic substance.

The concept of STYLE is fundamental to an understanding of both prehistoric and later art, for the subtle differences in style reveal man's changing ideas of the beautiful or the significant. Style is a characteristic manner of expression and the kind of content that goes with it. It exists on several levels. PERIOD STYLE is the composite of very general characteristics that may be common to much work at a given time or cultural phase. Sometimes, especially in the nineteenth and twentieth centuries, a number of contrasting stylistic tendencies exist simultaneously, making it difficult or misleading to speak of a period style. REGIONAL STYLE may be detected in the work of various artists working in the same country or area, if there has not been too much influence from other regions. INDIVIDUAL STYLE is seen in the work of a particular artist, whose style may change several times in the course of his career.

Chapter 6

Ancient Near Eastern Art:

4000–330 B.C.

Of all the ancient Near Eastern cultures, that of Egypt has been most excavated and is best known; yet recent discoveries suggest that the Tigris-Euphrates Valley, in Mesopotamia, was slightly ahead of Egypt in developing an urban society and a form of writing. Political instability, frequent warfare, a lack of natural boundaries, and a constant mixing of different peoples all complicate our efforts to understand this area.

For a short survey, the developments might be grouped into three successive and overlapping cultures: (1) Sumerian-Akkadian-Babylonian, from about 4000 to 1594 B.C. and 612 to 539 B.C. (Neo-Babylonian); (2) Assyrian, from about 1350 to 612 B.C.; and (3) ancient Persian, from about 1000 to 330 B.C. This simplified classification neglects many cultural groups about which we presently know very little, such as the Hittites in Asia Minor, the Mitanni in northern Mesopotamia, and the Aramaeans and Phoenicians in northern Syria. Persian culture itself was so varied that, for the purposes of this introduction, we will consider only its culmination under the Achaemenian kings (559–330 B.C.), whose era ended with the Persian surrender to Alexander the Great.

The major Sumerian city-states, such as Uruk, Eridu, and Ur, were near the Tigris-Euphrates Delta on the Persian Gulf. Each city had its patron god (represented by the local king), in addition to a common pantheon of nature gods including Enlil, the storm god; Anu, the sky god; Ea, the water god; and Eanna, the Great Mother or Lady of Heaven, who was later known as Ishtar, goddess of love, fertility, and war. The temple was the religious and administrative center for each city-state, handling the distribution of labor and food. The Sumerians eventually came under the domination of a Semitic people from the north, the Akkadians, whose great leader, Sargon of Akkad (c. 2637–2582 B.C.), established a centralized government and the concept of a god-king as central ruler to whom local god-kings were subject. The Akkadians adopted much from Sumerian culture, including the Sumerian script in *cuneiform* (a form of writing employing different combinations of wedge shapes). The Akkadian control was broken by the Gutti people, who were, in turn, overthrown by Sumerians. The Neo-Sumerian period (2125–2025 B.C.) was particularly productive during the Third Dynasty of Ur. Invasions by Elamites and Amorites led to the collapse of central government and the rise of another era of independent city-states, the Isin-Larsa period (2025–1763 B.C.). Central control was revived during this

period by Hammurabi of Babylon (1792–1750 B.C.). Despite these violent disruptions, there is a discernible cultural continuity.

As the Assyrian Empire expanded from Assur, Nimrud, and Nineveh (c. 1350–612 B.C.) to absorb Mesopotamia, Egypt, Asia Minor, and Persia, the Assyrians also adopted much from Sumerian culture, including a number of gods. The Assyrian state-god, Assur, is a version of Enlil. The Assyrians, however, unlike the Sumerians, thought of their gods as remote from man. Assyrian art shows no confrontation of god and man as it is portrayed in the earlier cultures. The history of Assyria is one of incessant war, and its art expresses an obsession with physical power.

The Persian Empire grew out of the conquest by the Medes of Nineveh in 612 B.C. and Babylon in 539 B.C. In 550 B.C., Cyrus, a Persian, became king of the Medes and Persians, two related tribes on the Iranian Plateau. From Persian centers at Pasargadae, Susa, Persepolis, and Babylon, expansion swallowed up Syria, Asia Minor, and Egypt. The religion of the Persians evolved from the worship of fire to the worship of Ahura Mazda, god of light. The Persian king was the earthly representative of the god. Impetus came from the religious teacher, Zoroaster.

Sumerian (c. 4000–2340 B.C.)
Akkadian (c. 2340–2180 B.C.)
Neo-Sumerian (2125–2025 B.C.)
Isin-Larsa, Babylonian (2025–1594 B.C.)
Neo-Babylonian (612–539 B.C.) Periods

ARCHITECTURE

Temples and palaces received greatest emphasis. Stone and timber were scarce in the south; the major building material was sun-dried mud brick, which accounts for the scarcity of ruins.

The exterior appearance of the buildings was that of a cubic, closed form. Mass, rather than space, was the major expressive element. Mud brick walls gained visual interest from the play of light and shadow over alternating niches and buttresses and from whitewash, relief sculpture, and color in the form of inset shells, colored stones, terra cotta cones, and glazed brick.

Imported wooden roof beams were covered with reed mats and earth. Arches were used in doorways, and corbeled stone vaults have been found in the royal tombs at Ur. Large brick *piers* (vertical supports, usually square in section and more massive than single columns) and occasional wooden columns provided interior supports.

The major temple was usually placed on a mound of earth, providing either token elevation or considerable height. While such mounds were produced automatically by repeated reconstruction of ancient mud brick cities (city mounds are called *tells*), it is probable that the temple mounds were deliberately constructed. Sumerian religious thought stressed the mountain as the home of the gods and as a link between the earthly and the divine. During the Neo-Sumerian period, the temple mounds evolved into *ziggurats* (Fig. 6-1). In addition to the elevated temples, there were, from the Neo-Sumerian period on, low temples without terraces but with impressive tower-flanked entrances.

Temple plans usually consisted of a rectangular *cella* (sacred room; plural, *cellae*) with a niche for a cult statue at one end, an offering table, and an entrance at one side. There was a long-lasting tendency to use a *bent-axis* approach to important spaces: Doors were set off, and entries required one or more turns, forcing an indirect approach to the area. In time, however, the bent axis was replaced by a *direct axial* plan, wherein the entrance led directly to the focal point of the interior space. The general evolution of temple-building was toward thicker walls and more secluded cellae; anterooms and courtyards lengthened the approach to the place of worship. There was a tendency, especially after the beginning of the Akkadian period, to divide the cella into two parts: the antecella and the main cella. Often the entrance was at the center of a long side, and the altar and niche were placed at the center of the opposite wall, producing an oblong cella with stress on the short axis.

Palaces consisted of combinations of a basic unit: rectangular rooms opening onto a courtyard. The dwelling areas and the rooms for official ceremonies were distinctly separated. The houses of the people ranged from reed huts to mud brick structures having two floors of rooms facing an inner court.

Tombs were modest compared with those in Egypt. The most impressive ones found thus far are the royal tombs at Ur, where stairways of fired brick set in bitumen lead to underground vaulted rooms arranged somewhat like a private house.

6-1 Reconstruction of the ziggurat at Ur. (Adapted from a drawing at the British Museum, London.)

Ziggurat at Ur (*c.* 2100 B.C.). The king Ur-Nammu built this, the best preserved of the ziggurats (Fig. 6-1). It is a mud brick mass with a facing of fired bricks in the form of niches and buttresses. The first level is 50 feet high, and the corners were oriented to the points of the compass. The closed form, with its simple masses, obvious axial balance, and gradation toward the summit of the temple, made a striking interruption in the stark plains. Interior space was limited to the gate, which functions as a kind of halfway house on the flights of stairs, and to the temple at the top; exterior space was organized by the stairways, which led the worshiper from height to height. A physical pilgrimage and ascent was intended to produce a spiritual parallel. Conversely, the god could descend to earth by way of the man-made mountain.

SCULPTURE

Sculpture served both religious and commemorative purposes. Statues of the gods were apparently used in the niches of the temple cellae, and statues of priests and worshipers were placed in temples to perform as "stand-ins" for their donors, insuring continuous obeisance to the deity. Relief sculpture was carved or modeled on votive plaques, stone maces, cult vessels, *steles* (upright slabs or pillars), *cylinder seals* (small stone rollers carved to produce a continuous relief design when rolled on soft clay or wax), and walls. Materials include a variety of stone, ivory, shell, clay, gypsum, bronze, gold, silver, and electrum (an alloy of silver and gold), often used in combinations for contrasts of color

and texture. Subjects depicted include deities, sacrifices, cult processions, religious epics, military victories, hunts, animals, and hybrid creatures. Generalizations about style must be cautious because of the limited material presently available from excavations.

Throughout Mesopotamian art, a concern for the physical appearance of men and animals runs in contrast to a love of fantasy and lavish abstract ornament. Neither relief sculpture nor the few surviving fragments of wall painting show any desire to suggest the illusion of deep space. The human body was usually represented by a general type with massive and simplified anatomy. Enlarged inlaid eyes and prominent noses are common, but individual features occur occasionally. In Sumerian figures, the body from the waist to the calf was hidden by a full skirt, often embellished with a surface pattern suggesting fringe and tufts of hair or wool. During the Akkadian period, the clothing fitted more closely and revealed the body, which appeared to be softer and more flexible. Rigidity returned in later periods. Repeated linear motifs in hair, beards, and garments express a love of decorative pattern.

Statuettes from Tell Asmar (ancient Eshnunna) (c. 2700–2500 B.C.). This group of marble figures (Fig. 6-2) was found under the floor of a temple. Identification is uncertain, but the subjects are probably priests and worshipers.

6-2
Statuettes from the Abu Temple, Tell Asmar, c. 2700–2500 B.C. Marble, tallest figure approx. 30″ high. Iraq Museum, Baghdad, and Oriental Institute, University of Chicago.

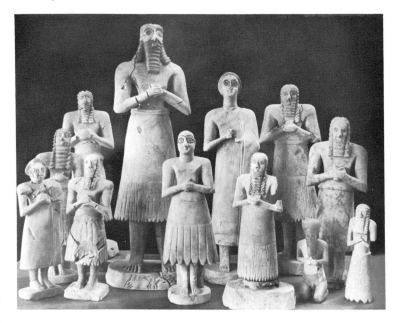

The tallest figure has been identified as Abu, the god of vegetation, although he lacks the horned hat normally worn by that god. The cups that he and the woman beside him hold in their hands may contain offerings or refer to the celebration of a cult marriage between earth and heaven. The hypnotically intense eyes, closed forms, full skirts, angular elbows, and tensely clasped hands are common to figures from the Sumerian and Neo-Sumerian periods.

PAINTING

Painting is found on walls, pottery, and sculpture. A dynamic style employing expansive abstract animal motifs and geometric designs enlivens the surfaces of pottery. The fragments of wall painting available to us indicate that painting followed the style of relief sculpture and depicted the same kinds of subjects. Painting was done on mud plaster or gesso (a mixture of plaster and glue) surfaces. There are no examples of the illusion of depth or mass modeled in light and shadow. Instead, flat, outlined shapes form lively geometric designs and figurative scenes.

Assyrian Art: 1350–612 B.C.

ARCHITECTURE

Excavations have not yet produced sufficient evidence to establish a clear understanding of Assyrian architecture. It certainly borrowed from the Sumerians and may owe much to the Hurrians and the Mitanni. Stone was more plentiful in the north, and the basic mud brick was supplemented by stone blocks in lower walls and around gates. Glazed brick provided color. Wall paintings and reliefs decorated interiors. The power of the empire made possible a new grandeur of scale and elegance expressing the divinity of the monarch and his relation to the other gods. Emphasis continued to be placed on temples and palaces. The ziggurat was sometimes freestanding, sometimes paired, and sometimes built into a temple and palace complex. Temple and palace entrances were centrally placed and flanked by a pair of towers. Typically, temples used oblong antecellae and cellae, and palaces employed combinations of the traditional units of rooms grouped around courtyards. A new motif in planning was a rectangular room with a pillared entrance, actually an enlarged

6-3
Reconstruction drawing of the
citadel of Sargon II,
Khorsabad. *c.* 720 B.C.

entry to a passageway leading to an interior court.
Sargon's records refer to this as a *bît hilani*, a borrowing
from Hittite architecture. Its origins seem to be in Syrian
architecture of the second millennium B.C., and it bears
a striking resemblance to the Greek *megaron* (Fig. 8-2).

Citadel of Sargon II at Khorsabad (ancient Dur Sharrukin) (*c.*
720 B.C.). The palace-temple complex (Fig. 6-3) covered
25 acres and was built into the city walls. Tower-flanked
gates with relief carvings of human-headed bulls wear-
ing the horned crown indicating deity opened into the
courtyard of the lower level, from which a ramp led
to the upper palace. A number of temples were built
into the complex, as was a ziggurat with a spiral ramp
leading to a summit that was originally about 140 feet
high. The 209 rooms and courts of the palace provided
a political, military, and religious center for the empire.
Like earlier Mesopotamian palaces, the plan is an
aggregation of rooms around courtyards. Roofs may
have been barrel vaults. Interiors were ornamented with
paintings and reliefs glorifying the king as hunter,
warrior, and conqueror of evil.

SCULPTURE

The Assyrians produced a great deal of relief sculpture
but apparently had little interest in freestanding statues.
Palace walls were covered with reliefs depicting the king
participating in sacred rituals, festivals, wars, and hunts.
In major palaces, the deeds of the god-king eclipsed
those of the other gods, whose images are more plenti-
ful in the provinces. Assyrian art continued the double
interest in decorative pattern and physical appearance,
but there was an increased study of animal behavior
and anatomical detail. Muscle structure was empha-

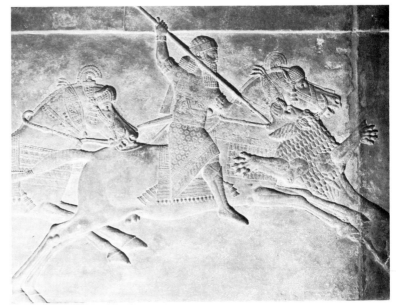

6-4
*Assurbanipal Killing
a Lion,* from Nineveh,
c. 650 B.C. Gypseous
alabaster, approx. 63¼"
wide. British Museum,
London.

sized; physical force was important. Yet even the taut
muscles and tendons are reduced to conventional forms
and used as motifs in linear patterns. Decorative rich-
ness and subtly modulated surfaces produce the effect
of opulence, even in the most brutal battle scenes. Relief
backgrounds are usually neutral, and, especially in ritual
scenes, cuneiform inscriptions may flow across both
raised figures and backgrounds. However, from the
ninth through the seventh centuries, there are frequent
scenes of battles and hunts with detailed, panoramic
landscape settings. Here, the earlier compulsion to
attach figures to *ground lines* (the horizontal bottom
edge of the composition) eases, and depth is occa-
sionally suggested by the placement of objects one
above the other and by increased overlapping of figures.

Assurbanipal Killing a Lion, from Nineveh (British Museum,
c. 650 B.C.). This section of a *frieze* (a horizontal band
of designs) from the palace at Nineveh (Fig. 6-4) dem-
onstrates the combination of violence, admiration for
physical power, and love of richly ornamented surfaces
that is characteristic of Assyrian art. The king is de-
picted with conventional body and face. More landscape
detail and suggestion of depth are found in some of the
other Nineveh reliefs from the reign of the same king.

PAINTING

The small number of surviving paintings show the same
subjects and stylistic character as the reliefs. Pigments
were mixed with some fatty binder, which has now

(a)

(b)

(c)

(d)

6-5

Mesopotamian decorative motifs:

(a) rosettes, palmettes, and pine cones;

(b) lotus flowers and buds;

(c) rosettes, palmettes, and pomegranates;

(d) guilloche, meanders, and chevrons.

disappeared, and were applied in flat shapes to walls that had been mud-plastered and whitewashed. Paintings in Sargon's palace at Khorsabad were done in black, red, brown, blue, and green. Assyrian design motifs include pine cones and lotus blossoms (derived from Egyptian lotus bud and blossom designs), palmettes (from Egypt), rosettes and guilloches (from Egypt or Chaldea), pomegranates and stepped pyramids (probably Chaldean), and chevrons (Fig. 6-5). Many of these forms occur with variations in Cretan art and, later, in Greek and Roman work.

Achaemenian Persian Art: 559–330 B.C.

ARCHITECTURE

Persian architecture during the Achaemenian period found its highest accomplishment in palaces. Though the Persians were eclectic, their borrowings were amalgamated into a distinctive style. Plans tended to be very open, and columns were used more extensively than in previous cultures in the Mesopotamian and Iranian areas. The typically three-part palace plan included a gatehouse, an *apadana* (a rectangular or square *hypostyle* [colonnaded] hall, probably derived from Egypt), and living quarters. These basic parts, as well as necessary storerooms, were often multiplied as successive rulers added to a palace (Fig. 6-8). The parts were sometimes widely separated, as at Pasargadae (sixth century B.C.), recalling the tent-cities of the Persian nomads, and sometimes loosely joined, as at Susa and Persepolis (both sixth to fourth centuries B.C.). The buildings were elevated on one or more terraces and often enclosed by a perimeter wall.

The most unusual element was the apadana. It had three to four colonnaded porches and entrances on four sides. The gatehouse was also rectangular or square and stood separately as a monumental entry. It was often given a bent-axis alignment with the apadana, producing a delayed confrontation with the sacred, or a ritualistic pilgrimage, as is suggested in many Mesopotamian temple plans and in the spiral ramp of Sargon's ziggurat. Columns were made of stone or wood, and wood shafts were often surfaced with plaster and painted with geometric designs. Shafts were both *fluted* (having vertical channels all the way around) and plain. Column designs (Fig. 6-6) reveal the influence of Egypt and of Ionia, the Greek territory in Asia Minor, areas from which

the Persians imported skilled carvers. Wall surfaces were decorated with colored and glazed brick reliefs and stone relief sculpture. The Achaemenians worshiped outdoors; temple architecture was not of major importance. Most Achaemenian royal tombs were carved in the face of a cliff and given the form of a Greek cross (equal-armed). The horizontal arm contains a centrally placed door flanked by *engaged columns* (columns emerging from the wall as does relief sculpture) supporting a carved lintel. The upper part of the cross presents several *registers* (bands) of relief sculpture. Interiors are simple shallow spaces probably filled, at the time of burial, with royal furnishings.

Palace at Persepolis (6th–4th cens. B.C.). The whole palace complex (Figs. 6-7 and 6-8) stands on an irregularly shaped terrace that is 40 feet high, about 900 by 1500 feet in plan, and set against a mountain range. There is uncertainty about whether or not the whole area was originally surrounded by a high mud brick wall. The terrace is approached by a stairway at the gatehouse; and, from the gatehouse, a ninety-degree turn is necessary to face the main stairway to the apadana. The apadana, or audience hall of Darius, is 250 feet square and originally had a roof about 60 feet high supported by thirty-six stone columns. These columns are complex, both in form and cultural allusion. The fluted shafts and parts of the base seem to have come from Ionia. The *capitals* (the top or crowning element of the column) often begin with a ring of drooping petals and

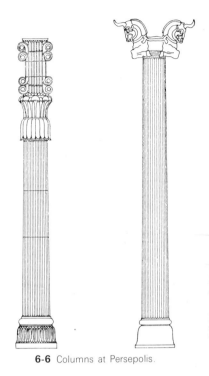

6-6 Columns at Persepolis.

6-7 Stairway to the Royal Audience Hall, Persepolis, *c.* 500 B.C.

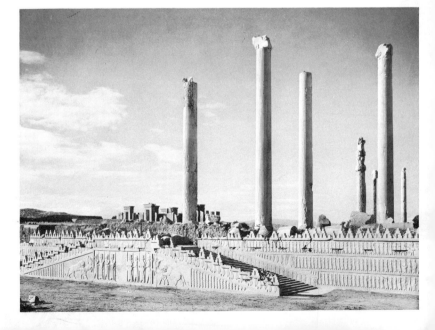

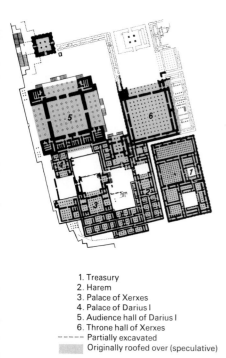

1. Treasury
2. Harem
3. Palace of Xerxes
4. Palace of Darius I
5. Audience hall of Darius I
6. Throne hall of Xerxes
- - - - Partially excavated
░░░ Originally roofed over (speculative)

6-8 Plan of the palace at Persepolis.

flaring papyrus blossoms that can be traced to Egypt. Above these is a vertical block with double *volutes* (scrolls) that are found, in various forms, throughout western Asia. These parts were used without additions or with pairs of griffins (winged, eagle-headed lions), bulls, human-headed bulls, or horned lions. Near the audience hall, a hundred-column throne hall was added later by Xerxes and his son, Artaxerxes. Behind the halls were living quarters, treasuries, and storerooms. Massive stone window and door frames survived the destruction of the palace by Alexander the Great, but mud brick walls have disappeared. Sculptural decoration was concentrated around stairways, gates, and columns; it was used to ornament the architecture rather than for its own sake. The total effect of Persepolis, even in ruins, is an expression of power, wealth, and regal ceremony.

SCULPTURE

Achaemenian sculpture was primarily the relief embellishment of architecture. Almost no freestanding statues have been found. The Assyrian interest in narration of battles and hunts is absent, although Assyrian influence is evident in the Persian love of linear patterns, and, specifically, in the human-headed bulls at the Persepolis gatehouse, which repeat those at Khorsabad. Assyrian violence is recalled by the motif of a lion biting a bull at Persepolis, but this may have been a symbolic action

6-9

Procession of Medes and Persians, detail from the eastern stairway to the Royal Audience Hall, Persepolis, *c.* 500 B.C. Black limestone, entire relief approx. 268'3" wide.

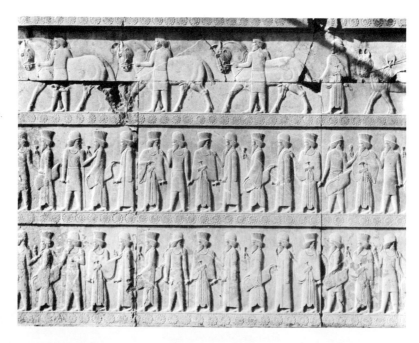

for the Achaemenians. Basically, subject matter consisted of real and fantastic animals and processions of retainers, warriors, or subjects. At Susa, relief was executed in richly colored glazed brick; at Persepolis, reliefs were carved in stone and originally painted. The carvings depict processions of soldiers, bearers of tribute from twenty-three nations of the empire, members of the court, guards, and scenes of the king giving audience and offering prayers, all parts of the Achaemenian New Year's festival celebrated at Persepolis. Another outlet for Persian talent in sculptural design was finely wrought gold, silver, and bronze metalwork ranging from cups and vases to jewelry and weapons.

Procession of Medes and Persians, eastern stairway of the audience hall of Darius (Persepolis, *c.* 500 B.C.). In this detail of the reliefs shown in Figure 6-9, the *Immortals* (imperial guards) are shown in alternation with Medes, who are clearly indicated by round hats and smooth clothing. Persian costumes are embellished with drapery folds in elegant, symmetrical patterns. The widespread sources of Persian art are revealed by this drapery, influenced by sixth-century Greece, and in the rosettes, taken from Egyptian and early Mesopotamian art. The distinctively Persian quality comes from the combination of repetitive processional compositions, neutral backgrounds, low but round relief modeling, and the love of opulent decorative patterns.

Suggestions for Further Study

Frankfort, Henri. *The Art and Architecture of the Ancient Orient* (Pelican History of Art). Baltimore: Penguin Books, 1955.

Ghirshman, Roman. *The Arts of Ancient Iran* (The Arts of Mankind). Translated by Stuart Gilbert and James Emmons. New York: Golden Press, 1964.

Mootgat, Anton. *The Art of Ancient Mesopotamia.* London and New York: Phaidon Press, 1969.

Porada, Edith. *The Art of Ancient Iran* (Art of the World). New York: Crown, 1962.

Parrot, André. *The Arts of Assyria* (The Arts of Mankind). Translated by Stuart Gilbert and James Emmons. New York: Golden Press, 1961.

Scranton, Robert L. *Aesthetic Aspects of Ancient Art.* Chicago: University of Chicago Press, 1964.

Strommenger, Eva, and Max Hirmer. *5000 Years of the Art of Mesopotamia.* New York: Abrams, 1964.

Chapter 7

Egyptian Art:

3200–30 B.C.

Ancient Egyptian history falls into three major periods, which are further divided into dynasties (ages during which a single family provided the succession of rulers). The *Archaic* period and the *Old Kingdom* may be considered together as the first major period, which began with the unification of northern and southern Egypt, saw the establishment of Memphis as a cultural center, and ended with the decline of central power and an era of confusion and civil war. Order was restored during the *Middle Kingdom,* but in a feudal system that weakened the authority of the *pharaoh* (king). This kingdom eventually collapsed under the burdens of civil war and invasion by the Hyksos (probably Canaanites and Anatolians), who exacted tribute from much of Egypt until they were expelled by princes from Thebes. Thebes became a major center for the *New Kingdom* or *Empire*, the period that brought Egypt to its greatest power. We may group the Empire with the less important periods that followed and with the age of defeats that ended Egypt's leading role in ancient history. She was invaded by Assyrians in the seventh century B.C., by the Persians in the sixth century B.C., and by the Macedonians in 332 B.C.; finally, in 30 B.C. Egypt became a Roman province.

Egyptian civilization began as a series of independent city-states, each with its own patron god. The unity of these parts was always precarious, as Egyptian literature and art reveal; for example, the pharaoh is sometimes depicted wearing the crown (with a flat top and a raised portion at the rear) of northern or Lower Egypt, sometimes wearing the crown (shaped like a bowling pin) of southern or Upper Egypt, and occasionally wearing a combination of both crowns. Life depended on the rhythmic cycles of the Nile River, whose floods enriched the bottom lands but necessitated the frequent resurveying of fields; hence the Egyptians quickly developed a practical mathematics as well as astronomy and a rational calendar.

Egyptian society consisted of the nobility, which owned much of the land; the middle class, which consisted of merchants, artists, civil servants, and—in the Empire—soldiers; and the serfs, who formed the bulk of the population. By the end of the Empire, the power of the nobility had been partially taken over by the growing priesthood and by the increasing number of civil servants.

All Egyptian culture was pervaded by a complex religion that stressed a life after death; therefore, most of the painting, sculpture, and architecture was religious

and sepulchral. Egyptian art presents a bewildering variety of gods—male and female human figures and combination animal-human creatures such as the sphinx. Some of the more important gods were Osiris, lord of the underworld (often shown as a swathed mummy); Anubis, the jackal-god of embalmment; Nut, the sky goddess (a human form arched over the earth); Hathor, the goddess of love and joy (usually shown with cow's horns); Horus, one aspect of the sun god (often shown as a hawk); and Re, or Ra, the sun god who traveled across the sky in his sun-ship during the day and through the underworld during the night. The pharaoh himself was believed to be a god. Many of the gods assumed each other's forms or evolved in form and name during the course of Egyptian history. The most striking development in this history was the effort of the XVIIIth-Dynasty king Akhenaten to establish a monotheistic religion founded on the worship of the sun god.

Archaic Period: 3200–2680 B.C., Dynasties I Through III, and Old Kingdom: 2680–2258 B.C., Dynasties IV Through VI

ARCHITECTURE

The palaces of the nobility and the homes of the wealthy were built either of wood frames with walls of colored reed mats or of mud brick with plaster or stucco surfacing decorated with paintings; more modest dwellings were probably made of reed mats plastered with mud. Such impermanent materials have left few remains. The Egyptians concentrated their efforts on tombs and temples, built to serve the deceased or the gods and to defy time and the destructive power of nature. Stone and brick were used for this more permanent architecture, but because the stone and brick sometimes encased only a rubble filling, the wall was not always as permanent as it might have been. The arch was known but rarely used; the basic structural system was post and lintel.

Egyptian architecture emphasizes mass and employs simple, rigid contours. Interior spaces are usually small in proportion to the masses enclosing them and are placed in a mazelike succession, with dead ends or roundabout connections. One of the basic tomb types

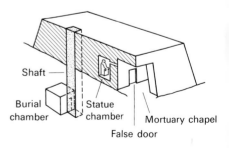

Shaft

Burial chamber Statue chamber Mortuary chapel

False door

7-1 Cross section of a mastaba.

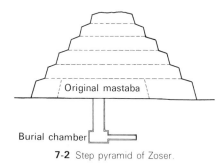

7-2 Step pyramid of Zoser.

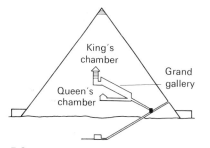

7-3 Cross section of the pyramid of Khufu.

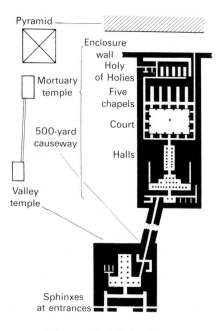

7-4 Pyramid of Khafre, Giza.

is the *mastaba* (Fig. 7-1), originally a rectangular block with *battered* (sloping) sides and more mass than enclosed space, though later mastabas are less regular in form and enclose more space. The basic parts are (1) the burial chamber, reached by a vertical or sloping shaft; (2) the statue chamber, a walled-up room containing a statue substitute for the body; (3) a mortuary chapel, where offerings could be left for the deceased; and (4) a false door through which the spirit of the dead was to have access to the offerings. Often the statue chamber has a peephole leading to the chapel. The statue chamber and burial chamber with its entry shaft are often encased in hard stone, meant to improve durability and to discourage tomb-robbers, who were attracted by the treasures buried with the dead. The mastaba was thought of as a house for the dead, and groups of mastabas formed cities of the dead (*necropolises*). It is conjectured that the *pyramid* tomb may have evolved from stacked-up mastabas of decreasing size, as in the tomb of King Zoser (Fig. 7-2).

Such a step-pyramid could have led to the true pyramid form, which protects its burial chamber and treasures under a mountain of stone (Fig. 7-3). The basic parts of an Old Kingdom pyramid complex are: (1) the pyramid, (2) a mortuary chapel or temple beside or against the pyramid, (3) a causeway leading from the mortuary temple to (4) a valley temple close to the Nile (Fig. 7-4). The huge pyramids only inspired greater efforts by tomb-robbers, however, and in later periods smaller tombs were built. For their post and lintel structures, the Egyptians derived column designs from plants and from construction methods in wood; some columns imitate a papyrus stalk and blossom; others imitate the form of bundles of palms tied together for strength. Polygonal fluted stone columns, like the later Doric columns of Greece, may imitate wooden palm bundles plastered with mud. Capitals atop the columns resemble lotus buds, papyrus blossoms, palm leaves, or leafy blossoms (Fig. 7-5).

Step-pyramid of Zoser (Saqqara, Dyn. III). The first large Egyptian architecture in stone, this 195-foot-high mass (Fig. 7-2) seems to have developed from an original mastaba by added stages. Around the pyramid, a wall originally enclosed a funerary community with chapels, palaces, and temples. Bundle, fluted, and papyrus blossom columns are used. The architect was Imhotep, one of the few Old Kingdom architects whose name is known to us.

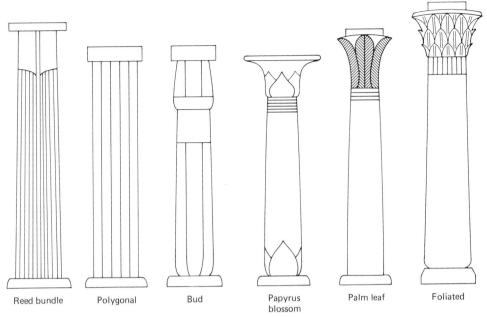

Reed bundle Polygonal Bud Papyrus blossom Palm leaf Foliated

7-5 Egyptian column designs.

7-6 Great pyramids of Giza: Menkure, *c.* 2575 B.C.; Khafre, *c.* 2600 B.C.; Khufu, *c.* 2650 B.C.

Pyramids of Khufu, Khafre, and Menkure (Giza, Dyn. IV). These largest of Egyptian tombs (Fig. 7-6) are in true pyramid form and were originally encased in polished limestone. The largest of the three, that of Khufu, has a base about 750 feet square and was originally about 475 feet high. The method of construction is not known with certainty; the mammoth stones may have been pulled on sledges up ramps of earth that were raised with each level of the structure. The massive, stable geometric form and the simple surfaces are characteristic of monumental architecture in Egypt.

SCULPTURE

Egyptian sculpture ranges from colossal statues to delicate goldsmith's work. The most significant pieces were done for tombs or temples. For large work, hard stones such as granite, diorite, or basalt were preferred. Softer alabaster was exploited for its translucence, and sandstone, limestone, and wood sculpture was often surfaced with plaster and painted. Small sculpture, or inlay work in large sculpture, might consist of gold, silver, electrum, lapis lazuli (a semiprecious, azure-colored stone), and enamel.

Relief sculpture, generally low relief consisting of sharp-edged, relatively flat forms, has some of the abstract symbolic character of Egyptian hieroglyphic writing. The human body is portrayed by conventionalized forms developed early in Egyptian history. A frontally seen eye, for example, is combined with a profile face, frontal shoulders, and profile hips and legs; the artist seems to have thought through an action step by step and shown these steps as in a diagram. The standardized bodies occasionally depict age, but otherwise the passage of time is ignored, for the sharp edges and angular poses tend to freeze any suggestion of motion. Motion implies time as mass implies space; neither is an element of Old Kingdom relief sculpture. Some overlapping of flat shapes suggests a very shallow space, but massive forms and a perspective illusion of space are not found. As a result, the reliefs do not weaken the mass of the wall or the *stele* that carries them.

In freestanding sculpture, the standard poses are free from the wall, but they may be attached to a supporting back-slab (Fig. 7-8). Much Egyptian sculpture retains the massive four-sidedness of the block from which it was carved, and the mass contributes to the impression of durability. Closed form is typical. Anatomy is simplified in the direction of geometric shapes, so that the

7-7 Victory palette of Narmer, front and back, from Hierakonpolis, *c.* 3000 B.C. Slate, 25″ high. Egyptian Museum, Cairo.

figures assume the rigidity and static permanence of Egyptian architecture. Individuality is concentrated in the face, which is often alert in expression but motionless. It should be noted, however, that the art of the different areas of Egypt varies in its adherence to the conventional forms. The functions of the various statues, as votive images to the gods or as images of servants meant to serve the deceased in his afterlife, also influenced the style of the work.

Victory palette of Narmer (Dyn. I, slate, 25″. Egyptian Museum, Cairo). This elaborate version of the palettes used for mixing eye paints (Fig. 7-7) commemorates the subjection of northern Egypt by the South. On one side, King Narmer, wearing the tall crown of the South, is about to strike a northerner. A hawk holds captive a plant with a human head, probably the papyrus symbol of the delta region. Above, the symbol for Narmer is framed by a small palace. On either side of this is a human head with cow's horns, the symbol for Hathor. On the other side of the palette, Narmer, wearing the crown of northern Egypt, surveys decapitated enemies. At the bottom, he is seen as a bull knocking down the walls of a city. Typically, the artist shows the figures in "elevation," standing on base lines that establish different registers in the composition, until a different point of view is needed to convey the information he is giving. The artist changes to an aerial view to show the number of slain enemies. Scale expresses importance; therefore, the king acquires giant stature.

Menkure and His Queen (Dyn. IV, slate, 56″ high. Museum of Fine Arts, Boston). The king wears a ceremonial false beard; the queen wears a wig (Fig. 7-8). The individual facial features are somewhat simplified, and yet they contrast with the more generalized treatment of the bodies. The pose is typical for standing figures. Closed form and anatomy reduced to geometric rigidity give a timeless dignity to the couple.

PAINTING

Papyrus was occasionally used by the Egyptians for painting, as well as for writing, but the most important paintings are on the walls of tombs and temples. Paint was also often used to enhance relief or freestanding sculpture. Grounds are smoothed stone or a coating of stucco, plaster, or mud and straw. Pigments made from powdered natural substances, such as soot, copper

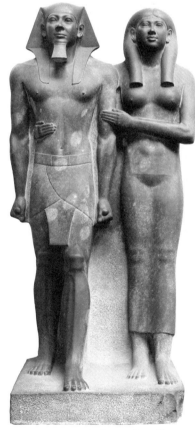

7-8 *Menkure and His Queen,* from Giza, Dyn. IV. Museum of Fine Arts, Boston.

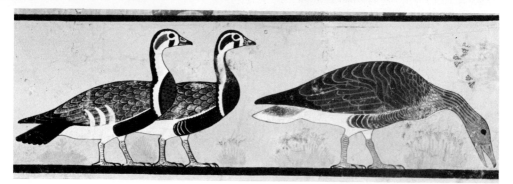

7-9 *Geese of Medum, c.* 2600 B.C. Dry fresco, entire fresco approx. 18″ high. Egyptian Museum, Cairo.

compounds, or earth colors, were mixed with a binder of water and gum and were applied to a dry ground.

Old Kingdom painting, like the sculpture and architecture, shows a preference for rigidly imposed rectilinear order and a limited number of standard forms. During the millennia of Egyptian history, the striking quality of all the arts is not the subtle change or occasional rebellion against the standard forms but rather their continuity. Old Kingdom painting was often applied to relief sculpture; it was left to later ages to stress painting as an independent art. Like relief, painting uses sharp-edged flat shapes, and the diagrammatic poses symbolize activity rather than express it. Spaces between figures are often filled with hieroglyphics, which counter any slight illusion of depth that might come from overlapping shapes. Typical forms and actions of animals are keenly observed, but the repetition of shapes and details within shapes imposes a regimented order upon the variety of nature. Subject matter comes from mythology, ritual, biography, or daily activities. Symbolism is pervasive. Many of the activities, such as sowing, reaping, and offering prayers and food, were apparently intended to "serve" the deceased in his afterlife. As in the reliefs, scenes are organized in registers. While overall symmetry was valued, each picture seems to function as an isolated unit, and the accretion of these units gives the painting some of the additive character of the architecture.

Geese, from the mastaba of Itet at Medum (Dyn. III, approx. 1′ x 6′. Egyptian Museum, Cairo). Though this is one section from one register in a large wall painting, the composition works effectively as an isolated unit (Fig. 7-9). The colors and the poised strutting of the geese are quite natural, but a typically severe order is evident in the symmetry of the poses and in the crisp patterns of the feathers.

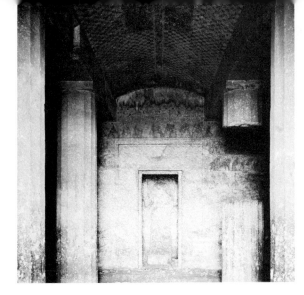

Middle Kingdom: 2134–1786 B.C., Dynasties XI and XII

ARCHITECTURE

The Middle Kingdom produced smaller tombs and tomb-temple combinations. This resulted in part from a smaller concentration of wealth; it may also be explained by the growth of the Osiris cult, which stressed an afterlife in the underworld rather than in the tomb. Many small stone-faced brick pyramids and mastabas have crumbled, but more permanent tombs, cut into the rock of the cliffs along the Nile Valley at places like Beni Hasan, still remain.

Rock-cut tomb of Amenemhat (Beni Hasan, Dyn. XII). Here (Figs. 7-10 and 7-11) typical features of the rock-cut tombs are seen: the modest size, the courtyard, pillared portico, the main room supported by fluted columns (sometimes called Proto-Doric because of their resemblance to later Greek Doric columns), and the shrine. Such tombs generally contained a simple grave pit for the body. The walls are painted with subjects in the tradition of the Old Kingdom; and the ceiling is decorated with geometric designs that probably imitate textiles.

SCULPTURE

Much Middle Kingdom sculpture was destroyed by the Hyksos and by New Kingdom rulers. What remains varies from crude to highly finished carving. The growing middle-class patronage and the dispersal of wealth

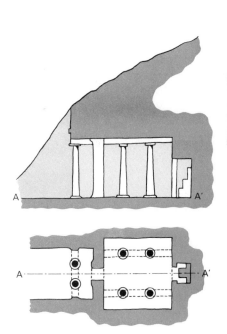

7-11 Plan and section of a rock-cut tomb. (After Sir Banister Fletcher.)

7-12 Relief on the sarcophagus of Mentuhotep's wife Kawit, Dyn. XI. Egyptian Museum, Cairo.

among the nobles seem in many works to have resulted in the sacrifice of quality for quantity. Frequent use was made of the cheaper method of *sunken relief*, in which the outlines of objects are cut into the wall and the form within the outlines is carved so that most of it is below the surface of the untouched background. Its style owes much to the Old Kingdom, although poses are often more affected. Freestanding sculpture developed even simpler bodies than in the Old Kingdom. Forms are either sleek and flowing or heavy, brutal, and blocky. Many seated figures have arms folded over drawn-up knees; such a statue was simply a modified block surmounted by a head and therefore involved a minimum of carving. The most distinctive feature of Middle Kingdom sculpture is the cynicism and care-worn weariness in many of the faces, a quality that is echoed in Middle Kingdom writings. This detailed realism is often in striking contrast to the simplified bodies. Middle Kingdom servant statues tend to be of cheaper materials and cruder execution than earlier examples.

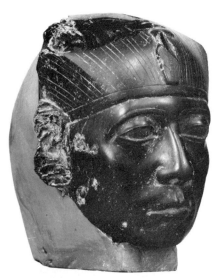

7-13 *Sesostris III or Amenemhat III,* *c.* 1850 B.C. Obsidian, approx. 4″ high. C. S. Gulbenkian Collection, National Gallery of Art, Washington, D.C.

Relief on the sarcophagus of Mentuhotep's wife, Kawit (Dyn. XI, limestone, originally painted. Egyptian Museum, Cairo). Quite unlike earlier work, this sunken relief (Fig. 7-12) exemplifies the sleek, suave contours and rather precious poses characteristic of some Middle Kingdom sculpture.

Sesostris III or Amenemhat III—identity uncertain (Dyn. XII, obsidian, 4″ high. National Gallery of Art, Washington, D.C.). The tired, lined face illustrates a Middle Kingdom tendency toward greater detail and more distinctly individualistic portrait features (Fig. 7-13). The small scale and hard stone demanded considerable skill.

PAINTING

The Middle Kingdom employed painting extensively, perhaps partly because painting was cheaper than relief. One of the chief sites for Middle Kingdom painting is the rock-cut tombs of Beni Hasan. The paintings are typically done in soft, subtle colors applied to broad, simple shapes that sometimes contrast with areas of meticulous detail.

Dancing Girls, from the tomb of Antefoker (Thebes, Dyn. XII, approx. 37″ x 67″). The mild value contrasts, bland colors, simple shapes, and wirelike outlines seen in Figure 7-14 are typical of much Middle Kingdom painting. The costumes are also representative of the period. The outstretched forefingers of the dancers on the right may be ritualistic gestures or a method of counting the steps of the dance.

7-14 *Dancing Girls,* from the tomb of Antefoker, Thebes, Dyn. XII.

7-15 Court and pylon of Rameses II, *c.* 1290 B.C., and court and colonnade of Amenhotep III, *c.* 1390 B.C., temple of Amen-Mut-Khônsu, Luxor.

7-16 Plan of the temple of Amen-Mut-Khônsu.

New Kingdom (Empire) and Later Periods: 1570–30 B.C., Dynasties XVIII Through XXXI

ARCHITECTURE

Thebes is the center for the important remains of New Kingdom architecture. In the cliffs on the western side of the river are two desolate rock-strewn valleys: the Valley of the Tombs of the Kings and the Valley of the Tombs of the Queens. Here many of the New Kingdom rulers had themselves buried in hidden mineshaft-like tombs. While these cannot really be considered as architecture, they were lavishly decorated with paintings and sculpture. When the tombs became secret, the mortuary temples occupied more convenient locations near the city. Mortuary temples and temples to the gods became especially large during the New Kingdom and later periods (Figs. 7-17–7-19). Both kinds were built in the same general plan: (1) entry through a massive sloping façade called a *pylon*, (2) an open *courtyard*, (3) a *hypostyle hall*, and (4) a sacred *inner sanctum*. The basic parts could be multiplied, and temples to more than one god might have several sanctums. From entry to inner sanctum, the progression is from larger to smaller spaces, the plan being essentially an elaboration

of the Middle Kingdom rock-cut tomb. The temples were often enlarged by a process of accretion over the centuries, and the resulting labyrinthine complexity, which does not lend itself to an easy comprehension of the whole interior, provided effective settings for the processionals so important in Egyptian worship.

Our knowledge of New Kingdom domestic architecture would be greater had not later generations carried away much of the stone from Akhenaten's new capital at Amarna. His North Palace has an extensive symmetrical plan organized around a large pool and tightly enclosed behind thick walls. Typical materials for such architecture were mud brick and stone.

Temple of Amun-Mut-Khônsu (Luxor, mainly Dyns. XVIII and XIX). This enormous temple (Figs. 7-15 and 7-16) was not for mortuary offerings but for the glory of the god Amun (whose identity merged with that of Re), his wife Mut, and their son Khôns. The basic temple parts have been multiplied. From the great pylon and the first court, built under Rameses II (Dyn. XIX), one enters the XVIIIth-Dynasty parts of the building: a double row of 52-foot-high papyrus blossom columns, a second court (bud columns), a hypostyle hall, smaller halls, and two sanctums. Originally, two *obelisks* (tapered shafts with pointed tips) stood in front of the temple. One remains; the other now adorns the Place de la Concorde in Paris. The total length of the structure is about 835 feet.

7-17 Temple of Horus, Edfu, mainly 237–212 B.C.

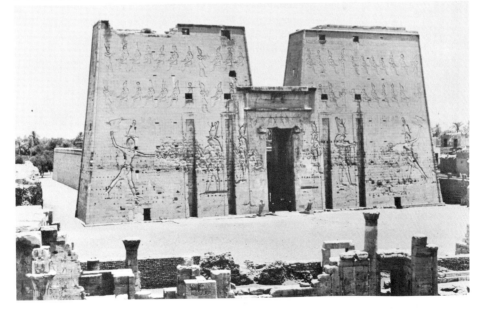

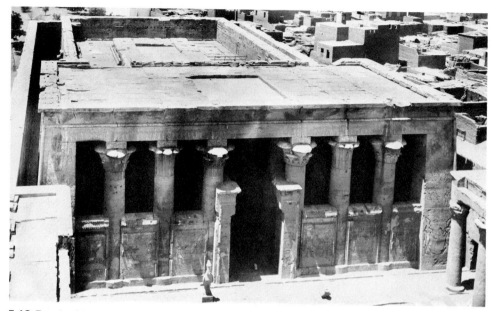

7-18 Temple of Horus, hypostyle hall from the court.

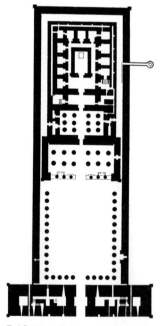

7-19 Plan of the temple of Horus.

Temple of Horus (Edfu, mainly 237–212 B.C.). The building (Figs. 7-17–7-19) comes from the Ptolemaic era, which followed the Macedonian conquest. It is notable for its well-preserved state and for its exemplification of the basic Egyptian temple unobscured by proliferation. The pylon (145' x 250') and massive exterior walls enclose court, vestibule, hypostyle hall, storage rooms, and inner sanctum. The plan indicates a characteristic axial progression to smaller and darker spaces. The columns typify the late period in the use of a variety of palm and foliated capitals.

SCULPTURE

Increasing prosperity during the Empire greatly encouraged artistic activity. Tomb statues were often carved in the living rock of the shaft tombs, and quantities of votive statues and reliefs decorated the temples. Sunken relief is common. Middle Kingdom style continued for a time, but the expansion of the Empire brought increased awareness of other peoples, and conventional forms soon relaxed to allow more representation of different racial types. The reign of Akhenaten marked a stylistic change toward more action, greater casualness in pose, increasing complexity in costume

and accessory detail, a softening of body forms, and more accurate indication of age. The king's heavy lips, pendulous jaw, long neck, and sagging stomach were stressed to the point of caricature in portraits that he must have encouraged. The royal features soon set the style, and portraits of other people acquired his "ideal" form. The old conventions were modified rather than abolished. Soon after the death of Akhenaten, the old canons returned, but with slightly softer contours in some works and more open form.

Akhenaten or Amenhotep IV (Dyn. XVIII, sandstone with coloring, 13' high. Egyptian Museum, Cairo). Although the traditional pose is taken, the features of face and body on this sculpture (Fig. 7-20) make a striking contrast to Old Kingdom statues like *Menkure and His Queen.*

Nefertiti, wife of Akhenaten (Dyn. XVIII, painted limestone, with eyes—one missing—of inlaid rock crystal, approx. 20" high. Staatliche Museen, Berlin). This bust (Fig. 7-21), found among the remains of a sculptor's studio, served as a model. Suggestions of fleshy softness under the chin and around the eyes and mouth lend a flesh-and-blood reality to the regal poise of the queen.

PAINTING

The best-preserved examples of Egyptian painting come from the highly decorated walls of the New Kingdom. Those from the beginning of the period are characterized by stiff poses and vivid opaque colors, with wide use of blue backgrounds. Later came a change to more graceful poses and more delicate transparent colors applied with brushwork that is occasionally loose and sketchy. The reign of Akhenaten produced startling changes in painting as well as in sculpture. When he moved the capital from Thebes to Amarna, he had his palace there decorated with paintings of landscapes and animal life, all done with a new concern for continuity of all the parts. The direct visual experience of nature breaks through the old symbolic concepts. Human forms acquire the casual poses, soft bodies, and elongated faces common to the sculpture of the period. This so-called *Amarna Style* died shortly after Akhenaten, but its influence is seen in the occasional flashes of individuality and naturalism that lighten later art. For the most part, later painting, in answering the demands for ostentatious elegance, tends to be repetitious, garish in color, and technically mediocre.

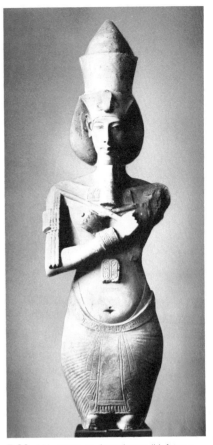

7-20 *Akhenaten or Amenhotep IV,* from a pillar statue in the temple of Aton, Tell el-Amarna, c. 1375 B.C. Sandstone, approx. 13' high. Egyptian Museum, Cairo.

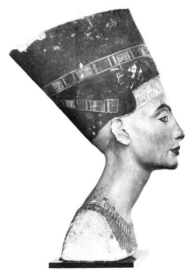

7-21 *Nefertiti,* from Tell el-Amarna, c. 1360 B.C. Limestone, approx. 20" high. Staatliche Museen, Berlin.

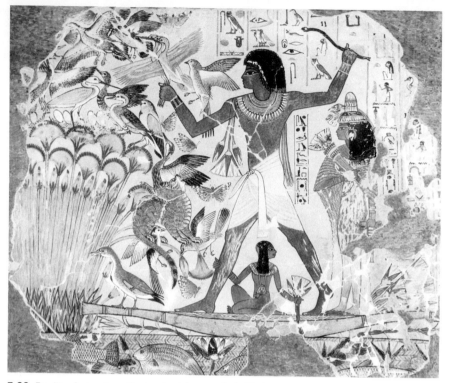

7-22 *Fowling Scene,* from the tomb of Amenemheb, Thebes, Dyn. XVIII. British Museum, London.

Fowling Scene, from the tomb of Amenemheb (Thebes, Dyn. XVIII, 2'10" high. Fragment in the British Museum, London). The artist gives us considerable information about types of fishes, birds, and plants, as well as methods of hunting—note the hunting cat (Fig. 7-22). The compositional arrangement of figures, boats, and papyrus is an ancient one for hunting scenes. The small scale of the hunter's companions indicates their lesser importance. The object on the head of the standing woman is a lump of perfumed ointment.

Wall paintings in the tomb of Nakht (Thebes, Dyn. XVIII). Nakht was a priest of the god Amun. The paintings (Fig. 7-23) describe offerings made at the painted false door of the chapel, the procedures of farming, and dancers and musicians entertaining guests at a feast. Here also the style indicates the period before Akhenaten, but the freedom of brushwork and the delicate color indicate the period just after the tomb of Amenemheb. Traditionally, men were given a darker skin color than women. The small but well-preserved chapel shows the typically sparkling decorative effect of the many flat shapes used in Egyptian painting.

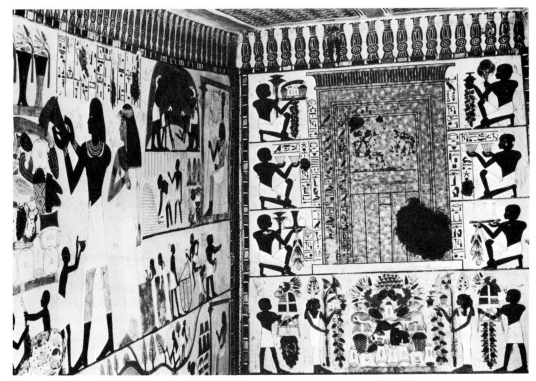

7-23 Wall paintings in the tomb of Nakht, Thebes, *c.* 1450 B.C. Rear wall 55″ x 60″.

Suggestions for Further Study

Aldred, Cyril. *The Development of Ancient Egyptian Art from 3200–1315 B.C.* London: Tiranti, 1952.

Desroches-Noblecourt, Christine. *Ancient Egypt: The New Kingdom and the Amarna Period.* Greenwich, Conn.: New York Graphic Society, 1960.

Edwards, I. E. S. *Pyramids of Egypt,* rev. ed. Baltimore: Penguin Books, 1963.

Frankfort, H. A. G. *Arrest and Movement.* Chicago: University of Chicago Press, 1951.

Lange, Kurt, and Max Hirmer. *Egypt: Architecture, Sculpture, Painting in Three Thousand Years,* 2nd rev. ed. Translated by R. H. Boothroyd. London: Phaidon Press, 1957.

Mekhitarian, Arpag. *Egyptian Painting.* (Great Centuries of Painting). Translated by Stuart Gilbert. Geneva: Skira, 1954.

Smith, E. Baldwin. *Egyptian Architecture as Cultural Expression.* New York: Appleton-Century-Crofts, 1938.

Smith, William Stevenson. *The Art and Architecture of Ancient Egypt* (Pelican History of Art). Baltimore: Penguin Books, 1958.

Woldering, Irmgard. *Gods, Men, and Pharaohs: The Glory of Egyptian Art.* New York: Abrams, 1967.

Chapter 8

Aegean Art:

2800–1100 B.C.

Aegean art comes from three main areas: Crete, the Cycladic Islands, and the mainland that later became Greece. On Crete, major sites are Knossos, Phaistos, Hagia Triada, Gournia, Mallia, Palaikastro, and Zabro; of the Cycladic Islands, Melos, Naxos, Paros, and Syros are especially important; on the mainland, the many sites include Mycenae, Tiryns, Pylos, Lerna, Orchomenos, and Iolkos. By 2800 B.C., the use of bronze was ending *Neolithic* (New Stone) Age culture and opening the *Bronze Age*. Cretan culture (often called *Minoan*, after the one or more ancient kings named Minos), Cycladic culture, and, on the mainland, pre-Greek culture (referred to as *Helladic*) have been divided chronologically into *early* (2800–2000 B.C.), *middle* (2000–1550 B.C.), and *late* (1500–1100 B.C.) periods, corresponding roughly to the Old, Middle, and New kingdoms in Egypt. Further subdivisions are used by experts, but because the three geographical areas did not develop technologically at the same pace the subdivisions are somewhat arbitrary. Dates for Egypt are more certain, and Egyptian artifacts found among the remains of other cultures allow dating by relation to Egyptian chronology.

By 1550 B.C., Cretan art was a dominant influence both on the mainland and in the Cyclades. There is evidence of widespread destruction in Crete about 1700 B.C. and of much rebuilding around 1550 B.C. In 1450 B.C., more serious destruction befell the island, probably as a result of the eruption of the volcano on the nearby island of Thera (modern Santorin). After this, the Cretans seem to have been ruled by the Mycenaeans from the mainland until about 1200 B.C., when a period of war and dissolution was followed by the conquest of both Crete and the mainland by the Dorians (later to become the Greeks). It was during this confused period between 1200 and 800 B.C. that the Homeric epics, the *Iliad* and the *Odyssey*, came into being.

Cretan culture grew in the environment of a temperate climate, fertile soil, and a protective sea. The Cretans benefited as well from their position at a trade crossroads; there is evidence of contact with Egypt and Mesopotamia. Notable in Cretan architecture and art is the absence of fortifications and military subject matter. Early hieroglyphic scripts, inspired by Egypt, overlapped the use of two later scripts, Linear A and Linear B. Only Linear B has been partially deciphered; it is a form of early Greek and was used mainly for inventories. Thus far, there are more questions than answers about Cretan government and religion. Gov-

ernment was apparently decentralized, and religion viewed nature as a friendly force. Public worship was held in caves and on mountain tops; private worship was performed in small chapels in houses and palaces. It is not known whether Cretan religion was monotheistic or not. Apparent deities are most frequently female, and it is possible that the various representations are all of a single goddess shown in different forms and functions. Donkey-headed and bull-headed creatures with human bodies (minotaurs) were apparently considered as demons. Sacred objects were special columns, trees, and double-bladed axes. Life in Crete seems to have been colorful, nature-oriented, and relatively secure, despite the occasional devastations apparently caused by earthquakes.

Our knowledge of Cycladic culture is meager. Cretan influence was strong, and the Cyclades prospered from resources of gold, silver, copper, marble, and emery. On the mainland, hilltop fortresses such as Mycenae and Tiryns bespeak a much less carefree life than that of the islands. Graves contain weapons, bodies mummified in the Egyptian manner, and Cretan objects. Mycenae's wealth of gold may have come as payment for mercenary service in Egyptian battles against the Hittites. The art and the tombs reveal influence from Egypt and Crete. Mycenaean power reached its apex between 1400 and 1200 B.C.

ARCHITECTURE

Cretan architecture took the form of town houses, country villas, palaces, market halls, and tombs. Temples apparently were not needed. Plans for buildings and towns often had a north–south orientation in their long axis. Houses were built of brick, stone, and wood, had symmetrical façades, and consisted of several floors built around an interior courtyard. Palace plans were irregular, labyrinthine, and organized around rectangular inner courts. Royal apartments, storage magazines, and audience chambers have been identified. Although palace entrances were not stressed, the west façade was usually built first, given special ornamental emphasis, and confronted by an exterior courtyard. Walls were of mud brick, rubble masonry, and plaster; stone blocks were used in corners and in frames for doors and windows. Roofs were flat, resting on wooden beams and wooden columns that carried brightly painted cushion-shaped capitals and had shafts that tapered downward. Interior palace floors were of gypsum; exterior floors

were made of limestone. Interior walls were often frescoed. Tombs were emphasized only in the early period, when circular stone structures, some probably vaulted, served the whole community.

Our sparse information about Cycladic architecture indicates that it was much like that of Crete; but mainland architecture included fortified citadels, the most famous being at Mycenae and Tiryns. Thick walls of huge stones encircled hilltop clusters of small houses and palaces with plans that developed around the *megaron*, a rectangular hall with central hearth, anteroom, and pillared porch. Such compressed quarters did not compare with the luxury of Cretan palaces, although mainland ruins reveal gypsum floor slabs and plastered walls with painted designs. Pit and shaft tombs in the early period and the first part of the middle period were replaced, at least for royalty, by round conical tombs with corbeled stone domes and ornaments of carved and painted stone as well as attached metal objects. Earth was piled over the tomb exteriors, obscuring everything but the *dromos*, a stone-lined approach to the entrance.

Palace at Knossos (*c.* 1600–1400 B.C.). The ruins of Knossos, the largest of the Cretan palaces, are those of the new palace, built some time after the destruction

8-1

Plan of the palace at Knossos.

1. West porch
2. Corridor of the Procession
3. South propylon
4. Central court
5. "Theater area"
6. North propylon
7. Pillar hall
8. Magazines
9. Throne room
10. Palace shrine and lower verandas
11. Stepped porch
12. Grand staircase
13. Light area
14. Hall of the Colonnade
15. Hall of the Double Axes (principal reception room)
16. Queen's Megaron

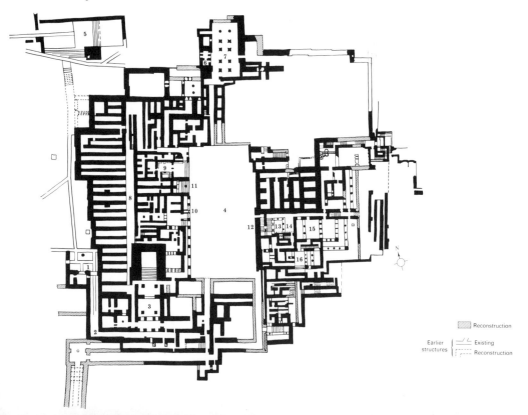

Reconstruction

Earlier structures { Existing
Reconstruction

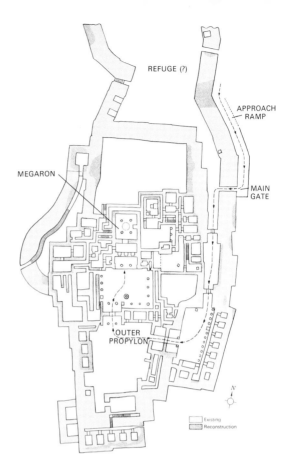

REFUGE (?)

APPROACH
RAMP

MEGARON

MAIN
GATE

OUTER
PROPYLON

N

Existing
Reconstruction

8-2 Plan of the citadel at Tiryns,
c. 1400–1200 B.C.

of about 1700 B.C. The complex, additive, asymmetrical character of the plan (Fig. 8-1) is typical, as are the indirect entrances on each side. The western half of the palace is divided by a long corridor into magazines (storage chambers) on one side and a complex of official rooms, including a throne room, on the other. The eastern half is divided into a northern section of workshops and a southern section of living quarters and reception rooms. Parts of the structure were three stories high, and interior staircases were built beside light wells. Beneath the palace, terra cotta pipes provided an efficient drainage system. Columns had the typical Cretan cushion capital and downward-tapering shaft. Colorful frescoes showing scenes of processionals and bull games adorned the walls.

Citadel at Tiryns (Peloponnesus, *c.* 1400–1200 B.C.). This small, heavily fortified hilltop (Fig. 8-2) is better preserved than the fortress at Mycenae. The Greeks believed that Tiryns was the birthplace of Hercules. Although it has none of the expansiveness of Cretan

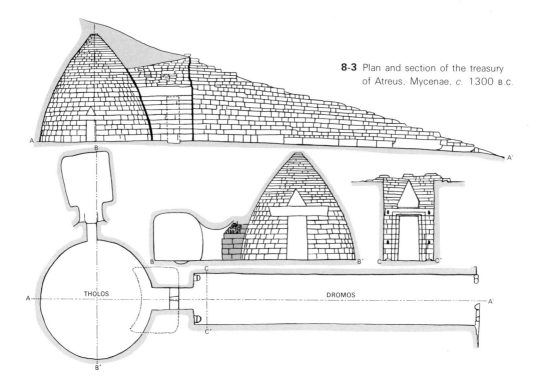

8-3 Plan and section of the treasury of Atreus, Mycenae, *c.* 1300 B.C.

THOLOS

DROMOS

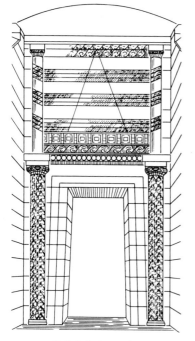

8-4 Relieving arch.

palaces, it suggests more careful planning. The focus is the megaron, which may have its source in Hittite architecture (see p. 60). Huge, rough-cut stones form massive walls that contain passageways with corbeled vaults.

Treasury of Atreus (Mycenae, *c.* 1300 B.C.). Of the nine *tholoi* (round tombs; sing., *tholos*) at Mycenae, this one (Fig. 8-3), mistakenly called the treasury of Atreus by its discoverer, Heinrich Schliemann, is the most impressive. Its diameter is 47'7" and the top of the corbeled dome is 43'4" from the floor. The span of the dome is the largest until the Roman Pantheon in the second century A.D. (see p. 126). The finely cut stones were buttressed and protected by the mound of earth that covered the exterior. The lintel over the door is protected from or relieved of the weight of the dome by a corbeled *relieving arch* (Fig. 8-4), originally filled by a decorated stone slab. Red and green marble embellished the entrance. Designs contained the running spiral, chevron, and petal forms characteristic of Cretan art, but these were used within more rigidly constricted framing shapes. Since the tomb was emptied in antiquity, we may never know who its original occupant was.

PAINTING

In Crete, the only painting that has been found in any quantity from the early and middle periods is on pottery. Stripes and soft mottled shapes were painted in red-brown or black on a lighter red-brown background. Toward the end of the early period, white designs were applied on a red-brown or black background. In the middle Minoan period (c. 2000–1550 B.C.), design motifs became bolder in contrast, surer in execution, and more varied. Running spirals, wavy lines, rosettes, lilies, palm trees, fish, seaweed, and net designs in white, red, orange, yellow, and black explode over the surfaces. The best examples are called *Kamares ware*, after the cave on Mt. Ida in which they were found. Late Minoan pottery painting exhibits several trends, some of which (the *Floral Style* and the *Marine Style*) continue the vitality of the earlier Kamares ware. Another style uses the same yellow, red, white, and black for more restrained, tightly grouped, and precisely repeated forms. This trend is also reflected in the so-called *Palace Style*, examples of which have been found only at Knossos and which represent the period of Mycenaean occupation rather than an indigenous Cretan art. Most of the Cretan wall paintings known to us come from the new palace at Knossos (c. 1600–1400 B.C.), and even these are fragmentary. As with the pottery, exuberance is combined with delicacy in drawing and color. True fresco is used; the images are of Cretans engaged in sports, processions, and ceremonies.

In the Cyclades, the style changes in pottery painting are similar to those of Crete, but they display less variety and sensitivity. Fragments of frescoes portraying plant and animal life in spontaneously painted flowing forms recall the art of Crete.

During the early and middle periods the mainland also developed pottery painting similar in style to that of Crete, but inferior in quality. The late period produced the ornate Palace Style, which the Mycenaeans carried to Crete. Fresco painting on the mainland was strongly influenced by Crete but tended toward rigid and static forms.

Bull Games, from the palace at Knossos (c. 1500 B.C., fresco, approx. 32″ high including border. Archeological Museum, Herakleion). A small room in the east wing of the palace was decorated with a sequence of scenes (Fig. 8-5) depicting a sport often shown in Cretan art. Male (red-skinned) and female (white-skinned) athletes grasp the

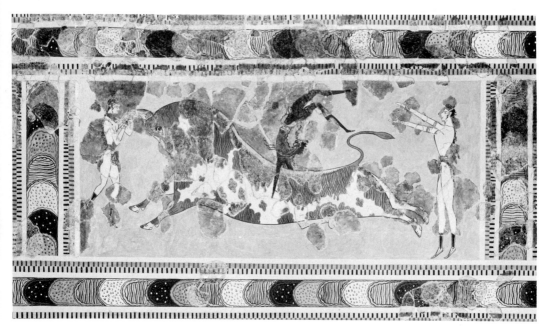

8-5 *Bull Games*, from Knossos, *c.* 1500 B.C. Fresco, approx. 32″ high including border. Archeological Museum, Herakleion.

horns of a charging bull and somersault over its back. Blue and yellow alternate as background colors. The light colors, supple curves, and wasp-waisted figures are typical of Cretan art.

Octopus Vase (Palaikastro, *c.* 1500 B.C., approx. 10″ high. Archeological Museum, Herakleion). The lively patterns and references to nature that characterize so much of Cretan art are displayed in this example of the late Minoan Marine Style (Fig. 8-6).

SCULPTURE

Although there is some evidence that the Cretans carved life-sized statues in wood, the only sculpture now known to us is less than three feet high. Idols, worshipers, children, animals, athletes vaulting over bulls, and individual limbs used as *ex-votos* (thank offerings for cures) were modeled, cast, or carved in terra cotta, glazed clay, bronze, ivory, or gold. From the early and middle periods come terra cotta figures found in communal tombs and mountain-top sanctuaries. These are severely simplified female images with full, bell-shaped skirts, and nearly nude males with the narrow waists and broad shoulders depicted in the later frescoes. As

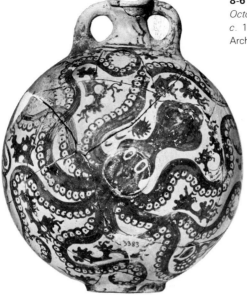

8-6
Octopus Vase, amphora from Palaikastro,
c. 1500 B.C. Approx. 10″ high.
Archeological Museum, Herakleion.

in Egypt, male skin was red and female skin was white
or pale yellow. More anatomical and decorative detail
is shown in the figures made of *faience* (glazed clay)
and in those of ivory with gold fittings. Jewelry and
stamp-seal engravings of subjects ranging from geo-
metric designs to animals and hieroglyphics reveal great
skill in miniature sculpture. The engravings were made
with stamp seals like those of Egypt rather than cylinder
seals like those of Mesopotamia.

Cycladic tombs have yielded up hundreds of slablike
marble statues varying in height from several inches
to life size. These so-called *Cycladic idols* are very
simplified human forms with the main body divisions
indicated by grooves or ridges. In silhouette, many
resemble a violin shape. Chronology is still in question,
but most seem to come from the early period.

On the mainland, there is little life-sized sculpture
preserved, but dimensions are more ambitious than in
Crete. Gravestones bore geometric designs and hunting
scenes in relief, and architecture apparently carried
sculptural reliefs, concentrated at major entrances.

Earth-Goddess with Snakes (Knossos, *c.* 1600 B.C., faïence,
11½″ high. Archeological Museum, Herakleion). This small
Middle Minoan figure (Fig. 8-7) is one of two found

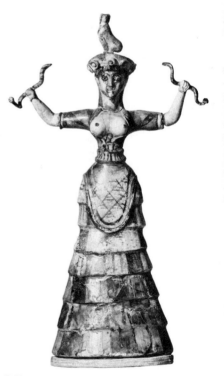

8-7 *Earth Goddess with Snakes,* from Knossos,
c. 1600 B.C. Faïence, approx. 11½″ high.
Archeological Museum, Herakleion.

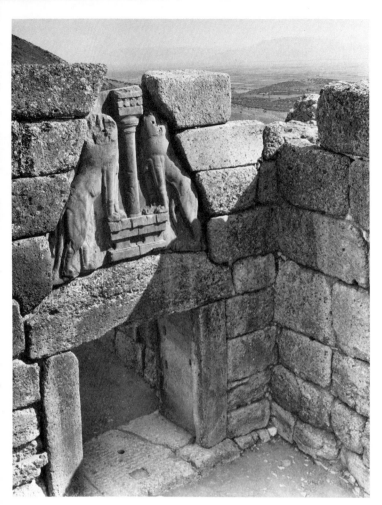

8-8
Lion Gate, Mycenae,
c. 1300 B.C. Limestone,
relief panel approx.
9½'' high.

in stone-lined pits in the palace. Although we are not certain that she is a goddess, her deity is assumed on the basis of other Cretan art depicting females in control of animals and nature. These may all be different forms of a single mother-goddess. The jackets, bare breasts, and full, ground-length skirts seem to have been standard costume for religious festivals.

Lion Gate (Mycenae, *c.* 1300 B.C., limestone, triangular slab approx. 9½′ high). The relief fits within an opening formed by the corbeled relieving arch above and the lintel below (Fig. 8-8). The column symbolized the strength and unity of Mycenae; the base may have served as an altar. The heads of the powerfully modeled lions were attached separately and were turned to confront the visitor approaching the gate. The approach ramp lies within the protection of the city wall.

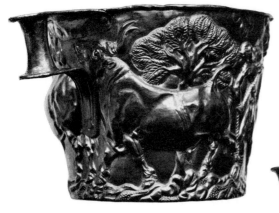

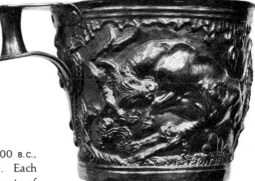

8-9 *Vaphio Cups, c.* 1500 B.C. Gold with repoussé decoration, approx. 3½'' high. National Museum, Athens.

Vaphio Cups, from a tholos tomb at Vaphio (*c.* 1500 B.C., gold, approx. 3½'' high. National Museum, Athens). Each of the pair of cups (Fig. 8-9) is made of two sheets of gold, the outer sheet worked in repoussé (hammered out from the back) and lined with a smooth inner sheet. The reliefs depict the trapping of bulls in a net by men with Cretan bodies and costumes. The cups could be Cretan work or Mycenaean art under the influence of Crete. The action, anatomy, and foliage reveal careful observation of nature.

Suggestions for Further Study

Blegen, Carl W., and Marion Rawson. *The Palace of Nestor at Pylos in Western Messena.* Published for the University of Cincinnati. Princeton, N.J.: Princeton University Press, 1966.

Branigan, Keith. *The Foundations of Palatial Crete: A Survey of Crete in the Early Bronze Age.* New York: Praeger, 1970.

Demargne, Pierre. *Aegean Art: The Origins of Greek Art* (The Arts of Mankind). Translated by Stuart Gilbert and James Emmons. London: Thames and Hudson, 1964.

Hafner, German. *Art of Crete, Mycenae, and Greece.* New York: Abrams, 1968.

Hutchinson, Richard Wyatt. *Prehistoric Crete.* Baltimore: Penguin Books, 1962.

Marinatos, Spyridon, and Max Hirmer. *Crete and Mycenae.* New York: Abrams, 1960.

Palmer, Leonard Robert. *A New Guide to the Palace of Knossos.* New York: Praeger, 1969.

Vermeule, Emily. *Greece in the Bronze Age.* Chicago: University of Chicago Press, 1964.

Greek Art:

1100–100 B.C.

About 1100 B.C., the Dorian invasions seem to have been the final step leading to the amalgamation of peoples that became the basis for Greek culture. By 100 B.C., Greece was part of the Roman Empire. In the intervening years, the underlying theme of Greek culture was man and his rational faculty for understanding and perfecting himself and nature. The mild climate favored outdoor activity, influencing architecture directly and painting and sculpture indirectly. The periodic Olympic games (first recorded in 776 B.C.) reflected the Greek interest in the physical life and the human body. Yet the Greeks grew even more interested in the development of the mind, especially the power of reason, and in the conception of ideal forms for all things. Perfection was sought within carefully chosen limits or rules. The conviction that man is the measure of all things was basic to this culture, and even the gods were seen in the image of man, with few combinations of man and animal like those found in Egyptian religion. For art the most important Greek gods are (1) Zeus (Jupiter to the Romans), lord of the sky and supreme ruler, who wielded thunderbolts; (2) Hera (the Roman Juno), wife and sister of Zeus and goddess of marriage; (3) Poseidon (the Roman Neptune), god of the sea, recognized by his trident spear; (4) Athena (the Roman Minerva), originally a goddess of war but more commonly the patroness of civilized life and wisdom; (5) Artemis (the Roman Diana), huntress and patroness of wildlife and the young, often shown with bow and arrows; (6) Apollo (known by the same name to the Romans), god of poetry, music, truth, prophecy, and—in later mythology—god of the sun (sometimes shown with a lyre or with bow and arrows); (7) Aphrodite (the Roman Venus), goddess of love and beauty; (8) Hermes (the Roman Mercury), messenger of the gods and patron of commerce (shown with winged sandals and a wand with entwined serpents); (9) Dionysus (the Roman Bacchus), a latecomer to Greek mythology, god of wine and feasting; (10) Pan (reflected in the Roman god Faunus), god of shepherds and flocks, a mischievous creature largely in human form but with horns and goat's legs; (11) satyrs (also found in Roman mythology), who look like Pan and seek all sensual pleasures; and (12) centaurs, who are half man, half horse and are considered (with the exception of Chiron) to be savage creatures. The most common idea of life after death was that of a gray world of drifting spirits, and in contrast to the Egyptians, the Greeks emphasized life, an earthly life of balanced attainments, based on the

idea that the complete man is one governed by reason and enlightened by wide interests. Consequently Greek tombs and burial customs were simple.

Geometric (1100–700 B.C.) and Archaic (700–500 B.C.) Periods

SCULPTURE

Greek sculpture was mainly religious. Of the works preserved from the Geometric period, many are small bronze votive statuettes dedicated to the gods. During this period, copper and fired clay were also common materials, and it is probable that there were large-scale wooden statues that have disappeared. Some of the metal statuettes were made of sheet metal riveted together; others were cast using a sand mold or the lost-wax process. Divisions between the parts of the body tend to be exaggerated, and some parts are modified according to the sculptor's instinct for design. The result is usually a rigid schematic form that resembles Egyptian art. This strict geometric order is the basis for the name given to the period. The stylistic trend during the Geometric period is toward more flowing transitions between body parts and more natural human form.

After the middle of the seventh century B.C., life-sized stone sculpture became more common, and the geometric rigidity of the earlier period slowly softened. Nudity, so rare in Egyptian art, occurs early in Greek sculptures of the male body. We have found many statues of young men (*kouroi;* sing., *kouros*) sculpted in the seventh and early sixth centuries B.C.; their frontal poses, stiff joints, and symmetrical hair and musculature recall Egyptian sculpture. It is rarely clear whether they were meant to be gods or mortals. A few works are signed, but little is known of sculptors from the Archaic period. A number of standing maidens (*korai;* sing., *kore*) have also been discovered. Their pose and clothing (female nudity was not represented until much later) have the same strict order as that of the male figures. On many kouroi and korai the corners of the mouth are turned up in the so-called Archaic smile.

Apollo (7th cen. B.C., bronze, 8″ high. Museum of Fine Arts, Boston). This Archaic work (Fig. 9-1) remains Geometric in style and has an inscription on the thighs dedicating the image to Apollo. The words ("Mantiklos dedicated me to . . .") reveal that the Greeks assigned an independent life to each work of art.

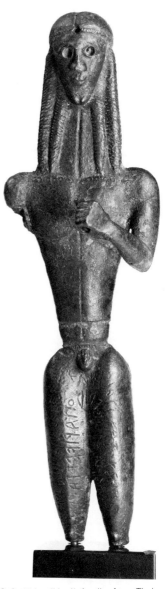

9-1 *"Mantiklos" Apollo,* from Thebes, c. 680 B.C. Bronze, approx. 8″ high. Museum of Fine Arts, Boston (Frances Bartlett Fund).

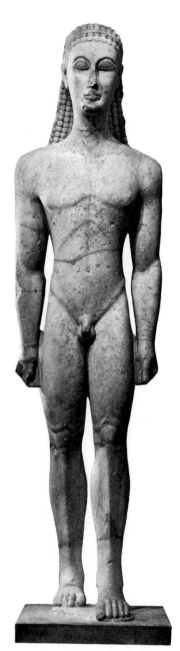

Standing Youth, from Attica (late 7th cen. B.C., marble, 78"
high. Metropolitan Museum of Art, New York). This Archaic
kouros statue (Fig. 9-2) reveals its ancestry in the Geo-
metric style. The frontal pose and the insistent sym-
metry are similar to Egyptian work, but there is no
back-slab, and the arms are separated from the body,
slightly opening up the form.

PAINTING

Greek painting of the Geometric and Archaic periods
is known to us only through vase decoration, but vase
painting was an important medium until the fourth
century B.C. Early Geometric painting consists of geo-
metric shapes in registers. When the human body began
to be depicted, it was reduced to sharply divided and
simplified parts. The basic colors were provided by
painting with a thinned mixture of brown-black clay
on the body of red-brown clay, but other colors and
white were sometimes added. The technique employing
black shapes on the lighter reddish background is called
black-figure vase painting.

Black-figure painting continued through most of the
Archaic period and into the third quarter of the sixth
century B.C., when it began to give way to *red-figure*
painting, a technique in which the background is filled
in with brown-black, leaving a base color of red-orange
or warm tan for the figures. During the Archaic period,
the figures became more lifelike, and geometric orna-
ment was reduced. Scenes depict events from mythol-
ogy, and ornament includes animals and floral motifs.
Anatomy acquired more flexibility and naturalness of
shape and proportion, but conventional formulas still
dominated the forms. Beginning in the second quarter
of the sixth century B.C., Athens was the center of great
activity in vase painting. Both potters and painters began
to sign their work (sometimes one man did both vase
and painting).

Athenian grave vase (8th cen. B.C., 61" high. No. 804,
National Museum, Athens). The geometry of the figures
in this funeral scene (Fig. 9-3) places it easily in the
large expanse of purely geometric decoration. One of
the most common geometric patterns looks like a row
of key ends standing upright; this is called the *Greek
key* or *fret* and is still in use today. Many such grave
vases have been found in the Dipylon Cemetery in
Athens. They are often from 5 to 6 feet high, and some
have perforated bottoms through which liquid offerings
could drip onto the grave.

9-2 *Standing Youth,* kouros from Attica,
late seventh century B.C. Marble, 78" high.
Metropolitan Museum of Art, New York
(Fletcher Fund, 1932).

Ajax and Achilles Playing Draughts (550–525 B.C., vase 24″ high. Vatican Museums, Rome). This black-figured scene (Fig. 9-4) decorates an *amphora* (tall vase with two handles) and was done by Exekias, one of the outstanding Archaic vase painters. Geometric ornament is sparse. The frontally seen eye is still used with the long-nosed profile of earlier work, and taut, flat shapes seem to bend stiffly at the joints (compare this with Archaic sculpture). Figures are anchored to a common base line; there is no effort to suggest round mass or deep space. The curve of the men's backs repeats the curve of the base. The diagonals of the spears intensify the focus of attention on the game—the center of the obvious axial balance—and relate the composition to the handles of the vase, which seem to continue the lines of the spears.

ARCHITECTURE

Our knowledge of architecture from the Geometric and Archaic periods is incomplete. The most important buildings seem to have been temples to the gods and treasuries to hold offerings. Prior to 650 B.C., the Greeks built with wood and sun-dried brick; hence we have few remains that date from before that time. As the use of stone increased, some of the wooden structural forms were imitated in stone and became decorative rather than structural. Limestone was the usual material, and it was sometimes covered with a white stucco made of marble dust. Roofs were tile, with colored clay ornaments along the tops and edges. The basic structural system was post and lintel. The dominant plan for temples and treasuries was rectangular; from a stepped

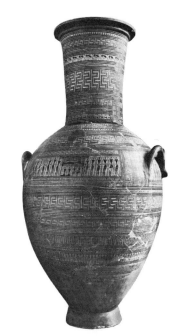

9-3 *Dipylon Vase,* Geometric amphora, eighth century B.C. Approx. 5′1″ high. National Museum, Athens.

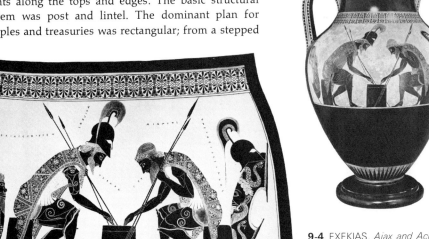

9-4 EXEKIAS, *Ajax and Achilles Playing Draughts,* vase painting, 550–525 B.C. Vatican Museums, Rome.

Geometric and Archaic Periods / 95

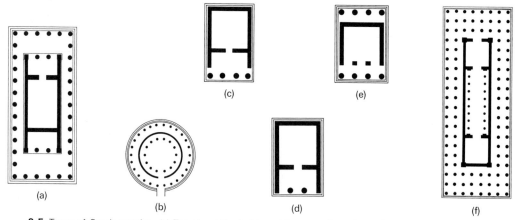

9-5 Types of Greek temples. (a) Temple of Hephaistos, Athens: peripteral temple (surrounded by colonnade) with cella in antis at both ends. (b) Tholos, Epidauros: tholos (round temple). (c) Temple B, Selinus, Sicily: prostyle temple (columns in front of antae). (d) Athenian Treasury, Delphi: temple in antis (columns set within antae). (e) Temple of Athena Nike, Athens: amphiprostyle temple (prostyle at both ends). (f) Temple of Zeus Olympios, Athens: dipteral temple (double colonnade) with cella prostyle at both ends.

base, windowless wall rose to enclose one to three cellae (Fig. 9-5a, c, d, e, f). A *peristyle* (a covered colonnade that surrounds a building or a court) was common. A second type of temple was the *tholos*, which was circular in shape and usually had a peristyle (Fig. 9-5b). The rhythmic alternation of columns and spaces gives the exterior of most Greek temples a lighter, more open

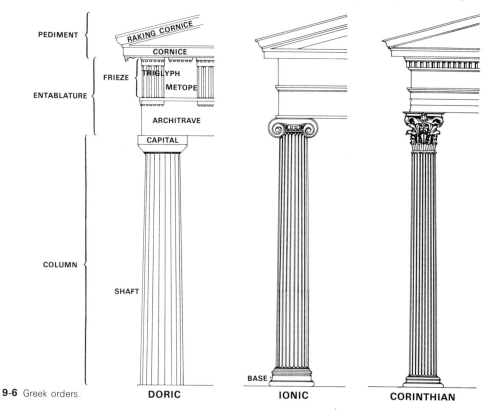

9-6 Greek orders.

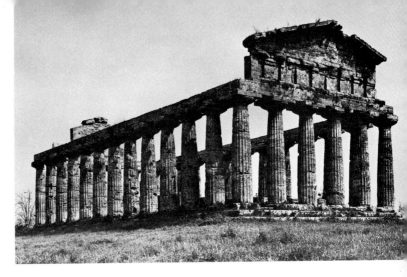

9-7
Temple of Ceres,
Paestum. Late sixth
century B.C.

form than that of Egyptian architecture. The modest
scale, simplicity, and clearly defined limits of Greek
buildings focus attention on the proportions and the
relationship of the parts to the whole form, which
normally uses obvious balance, either axial or central.
Two of the three basic types of Greek columns were
developed during the Archaic period: the Doric and the
Ionic, the latter being more prevalent in Ionia in Asia
Minor. These columns each had a special *entablature*
to match. The combination of column and entablature
is called an *order* (Fig. 9-6).

Temple of Ceres (Paestum, late 6th cen. B.C., limestone,
approx. 48′ x 108′). Only the peristyle remains from
this Doric temple (Fig. 9-7) built in the Greek colony
at Paestum on the Italian peninsula. The ponderous
proportions of the pediment and the abrupt mush-
rooming of the capitals are typical of Archaic temples
and indicate some awkwardness on the part of the
provincial builders.

Fifth Century B.C.

ARCHITECTURE

Despite the wars with Persia, the Athenian struggle for
empire, and the Peloponnesian War, the fifth century
B.C. showed remarkable activity in the arts. Of the many
types of buildings, temples and treasuries continued to
be most important. These are often found in sacred
precincts such as Delphi, Aegina, Olympia, and the
Acropolis at Athens. Although systematic city planning
appeared in the fifth century, vast schemes of axial

Leaf and dart
Bead and reel
Egg and dart
Bead and reel

Anthemion band

9-8 Greek moldings.

planning with space and mass were not developed until much later by the Romans; the sacred precincts of the Greeks are, by comparison, more freely arranged. The Athenian Acropolis presents some alignment of parts, however, and contains the most celebrated examples of fifth-century architecture. The major buildings, which owe their beginnings to the statesman Pericles, date from the second half of the century. Marble was used instead of the more economical limestone, and extraordinary efforts were made to achieve the most satisfying proportions and the highest quality of stone carving in both Ionic and Doric temples. The Doric order (Fig. 9-6) received a subtler *entasis* (the slight outward curving of the shaft) than in either the previous or the succeeding century, and the capital became a smoother transition between the vertical shaft and the horizontal entablature. In the most refined Doric temples, the temple platform is slightly domed and all columns lean inward almost imperceptibly, giving the building a more compact, self-contained unity that reinforces the stable equilibrium of vertical and horizontal lines. Unlike the Doric, the Ionic order employed a very slender shaft (sometimes with very slight entasis), a base between shaft and stylobate, a three-part architrave, and usually a continuous frieze instead of the Doric metopes and triglyphs (Fig. 9-6). The third Greek order, the Corinthian, appeared in the second half of the century. It differed from the Ionic only in its leafy capital. The use of two or three orders in the same building became common toward the end of the fifth century. Temples were richly decorated with sculpted moldings (Fig. 9-8) and figure sculpture. Major sculptural compositions were placed in the *pediments* (the triangular gables at the ends of the building), in the frieze area, and sometimes on the outside of the cella walls. As with sculpture, parts of Greek architecture were painted. Blue was common for pediment backgrounds and for Ionic friezes; red was often used as a background for metope sculpture and for capitals and architraves.

Parthenon, built by Ictinos and Callicrates (Acropolis, Athens, 447–432 B.C., marble, approx. 228′ x 104′ with columns approx. 34′ high). The Parthenon (Figs. 9-9 and 9-10) has the most subtle proportions of all Greek Doric temples and has long been considered the high point of Greek architecture. It is the major building on the Acropolis, was dedicated to Athena, patroness of Athens, and formerly sheltered a colossal gold-and-ivory statue of the goddess. Originally, the Parthenon

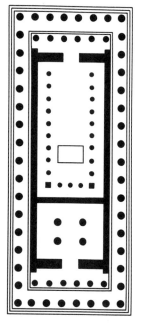

9-9 Plan of the Parthenon.

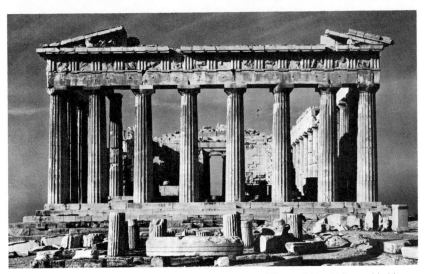

9-10 ICTINOS and CALLICRATES, Parthenon, Acropolis, Athens, 447–432 B.C. Marble, approx. 228' x 104' with columns approx. 34' high.

had sculpture in the pediments, in the metopes (Fig. 9-19), and in a frieze around the outside of the cella wall.

Erechtheum, built by Mnesicles (Acropolis, Athens, 420–409 B.C., marble, approx. 80' x 90'). This irregularly shaped temple (Fig. 9-11) is famous for the subtle proportions and precise carving of its Ionic order and for its porch with *caryatids* (columns in the form of female figures).

SCULPTURE

For sculpture, as for architecture, the fifth century was a time of brilliant activity. Sculpture was present in public places, in sacred precincts, and on temples. Bronze and marble were the main materials. Subjects

9-11 MNESICLES, Erechtheum, Acropolis, Athens, 420–409 B.C. Marble, approx. 80' x 90'.

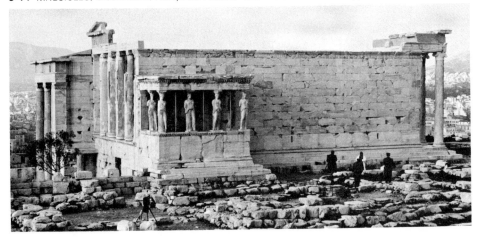

9-12 Reconstruction drawing of the east pediment of
the Temple of Aphaia at Aegina. *c.* 490 B.C.

9-13 *Fallen Warrior,* from the east pediment of the Temple of Aphaia at Aegina.

were usually taken from mythology, although there are occasional portraits, figures of athletes or heroes, and representations of animals; rather than depicting specific historical events, the Greeks used allegory that borrowed themes from mythology. Early fifth-century sculpture represents ideal youthful bodies with simplified, symmetrical anatomy. Proportions are more natural than in earlier work, but action is still slightly stiff, and the musculature is hard. Toward the middle of the century, the work of the great sculptor Myron shows a slight softening and increased flexibility in pose. After mid-century, Phidias started a trend toward more active, flexible poses and more expression of emotion, only to change in his later work to more restrained action and a calmer, poised equilibrium of pose. His rival, Polyclitus, also concerned himself with ideal form, monumental dignity, and the rhythmic grace of the *contrapposto* pose (in which the body relaxes with the weight on one leg, and the tilt of the hips is countered by the tilt of the shoulders). Late fifth-century sculpture worked toward the suggestion of softer flesh and more flexible poses. Throughout the century, however, space remains strictly limited. In reliefs, a blank background restricts action to a shallow layer of depth; in freestanding statues, the form opens predominantly in two dimensions—shallow crates would suffice for packing the works—and there is almost no spiral twisting of the torso.

Pediment sculptures, from the Temple of Aphaia at Aegina (marble with traces of paint, slightly less than life size. Glyptothek, Munich). Three sets of pedimental sculpture were found in debris at the base of the temple, apparently dating from 510 to 490 B.C. Scenes of the Trojan War are depicted, but the exact composition of the pediments is not certain. The reconstruction of the east pediment (Fig. 9-12) utilizes obvious axial balance in poses and actions within the triangular pediment. From the tall figure of the goddess Athena, action diverges until it is countered by movements converging from the corners. The poses are more open and active than those in Archaic work, and the anatomy shows more observation of nature; there is, however, still some stiffness of pose and hardness of flesh. The pose of the *Fallen Warrior* (Fig. 9-13), for example, is complex and generally natural; yet some details, such as the misplaced navel, indicate reliance on earlier stylistic conventions rather than on observation of nature.

Artemision Statue (*c.* 460–450 B.C., bronze, eyes formerly inlaid, 6'10" high. National Museum, Athens). One of the finest of the votive statues that have been found, this work (Fig. 9-14) was discovered in the sea off Cape Artemision. The right hand originally held an object that is now lost, possibly a thunderbolt (indicating Zeus) or a trident (for Poseidon). The musculature and pose show the degree of flexibility, vitality, and poise characteristic of work just before mid-century. The composition opens mainly in two dimensions, with severely limited depth.

9-14 *Artemision Statue,*
 c. 460–450 B.C. Bronze,
 6'10" high.
 National Museum, Athens.

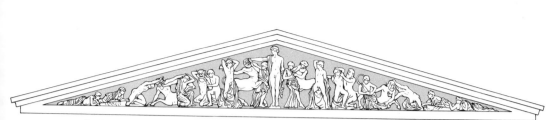

9-15 Reconstruction drawing of the west pediment of the Temple of Zeus at Olympia, 468–460 B.C. Approx. 91' wide.

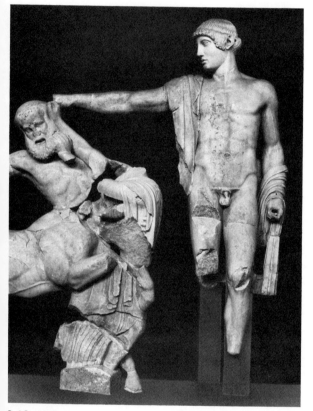

9-16 *Apollo,* from the west pediment of the Temple of Zeus at Olympia. Marble, over life size. Archeological Museum, Olympia.

9-17
MYRON, *Discus-Thrower* (*Discobolus*), Roman marble copy after a bronze original of *c.* 450 B.C. Life size. Museo delle Terme, Rome.

Pediment sculptures, from the Temple of Zeus at Olympia (465–457 B.C., marble, central figures approx. 10' high. Archeological Museum, Olympia, and Louvre, Paris). The eastern pediment showed the preparation for the chariot race between Oenomaus and Pelops; the western pediment depicted Apollo observing the battle between the Lapiths and centaurs (Figs. 9-15 and 9-16). Stylistically, the work is close to the *Artemision Statue.*

Discus-Thrower, by Myron (*c.* 450 B.C., reconstruction of a Roman copy, 4'6" high. Museo delle Terme, Rome). Myron chose to depict the moment of equilibrium before the forward swing of the throw (Fig. 9-17). The symmetry of the musculature continues to suggest ideal form, and the composition is very limited in depth, but the pose is more complex than that of the *Artemision Statue.*

Spear-Bearer, by Polyclitus (450–440 B.C., Roman marble copy, 6'6" high. Museo Nazionale, Naples). Polyclitus was known for his theories of ideal proportions. The muscular figure (Fig. 9-18) attains flexibility through its contrapposto pose. However, the hips and shoulders are aligned in the same shallow space, and the only strong three-dimensional extension is the forward-reaching arm. The hair is organized in groups of wavy lines, and the face is simplified in broad planes. The musculature is still quite firm in the torso, but increasing softness and detail are evident in the arms, hands, and knees.

Lapith Fighting with Centaur (447–432 B.C., marble, 3'11" x 4' 2". British Museum, London). The Parthenon metopes, of which this (Fig. 9-19) is an example, were probably carved under the direction of Phidias. Here

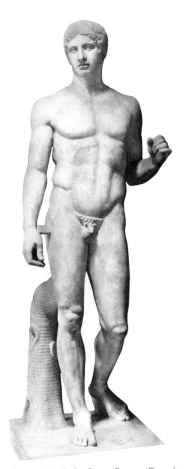

9-18 POLYCLITUS, *Spear-Bearer* (*Doryphorus*), Roman marble copy after original of *c.* 450–440 B.C. 6'6" high. Museo Nazionale, Naples.

9-19 *Lapith Fighting with Centaur,* metope from the Parthenon. Marble, 4'8" high. British Museum, London.

the rhythmic curves of the cloak unite and soften the divergent thrusts of the bodies. The blank background, which limits spatial extension, is typical of Greek reliefs. Despite the weathering of the stone, the carving still suggests the softness of skin overlying the bone structure of the ribs and the muscles of the abdomen.

PAINTING

We must turn again to vases, for the celebrated wall paintings of Polygnotus and Zeuxis are lost. Descriptions by ancient writers indicate that the wall paintings contained some illusion of depth and that theories of perspective had been formulated. The growing interest in depth may have contributed to the decline, after the fifth century, of the importance of vase painting, for depth in vase painting works against the form of the vase by denying its surface. Although red-figure painting continued, there was an increasing tendency to use delicate colors and light linear drawings on vases with white grounds. Figures became rounder, softer, and more flexible as contours overlapped to indicate folds in the flesh. Objects were drawn with more *foreshortening* (as though extending diagonally into space); the eye appears in profile for the first time.

Athenian mixing bowl, from Orvieto (475–450 B.C., approx 21″ high. No. G 341, Louvre, Paris). This work (Fig. 9-20) is traditional in its red-figure technique, but it demonstrates the increasing interest in natural anatomy, mass, and space. It depicts warrior heroes (perhaps the Argonauts) in casual poses freed from a common base line; the figures are placed at various levels, suggesting different degrees of depth. Overlapping contours and foreshortening imply mass in space.

9-20 Athenian mixing bowl, from Orvieto, 475–450 B.C. No. G 341, Louvre, Paris.

Fourth Century B.C.

ARCHITECTURE

Defeat in the Peloponnesian War put an end to Athens' leadership in architecture. During the fourth century, many important buildings were produced in cities like Delphi, Tegea, Epidauros, and—in Asia Minor—at Priene, Ephesus, and Halicarnassus. Efforts spread to a wider variety of types of buildings, many of them secular: *Stoas* (colonnaded, open-fronted sheds used in city centers as promenades and shopping areas), thea-

ters, council halls, and tombs all received special attention, although they had prototypes in earlier centuries. All types of architecture used one or more of the three orders. The Corinthian capital shifted from interior to exterior use, and there was widespread development of the Ionic temple, particularly in Asia Minor. Theaters usually consisted of a slightly more than semicircular area of tiered seats set into a hillside, a round central space (orchestra), and a structure consisting of a raised stage and a building that provided an architectural background and housed dressing rooms and properties. Council halls were oval, square, or rectangular, often with tiered seats around a central altar. The tholos temple reached a height of subtlety and richness of design, and tomb architecture acquired monumental scale.

9-21 Reconstruction drawing of the tomb of Mausolus (Mausoleum) at Halicarnassus, 360–350 B.C.

Mausoleum (Halicarnassus, 360–350 B.C., 136' high). The building (Fig. 9-21) is no longer extant, and its exact form is uncertain. Standing on a rectangular base, it had an Ionic peristyle and was topped by a stepped pyramid and a *quadriga* (chariot pulled by four horses). The structure served as a tomb for Mausolus, a satrap of the Persian kings. In antiquity, it was considered one of the Seven Wonders of the World.

Choragic monument of Lysicrates (Athens, 334 B.C., limestone and marble, 54' high). This monument (Fig. 9-22), developed from the tholos form, was built to commemorate a victory in a choral contest. It seems to be the earliest example of the exterior use of Corinthian columns. The small size recalls the decrease in monumental building in Athens after the defeat in the Peloponnesian War in 404 B.C.

SCULPTURE

Trends that began in the late fifth century grew more evident during the fourth century. Stone and bronze took on the softness of flesh, contrapposto poses became more pronounced, and poses opened up three-dimensionally, with more spiral twisting in the torso. Stone surfaces were polished until the details softened, as though seen through a veil. The famous Praxiteles led these developments in the mid-fourth century. In some work, the serene poise of earlier Greek art gave way to representations of violent motion; and deep-set eyes and beetling brows created an expression of suffering or consternation.

9-22 Choragic monument of Lysicrates, Athens, c. 334 B.C.

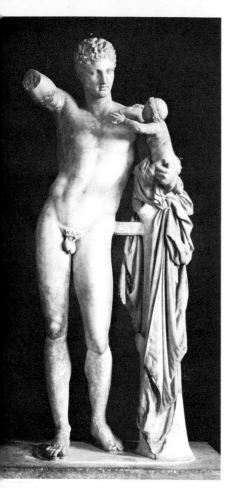

9-23 PRAXITELES, *Hermes with the Infant Dionysus,* c. 350 B.C. Marble, 6'11" high. Archeological Museum, Olympia.

Hermes with the Infant Dionysus (c. 350 B.C., marble, 6'11" high. Archeological Museum, Olympia). The group (Fig. 9-23) may be an original by Praxiteles. Hermes, whose divine powers were of a particularly intellectual bent, was shown teasing the young god of wine, who often represented human passions, by holding some grapes beyond the child's reach. The cloudlike softness of the modeling, the three-dimensional extension of the arms, the spiral twist of the body, and the relaxed contrapposto pose are typical of later work.

Battle of Greeks and Amazons, from the east frieze of the Mausoleum at Halicarnassus (c. 350 B.C., marble, 35" high. British Museum, London). Ancient writers say that the east frieze of the Mausoleum was carved by Scopas, one of the most famous sculptors of the time. In the surviving fragments of the frieze (Fig. 9-24) tense poses and contorted faces express a physical and emotional violence quite unlike the characteristic poise and equilibrium of earlier work. Scopas reveals an interest in depicting the inner man; his style is characterized by deep-set eyes and expressions of anguish.

Hellenistic Period: 323–100 B.C.

The Greeks called themselves Hellenes, and their culture is often called *Hellenic.* With the conquests of Alexander the Great, Greek culture, modified by local cultures, spread over the civilized world. This international Greek-inspired culture is called *Hellenistic.* Various dates are given for the Hellenistic period, but 323 B.C., the year of Alexander's death, and 100 B.C., a year well after Rome had conquered Greece and had begun

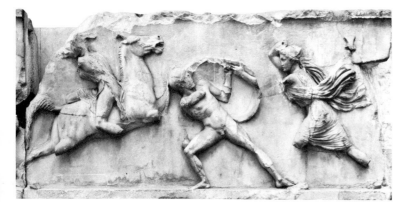

9-24

SCOPAS (?), *Battle of Greeks and Amazons,* from the east frieze of the Mausoleum at Halicarnassus, 359–351 B.C. Marble, 35" high. British Museum, London.

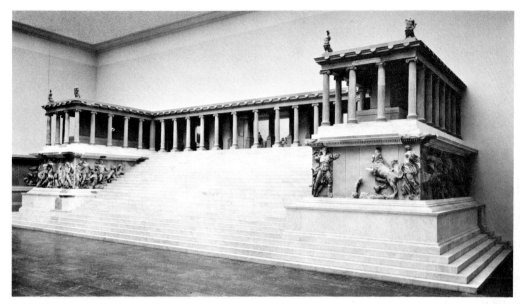

9-25 West front of the Altar of Zeus and Athena, Pergamon (restored). Staatliche Museen, Berlin.

to transform Hellenistic art into Roman art, can be considered the approximate beginning and end dates.

ARCHITECTURE

The Hellenistic period saw the rise of important art centers in places far from Greece, such as Pergamon, Rhodes, Tralles, and Alexandria. An increase in the wealth of many cities led to larger *agoras* (city centers) with more elegant surrounding stoas. A grid plan of rectangular blocks and intersecting streets gave order to some cities. As in the fourth century B.C., there was a wide variety of building types. Town houses often had two stories built around a central court, and, in better houses, the court eventually acquired a peristyle. Stone, mud brick, and wood were enhanced by stucco and painted walls. In temple-building, the Doric order became less popular. When it was used, columns were more slender and wall surfaces more ornate; semi-circular extensions (*apses*) sometimes emphasized one end of the cella interior. Ionic and Corinthian temples were occasionally raised on high platforms, prefiguring later Roman temples. Some of the Ionic temples were *pseudo-dipteral* in plan; that is, the inner peristyle of the *dipteral* plan (Fig. 9-5f) was omitted, leaving a deep porch around the cella.

Altar of Zeus and Athena (Pergamon, 180–150 B.C., marble; no longer extant except in reconstruction). The altar was

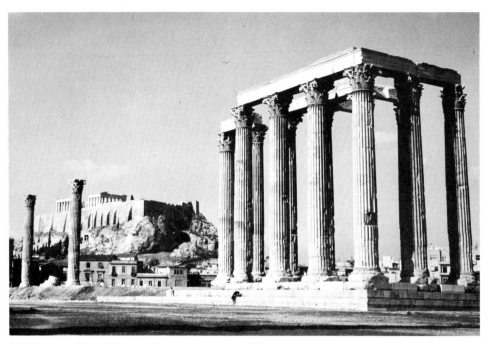

9-26 Temple of Zeus Olympios, Athens, planned *c.* 174 B.C.

a U-shaped *peripteral* building (one surrounded by columns, as in Fig. 9-5a) on a base 17′6″ high and about 112′ x 120′ wide (Fig. 9-25). The order was Ionic, and the base was heavily decorated with sculpture, typifying the increasing complexity and variety of architectural shapes and the tendency to cover more of the surfaces with decoration.

Temple of Zeus Olympios (Athens, marble, begun in 174 B.C. from the designs of the Roman architect Cossutius, and completed in 132 A.D. under the reign of the Roman Emperor Hadrian). The temple (Fig. 9-26), which measures 135′ x 354′, demonstrates the increasing interest in the ornate Corinthian order. The unusually thick columns are over 55 feet high, and their capitals influenced Roman architecture in Italy. The group of thirteen columns still standing at one corner of the temple is evidence of its original vastness.

SCULPTURE

Hellenistic sculpture, like Hellenistic architecture, was produced at creative centers far from the Greek mainland. Because artists moved from one center to another, it is hard to assign local styles to the different areas. Most sculpture of this period was not architectural but

set in open spaces, in freestanding figures or groups. Portraits and specific historical events were common subjects and encouraged a detailed realism, as did the developing taste for *genre* subjects (scenes from everyday activity), which were sometimes humorous, undignified, or pathetic, and often revealed human character. Proportions became more elongated, figures became taller and more slender, poses were restless and required more three-dimensional space, and surfaces were treated with greater refinement than previously.

Apoxyomenos, by Lysippos (original probably done between 325 and 300 B.C., Roman marble copy 81″ high. Vatican Museums, Rome). Lysippos, court sculptor to Alexander the Great, preferred slender proportions and poses that expand in all three dimensions and consume a comparatively great volume of space. The *Apoxyomenos* (Fig. 9-27) is an athlete scraping the sand of the arena from his body. He is in the process of shifting his weight from one leg to the other, creating a more dynamic version of the contrapposto pose.

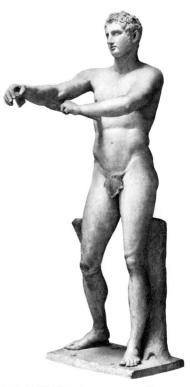

9-27 LYSIPPOS, *Apoxyomenos,* Roman marble copy, probably after a bronze original of *c.* 320 B.C. 6′9″ high. Vatican Museums, Rome.

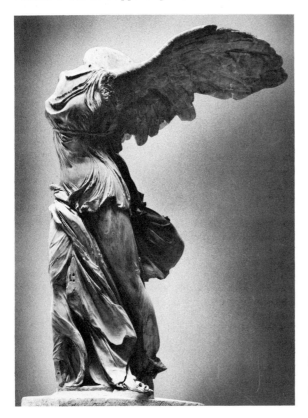

9-28
Winged Victory (Nike) of Samothrace,
c. 190 B.C. Marble, approx. 8′ high.
Louvre, Paris.

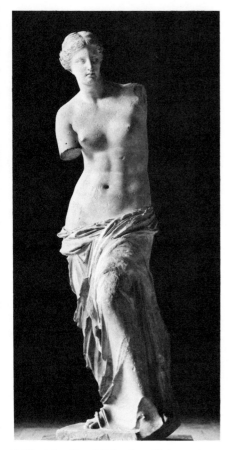

Winged Victory, from Samothrace (250–180 B.C., marble, approx. 8′ high. Louvre, Paris). The goddess (Fig. 9-28) is of the "nike" type; that is, she commemorates a military victory. The "wet drapery" effect reveals the Greek interest in the body, and the delicate carving of drapery details reveals an interest in the refinement of surfaces. Although the weight is supported by both legs, the body twists in space. The lines of the wind-whipped costume break the large masses into a restless complexity of lights and shadows.

Aphrodite, from Melos (late 3rd or early 2nd cen. B.C., marble, 6′8″ high. Louvre, Paris). This statue (Fig. 9-29) is popularly known as the *Venus de Milo.* After the fifth century, Greek sculpture included more female nudes. In the extreme softness of modeling, the proportions of small head, narrow shoulders, and wide hips, and the

9-29 *Aphrodite of Melos,* late third or early second century B.C. Marble, approx. 6′8″ high. Louvre, Paris.

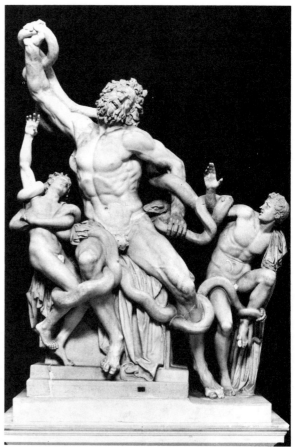

9-30 *Laocoön and His Sons,* first century B.C. Marble, 8′ high (partially restored). Vatican Museums, Rome.

pose with contrasting diagonals or spiral axes, this is one of the finest examples of Hellenistic work.

Laocoön and His Sons (1st cen. B.C., marble, 8' high. Vatican Museums, Rome). Laocoön, with his sons, is being slain by serpents for his disobedience to the gods. The present restoration (Fig. 9-30) is probably incorrect; the right hand of Laocoön should be closer to the head, thus completing the oval outline of the group. Although the composition has shallow depth, the intricate, restless, open form, the emphasis on anatomical detail, and the portrayal of mental and physical anguish are typical of late Hellenistic sculpture.

Suggestions for Further Study

Bieber, Margarete. *The Sculpture of the Hellenistic Age,* rev. ed. New York: Columbia University Press, 1961.

Blümel, Carl. *Greek Sculptors at Work.* Translated by Lydia Holland. London: Phaidon Press, 1955.

Boardman, John, José Dörig, Werner Fuchs, and Max Hirmer. *Greek Art and Architecture.* New York: Abrams, 1967.

Dinsmoor, William B. *The Architecture of Ancient Greece,* rev. and enl. ed. based on *The Architecture of Greece and Rome* by W. J. Anderson and R. P. Spiers. London: Batsford, 1950.

Lawrence, Arnold W. *Greek Architecture* (Pelican History of Art). Baltimore: Penguin Books, 1957.

Lullies, Reinhard, and Max Hirmer. *Greek Sculpture,* rev. ed. Translated by Michael Bullock. New York: Abrams, 1957.

Pfuhl, Ernst. *Masterpieces of Greek Drawing and Painting.* Translated by J. D. Beazley. New York: Macmillan, 1955.

Pollitt, J. J. *The Art of Greece, 1400–31 B.C.* (Sources and Documents). Englewood Cliffs, N. J.: Prentice-Hall, 1965.

Richter, Gisela M. A. *Archaic Greek Art Against Its Historical Background: A Survey.* New York: Oxford University Press, 1949.

———. *Attic Red-Figured Vases: A Survey,* rev. ed. New Haven, Conn.: Yale University Press, 1958.

———. *A Handbook of Greek Art,* 2nd rev. ed. London: Phaidon Press, 1959.

———. *The Sculpture and Sculptors of the Greeks,* rev. ed. New Haven, Conn.: Yale University Press, 1950.

———. *Three Critical Periods in Greek Sculpture.* Oxford: Clarendon Press, 1951.

Robertson, Martin. *Greek Painting* (Great Centuries of Painting). Geneva: Skira, 1959.

Etruscan Art:

700–41 B.C.

The origins of Etruscan culture are still unclear. It either arose from an existing *Villanovan* culture (named after a site near Bologna) or was the result of an infiltration and reformation of an older culture by a new people. Greek and Roman authors spoke of the Etruscans as immigrants from Asia Minor. It is clear that Villanovan culture changed suddenly between 700 and 675 B.C. under the influence of new ideas and perhaps the influx of a new population. Tumulus-covered tombs appeared (*tumuli* are earth mounds), some filled with a mixture of Villanovan, Greek, and Near Eastern objects; two different sculptural styles developed, one geometric and one Near Eastern in character; and new wealth is evident. By the late seventh century B.C., the two sculptural styles had fused into one, and a unified culture had formed.

The Etruscan culture existed as a group of independent city-states that generally had republican governments by the late fifth century B.C. In spite of various alliances between the city-states, rivalry prevented any lasting unity. Some of the major cities were Veii, Caere (modern Cerveteri), Tarquinii (modern Tarquinia), Perusia (modern Perugia), and Volsinii (modern Orvieto). Ancient Etruria spread from the areas of Tuscany, Umbria, and Latium as far north as the Alps. The land and sea power of the Etruscans reached its height in the seventh and sixth centuries B.C. Etruria profited as an intermediary in trade between continental Europe and the Mediterranean countries, and the Etruscans' wealth was supplemented by their widely feared piracy. The Tyrrhenian Sea took its name from the ancient name for the Etruscans, the Tyrsenoi; the Adriatic was named after Hadria, an Etruscan colony. Although Rome often warred against Etruscan cities and eventually absorbed them, Rome was ruled by Tarquinian Etruscans from 615 to 510 B.C. Etruscan power declined during the fifth and fourth centuries B.C., and Rome defeated Perusia, the last Etruscan stronghold, in 41 B.C.

The Etruscans borrowed the Greek alphabet and became literate in the mid-seventh century B.C., but only about a hundred words of Etruscan have been deciphered. A considerable literature has been lost; only funerary and ritual inscriptions remain.

Religion was important to the Etruscans. Their gods were of three kinds: those inherited from pre-Etruscan Italic cultures; native Etruscan gods later identified with Greco-Roman deities; and gods adopted from the Greeks.

Although there are different points of view, the

major periods of Etruscan art may be classified as follows: *Archaic* (including pre-Etruscan Villanovan geometric styles, the new Near Eastern or Orientalizing elements, and their merger by the late seventh century B.C.), *c.* 900–470 B.C.; *Classic* (with much Greek influence), *c.* 470–300 B.C.; and *Hellenistic* (continuing Greek influence), *c.* 300–41 B.C.

ARCHITECTURE

Remains are sparse because the Etruscans preferred wood and unbaked brick, and the Romans destroyed or built over much Etruscan work. Houses, known to us chiefly through the forms of cinerary urns, apparently ranged from *wattle and daub* huts (those having walls of woven saplings plastered with mud) to elaborate town houses of the Roman atrium type (see p. 119).

Tombs are the best-preserved remains of Etruscan buildings because they were built of stone blocks or carved from *tufa*, an easily worked stone that hardens when exposed to air. Cemeteries were arranged with grid plans as necropolises, and one tumulus might contain one or several rectangular tombs. The common tomb plan consisted of a rectangular room, with occasional subsidiary rooms, and a pitched roof rising to a ridge beam. When interior supports were used, they had the form of square piers with block capitals into which were incised *volutes* (spirals) that seem to be Asian rather than Greek in origin. Tomb interiors contain the best examples of Etruscan painting—murals depicting mythological scenes, feasting, and sports. Some tomb interiors seem to have imitated house interiors, even to the extent of having household utensils carved on the walls.

Until about 600 or 550 B.C., when temples began to be constructed, Etruscan religious ceremonies were apparently conducted at open-air sanctuaries consisting of platforms within sacred precincts. Although there are no remains that rise much above the stone foundation level, the Roman architect Vitruvius left a description of an Etruscan temple (Fig. 10-1). Its deep porch and three parallel cellae produce an almost square foundation. Widely spaced columns and overhanging eaves offer a topheavy façade. Vitruvius (1st cent. B.C.) probably would have known only late examples. Excavated foundations reveal variations in his plan, one of which may have evolved from the megaron. The decoration of pediments, ridgepoles, cornices, and roof edges with colorful clay sculpture is attested to by numerous frag-

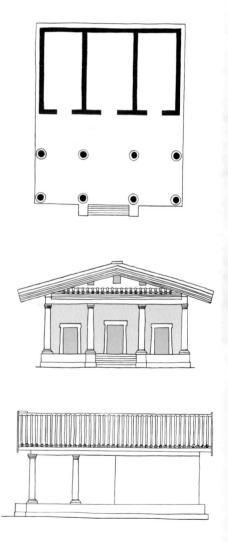

10-1 Plan, section, and elevation of an Etruscan temple. (After Vitruvius.)

ments found at temple sites. The Etruscans used an occasional corbeled dome in tombs and employed the corbeled arch. Their use of the true arch may have come from the Romans, who, in turn, had taken it from Greece or the East. The Porta Augusta in Perugia is a city gate with a true arch and was probably the result of Roman influence. By the second century B.C., Etruscan architecture had largely been absorbed by Roman and Hellenistic Greek forms.

Tomb of the Painted Reliefs (Caere, 5th–4th cens. B.C.). The necropolis at Caere consists of tumuli containing tombs carved and constructed of tufa. This single-chamber tomb (Fig. 10-2) imitates the beamed and pitched roof of a house, although a house would have used supports under the ridgepole, if at all. Here, the piers, carved from tufa left in place, have typically voluted *Aeolic*

10-2 Tomb of the Painted Reliefs, Caere, fifth to fourth centuries B.C.

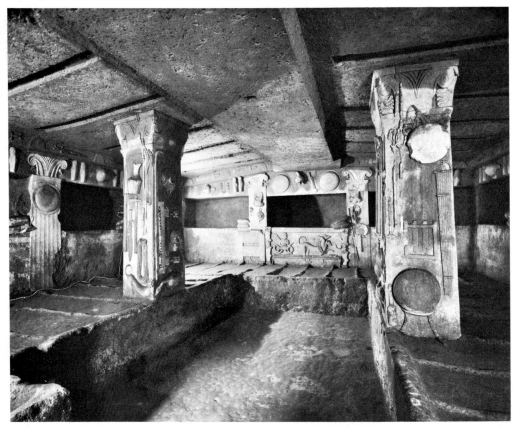

capitals. The reliefs, both carved and modeled from stucco, depict weapons, household utensils, and even pets.

SCULPTURE

Etruscan sculpture took the form of cinerary urns, sarcophagus effigies, pottery, reliefs, freestanding statues, architectural ornaments, furniture decorations, bronze mirrors, containers, and jewelry. While they used a wide variety of materials, the Etruscans were especially renowned for their technical skill with clay and bronze. They were less interested in stone and used it principally for funerary sculpture. Villanovan or pre-Etruscan sculpture was geometric in style and had descended from Neolithic cultures. Circles, spirals, triangles are often combined with severely simplified images of men and animals. From 675 to 600 B.C., Oriental or Near Eastern elements appeared in the form of sphinxes, hawks, and other gods from Egypt, and winged lions and fertility goddesses from Assyria. Greek influence is also evident and continued to be important throughout Etruscan history. The geometric patterns in hair and drapery, the almond eyes and straight-ridged nose, and the stiff poses of Greek Archaic sculpture mixed with Oriental motifs in Etruria. During subsequent centuries, Etruscan sculpture, like that of Greece, moved toward greater flexibility in pose and naturalness in anatomical detail; yet the Etruscans never lost a suggestion of tenseness in the joints and musculature of the figure, a kind of aggressive awkwardness that is emphasized by large proportions in head, hands, and feet. In spite of Etruscan interest in effigies of the deceased on sarcophagi and cinerary urns, only a specific type of personality and age was expressed until about 300 B.C., when highly individualistic portraiture was imported from Greece.

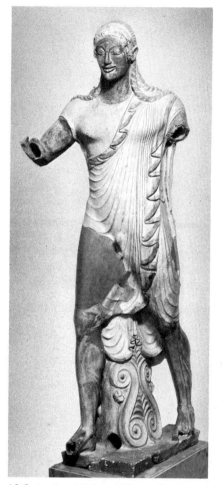

10-3 *Apollo of Veii, c.* 510 B.C. Clay, approx. 69″ high. Museo di Villa Giulia, Rome.

Apollo of Veii (*c.* 510 B.C., clay, 69″ high. Museo di Villa Giulia, Rome). This life-sized god (Fig. 10-3) was one of four deities originally placed at the ridgepole of the tile roof of a temple at Veii. The figures enacted the contest between Hercules and Apollo for the sacred hind. Greek influence is evident in the Archaic features of face, hair, and clothing. The taut leg muscles and the awkward forward movement are typical of Etruscan art.

Sarcophagus, from Caere (*c.* 520 B.C., clay, approx. 6′7″ long. Museo di Villa Giulia, Rome). Such sarcophagi

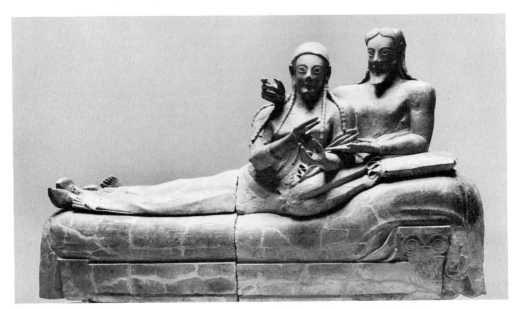

10-4 Sarcophagus from Caere, *c.* 520 B.C. Clay, approx. 6'7'' long. Museo di Villa Giulia, Rome.

(Fig. 10-4) provided images of the deceased, just as did many cinerary urns. In this period, the faces, with their abruptly changing planes and Archaic smiles, had little portrait character beyond an indication of age.

PAINTING

Of the paintings on vases, clay plaques, and tomb walls, the tomb murals are the most rewarding. Mineral and vegetable pigments were applied directly on the stone walls or on a plaster ground. Only a few tombs remain from the Orientalizing period. The flowering of tomb painting seems to have come in the second half of the sixth century B.C. Until the mid-fourth century B.C., subjects were generally happy depictions of hunting, feasting, dancing, and funeral games. The flatly painted, unmodeled images are placed on a base line against a neutral background. Human musculature is inflated and tense. By the mid-fourth century, subjects were more somber, depicting underworld scenes or mythical scenes of death and suffering. Proportions and musculature are more natural and mass and depth are suggested by overlapping shapes and outlines. The development parallels that in Greek art, which also expresses a greater awareness of tragedy and of mass in space during the Hellenistic period.

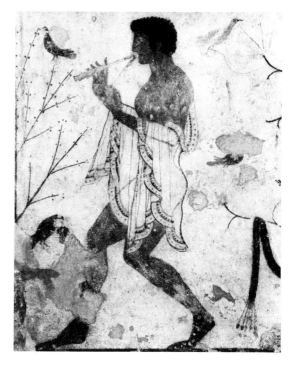

10-5 *Pipe-Player and Birds,* from the tomb of the Triclinium, *c.* 470 B.C. Museo Nazionale Tarquiniense, Tarquinia.

Pipe-Player and Birds, from the tomb of the Triclinium (*c.* 470 B.C. Museo Nazionale Tarquiniense, Tarquinia). The unmodeled figure, base line, and neutral background (Fig. 10-5) are typical of Etruscan painting of this period, but such delicacy of line, shape, pattern, and movement is unusual. The carefree nature of the subject was to change in the following century. Greek influence is evident, especially in facial profile and drapery.

Suggestions for Further Study

Bloch, Raymond. *The Ancient Civilization of the Etruscans.* New York: Cowles, 1969.

———. *Etruscan Art.* Greenwich, Conn.: New York Graphic Society, 1959.

Mansuelli, G. A. *The Art of Etruria and Early Rome* (Art of the World). Translated by C. E. Ellis. New York: Crown, 1965.

Pallottino, Massimo. *The Etruscans.* Translated by J. Cremona. Harmondsworth, Eng.: Penguin Books, 1955.

———. *Etruscan Painting.* Translated by M. E. Stanley and Stuart Gilbert. Geneva: Skira, 1952.

Richardson, Emeline Hill. *The Etruscans, Their Art and Civilization.* Chicago: University of Chicago Press, 1964.

Roman Art:

200 B.C.-330 A.D.

Roman art emerged as a distinct personality during the last two centuries before Christ. In style it persisted until perhaps 500 A.D., but its subject matter was reoriented by Christianity long before then. The year 330 A.D., when Constantinople was dedicated as the new capital of the Roman Empire, can thus be considered the end of the Roman period.

The major sources of Roman culture are the Greek and Etruscan civilizations. Like the Greeks, the Romans had little interest in an afterlife; they focused their attention on the organization and exploitation of the physical world, and this is evident in their art. But the Romans considered the manual arts of painting and sculpture less dignified than the arts of music and poetry. Roman art and literature took Greek works for their models, and Greek gods reappeared in Roman culture with Latin names. The Romans, however, were more concerned than the Greeks with historical documentation; Roman historical writings are paralleled by Roman history-recording art.

Second and First Centuries B.C.

ARCHITECTURE

Remarkable engineering skill was applied by the Romans to a variety of building types, most of which received their basic forms in this period. Materials were wood, mud brick and fired brick, stone, stucco, and concrete. The Romans were the first to use concrete extensively; they reinforced it with rubble and often concealed it behind a veneer of stucco, brick, marble, or travertine (a hard, light-colored limestone). The Romans did not limit themselves to the post and lintel system but went far beyond their predecessors in the development of the arch, the vault, and the dome. The semicircular *Roman arch* (Fig. 4-6, p. 43) could be extended in depth to form a *tunnel vault* (Fig. 4-7, p. 43). From this, the Romans created *cross vaults* (Fig. 4-10, p. 44) as early as the beginning of the second century B.C. Roman architecture used elaborated and modified basic Greek forms, including the three orders. Whereas the Greeks used columns as structural members, the Romans frequently added them as decoration without structural function. Greek column shafts are made with drums (cylindrical sections) placed one on top of the other and fastened with interior metal clamps; Roman shafts are generally monolithic.

Round Roman temples were inspired by the Greek tholos. Rectangular temples have the high base, frontal steps, and deep porch of pre-Roman Etruscan temples, but the Romans used Greek columns and modified Greek proportions in the entablature and pediment (Fig. 11-2). The wider Roman cella often has engaged columns, a device used less frequently by the Greeks. The most common form of Roman monument was the *triumphal arch* (Fig. 11-15 shows a late example), a freestanding structure with inscriptions and relief sculpture describing the event commemorated. One type of Roman building most influential for later architecture is the *basilica*, a rectangular structure with an apse at one or both ends and entrances in the sides or at one end (see the basilica part of Fig. 11-9). Columns divided the interior into center and side aisles. The roof (usually wooden) of the center aisle is higher than that of the sides so that *clerestory* windows (windows looking out over a lower roof) provide direct lighting for the center. Basilicas functioned as law courts, public halls, and audience chambers for rulers. The masses of the urban population lived in multistory tenements, usually built of mud brick and wood, but private city houses were also built, simple or complex according to the builder's financial means (Fig. 11-1). Larger houses occupied the center of a block and were insulated from the street by shops around the perimeter; therefore, all efforts at impressive architecture were concentrated on the interior of the home. The front door opened into a vestibule that led to the *atrium*, a receiving hall. In the center of this room was a pool into which water drained from an opening in the roof (the *impluvium*). The atrium ended in the *tablinium*, where family statues were kept. One then entered the peristyle, a colonnaded walkway around an open court (adapted from Hellenistic houses). Typically, a strong axis from front to back gave order to the progression of interior spaces.

House of Menander (Pompeii). The plan (Fig. 11-1) is typical in allowing a spatial vista down the major axis and in its alternation of small and large spaces. The high ceilings and the free passage of air from garden to front door helped to cool the house.

Maison Carrée (Nîmes, completed in 16 B.C., 59' x 117'). This small provincial temple (Fig. 11-2) is very well preserved. It exemplifies the Roman love of the Corinthian order and the high base, frontal steps, and deep

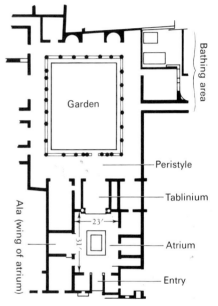

11-1 Plan of the House of Menander, Pompeii. Only the central portion is shown.

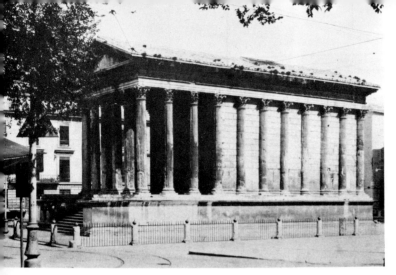

11-2
Maison Carrée,
Nîmes,
completed 16 B.C.

porch inherited from the Etruscans. It is one of the few Roman temples having some of the refinements of proportion found in the best Greek work. The *rinceau* (band of scroll-like vine ornament) in the entablature frieze was widely used in Roman architecture.

SCULPTURE

Roman sculpture owes much to the Etruscans and the Hellenistic Greeks. In spite of extensive importation of Greek sculpture and the demand for copies of famous Greek originals, the Romans developed certain types of sculpture that are distinctly expressive of Roman culture. The Roman interest in the actual world is reflected in the rise of portraiture as a major field. The custom of making wax images of dead ancestors, the love of factual documentation, and the late Hellenistic tendency toward realism in portraiture all helped to mold the Roman desire for absolute fidelity to physical appearance. Such realism was countered, however, by occasional periods of interest in the idealism of earlier Greek sculpture. Particularly in certain portraits of Augustus as Emperor, the idealistic simplification and strengthening of basic features can be seen. Relief sculpture became the other important form for the Romans and was used chiefly to commemorate events from Roman history. Roman sculpture went much further than Hellenistic sculpture in depicting specific events with specific details in face, costume, and environment. In place of the blank background of earlier Greek relief, the Romans tried for the illusion of infinite space by graduating the relief from high projection in the foreground to fainter projection for distant objects,

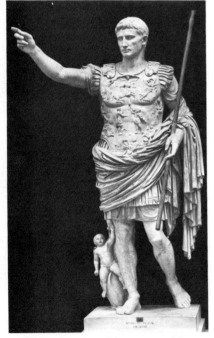

11-3 *Augustus,* from Primaporta, *c.* 20 B.C. Marble, 6'8" high. Vatican Museums, Rome.

and by using diagonally receding forms. When occasional allegorical scenes make broader reference to Roman history, more general features reminiscent of earlier Greek art appear. Basic materials of Roman sculpture are wax, terra cotta, stone, and bronze. Parts of stone sculpture were sometimes painted.

Augustus, from Primaporta (*c.* 20 B.C., marble, 6'8'' high. Vatican Museums, Rome). Individualism is veiled by the interest in ideal form (Fig. 11-3); much detail was omitted in the face, and the large planes are emphasized (note the brows). The visionary stare of the softly carved pupils contrasts with heroic body proportions, a pose of authority, and allegorical scenes on the breastplate referring to the exploits of Augustus. The Cupid and dolphin beside the right leg symbolize Aeneas, the half brother of Cupid and the divine source of the Julian family. The statue thus presents the emperor as a divinity.

Ara Pacis or **Altar of Peace** (Rome, completed in 9 B.C., marble, processional panels 63'' high). The relief sculpture decorates a walled enclosure for the altar (Fig. 11-4). On two walls, a procession of Augustus with his family and retinue is depicted. An end wall shows an allegorical scene in which Tellus (Mother Earth) is surrounded by symbols of the abundance that Augustus brought to the Empire. There is marked contrast between the detailed portraiture of the procession and the ideal figures of the allegory, although the latter has specific details in plants and animals. The illusion of infinite space is present throughout. The lower part of the walls is covered with crisply carved symmetrical vine ornament.

11-4 *Tellus Relief,* from the Ara Pacis Augustae, Rome, 13–9 B.C. Marble.

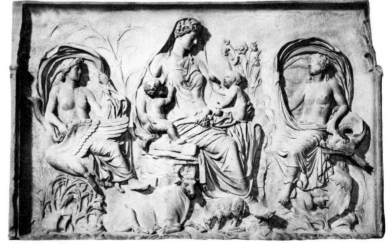

Portrait of a Roman (1st cen. B.C., terra cotta. Museum of Fine Arts, Boston). Suffering and disillusionment are nakedly revealed by the sagging muscles of the eyes and mouth (Fig. 11-5). The lifeless hair plastered over the wrinkled forehead gives an added feeling of dejection to the figure.

11-5 Portrait of a Roman, first century B.C. Museum of Fine Arts, Boston.

PAINTING AND MOSAICS

Our knowledge of Roman painting comes largely from wall paintings found in three cities buried by an eruption of Mt. Vesuvius in 79 A.D.: Pompeii, Stabiae, and Herculaneum. On such a limited basis, generalization must be tentative. We may assume probable influence of the lost paintings of the Hellenistic age, however, because imported Greek artists were responsible for some of the Roman paintings, as is evidenced by Greek signatures and inscriptions. Wall painting of the second century B.C. consisted of rectangular panels of color, often imitating marble. This *First Style* was succeeded around 100 B.C. by a *Second Style* depicting landscapes, figures, and architectural vistas. For the illusion of deep space, a makeshift system of linear perspective was devised, which consisted of different horizon lines and thus varying eye levels. Effects of light and shadow, aerial perspective, and convincing anatomy were achieved. The wall paintings seem to have been done in tempera with a binder of lime emulsion. Encaustic was used for a few colors. The ground was made with three coats of sand mortar and three of fine-grained plaster, often mixed with marble dust. The plaster was polished before the paint was applied. The permanence of such work has been remarkable. Sometimes wood

11-6 *Ulysses in the Land of the Lestrygonians,* from *The Odyssey Landscapes,* c. 100 B.C.–1 A.D. Vatican Library, Rome.

panels were given the plaster ground and utilized as supports for paintings, but most of these panels have perished. Mosaics were widely used, both on floors and on walls. In both mosaics and painting, the style indicates a strong interest in the visual experience of the physical world.

Odyssey Landscapes (*c.* 100 B.C. Vatican Library, Rome). These Second Style paintings (Fig. 11-6) were discovered in the ruins of a house on the Esquiline Hill in Rome. Eight episodes from Books X and XI of the *Odyssey* are shown in a continuous landscape (44′ x 5′) divided only by a painted architectural framework. Lively figures are placed in a world of shimmering light and space. Shadows are used to define the ground plane and to locate objects on it. Aerial perspective creates depth. The breathtaking effects of color and light seem to be achieved without effort.

Mosaic showing street musicians (Museo Nazionale, Naples). The Greek Dioskourides of Samos signed this work (Fig. 11-7), probably during the period of the Second Style. The everyday subject, the characterization in faces and gestures, and the factual treatment of light and shadow—qualities first developed in late Hellenistic painting—are typical of much Roman painting. The handling of color is particularly subtle, and shadow areas are enlivened with reflected lights.

11-7
Mosaic showing street musicians, probably first century B.C. Museo Nazionale, Naples.

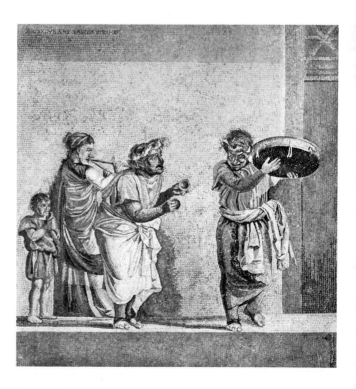

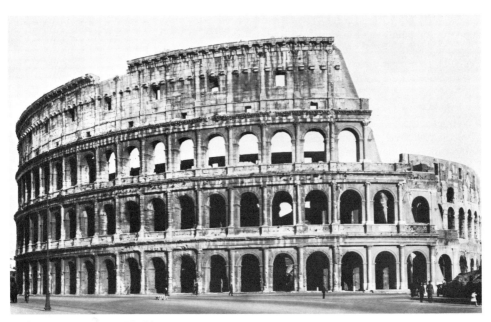

11-8 Colosseum, Rome, 72–80 A.D.

First Century to 330 A.D.

ARCHITECTURE

The Roman Empire reached its height in the second century A.D., and its power and wealth are reflected in architectural design. Vast size and lavish decoration are typical of the period from the first to the fourth centuries. Roman architects tended to impose a scheme of order upon the whole site, arranging landscape as well as spaces and masses to achieve effects of gradation and climax. Plans often used obvious axial balance. Examples may be found in the *forums* (civic centers for Roman towns), where temples, government buildings, and commercial houses were organized around an open space (Fig. 11-9). The forum has its sources in pre-Roman Etruscan town plans and in the Greek agora. Of the three Greek orders, the Romans preferred the most ornate, the Corinthian. From this they derived the *composite* capital by adding Ionic *volutes* (spirals) to the Corinthian capital. In addition they developed the *Tuscan order*, using a base, an unfluted shaft, a derivation of the Doric capital, and an entablature without frieze ornament. It was Roman architecture that established the system of superposed orders for buildings

of several stories. Doric or Tuscan was used on the ground floor, Ionic on the next, and Corinthian above. These post and lintel forms were often combined with the arch, as in the *Roman arch order,* an arched opening framed by engaged columns or *pilasters* (flattened column shapes that project as planes from the wall) and an entablature. The Romans also adopted and elaborated Greek architectural moldings (Fig. 9-8, p. 98).

For an understanding of Roman culture, it is significant to note that wealth was spent not just on temples but on monuments to Roman leaders, on palaces, and on places of public entertainment such as baths and amphitheaters. For the late period, public entertainment was very important to Roman politics. The amphitheaters (as distinct from theaters, which followed the Greek form) were built for athletic or gladiatorial contests. The tiered seats surrounded an elliptical arena, and the exterior might be banked earth or arcaded galleries. Some of the largest Roman buildings were the public baths (*thermae*), which served as community centers with lecture halls, libraries, lounges, and outdoor playing fields in addition to bathing pools of various temperatures. All was planned around dramatic axes of interior and exterior spaces. Statues and mosaics decorated the interior; walls and mammoth cross vaults were veneered with sumptuous marble. The populace enjoyed these elegant public facilities and found them a relief from the apartments (mostly of concrete by the first century A.D.) in which many Romans led crowded lives.

Colosseum (Rome, completed *c.* 80 A.D. and frequently restored, elliptical, approx. 620' x 513'). This vast area (Fig. 11-8) seated 50,000 spectators. Tunnel and cross vaults were used in corridors and stairways. The core is concrete, and the façade is faced with travertine. The arcades of the façade employ the Roman arch order with engaged columns in the following sequence: Doric, Ionic, and Corinthian. The fourth level has Corinthian pilasters.

Forum of Trajan, designed by Apollodorus of Damascus (Rome, completed *c.* 113 A.D., central square approx. 300' x 350'). The Roman preference for grand organizations of spaces and masses is exemplified here (Fig. 11-9). The symmetrical order moves along the axis from the front gate, through the main forum space, into the basilica, past the column dedicated to Trajan's wars, to the climactic temple of the deified emperor.

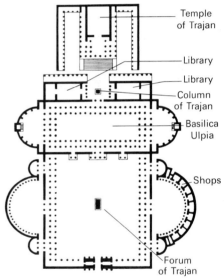

11-9 Plan of the Forum of Trajan.

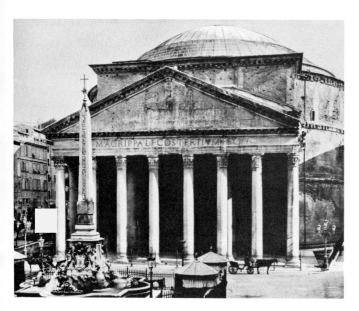

11-10 Pantheon, Rome, 118–25 A.D.

11-11 GIOVANNI PAOLO PANNINI, *Interior of the Pantheon, c.* 1750. Kress Collection, National Gallery of Art, Washington, D.C.

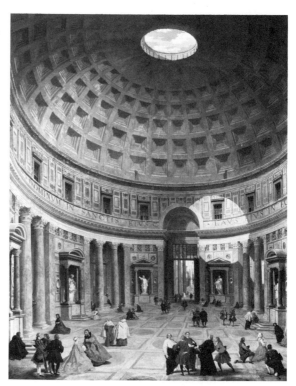

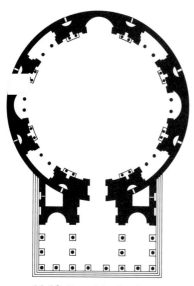

11-12 Plan of the Pantheon.

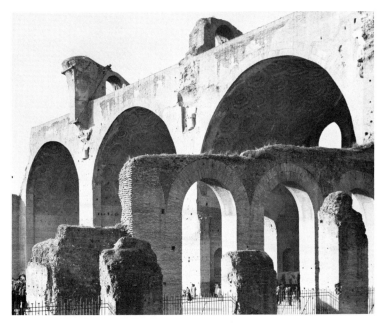

11-13 Basilica of Constantine, Rome, *c.* 310–20 A.D.

Pantheon (Rome, mainly built 118–26 A.D.). The concrete and brick core of this building (Figs. 11-10–11-12) formerly had a marble and stucco veneer. The dome (142 feet in diameter) was the most celebrated in ancient architecture. The concrete ranges in thickness from six to twenty feet, and the interior of the dome has *coffering* (an excavated grid effect), a device often used in vaulting by the Romans to lighten the structure without weakening it. Aside from the main door, the only light source in the Pantheon is the *oculus* (a round opening in the center of the dome). The dramatic lighting and the vast scale make the much-copied Pantheon one of the supreme examples of effective use of interior space.

Basilica of Constantine (Rome, completed *c.* 320 A.D., after having been started by Emperor Maxentius in 310, 265' x 195'). Most basilicas had wooden roofs, but vast concrete tunnel and cross vaults were used here in one of the largest vaulted interiors of the ancient world (Figs. 11-13 and 11-14). Formerly huge columns were part of the decorative veneer. The effect was more like that of the great hall of a Roman bath than the hall of a basilica. The building provided a grandiose setting for the ritual of Roman government.

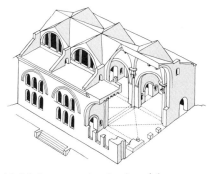

11-14 Reconstruction drawing of the Basilica of Constantine.

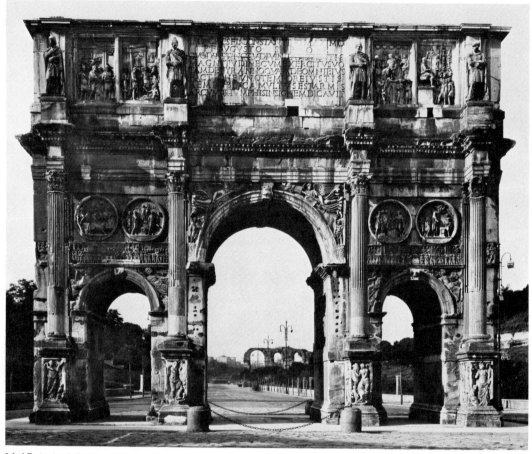

11-15 Arch of Constantine, Rome, 312–15 A.D.

Triumphal Arch of Constantine (Rome, *c.* 312 A.D.). The three arches, the quantity of sculpture (some of it borrowed from earlier monuments), and the decorative Corinthian columns all break up the surfaces and create a sumptuous and dramatic play of light and shadow on the structure (Fig. 11-15).

SCULPTURE

During this period the other-worldly interests of Christianity began to undermine the Roman world of fact, flesh, and blood. In portrait sculpture, the third century brought increased animation in the twist of the head and the turn of the eyes, and the bust-type portrait came to include the shoulders and often one or both arms;

but by the fourth century, the eyes had become large
and preoccupied, the carving crude or summary, and
the forms more stereotyped. Historical and mythologi-
cal reliefs, used on triumphal arches, commemorative
columns, altars, and sarcophagi, became, during the late
second and third centuries, more compressed into
shallow foreground space, more complex in parts, and
less definite about the climactic centers of the composi-
tion. By the fourth century, representations of specific
events acquired the effect of scenes staged with dolls;
the episode became ritual. The figure functioned some-
what abstractly as a symbol for man and for his role
in a social or divine order. Heads were shown dispro-
portionately large, without much variety in features or
expression; costume folds were indicated by quickly
carved grooves, poses were more rigid, and abrupt
modeling created sudden dark shadows that tended to
isolate the many parts.

Reliefs on the Arch of Titus (Rome, 81 A.D., marble). The
arch was built to celebrate the subduing of Jerusalem
by Titus. The reliefs (Fig. 11-16) depict a triumphal
procession carrying booty (note the seven-branched
candelabrum). Diagonal masses and increasingly faint

11-16 *Spoils from the Temple in Jerusalem,* relief on the Arch of Titus. Marble, approx. 7' high.

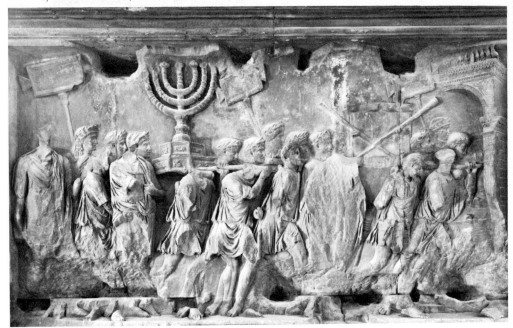

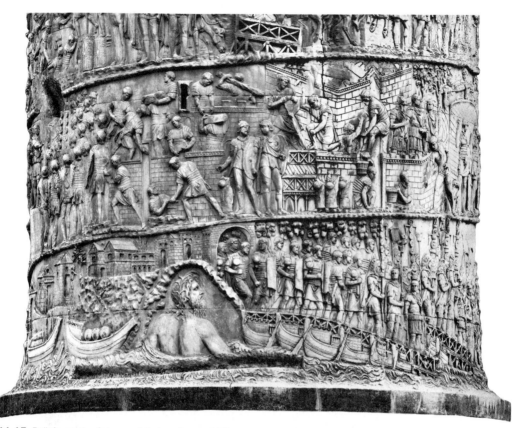

11-17 Reliefs on the Column of Trajan, Rome, 113 A.D.

relief suggest atmospheric perspective and deep space. The factual detail expresses the disorder of the event without the theme and variations of line and shape that would lend subtle harmony to a Greek interpretation of a similar subject.

Column of Trajan (Rome, completed *c.* 113 A.D., marble, 125' high). The column is divorced from its structural role to become a monument. A spiral relief 656 feet long and 50 inches high winds from bottom to top depicting Trajan's Dacian Wars (Fig. 11-17). Architecture and landscape are reduced to undersized stage settings in order for the figures to present clearly the historical narrative.

Julia Domna, wife of Septimius Severus (early 3rd cen. A.D., marble, 26" high. Metropolitan Museum of Art, New York). The animated turn of head and eyes and the inclusion

of the body almost to the waist are typical of much third-century portraiture (Fig. 11-18).

Constantine Addressing the Senate, frieze on the Arch of Constantine (Rome, early 4th cen. A.D.). The style in Figure 11-19 reflects the development of late Roman sculpture, in which the depicted object was becoming an abbreviated symbol. The roughly carved, doll-like figures are shown with enlarged heads and repetitive poses; they provide a striking stylistic contrast with the relief medallions right above, which are from the second century.

PAINTING AND MOSAICS

In wall painting a *Third Style* seems to have prevailed between 1 and 50 A.D. Here, the wall was treated more flatly but illusional paintings of columns and moldings of delicate proportions were used. Monochrome landscapes were often added to suggest panel paintings hung on the walls. A *Fourth Style*, between about 50 and 79 A.D. in Pompeii, again opened up the wall with palatial,

11-18 *Julia Domna* (wife of Septimius Severus), early third century A.D. Metropolitan Museum of Art, New York.

11-19 *Constantine Addressing the Senate,* frieze on the Arch of Constantine.

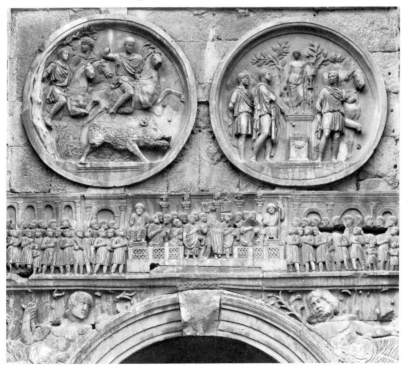

11-20 Third Style wall painting, from Pompeii, 1–50 A.D. Museo Nazionale, Naples.

11-21 Fourth Style wall painting, from Herculaneum, c. 50–79 A.D. Museo Nazionale, Naples.

11-22 Portrait of a man, from Faiyum, second century A.D. Encaustic on wood panel, approx. 13¾″ x 8″. Albright-Knox Art Gallery, Buffalo (Charles Clifton Fund).

theatrical architecture, landscapes, cityscapes, and mythological scenes. It pushes illusionism even further than before. From Lower Egypt, during the period of Roman occupation, come a number of portraits on panels that have been preserved by the dry climate. These were attached to mummies. The technique is encaustic, and the style is similar to that of some miniature portraits painted on glass medallions during the third century A.D., probably in Italy. There is some evidence that painters (particularly those working for Christians), like sculptors, became less interested in accurate appearance by the fourth century and turned increasingly to flat, schematic shapes whose power lay in their symbolic content rather than in their imitation of physical reality.

Third Style wall painting, with monochrome landscape (c. 1–50 A.D. Museo Nazionale, Naples). The landscape is presented as a monochrome panel, emphasizing the flat surface of the wall (Fig. 11-20). Illusionistic space is kept shallow, and the painted columns and moldings are delicate and slender, decorated with plant ornament.

Fourth Style wall painting, from Herculaneum (*c.* 50–79 A.D. Museo Nazionale, Naples). Delicate motifs from the Third Style are combined with bold architecture and deep space (Fig. 11-21). Curtains and an actor's mask give the effect of stage decoration.

Portrait of a man, from Faiyum (2nd cen. A.D., 13¾" x 8". Albright-Knox Art Gallery, Buffalo). Encaustic on wood was used here (Fig. 11-22) for the type of portrait that was attached to mummies. Individual features are rendered in somewhat stereotyped forms by an artist accustomed to working quickly and producing in quantity.

Suggestions for Further Study

Anderson, William J., and R. P. Spiers. *The Architecture of Ancient Rome* (Part II of *The Architecture of Greece and Rome*). Revised and rewritten by Thomas Ashby. London: Batsford, 1927.

Boethius, Axel. *The Golden House of Nero: Some Aspects of Roman Architecture.* Ann Arbor: University of Michigan Press, 1960.

Brown, Frank E. *Roman Architecture* (Great Ages of World Architecture). New York: Braziller, 1961.

Hanfmann, George M. A. *Roman Art: A Modern Survey of the Art of Imperial Rome.* Greenwich, Conn.: New York Graphic Society, 1964.

Kähler, Heinz. *The Art of Rome and Her Empire* (Art of the World). New York: Crown, 1963.

Maiuri, Amedeo. *Roman Painting* (Great Centuries of Painting). Translated by Stuart Gilbert. Geneva: Skira, 1953.

Nash, Ernest. *Pictorial Dictionary of Ancient Rome.* 2 vols. New York: Praeger, 1961–62.

———. *Roman Towns.* Locust Valley, N.Y.: Augustin, 1944.

Pollitt, J. J. *The Art of Rome, c. 753 B.C.–337 A.D.* (Sources and Documents). Englewood Cliffs, N.J.: Prentice-Hall, 1966.

Richter, Gisela M. A. *Roman Portraits.* New York: Metropolitan Museum of Art, 1948.

———. *Three Critical Periods in Greek Sculpture.* Oxford: Clarendon Press, 1951.

Rivoira, Giovanni T. *Roman Architecture and Its Principles of Construction Under the Empire.* Oxford: Clarendon Press, 1925.

Robertson, Donald S. *A Handbook of Greek and Roman Architecture.* New York: Cambridge University Press, 1954.

Strong, Mrs. Arthur. *Roman Sculpture from Augustus to Constantine.* New York: Scribner's, 1907.

Vermeule, Cornelius C. *Roman Imperial Art in Greece and Asia Minor.* Cambridge, Mass.: The Belknap Press of Harvard University Press, 1968.

Early Christian and Byzantine Art:

100–1453

One of the most far-reaching changes in Western thought came through the impact of Christianity upon the Roman world. Late Roman history reveals an increasing interest in foreign religions, such as the worship of Isis (Egypt) or of Mithras (Persia), but Christianity won out and provided the basis for a new world view. For the Christian, reality was the drama within, the struggle of good against evil, the salvation of the soul, and the attainment of life after death; the physical world was inimical, irrelevant, or symbolic of the inner reality. As reality became less materialistic, the role of art became more complex.

Long before the legalization of Christianity by Constantine in 313, paintings with Christian subject matter were done on the walls of *catacombs* (underground passageways with niches used for burial by Christians). Thus the period of Early Christian art overlaps that of Roman art. The term *Early Christian art* refers not so much to a certain style as to a period, from about 100 to 500, and to art with Christian subject matter within that period. The term *Byzantine* refers not only to the geographical area of the Eastern Roman Empire, with its capital at Constantinople (the ancient Byzantium), but also to particular stylistic features common to much art of that region from about 500 until the fall of Constantinople to the Turks in 1453. There is, however, no sharp dividing line between Early Christian and Byzantine art. Important art centers were Rome, Constantinople, Antioch, and Alexandria. Much of the Byzantine painting and sculpture was destroyed and its stylistic development affected by *iconoclasm*, a controversy between the *iconophiles*, who wanted religious images, and the *iconoclasts*, who felt that images were idols and that religious art should present symbols rather than images of sacred persons. The battle began with an edict from the Eastern emperor in 726 prohibiting figurative images and ended with the victory of the iconophiles in 843.

Early Christian Period: 100–500

ARCHITECTURE

Early Christian architecture inherited the techniques and the forms of Roman building, but aims had changed and form was modified accordingly. Early Christian builders concentrated on churches, *martyria* (buildings marking the tomb of a martyr or the site of his death,

or containing a sacred relic), and baptisteries. They did not seek the earthly grandeur of Roman temples but stressed instead a withdrawal from the physical world and a mystical experience of salvation for the worshiper. Exteriors were left starkly simple; in interiors glittering mosaics and Greco-Roman colonnades, arcades, or masonry piers (often made of columns taken from the ruins of Roman temples) were arranged for effects of gradation and climax that focus on the altar. Plans are of two basic types, the *longitudinal* and the *central,* both having roots in Roman architecture. The longitudinal type was a modified Roman basilica plan and is therefore called a basilica (Fig. 12-1). From an entry gate, one passes through the *atrium* (open court) into the *narthex* (vestibule), where one can see the altar at the far end of the nave. By means of these spaces, which provide progressive degrees of withdrawal from the outside world, the altar gains significance. The longitudinal axis, which lends itself so well to dignified processionals, is sacrificed in the central type of building. In the fourth century, the central plan was generally used for martyria, but it soon appeared in churches as well. Although the central space receives the major emphasis, a slight axis may be suggested by placing the altar just off center against an apse. Central plans have a variety of forms, especially in Syria and Armenia, ranging from circular to square or Greek cross (arms of equal length) within a square. Other variations were developed in the Byzantine period. Central churches often had vaulting or domes of stone or brick. Large basilicas were usually roofed with timber, although tunnel vaults were frequently used over side aisles; smaller basilicas, particularly in Syria and Asia Minor, used stone and brick vaulting.

Old Basilica of St. Peter (Rome). This old basilica (Fig. 12-1) was destroyed to make room for the Renaissance structure, but the original is known through drawings and descriptions. Built over the tomb of St. Peter between 324 and 354 by order of Constantine, it exemplifies an early but fully developed basilica plan. The nave was roofed with timber and the outer side aisles with tunnel vaults. Although in later Christian churches the main entrance was traditionally placed at the west, Old St. Peter's had its entrance at the east end.

Santa Costanza (Rome). The central building (Fig. 12-2) was ordered by Constantine in 324, possibly as a mausoleum for a member of his family, and was converted

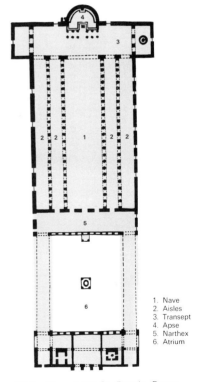

1. Nave
2. Aisles
3. Transept
4. Apse
5. Narthex
6. Atrium

12-1 Plan of Old St. Peter's, Rome, fourth century.

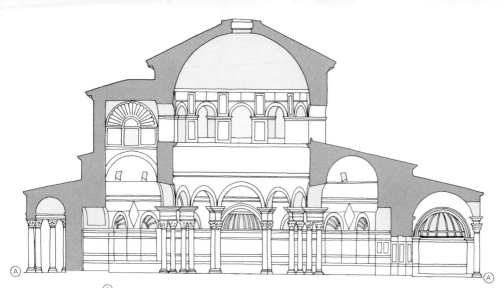

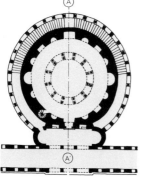

12-2 Plan and section of Santa Costanza.

to a church in the thirteenth century. The central space, about 40 feet in diameter, is covered by a dome on a drum that rests on arcades carried by twelve pairs of columns. Around the central space is a circular side aisle with a tunnel vault and mosaics. The building was originally peripteral. It is an important prototype for later central churches.

PAINTING AND MOSAICS

Painting was done on walls and panels and in book illustrations. Tempera, encaustic, and fresco-secco were employed. The earliest Christian painting is found in the catacombs in Rome. These fresco-secco works depict praying figures and episodes of miraculous salvation taken from the Old and New Testaments. The scenes are reduced to the minimum essentials; the figures are sketchily painted and have large heads, staring eyes, and doll-like bodies. There is little interest in landscape or depth, but the abbreviated episodes are sometimes set into painted geometric designs. The effect is that of brief pictorial prayers. Few catacomb paintings were done after the fifth century.

Until the development of the printing press during the Renaissance, books were copied and illustrated by hand. These *illuminated manuscripts* were at first in the *rotulus* form, following the Roman scroll books; rather than using separate pages bound at one side, the text was written on a continuous band held on two rollers, and the reader unrolled one side as he rolled up the other. Between the first and the fourth centuries, the

rotulus type was slowly replaced by the *codex* form that we use today. Parchment (made from animal skin) was common for centuries; paper was not used until after the eleventh century. The painted illustrations in the Early Christian manuscripts showed varying degrees of naturalness, modified by a tendency to harden into conventional shapes that were repeated without direct observation of nature. They are often characterized by flat figures, abrupt modeling, and fanciful colors; the rigid boldness and intensity of these partially abstract and highly symbolic works made them an effective expression of Early Christian theology. A similar stylistic tension between nature and symbol is evident in the mosaics. Generally it is felt that, like Christianity itself, the tendency toward flat symbolic forms had its origin in the Near East.

The Good Shepherd and **The Story of Jonah** (Rome, 4th cen.). The painting is on a ceiling in the catacomb of Saints Pietro and Marcellino (Fig. 12-3). Within a simple geometrical design in obvious central balance, Christ as the Good Shepherd is shown in a landscape with two sketchily painted trees and several sheep. From the central scene radiate episodes from the story of Jonah done in a quick, abbreviated manner. Between the episodes, praying men hold out their hands to heaven. Some of the contrapposto poses echo pre-Christian Roman art, but the sketchiness and the disregard of scale relationships between Jonah, the ship, and the whale reveal a declining interest in the observation of the physical world.

12-3
The Good Shepherd and *The Story of Jonah,* from the catacomb of Saints Pietro and Marcellino, Rome, fourth century.

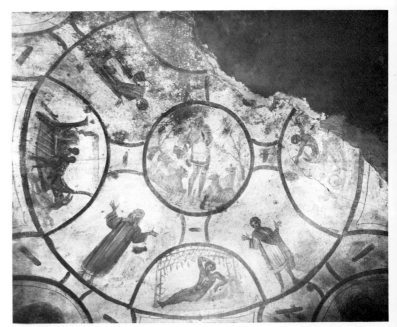

SCULPTURE

Sculpture showed a remarkable decline in importance, partly because of the Biblical injunction against idols and partly as a reaction against the widespread use of idols in Roman temples. It was generally confined to small-scale work, such as sarcophagi, metal plates and chalices, *reliquaries* (elaborate containers for sacred relics), and ivory carvings. What portraits there were showed less and less interest in specific details of physical appearance. Christian sarcophagi of the fourth and fifth centuries are *frieze-type*, with episodes carved in an unbroken frieze along the sides, or *columnar-type*, with scenes divided by engaged columns. Sometimes double registers were used. As in the catacomb paintings, favorite subjects included such miracles as Jonah and the Whale, the Raising of Lazarus, the Sacrifice of Isaac, Daniel in the Den of Lions, the Healing of the Blind, and Moses Striking Water from the Rock.

During the fourth century, sculptural style moved closer to that of the doll-like figures and repetitious poses on the Arch of Constantine. The declining interest in the physical world, the increasing love of flat geometric or floral decoration, and the inclination toward abstract symbols—such as the Cross instead of the figure of Jesus, or the monogram made by superimposing X and P (Chi and Rho), the first letters of Christ's name in Greek—grew from the other-worldly emphasis and the symbolic character of Eastern thought and art. Long before the time of Jesus, Persian art stressed flat patterns and nonfigurative designs. In Constantinople, Christian-Roman culture had been transplanted into the midst of ancient Eastern culture. Thus the more abstract

12-4 Sarcophagus of Junius Bassus, *c.* 359. Marble, 3'10½'' x 8'. Vatican Grottoes, Rome.

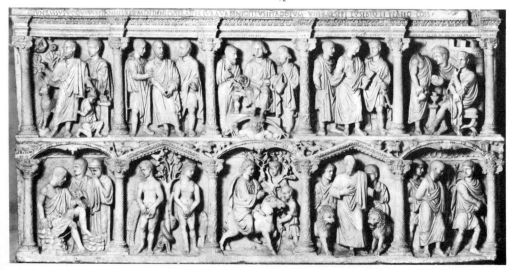

sarcophagi generally come from Constantinople and other Eastern centers or from artists trained in those areas. The same might be said for the style of the ivory carvings. *Consular diptychs* (two-part ivory plaques celebrating election to the office of consul) from Rome show more interest in anatomy and natural drapery than those carved in Constantinople, even though the Roman work reflects the changes seen in the sculpture on the Arch of Constantine.

Sarcophagus of Junius Bassus, from St. Peter's (Rome, c. 359, marble, 46½" x 96"). This fine double-register columnar sarcophagus (Fig. 12-4) mixes Old and New Testament episodes without regard for chronology. Each episode was an abbreviated symbol for the initiate. In the center of the top register, the enthroned Jesus is giving missions to Peter and Paul. At his feet is the head and wind-blown canopy of Cailus, a Roman sky god. Directly below, the Entry into Jerusalem is flanked by Adam and Eve and Daniel in the Den of Lions. In the spandrels of the lower colonnade, lambs are used to represent episodes ranging from Moses Striking the Rock to the Raising of Lazarus. Much natural detail is retained in faces, poses, and costumes, but legs are shortened and heads are enlarged. Compared with earlier sarcophagi, the architecture here is smaller in scale and has more surface decoration.

Byzantine Period: 500–1453

ARCHITECTURE

Long before the time of Christ, the dome had been used as a symbol of the heavens and as a covering for sacred places or objects. The domed central plan is particularly characteristic of Byzantine churches; in Constantinople and surrounding regions, however, the central and longitudinal plans are often fused in the form of short, wide, domed basilicas. Domes, usually over square spaces, are supported by pendentives, which were probably developed in Syria, or squinches, which may have originated in Armenia (Fig. 4-15, p. 46). Domes were sometimes constructed of porous stone or hollow pottery in order to reduce weight and avoid the need for heavy buttressing. Byzantine architecture tends to conceal structural masses with flat mosaic decoration and multicolored marble veneer. Domes and walls appear to be eggshell thin, and capitals of supporting

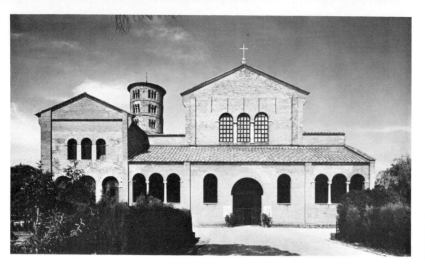

12-5
Sant' Apollinare in
Classe, Ravenna,
530–49.

12-6
Interior of Sant' Apollinare
in Classe, view toward apse.

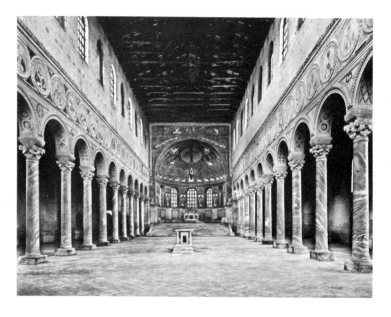

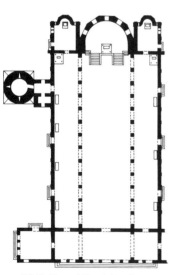

12-7 Plan of Sant' Apollinare
in Classe.

columns are perforated in basketlike designs that make
them look hollow and delicate. The supernatural quali-
ties of the sacred place are expressed in the seeming
weightlessness and the shimmering color of walls and
domes.

Sant' Apollinare in Classe (Ravenna, 530–49). The
three-aisled basilica has a characteristically plain exte-
rior (Fig. 12-5) with one of the earliest *campanili* (bell
towers). Inside (Figs. 12-6 and 12-7), the raised altar re-
ceives additional focal emphasis from the framing of

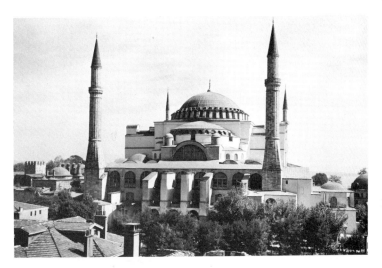

12-8
Hagia Sophia, Constantinople,
552–57.

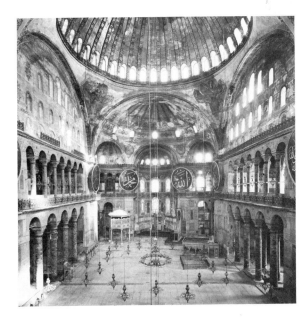

12-9 Interior of Hagia Sophia.

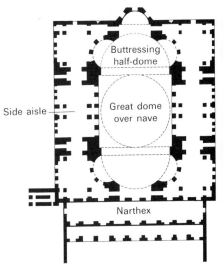

12-10 Plan of Hagia Sophia.

the apse and the concentration of the mosaics. Byzantine patronage is evident not only in the mosaics but also in the nave columns; the soft, spongy-appearing capitals are an abstraction from the crisp, leafy, Corinthian form.

Hagia Sophia (Constantinople, 532–37). Emperor Justinian commissioned this domed basilica (Figs. 12-8 and 12-9) during the first golden age of Byzantine art. A short basilica plan (Fig. 12-10), similar to that of the Basilica of Constantine, is combined with a central

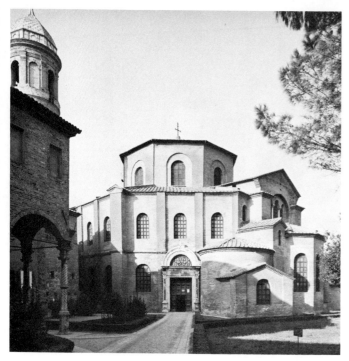

12-11
San Vitale, Ravenna, 526–47.

12-12 Interior of San Vitale.

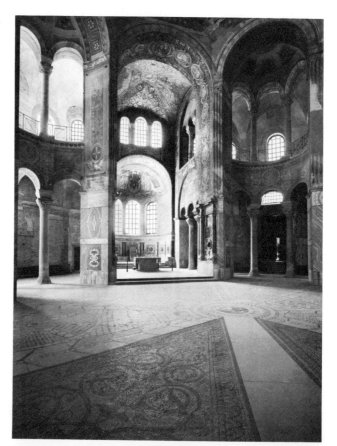

142

dome inspired by the Pantheon; but the effect of this dome (180 feet high) on pendentives is quite different from that of its prototype. The blossoming of light from windows around its base makes the Byzantine dome seem to be a hovering canopy. The delicately perforated capitals, the flat shapes in the mosaics, the concealment of the massive supports in the architecture, and the location of the windows all deny the physical weight of the structure and create the effect of a glittering vision, an expressive symbol of heaven.

San Vitale (Ravenna, 526–47). This polygonal central church (Figs. 12-11–12-13), built under the patronage of Justinian, shows both the direct influence of Constantinople and its more distant ancestry in buildings like Santa Costanza. The central space is scalloped by semicircular niches in the side aisles and gallery. The lightweight dome is constructed of pottery and mortar, allowing large clerestory windows in the drum. Mosaics cover the interior walls, and the capitals (Fig. 12-14) have intricate Byzantine basketwork weaving.

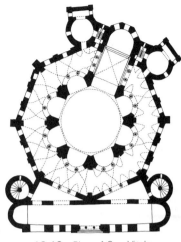

12-13 Plan of San Vitale.

PAINTING AND MOSAICS

By the sixth century, Western (Roman) and Eastern qualities had fused in much of the art produced in and around Constantinople. The resulting style combines frozen figure poses, a disregard for natural scale relationships, and a love of sumptuously decorated flat surfaces. Thus rigid formality is joined with sensuous luxury of design. This style, called Byzantine (after the Byzantine Empire of Constantinople), was not a stable formula, however. Periodic revivals of interest in Greco-Roman art, particularly during the tenth and twelfth centuries, complicated the stylistic development between 500 and 1453. Wall paintings and mosaics in Italian churches range from the worldly interests of ancient Roman painting to the symbolism of Byzantine art. Eastern influence is especially strong in the mosaics at Ravenna, one of the main outposts of the Byzantine Empire on Italian soil during the sixth century. The iconoclasm of the eighth and ninth centuries brought to Rome the talents of displaced Byzantine artists. Christian painting in Syria and Egypt (except for Alexandria) shows much Byzantine character, although Christian art was interrupted in these areas by Moslem conquests in the seventh century. After the iconoclast period, the second golden age of Byzantine art, lasting roughly from the ninth to the twelfth centuries, brought

12-14 Capital from San Vitale.

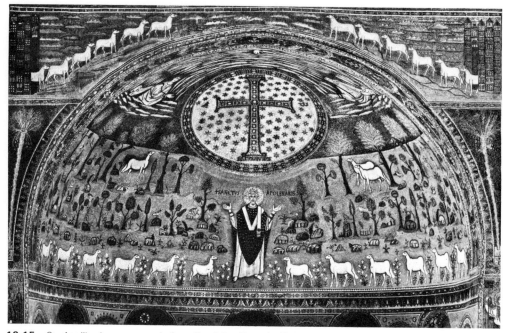

12-15 *St. Apollinaris,* apse mosaic from Sant' Apollinare in Classe.

a number of stylistic changes. More expression of emotion, more massiveness, and more natural anatomy appear, but the formal order of Byzantine art never relinquishes its hold on movement, costume, and figure.

In the decoration of Byzantine churches, subjects tend to be located according to order of importance. The dome was reserved for Christ as Judge, the drum and pendentives for angels and Evangelists, the vault of the apse for the Virgin, and the other regions of the walls for the Twelve Feasts of the Church (Annunciation, Nativity, Presentation, Baptism, Transfiguration, Raising of Lazarus, Entry into Jerusalem, Crucifixion, Harrowing of Hell, Ascension, Pentecost, and Death of the Virgin) and other scenes from the lives of Jesus and Mary. The west wall often showed the Last Judgment.

In manuscript illumination, as in other painting, the anthropomorphic symbolism, landscape interest, mass, space, and natural poses of the old Roman style—sometimes called the Latin style—were affected in varying degrees by the Eastern influence. The stylistic heritage of a painting is sometimes revealed by details; a bearded Christ or one riding sidesaddle into Jerusalem denotes an Eastern background, while a beardless Christ or one riding astride the donkey denotes a Latin source.

St. Apollinaris, apse mosaic from Sant' Apollinare in Classe (Ravenna, 533–49). This (Fig. 12-15) is one of the most striking examples of Byzantine art on the Italian peninsula. St. Apollinaris, who was martyred in Ravenna, is shown as an imitator of Christ's martyrdom. Above the saint, the Transfiguration of Christ is symbolized by the vision of the Cross between Moses, Elias, and three lambs representing disciples. The severe symmetry of the flat shapes and their exotic colors emphasize the symbolic nature of the event.

Justinian and Attendants, mosaic from San Vitale (Ravenna, c. 547). The Emperor, accompanied by his representative in Ravenna, Maximianus, carries an offering to Christ (Fig. 12-16). The solid, individually detailed portrait heads contrast with the flat shapes of the costumes, and depth is further negated by the brilliant warmth of the gold background. The artist's indifference to weight and space left him free to allow the feet of several figures to stand upon each other. The ritualistic formality of the staring, symmetrically placed images conveys the hypnotic fascination of Byzantine art. The wall on the opposite side of the altar carries a similar composition depicting Justinian's wife, Theodora, with attendants.

12-16 *Justinian and Attendants,* mosaic from San Vitale.

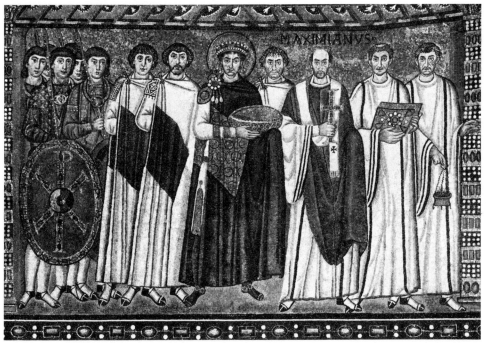

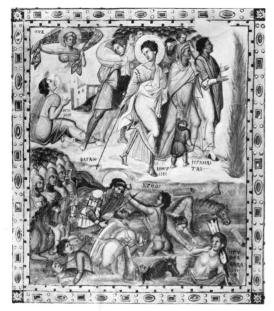

12-17 *Crossing the Red Sea,* page from the
Paris Psalter, tenth century (?).
Bibliothèque Nationale, Paris.

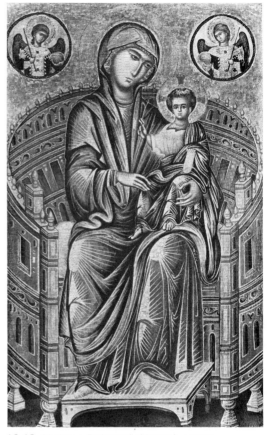

12-18 *Madonna Enthroned,* thirteenth century.
Panel, 32″ x 19½″. Mellon Collection,
National Gallery of Art, Washington, D.C.

Crossing the Red Sea, a page from the *Paris Psalter* (Bibliothèque Nationale, Paris). The *Paris Psalter* (Psalm book) contains fourteen full-page illuminations on parchment, one of which is shown in Figure 12-17. The distortions in scale and anatomy and the schematic treatment of costume reveal Byzantine interests. The modeled roundness of some forms, the relatively natural musculature of the nude sea gods and goddesses, and the landscape setting are debts to earlier Roman art. The use of human figures for nature divinities, such as the sea gods and the figure of night (in upper left with canopy), is also characteristic of earlier Roman art. The date of the *Paris Psalter* is uncertain; it may come from the tenth century.

Madonna Enthroned 13th-cen. panel painting, 32″ x 19½″. (National Gallery of Art, Washington, D.C.). Standard forms are used in the costume folds and in the flat modeling of the faces (Fig. 12-18). Repetition and variation occur in thematic shapes, such as the radiating highlights in the clothing. Mass, depth, and natural effects in proportion and drapery are sacrificed for stern order and elegant formality. The result is a symbolic image that stands outside the realm of the everyday world.

SCULPTURE

There was very little monumental sculpture in the Byzantine Empire during the Byzantine period; the case is quite different in northern Italy and in Europe, as we shall see in the next chapter. Sarcophagi produced in Constantinople or in its spheres of influence show variations of the Byzantine style. Most of the ivory consular diptychs in the Byzantine style seem to come from the area of Constantinople and to date from the sixth century. Icons or reliquaries combine small-scale relief sculpture, often in gold, with enamel painting. Their portability helped to spread the influence of Byzantine art.

Sarcophagus of Theodorus, from Sant' Apollinare in Classe (Ravenna, 7th cen., marble, 39½″ x 81″). The Byzantine tendency to use symbols rather than literal description is well illustrated here (Fig. 12-19). The peacocks were

12-19 Sarcophagus of Theodorus, from Sant' Apollinare in Classe, seventh century. Marble.

symbols of immortality; the grapevines referred to the wine of the Eucharist. In the center and on the lid, the Chi-Rho symbol is hung with Alpha and Omega, the first and last letters of the Greek alphabet, standing for the all-inclusiveness of Christ. The symbols are framed by wreaths of victory. There is little interest in the natural detail of the vines or animals and no illusion of depth. The forms have little modeling and appear as shallow layers applied to a flat surface.

Diptych of Anastasius (dated 517, ivory, each leaf 14″ x 5″. Bibliothèque Nationale, Paris). The two halves of a diptych frequently carried approximately the same scene. Here (Fig. 12-20) the newly elected consul, Anastasius, is

12-20 Diptych of Anastasius, 517. Ivory, each leaf 14″ x 5″. Bibliothèque Nationale, Paris.

shown in the official act of throwing down the *mappa* (a piece of cloth used as a signal to start the games in an arena). He is surrounded by winged goddesses of victory. The disregard for natural scale relationships between the figures, the preference for flat ornate surfaces rather than mass and the illusion of deep space, the stiff frontal pose, and the masklike faces are all characteristic of Byzantine art.

Suggestions for Further Study

Ainalov, D. V. *Hellenistic Origins of Byzantine Art.* Translated by E. Sobolevitch and S. Sobolevitch. New Brunswick, N.J.: Rutgers University Press, 1961.

Beckwith, John. *The Art of Constantinople: An Introduction to Byzantine Art, 330–1453.* London: Phaidon Press, 1961.

Demus, Otto. *Byzantine Mosaic Decoration.* London: Routledge & Kegan Paul, 1941.

Grabar, André. *Byzantine Painting* (Great Centuries of Painting). Translated by Stuart Gilbert. Geneva: Skira, 1953.

————. *Byzantium from the Death of Theodosius to the Rise of Islam* (The Arts of Mankind). Translated by Stuart Gilbert and James Emmons. London: Thames and Hudson, 1966.

Krautheimer, Richard. *Early Christian and Byzantine Architecture* (Pelican History of Art). Baltimore: Penguin Books, 1965.

Mathew, Gervase. *Byzantine Aesthetics.* New York: Viking Press, 1963.

Morey, Charles R. *Early Christian Art,* 2nd rev. ed. Princeton, N.J.: Princeton University Press, 1953.

Rice, David Talbot, and Max Hirmer. *The Art of Byzantium.* New York: Abrams, 1959.

Strzygowski, J. *Origin of Christian Church Art.* Translated by O. M. Dalton and H. H. Braunholtz. Oxford: Clarendon Press, 1923.

Swift, Emerson H. *Roman Sources of Christian Art.* New York: Columbia University Press, 1951.

Volbach, W. F., and Max Hirmer. *Early Christian Art.* Translated by Christopher Ligota. New York: Abrams, 1962.

Von Simson, Otto G. *The Sacred Fortress: Byzantine Art and Statecraft in Ravenna.* Chicago: University of Chicago Press, 1948.

Weitzmann, Kurt. *Illustrations in Roll and Codex: A Study of the Origin and Method of Text Illustration.* Princeton, N.J.: Princeton University Press, 1947.

Chapter 13

Medieval Art in the North: 400–1400

Early Christian and Byzantine art is often considered the Mediterranean branch of Medieval art. *Medieval* and *Middle Ages* are both vague and unsympathetic labels invented by scholars who thought of the years between the decline of Rome and the beginning of the Renaissance as a barren transitional period. Today we are more appreciative of the age, but the labels remain standard terms. The beginning and end dates of the Medieval period vary with different interpretations. This text will follow one widespread practice in using the term Medieval with particular emphasis on Europe north of Rome during the period between 400 and 1400.

While Early Christian and Byzantine culture was developing in the Mediterranean area, cultures developed to the north in areas that now include France, Germany, Scandinavia, the Netherlands, Belgium, and the British Isles. The Celto-Germanic people inhabiting these areas, called Barbarians by the Greeks and Romans, had an indigenous art before their widespread conversion to Christianity during the third to the tenth centuries. Celto-Germanic art slowly changed through the influence of the Early Christian and Byzantine art brought north by missionaries. Art in the northern countries may be divided into at least four periods: *Celto-Germanic art* (400–800), *Carolingian art* (750–987), *Romanesque art* (mainly eleventh and twelfth centuries) and *Gothic art* (overlapping the Romanesque in the twelfth century and extending in some areas into the sixteenth century). The terms Romanesque and Gothic are also misleading and are retained only because of entrenched usage. Romanesque, or "Roman-like," is an inadequate description of eleventh- and twelfth-century art, just as Gothic, originally meant to imply the barbarism of the Gothic tribes, is a pathetic misnomer for such things as the thirteenth-century French cathedrals.

The greatest efforts of Medieval art were in the service of Christianity, the unifying element in a very divided Europe. The modern distinction between artist and craftsman did not exist; the best talent was often employed to design liturgical equipment, furniture, or jewelry. Since individual identity and originality were not so highly valued as they are today, many works were unsigned and stylistic change was generally gradual. The spread of stylistic influences can be traced along trade routes, the Crusade routes, and the pilgrimage routes. From the sixth century on, pilgrims traveled from northwest Europe to three major destinations: Rome, the Shrine of St. James at Santiago de Compostela in Spain, and the Holy Land.

The art of the first three periods developed mainly in the monasteries. Gothic art was more urban and came from the cathedral centers developed by the *secular clergy* (clergy who did not withdraw from lay society to live by rigid rules, as did the regular or monastic clergy). The word *cathedral* comes from the cathedra, the throne of the bishop, placed in the main church of the bishop's diocese.

Celto-Germanic and Carolingian Art: 400–987

METALWORK

Many of the earliest remains from the Celto-Germanic period are metalwork of bronze or gold decorated with enamel. Bracelets, brooches, armbands, swords, and purse covers are typical. The style combines lively, intricate, geometric designs with fantastic animal and human forms. Constantly expanding and contracting shapes, sudden changes of direction, and amazing intricacy account for the vitality and richness of the work. There is no illusion of mass or space.

Purse cover, from the Sutton Hoo ship-burial (British Museum, London). This enamel and gold purse cover (Fig. 13-1) came from the grave of an East Anglian king who died in 654. It is a fine example of early Celto-Germanic metalwork. The style may have been brought to western Europe by migrating tribes from central Asia; it resembles the abstract animal style of nomadic art from southern Siberia and northern Persia.

13-1 Purse cover, from the Sutton Hoo ship burial, before 655. Gold and enamel. British Museum, London.

PAINTING

The most significant painting of the Celto-Germanic period that has been preserved from northwestern Europe is in illuminated manuscripts from the British Isles; the style is called *Hiberno-Saxon* or *Celtic* after the Celts of ancient Ireland. Monasteries became centers of learning where the manuscripts, mainly of the Scriptures, were copied and illuminated. Colors with gum, glue, or gelatin binders were used on parchment or *vellum* (calfskin or kidskin). Like the metalwork, the illuminations employ intricate spiral designs, interlaced shapes in *strapwork* (flat bands resembling cut leather), and fantastic animals. The Celto-Germanic style was characteristic of Hiberno-Saxon painting until the ninth

century. The style slowly changed, however, under the influence of Byzantine paintings and ivories brought from the south by Christian missionaries, and the Hiberno-Saxon illuminations developed various mixtures of abstract Celto-Germanic design and the relatively more static and representational Early Christian and Byzantine art. During the Carolingian era (750–987), important centers of manuscript illumination were established on the Continent under the patronage of Charlemagne, and different styles evolved in different geographical areas. In the Carolingian Empire, as in the British Isles, Celto-Germanic stylistic traits were increasingly modified by the influence of Early Christian and Byzantine art. In addition, Carolingian painting shows contact with older Roman art; poses, drapery, and landscape sometimes are closer to Roman art than to the Early Christian and Byzantine styles that intervened.

13-2 Initial page (XPI) of the *Book of Kells*, eighth century. Trinity College Library, Dublin.

Initial page (XPI) of the *Book of Kells* (8th cen., 12⅝″ x 9½″. Trinity College Library, Dublin). The manuscript was probably made at the monastery of Kells in Ireland or at that of Iona in Scotland. It contains tables of references, prefaces and summaries, the Gospels, and part of a glossary of Hebrew names. Here Celto-Germanic art serves Christianity. Intermingled with the interlaces and spiral designs are human heads and animals. Other pages in the book depict more of the human figure, but this illumination of the sacred initials of Christ (Fig. 13–2) illustrates the typical shapes and the swirling dynamism of line that modified Roman, Early Christian, and Byzantine elements to form Medieval art.

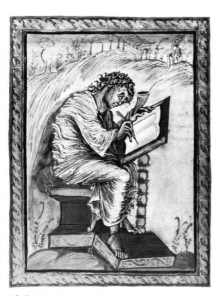

St. Matthew, from the *Gospel Book of Ebbo of Reims* (Épernay, 9th cen., 6⅞″ x 5⁹⁄₁₆″). The so-called Reims School (a regional style) of Carolingian illumination had classicizing tendencies; that is, the pose, costume, massiveness, facial type, and sketchy brush strokes all reflect the influence of ancient Roman art. The Carolingian painter intensified the nervous activity of the lines here (Fig. 13-3) to give the image considerable dramatic vitality.

13-3 *St. Matthew,* from the *Gospel Book of Archbishop Ebbo of Reims,* Épernay, *c.* 816–35. Bibliothèque Nationale, Paris.

ARCHITECTURE

Celto-Germanic and Carolingian architecture made extensive use of wood. *Half-timber* construction consisted of a carefully joined wood frame filled in with mud or plaster on reed mats called wattle and daub. Some-

times walls were *palisades* (logs planted vertically side by side, as in a stake fence). Norsemen built frame houses around a central pole resembling the mast of a ship. Such *mast construction* was often covered with vertical wood sheathing. Carolingian builders used stone only for important buildings. The little that remains of their architecture reveals a strong interest in longitudinal plans. The basilica plan was elaborated to create more space for altars, reliquaries, and worshipers. An *ambulatory* (aisle around the outside of the apse) was added (for a Gothic example, see Fig. 13-30); secondary chapels were provided by *radiating apses* around the outside of the ambulatory or by *apses in echelon* (apses placed beside the main apse or on the arms of the transept); and the main apse was separated from the transept by a nave extension called the *choir* (see Fig. 13-30), which allowed space for the clergy choirs. Under the raised choir and apse, a *crypt* provided space for special tombs of local saints and founders of the church or for relics. A Carolingian basilica might be a *double-ender*—that is, it might have an apse at the west end as well as at the east—or it might have a *westwork*, a high, blocklike enlargement giving the effect of a west transept and containing a narthex on the ground level and a chapel above. Carolingian basilicas had timber roofs and many towers; a tower over a westwork and flanking towers at the sides would be echoed by a tower over the *crossing* (where the transept crosses the nave) with flanking towers at the sides. Central-form churches might be octagonal, with tunnel and cross vaults, or a combination of the apse-buttressed square and cross-in-square, four-column type. Such central churches show Byzantine influence in their form and in the rich, flat patterns of decorative details, which were sometimes imported from Italy.

Chapel of Charlemagne (Aachen; French, Aix-la-Chapelle). The major extant example of Carolingian architecture is this central church (Figs. 13-4 and 13-5) designed by Odo of Metz and dedicated in 805. It reveals Charlemagne's admiration for Byzantine culture because the polygonal plan and the general form come from San Vitale in Ravenna. Marble columns, a mosaic, and bronze fittings were imported from Italy. The central octagonal space is covered by a domical vault instead of a true dome, and is surrounded by a cross-vaulted side aisle and a gallery with special tunnel vaults. The chapel, which also served as a tomb for Charlemagne, was originally part of a palace complex and contained a throne in its westwork.

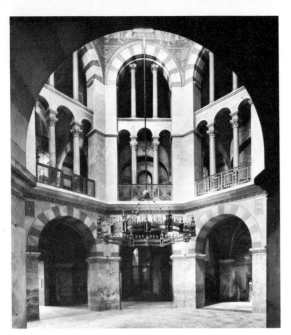

13-4 Interior of the Palatine Chapel of Charlemagne, Aachen, 792–805.

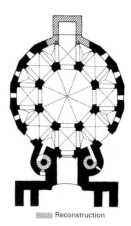

//// Reconstruction

13-5 Restored plan of the Palatine Chapel of Charlemagne.

Romanesque Art: 1000–1200

ARCHITECTURE

The Romanesque period produced more buildings, greater variety, and more advanced masonry techniques than the Celto-Germanic and Carolingian periods. The wooden roofing used over the naves of many basilicas from Early Christian through Carolingian times— a roofing that invited disastrous fires—was slowly replaced by fireproof stone vaulting. Ancient Roman features, such as massive walls, vaults, engaged columns, and pilasters, were used, but with significant changes. Unlike Roman concrete construction, Romanesque building is of masonry, and Romanesque cross vaults have ribs (see pp. 44–45). The leading construction of ribbed cross vaults over the nave occurred in the early twelfth century in Durham Cathedral (Anglo-Norman England), in St. Étienne at Caen (Normandy), and in Sant' Ambrogio at Milan (Lombardy).

Despite its variety, much Romanesque architecture is characterized by: (1) fortresslike massiveness; (2) Roman arches; (3) two or more towers; (4) *splayed openings*—doorways or windows formed by layers of increasingly smaller arches producing a funnel effect (for a Gothic example, see Fig. 13-26); (5) *blind arcades*—arcades attached to a wall for decoration or for buttressing rather than to create openings; (6) *corbel tables* (Fig. 13-6)—a *stringcourse* (horizontal band or molding) supported in the Lombard type by a row of

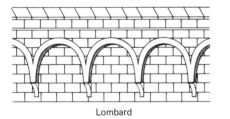

Lombard

French

13-6 Types of corbel tables.

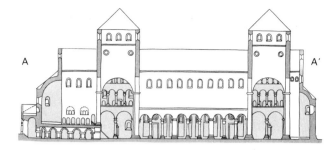

continuous small, blind arches, and in the French type by small brackets projecting from the wall; and (7) *wheel windows*—round windows divided into sections by stone dividers radiating from the center like the spokes of a wheel. The use of *Lombard pilaster strips* (slender pilasters) spread northward along the trade routes to Germany, as did the exterior arcaded galleries developed in Tuscany and Lombardy, while the Lombard porch, supported by two columns resting on the backs of lions, did not find wide acceptance elsewhere. Tuscan churches employed the Early Christian basilica plan, with the entrance at the west end and the apse at the east; they were often decorated with patterns of different colors in stone veneer. In Germany the double-ender plan was often employed, while in France, in addition to the pilgrimage church type (see p. 157), some basilicas were built in the form of *hall churches*, where the side aisles are as high as the nave, and the nave arcade rises to the springing of the vaults. Some of the most unusual examples of French Romanesque architecture are the domed churches in Aquitania; their source would seem to be Byzantine architecture, perhaps by way of St. Mark's in Venice. The pointed arches that occur occasionally in Romanesque buildings and are typical of later Gothic work appear to have their source in Islamic architecture.

Church of St. Michael (Hildesheim). This church (Figs. 13-7 and 13-8) was built under the direction of Bishop

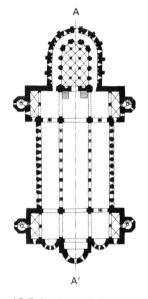

13-7 Section and plan of St. Michael's.

13-8 Abbey church of St. Michael, Hildesheim, *c.* 1001–33 (restored).

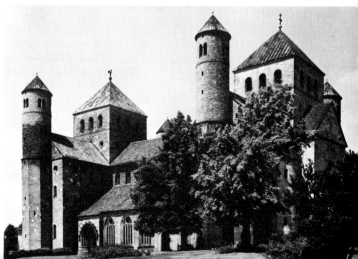

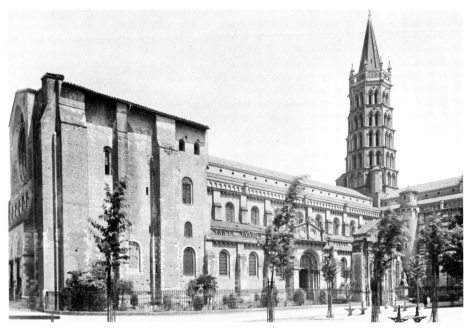

13-9 St. Sernin, Toulouse, eleventh and twelfth centuries.

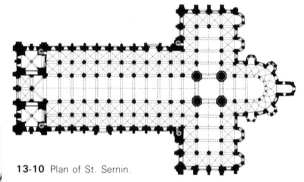

13-10 Plan of St. Sernin.

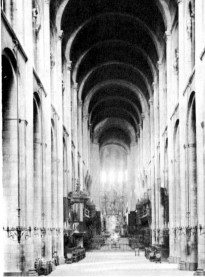

13-11 Interior of St. Sernin (view toward apse).

Bernward and completed in 1033, during the period of the Ottonian emperors in Germany. Carolingian architecture had provided all the basic elements. St. Michael's is a double-ender with a second transept, a choir, an apse, a crypt, and a crypt ambulatory in the west end. The nave roof is of wood. The entrances are at the sides of the nave, partly sacrificing the axial emphasis of a basilica plan. Towers over the crossings of both transepts and at their ends produce an almost equal exterior balance of east and west. The church was severely damaged in the Second World War.

St. Sernin (Toulouse). The church (Figs. 13-9–13-11) was begun in the eleventh century and finished in the twelfth, with the exception of the upper part of the crossing tower (thirteenth century) and the west façade, which was never completed. The twelfth-century

architect was Raymond Gayrard. St. Sernin is a pilgrimage church and one of the largest surviving Romanesque churches in France. It illustrates the elaboration of the basilica plan by means of choir, ambulatory, apses in echelon, radiating apses, double side aisles, and aisles around the transept. The high nave arcade rests on *compound piers* (piers of several parts, here having the form of superimposed pilasters and engaged columns) and is topped by a gallery, which provides more room for the congregation. There is no clerestory, for the heavy tunnel vault needs the abutment of the gallery vaults to sustain it. The bays are clearly marked by the transverse arches resting on engaged columns rising all the way from the floor. The columns break through the horizontal lines to establish a vertical emphasis that suggests the Gothic architecture to come. The exterior exhibits round-arched windows, French and Lombard corbel tables, and blind arcades.

St. Étienne (Caen, 11th–12th cens.). The west façade (Fig. 13-14) of the Norman basilica has a strong relationship to the interior (Figs. 13-12 and 13-13). The three divisions on the horizontal plane reflect the interior divisions into nave and side aisles; the three divisions from the bottom to the base of the towers echo the three-part elevation of the nave within. The Gothic steeples must be ignored; the towers were originally flat. An eleventh-century wooden roof over the nave was re-

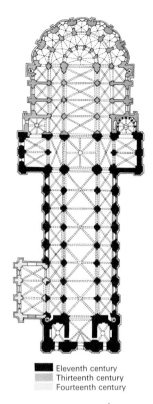

■ Eleventh century
▨ Thirteenth century
☐ Fourteenth century

13-12 Plan of St. Étienne.

13-13 Interior of St. Étienne, vaulted *c.* 1115–20. **13-14** West façade of St. Étienne, Caen, begun *c.* 1067.

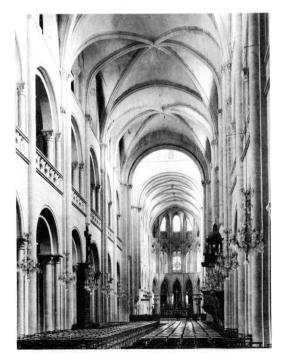

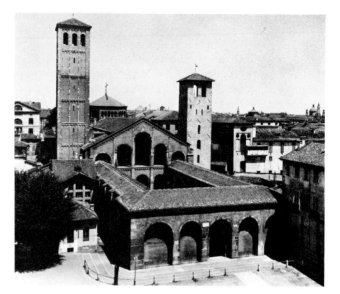

13-15
Sant' Ambrogio, Milan, late eleventh
to early twelfth centuries.

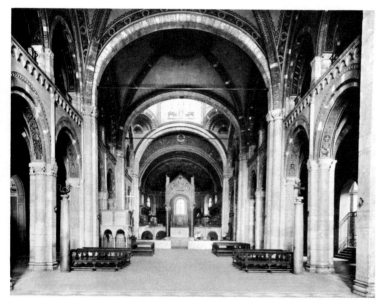

13-16
Interior of Sant' Ambrogio.

placed in the twelfth century by six-part ribbed cross
vaults (Fig. 4-12, p. 44). To avoid a domical effect, the
diagonal ribs were depressed to less than a semicircle
(Fig. 4-13b, p. 45). Every other compound pier is given
extra engaged elements that rise to support the ribs and
transverse arches. This creates an *alternating system* of
supports in the nave arcade. The vaulting of St. Étienne
places its Norman builders among the pioneers of
Romanesque architecture. The *chevet* (the apse, ambu-
latory, and radiating chapels) is thirteenth-century
Gothic.

Sant' Ambrogio (Milan). Construction on the cathedral (Figs. 13-15–13-17) extended from the ninth to the twelfth century, with the ribbed four-part cross vaults dating from the early twelfth century. The exterior is massive and simply decorated with pilaster strips and Lombard corbel tables. There are two towers of unequal height beside the narthex and a low polygonal tower over the octagonal domed vault at the crossing. From the atrium, one passes through the narthex to a nave of three low, dark bays. A domical effect comes from the cross vaults because the bays are square, and the ribs and transverse arches are semicircular (Fig. 4-13a, p. 45). An alternating system of piers divides each bay into two nave arches and two gallery arches. The gallery vaults buttress the nave vaults and leave no room for a clerestory. The side aisles terminate in apses in echelon beside the main apse. There is no ambulatory and only the suggestion of a choir. The nave vaults of this Lombard church place it beside St. Étienne in France and Durham Cathedral in England (built under Norman occupation) as a leader in Romanesque vaulting.

Durham Cathedral (England, 11th–12th cens., with later additions such as 13th- and 15th-cen. towers). Durham Cathedral (Figs. 13-18–13-20) is a basilica 469 feet long with a large crossing tower and a square east end. An alternating system of supports is used in the nave, and the heavy round columns that constitute the secondary supports are carved with bold geometric decoration. Some authorities believe that Durham was more important than St. Étienne in Caen or Sant' Ambrogio in Milan for the development of ribbed cross vaults. Norman craftsmen were imported for the construction of Durham, however, so its inspiration came from Normandy, which, in turn, may have owed much to the Lombard builders of Sant' Ambrogio. The somber darkness of the Italian church is avoided at Durham,

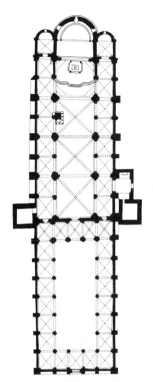

13-17 Plan of Sant' Ambrogio.

13-18 West façade of Durham Cathedral, eleventh and twelfth centuries.

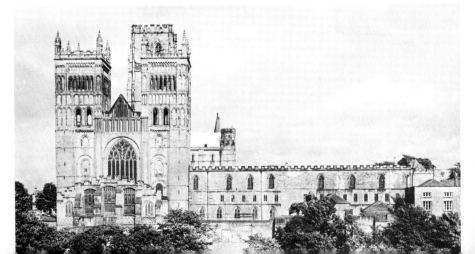

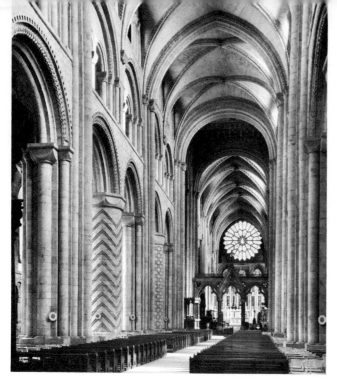

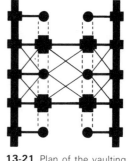

13-21 Plan of the vaulting in Durham Cathedral.

13-19 Nave of Durham Cathedral, begun *c.* 1093.

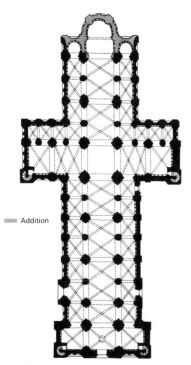

▧▧▧ Addition

13-20 Plan of Durham Cathedral.

where clerestory windows flood the vaults with light. The segmented domical effect of the bay vaults in Sant' Ambrogio gives way to a level roof ridge formed by the *crowns* (the highest point in an arch or vault) of the vaults in the English church (the Durham vaults are 73 feet high). The level vaulting is achieved by employing pointed arches in the transverse and side arches so that they reach the height of the semicircular diagonal ribs. (Fig. 4-13c, p. 45, shows how this can be done with the exclusive use of pointed arches.) Durham's nave vaults are distinctive in their use of two sets of diagonal ribs for each bay (Fig. 13-21). Like the church of La Trinité in Caen (the sister church to St. Étienne), Durham has flying buttresses that support the wall at clerestory level, although these buttresses are hidden under a shed roof. Both in vaulting and buttressing, Durham provided an important basis for Gothic architecture.

SCULPTURE

The main sources for Romanesque sculpture are Celto-Germanic art, Roman art, and Early Christian and Byzantine art. The Carolingian period had shared the Byzantine preference for miniature sculpture. The revival of monumental sculpture came with the Romanesque period, although even then many large sculptural

compositions were based on small ivory carvings or on manuscript illuminations. Romanesque sculpture is generally found around the entrances to churches, that is, on the *jambs* (layers of the splayed opening) of the door, in the *tympanum* (framed surface over the door), and on the *trumeau* (center post) of a double door; on columns, piers, and capitals; on altars and baptismal fonts; and on tombs. Subjects came from the Old and New Testaments, the Apocrypha, the lives of the saints, the labors of the months (a visual calendar of man's duties in the husbandry of the land), allegorical figures representing the Virtues and the Vices or the liberal arts, and the signs of the zodiac. There are also fantastic animals, which may have personified evil, and geometric or floral designs. Such elements suggest the influence of Celto-Germanic art. The capitals of columns may have been modifications of Greco-Roman forms, geometric ornament, or narrative relief. A number of pre-Christian Roman symbols are woven into the Christian subjects, as in Byzantine art. Romanesque sculpture has considerable regional variation ranging from angular, jerky, stiff figures in crowded linear designs (Fig. 2-4) to relatively massive calm forms. The more massive work is found in southern France and in Italy, where the tradition of ancient Roman art was strong. The beginnings of individual artists' styles can be seen in the work of some of the sculptors whose names have been preserved, such as Gislebertus of France (Cathedral at Autun), Antelami of Italy (Fidenza Cathedral), and Renier of Huy of Belgium (Baptismal Font at St. Barthé-lemy, Liège).

Adam and Eve Reproached by the Lord, panel from the doors of Hildesheim Cathedral (bronze, each panel 23″ x 43″). This example of Ottonian bronze casting (Fig. 13-22), done about 1015, was probably inspired by sculptured doors

13-22
BISHOP BERNWARD, *Adam and Eve Reproached by the Lord,* from the bronze doors of St. Michael's, Hildesheim, *c.* 1015. Approx. 23″ x 43″.

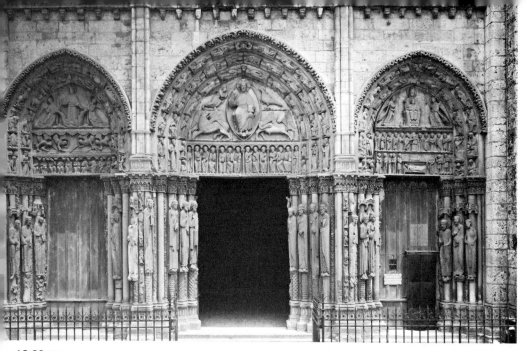

13-23 West ("royal") portals of Chartres Cathedral, c. 1145–70.

that Bishop Bernward had seen in Rome; it was origi-
nally made for the Church of St. Michael. Each of the
two doors is divided into eight panels. The subjects
depicted are the advent of sin and the means of salva-
tion; the left door deals with the Fall of Man and the
Murder of Abel, and the right door tells the story of
Christ from the Annunciation to the Ascension. As in
Ottonian manuscripts, the abrupt angularity of the
figures, the active poses, and the severely simple back-
grounds create dramatic intensity.

The Apocalyptic Christ (Moissac, 12th cen., 18′ 8″ wide).
St. John's vision in Revelations and an illumination in
the *Beatus Commentary on the Apocalypse* were the
sources for this tympanum composition (Fig. 2-4) de-
picting Christ surrounded by the symbols of the Evan-
gelists (a man for Matthew, a lion for Mark, a bull for
Luke, and an eagle for John), angels, and the Elders.
The overlapping layers of *plate drapery* are characteristic
of the Languedoc region. The sharp edges of the plate
folds make linear patterns of repeated and varied shapes
that turn and twist with jerky vitality. The scene is
framed at the sides by a twisted ribbon design and at
the bottom by a lintel carved in delicate *rosettes* (round
flower shapes), all having their origins in Greco-Roman
architectural ornament. A powerful effect of gradation
and climax comes from the enlarged scale of the central
figures and their position at the apex of the tympanum
and at the center of the obvious axial balance.

Sculpture from the west entrances (''royal portals'') of Chartres Cathedral (1145–70). The twelfth-century façade (Fig. 13-23) is attached to a thirteenth-century church because a fire destroyed all but the façade of the twelfth-century structure. The center tympanum shows Christ and the symbols of the Evangelists, while the surrounding arches are carved to represent the Elders. The Apostles are represented on the lintel. The right tympanum contains the Madonna and Child, and the lintel, in two registers, shows the Nativity and the Presentation in the Temple. The arches personify the liberal arts. The left tympanum depicts the Ascension; the lintel contains angles and Apostles. The arches carry the signs of the zodiac and the labors of the months. The jambs beside all three doors carry large figures that seem to portray the kings, queens, and prophets of the Bible. The capitals of the engaged columns have reliefs depicting the lives of Christ and Mary. The sculpture of Chartres-west is sometimes called early Gothic; however, it is much easier to understand as late Romanesque. A new clarity of parts is combined with the rigid poses and linear design of previous work.

PAINTING

During the eleventh and twelfth centuries, Romanesque painting, like Romanesque sculpture, proliferated in many regional styles, but its geographical bases were more widespread and its subject matter more varied. The term Romanesque was invented with architecture in mind, and it would be unrealistic to attempt a sharp distinction between Carolingian and Romanesque painting. During this period, the general tendency in the north was toward flat shapes and more insistence on line, line that is more active in its twisting and looping than the line in Byzantine art. Later twelfth-century work becomes more sculptural but often less lively. Byzantine influence is often evident in geometric drapery panels. Italian painting has Byzantine qualities but often loosens up Byzantine formality by means of more natural poses and more sculpturesque form.

St. Peter Receiving the Keys, from the *Book of Pericopes of Henry II* (Staatsbibliothek, Munich, 10⅜″ x 7½″). This eleventh-century work (Fig. 13-24) is from Reichenau, a school known for illuminations depicting figures with large, dark, staring eyes, bold gestures, and slightly modeled but strongly outlined forms. The bodies here are crowded into spaceless groups and placed against

13-24 *St. Peter Receiving the Keys,* from the *Book of Pericopes of Henry II,* eleventh century. Staatsbibliothek, Munich.

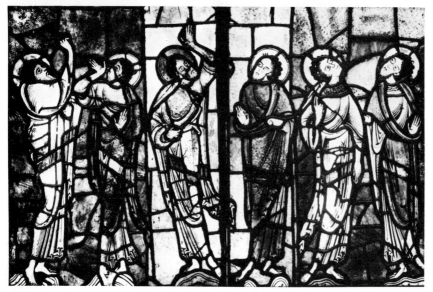

13-25 Detail from the *Ascension* window of Le Mans Cathedral, *c.* 1150. Stained glass, 45″ x 74″.

a simple flat background; nothing detracts from the focus on the central action.

Sections from an Ascension scene, stained glass in Le Mans Cathedral (*c.* 1150, 75″ x 45″). Originally, this Romanesque window (Fig. 13-25) depicted Mary and the twelve Apostles watching the Ascension of Jesus; however, the figure of Christ has been lost, and the proper arrangement of the surviving panels is uncertain. The colors are blue, red, yellow, purple, green, and white. The thin figures and the linear drapery designs link the style to that of sculpture and manuscript illumination of the period.

Gothic Art: 1150–1400

ARCHITECTURE

In the mid-twelfth century, the first churches that are called Gothic appeared in the Ile-de-France region—north-central France, with Paris as its center. From France the Gothic style spread to other countries, where it acquired regional characteristics. The major features of Gothic architecture are height, open walls, and complex linear design, all of which are integrated into a vast system of theological symbolism. The basilica plan attained grand proportions. To its longitudinal focus was added a vertical emphasis achieved through the use of ever higher nave vaults, the pointed arch, and dominating vertical lines in interior and exterior design. The trend toward greater height, complexity, and openness

in walls is illustrated by a number of major French cathedrals such as St. Denis, Noyon, Laon, Paris, Chartres, Reims, Amiens, and Beauvais. Late Gothic work of the fifteenth and sixteenth centuries elaborated the pointed arch and the *tracery* (intricate stone carving within a window) in flamelike curves and is therefore known as *flamboyant Gothic*. Examples may be found in the cathedral and the small church of St. Maclou in Rouen. As Gothic architecture developed, Romanesque massiveness disappeared (Figs. 1-29, 13-29, and 13-30); walls became perforated screens for the glowing colored light from stained glass. In Medieval theology, this light was a symbol for God. As walls became more open, mass was further denied by an increase in delicate sculptural detail, which gave a total effect of line rather than mass. On the interior, the stone vaults floated like canopies anchored by engaged columns and thin ribs over the clerestory windows. On the exterior, the openness of the forms, the vertical lines, and the fragile silhouette suggested a weightless vision of soaring splendor. During the Gothic period, the French cathedral became a complex symbol for the City of God; this was expressed not only by architectural form but by the extensive iconography presented in sculpture and stained glass windows.

Early English Gothic stressed length in plan and elevation, the major exception being an occasional tall spire or tower over the crossing. Few flying buttresses were needed. Late English Gothic emphasized height and opened the walls for more glass. Thus it is called the *Perpendicular period*. Typically English is the multiplication of vault ribs into an intricate network. The basilica plan in England tends to be rambling, with several transepts and frequently a square east end.

Germany was slow to turn to Gothic architecture but eventually was influenced by the French style. German Gothic made effective use of the hall church.

Cathedral of Notre Dame (Paris, 1163–1250). The Gothic façade (Fig. 13-26) here has more openings in the masses, more elaborately carved splayed openings, and more consistent use of the pointed arch than does earlier architecture. Open arcades and delicate detail soften the limits of the forms. The rose window shows the evolution from the wheel window as the sections became petal-like. Verticality is more insistent, although the three-part division from side to side and from the bottom to the base of the towers is still evident, as it was at Caen. The west towers are woven into an intricate geometric organization that integrates the sculpture and

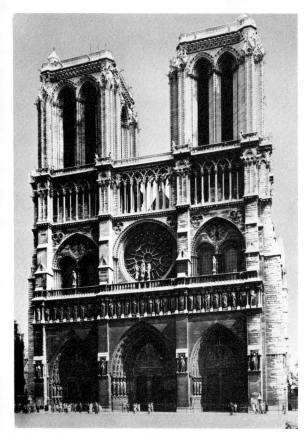

13-26 Notre Dame, Paris, 1163–1250.

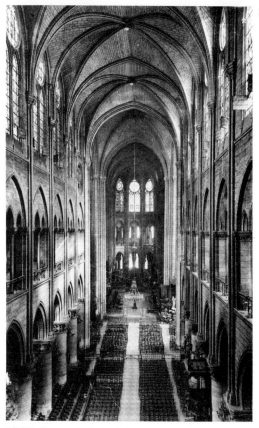

13-27 Nave and choir of Notre Dame..

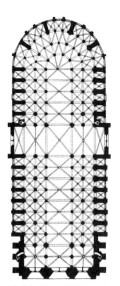

13-28 Plan of Notre Dame.

the architecture. Over the crossing, the tower used in earlier churches has been replaced by a tall, thin spire. The six-part ribbed and pointed cross vaults (Fig. 13-27) reach a height of $108\frac{1}{2}$ feet and are supported on the outside by flying buttresses. The pointed arch allows the necessary flexibility for level crowns in the vaults (Fig. 4-13c, p. 45). Because of the six-part vaults, a typical bay of the nave elevation would include two arches of the nave arcade, two sets of gallery arches, and two sets of clerestory windows, each set consisting of two *lancets* (bullet-shaped windows) and a rose. The plan (Fig. 13-28) has a long choir, double side aisles, and a double ambulatory.

Amiens Cathedral, by Robert de Luzarches (13th cen., with later additions, such as 14th- and 15th-cen. towers and 16th-cen. rose window in west façade). The façade (Fig. 1-29) shows a further dissolution of solid wall into superimposed layers of meshlike openings and sculpture. The splayed openings no longer seem to be cut out of the wall; they are extended in the form of

porches. Again we find the three-part divisions of the façade, but these have become more complex. The increased perforation and lightness of the walls match the ever more insistent vertical emphasis. The interior vaults (Figs. 13-29, 13-31) reach 139 feet above the floor. From compound columns with leafy capitals, the soaring engaged columns rise through a foliage stringcourse and a plain stringcourse to the four-part vaults above. A typical bay elevation consists of one arch in the nave arcade, two compound arches (each with three arches and a trefoil) at the gallery, which has now become a shallow passage, and a clerestory of four lancets and three roses. There is some variation, however, in the elevation in different parts of the church. A forest of flying buttresses provides exterior support. Although Amiens no longer has its original stained glass, the celebration of light and the double directional emphasis—toward the altar and toward the heavens—are dramatically evident.

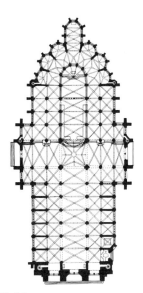

13-30 Plan of Amiens Cathedral.

13-29 ROBERT DE LUZARCHES, interior of Amiens Cathedral.

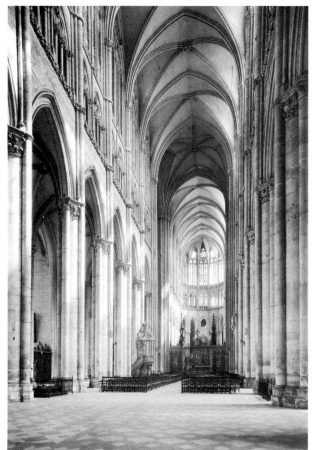

13-31 Choir vaults of Amiens Cathedral.

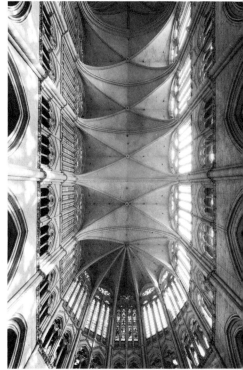

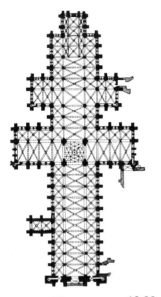

Salisbury Cathedral (begun in 1220). Verticality is stressed only in the tower and spire over the crossing. The façade (Fig. 13-33), heavily sculpted but with many horizontal lines, does not have the lightness and openness or the three-dimensional complexity of French Gothic. The length is the same as that of Amiens (450 feet), but Salisbury's interior (Figs. 13-32 and 13-34) seems much longer because of the narrower nave, lower vaults (about 81 feet), and emphatic horizontal lines. Few flying buttresses are needed. The cathedral has a three-level nave elevation and four-part ribbed and pointed cross vaults. The crossing has an elaborate *star vault* (multiple ribs suggesting superimposed star shapes). The plan is typical in its square east end and secondary transept.

▨ Additions **13-32** Plan of Salisbury Cathedral.

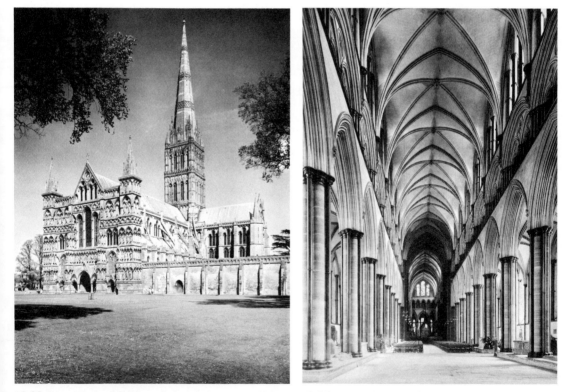

13-33 West façade of Salisbury Cathedral, begun *c.* 1220. **13-34** Nave of Salisbury Cathedral.

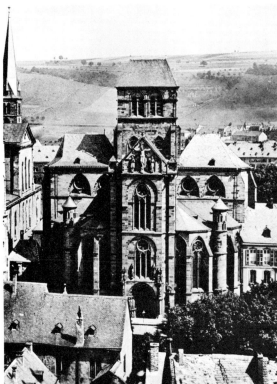

13-35 Liebfrauenkirche, Trier, begun *c.* 1227.

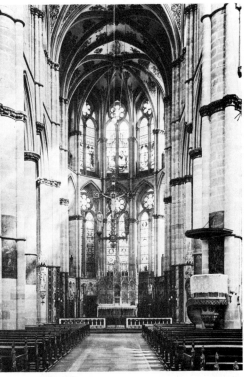

13-36 Interior of Liebfrauenkirche.

Liebfrauenkirche (Trier, 1227–43). The central plan is an exception to the predominance of the basilica in German Gothic architecture. Radiating chapels fill in the corners of a Greek cross plan that has an extended choir and apse for some longitudinal emphasis. The exterior (Fig. 13-35) illustrates the German reluctance to leave Romanesque forms; round arches and fortress towers are mixed with large pointed windows. Inside (Figs. 13-36 and 13-37), the arms of the cross have high ribbed and pointed four-part vaults. The elevation is in two levels: a high arcade and a clerestory of two lancets and a rose. Because the clerestory area is partly covered by the roofing of the outside chapels, however, the lancets had to be filled in until only curved triangular windows remained.

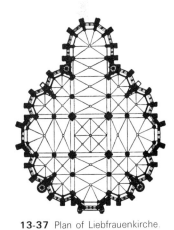

13-37 Plan of Liebfrauenkirche.

SCULPTURE

The beginnings of Gothic sculpture may be placed in the second half of the twelfth century. At this time, drapery and poses became calmer, and forms became somewhat less entangled. Figures began to pull away from their architectural backgrounds. In the early thirteenth century, bodies acquired more three-dimensional mass, more flexibility, more natural poses and drapery, and more individual faces. However, faces and figures retained some simplification and emphasis on large planes. Considerable stoniness and restraint of emotional expression are found in the important figures, giving them a more-than-human dignity and permanence. Later thirteenth-century sculpture gave up this monumental power for more specific anatomy, actions, and emotions; the development produced the effect of the superhuman descending to the human level (Fig. 13-40). Plants and animals were also depicted more naturally and less imaginatively. Late fourteenth-century work continued in the direction of greater mass and more portrait detail in faces. Stylistic development was quite uneven, and considerable variety may often be seen in the sculpture of one church because it was done by traveling sculptors from different regions or in different periods over a wide time span. In Italy, the remains of ancient Roman sculpture fostered an interest not only in mass but in certain facial types, poses, and methods of draping costumes. Classicizing tendencies may be seen in the work of men like Nicola Pisano.

By the thirteenth century, France had organized the involved subject matter of earlier sculpture into a complete world view including the hierarchy of heavenly beings, the role and duties of man, and the history of the world from events in the Old Testament to the Last Judgment (Fig. 13-39). So equipped with sculpture (and stained glass), the French Gothic cathedral, more than that of any other country, is a remarkable monument to its age.

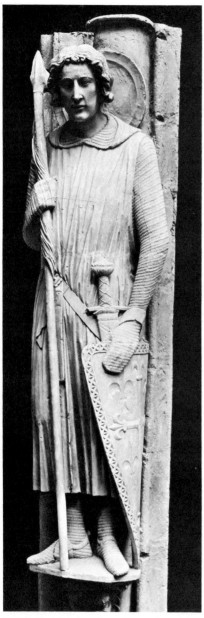

13-38 *St. Theodore,* from the south transept portal of Chartres Cathedral, *c.* 1215–20.

St. Theodore, from south transept portal of Chartres Cathedral (1215–20). The figure (Fig. 13-38), holding a spear and sheltered under a stone canopy, is quite distinct from its supporting column. The more human presentation is carried through in the naturalistic facial features and body proportions. Large, simple planes in the face and figure provide both a sense of monumental strength and a modification of the earthly reality implied by the image.

The Last Judgment, from central portal of west façade of Amiens Cathedral (*c.* 1220–30). In the lower register of this portal sculpture (Fig. 13-39), the dead arise from their tombs to be judged on the scales of St. Michael. Above, the Damned and the Elect are going to their respective rewards; and, at the top, Christ is surrounded by Mary, John, and angels bearing the instruments of the Passion. The splayed arches that frame the tympanum depict the Elect with angels, Martyrs and Confessors, the Wise and Foolish Virgins, the Elders, the Tree of Jesse (to represent the genealogy of Christ), and the Partriarchs of the Old Law. On the jambs below are larger-than-life-size figures of the Prophets and Apostles, each identified by some attribute indicating the instrument of his martyrdom or symbolizing his role. Below these statues are quatrefoil medallions with relief sculpture depicting prophecies, Virtues, and Vices. The trumeau statue, known as *Le Beau Dieu*, represents Christ. The sizes of the figures in the tympanum and surrounding arches vary according to their importance in the hierarchy. The large scale of the jamb statues and their nearness to entering worshipers give them special grandeur and visually strengthen the supporting columns for the whole portal. Anatomy in faces and nude figures still has austere simplicity, and drapery is arranged in orderly cascades or pleated folds; yet the total effect is so natural that the turning and twisting Apostles and Prophets seem to converse with each other.

13-39 *The Last Judgment,* from the central portal of the west façade of Amiens Cathedral, *c.* 1220–30.

Vièrge Dorée (Golden Virgin), from
the south transept trumeau of Amiens
Cathedral, 1250–70.

Vièrge Dorée (Golden Virgin), from south transept trumeau
of Amiens Cathedral (*c.* 1250–1270). This popular statue
(Fig. 13-40) took its name from the gilt paint originally
used in the costume. The austere strength of earlier
work is here replaced by extreme gracefulness and
human emotion. Although the bulky garment obscures
the lower body, the three-dimensional folds seem con-
vincingly activated by a contrapposto pose.

Crucifix (Pestkreuz), from St. Marie im Kapitol (Cologne,
1304, wood, 57″ high). The emaciated body in Figure
13-41 is shown with harsh angularity and much detail
in the bleeding wounds and the sores that suggest that
Jesus has suffered from disease and will be sympathetic
to the pleas of the sick. The symmetry and orderly
repetition of forms in the crown of thorns and the ribs
make the wounds and the convulsed hands more
shocking by contrast. The hands and arms indicate the
increasing study of nature that characterizes much
Gothic sculpture.

The Well of Moses, from former Monastery of the Chartreuse
de Champmol (Dijon, 1395–1406, stone, Prophets approx.
72″ high). This (Fig. 13-42) is the sculpture of Claus
Sluter, who came from Holland to the court of the
Dukes of Burgundy at Dijon. The well is surmounted
by a badly preserved crucifix placed on a base contain-

13-41
Crucifix from St. Marie im Kapitol, Cologne,
1304. Wood, 57″ high.

ing the figures of six Prophets from the Old Testament. In accordance with a Medieval passion play, the Prophets are depicted as judges who decide that Jesus must be crucified for the sake of mankind. Each Prophet holds a scroll that contains a quotation from the Old Testament predicting the sacrifice. The massive forms, with their deeply cut depressions, the realism of costume detail, and the individualized faces of Sluter's style forecast the Renaissance, but the slightly exaggerated rhythmic curves in some sections of the drapery relate it to the late Medieval period.

PAINTING

As walls became more open, Gothic painters in the North had less wall surface on which to work. Their talents were employed in designing stained glass, which in turn affected the style in manuscript illumination. Thirteenth-century illuminations often depict slender, willowy figures in gracefully curving and folding costumes, all within the architectural frame of a cathedral window. The modeling of the objects is counteracted by strong, flattened contours. Space around objects is often denied by the use of flat gold backgrounds. By the fourteenth century, illuminations make less use of the window framework and close observation of nature is evident. Jean Pucelle, in Paris, placed paintings at the

13-42
CLAUS SLUTER, *The Well of Moses*, 1395–1406. Figures approx. 72'' high. Chartreuse de Champmol, Dijon.

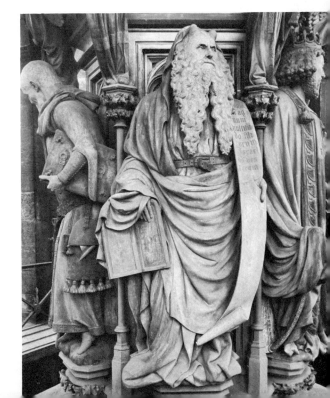

top and bottom of a page and surrounded the intervening text with elaborate decorative plants, animals, and geometric shapes. The most pioneering Gothic painting was done by the Italian Giotto di Bondone (1267?–1337). Under the influence of thirteenth-century sculpture, Giotto broke with Byzantine traditions to obtain massive bodies and more natural drapery. Landscape, architecture, and figures are severely simple. The directional movements of all his forms give ponderous dignity to the restrained gestures and facial expressions. The massiveness, the more individualized faces, the more natural poses, and the convincing but underplayed emotions all bring a new humanism to Medieval art. Yet Giotto's painting was not fully appreciated by his immediate successors, and it was only with the Renaissance that his interests were developed further. Duccio de Buoninsegna of Siena (about 1255–1319) made a more gentle break with Byzantine style.

13-43 Detail from the *Good Samaritan* window of Chartres Cathedral, early thirteenth century. Stained glass.

The *Good Samaritan* **window,** Chartres Cathedral (early 13th cen., stained glass). Chartres has one of the best-preserved sets of stained glass windows. The *Good Samaritan* window is a tall lancet contributed by the shoemakers of the town. Three medallions (circular clusters of scenes), one above the other, are separated by sets of three scenes each. The detail here (Fig. 13-43) shows only the central medallion and parts of the scenes above and below it. The compositions are read from the bottom up. The lower third of the window tells the story of the traveler's departure from Jerusalem, of his being robbed, beaten, and left along the road, and of his rescue by the Good Samaritan. The medallion in our reproduction begins an interpretation of the parable, depicting, in the bottom portion, the traveler in bed receiving care. The other scenes represent the creation of Adam (left) and Eve (right) and God's warning not to eat the fruit of the Tree of Knowledge (top). The top third of the window continues with the story of the Fall of Man and culminates with the figure of Jesus. Thus, Jerusalem represents Eden, the story of the traveler is related to the Fall of Man, and the Good Samaritan for all men becomes Jesus the Savior. The types of figure and drapery patterns, as well as the abbreviated symbols for trees and architecture, are artistic conventions of the time. The theological significance of light is enhanced by the glowing colors of the stained glass, colors that were projected in mottled hues onto the interior columns and floors.

Illuminated page from the *Psalter of St. Louis* (Bibliothèque Nationale, Paris, *c.* 1260, approx. 5″ x 4″). The illumination (Fig. 13-44) depicts Nahash the Ammonite threatening the Jews at Jabesh. Compared with most Romanesque work, the human figures here are natural in proportion and flexible in pose; but less important items, such as the horses (or architecture in other scenes), are given a diminished scale. Light and shadow are used sparingly to create a roundness that is countered by strong outlines. Depth is canceled by the gilt background. Shapes are filled with strong, relatively unmodulated colors, with blues and reds predominating. In each illumination in the psalter, the upper area is treated like a set of stained glass windows set into a Gothic building.

Lamentation or ***Pietà,*** by Giotto, (Arena Chapel, Padua, fresco, part of a series of paintings done in 1305-06, 7′7″

13-44 *Nahash Threatening the Jews at Jabesh,* illuminated page (I Kings 11:2) from the *Psalter of St. Louis, c.* 1260. Bibliothèque Nationale, Paris.

13-45
GIOTTO, *Pietà*, 1305–06. Fresco. Arena
Chapel, Padua, 7'7'' x 7'9''.

13-46 DUCCIO, *Christ Entering Jerusalem*,
detail from the *Maestà Altarpiece*,
1308–11. Siena Cathedral.

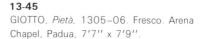

x 7'9''). The significance of the event is expressed here
(Fig. 13-45) not through awe-inspiring otherworldly
images, but through massive human forms whose ac-
tions have solemn dignity. The drapery is simplified
and used not to reveal the body but to emphasize the
major movement of each figure. As the figures focus
on Christ, so does the diagonally descending landscape.
Giotto's emphasis on three-dimensional mass and his
use of more normal human proportions constituted a
new concept of reality in painting and broke with the
conventions of Byzantine art. For this reason, Giotto
is often seen as a forerunner of the Renaissance. His
major frescoes are in Santa Croce in Florence and in
the Arena Chapel in Padua.

Christ Entering Jerusalem, by Duccio (from the *Maestà Altar-
piece,* Siena Cathedral, 1308–11, tempera on wood, detail
40'' x 21''). The great altarpiece depicts, on the front,
a Madonna enthroned and, on the back, scenes from
the life of Christ. Compared with Giotto's work,
Duccio's use of human proportions and flat shapes (Fig.
13-46) was a much less radical departure from Byzantine
traditions. Rigid Byzantine drapery patterns appear in
certain instances, particularly when Duccio shows Christ
in less natural states—during the Transfiguration, for
instance, or after the Resurrection. However, the details
in gestures and faces have a delicate expressiveness and
reflect a keen observation of nature. Duccio did not use
a consistent system of linear perspective. The architec-
ture is miniature in scale and may have been influenced
by stage sets for religious drama.

Suggestions for Further Study

Conant, Kenneth J. *Carolingian and Romanesque Architecture: 800–1200* (Pelican History of Art). Baltimore: Penguin Books, 1959.

Decker, Hans. *Romanesque Art in Italy.* Translated by James Cleugh. New York: Abrams, 1959.

Dupont, Jacques, and Cesare Gnudi. *Gothic Painting* (Great Centuries of Painting). Translated by Stuart Gilbert. Geneva: Skira, 1954.

Frankl, Paul. *Gothic Architecture* (Pelican History of Art). Translated by Dieter Pevsner. Baltimore: Penguin Books, 1962.

Gardner, Arthur. *Medieval Sculpture in France.* New York: Macmillan, 1931.

Grabar, Arthur, and Carl Nordenfalk. *Romanesque Painting* (Great Centuries of Painting). Translated by Stuart Gilbert. Geneva: Skira, 1958.

——————. *Early Medieval Painting from the Fourth to the Eleventh Century* (Great Centuries of Painting). Translated by Stuart Gilbert. Geneva: Skira, 1957.

Katzenellenbogen, Adolf. *The Sculptural Programs of Chartres Cathedral: Christ, Mary, Ecclesia.* Baltimore: The Johns Hopkins Press, 1959.

Landolt, Hanspeter. *German Painting: The Late Middle Ages (1330–1500).* Translated by Heinz Norden. Geneva: Skira, 1968.

Mâle, Émile. *The Gothic Image: Religious Art in France in the Thirteenth Century.* Translated by Dora Nussey. New York: Harper & Row, 1958.

Meiss, Millard. *French Painting in the Time of Jean de Berry.* 2 vols. New York: Phaidon Press, 1967.

Panofsky, Erwin. *Gothic Architecture and Scholasticism.* New York: Meridian Books, 1957.

Pope-Hennessy, John. *An Introduction to Italian Sculpture,* Vol. 1. New York and London: Phaidon Press, 1955.

Porter, Arthur Kingsley. *Medieval Architecture: Its Origins and Development.* 2 vols., reprint of the 1909 ed. New York: Hacker Art Books, 1966.

——————. *Romanesque Sculpture of the Pilgrimage Roads.* 10 vols. in 3, reprint of the 1923 ed. New York: Hacker Art Books, 1966.

Rickert, Margaret Josephine. *Painting in Britain: The Middle Ages* (Pelican History of Art). Baltimore: Penguin Books, 1954.

Saalman, Howard. *Medieval Architecture: European Architecture, 600–1200* (Great Ages of World Architecture). New York: Braziller, 1962.

Stone, Lawrence. *Sculpture in Britain: The Middle Ages* (Pelican History of Art). Baltimore: Penguin Books, 1955.

Von Simson, Otto G. *The Gothic Cathedral: Origins of Gothic Architecture and the Medieval Concept of Order.* New York: Pantheon Books, 1956.

Webb, Geoffrey. *Architecture in Britain: The Middle Ages* (Pelican History of Art). Baltimore: Penguin Books, 1956.

White, John. *Art and Architecture in Italy, 1250–1400* (Pelican History of Art). Baltimore: Penguin Books, 1966.

Witzleben, Elizabeth von. *Stained Glass in French Cathedrals.* Translated by Francisca Garvie. New York: Reynal, 1968.

Chapter 14

Renaissance Art:

1400–1600

The term *Renaissance* implies a rebirth, and the period is often thought of as a rebirth of the glory of ancient Greek and Roman culture; yet the Renaissance involved much more than imitation of the past. It was a time of emphasis on the importance of the individual, of interest in the physical characteristics of man and nature, and of search for rational order and ideal form in the arts. The period saw widespread geographical exploration, much activity in scholarship, a rapid growth in the sciences, reformation in religion, and broad changes in the arts. These trends had been gathering momentum since the twelfth century, with the exchange of ideas fostered by the Crusades, the emergence of free cities, the rise of the universities, and the developing interests in nature and antique art during the Gothic period. Furthermore, some of the climactic effects of Renaissance trends occurred only afterwards, in the seventeenth century. Thus the beginning and end dates for the period are rather arbitrary markers in the continuous stream of history.

Our concepts of Renaissance art are based primarily on Italy, for it was here that the trends were most distinct. The period from 1400 to 1500 in Italy is called the *Early Renaissance*, the years from about 1500 to 1520 are considered to be the *High Renaissance*, and the remainder of the sixteenth century may be termed *Late Renaissance*. The urbanization that took place in the Gothic period made the cities important centers for the growth of Renaissance ideas and the patronage of art. Artists often joined the courts of nobles and received sustenance and salary in return for painting, sculpture, and design ranging from architecture to theatrical costumes. Florence played the major role in the fifteenth century but was superseded in the sixteenth century by Rome and Venice. Outside Italy, the most productive geographical area for the arts in the fifteenth century was the region of present-day Belgium, with the major centers at Tournai, Bruges, Ghent, Brussels, Louvain, and Antwerp. In Burgundian France, Dijon was an important art center until 1420, when the court of the Dukes of Burgundy was moved to Flanders. Paris continued to be important, along with Fontainebleau in the sixteenth century. In the Germanic areas, Cologne, Nuremberg, Vienna, and Basel were especially significant. London was the center of a tardy development of the Renaissance in England.

During the Renaissance, the Church continued to be an important patron of the arts, but the aristocracy and the growing merchant class commissioned art for

themselves as well as for the Church. The Visconti and Sforza families in Milan, the Gonzaga family in Mantua, the Este family in Ferrara, and the Medici family in Florence, all powerful families, earned places in history through their patronage. The new individualism stimulated the quest for renown—for accomplishments in the earthly life—and architecture, painting, and sculpture could be seen as permanent monuments to the patron's importance. The desire to live fully was expressed in the concept of the universal man, the man of many abilities and interests as inspired by Greek thought and described in Baldassare Castiglione's sixteenth-century book, *The Courtier.*

Breadth of interests affected not only the patronage of art but also the attitude of the artist; Michelangelo was poet, painter, architect, and sculptor, and Leonardo da Vinci was artist, scientist, and engineer. The social status of the artist rose during the fifteenth and sixteenth centuries. By the sixteenth century, the craftsman-artist, trained in a *bottega* (shop) under the the apprentice system and the strict rules of a guild, had become the artist-genius, trained in an academy; he was a scholar and a fit companion for princes, a person emancipated from the regulations of the guilds.

During the fifteenth century, the development of the graphic arts in Germany made art in the form of prints available to a larger segment of the population, extending patronage and broadening the artist's audience. Woodcut, wood engraving, and metal engraving were the important media.

The Fifteenth Century

PAINTING IN THE NORTH

In the countries north of Italy, fifteenth-century painting is sometimes considered to be late Medieval rather than Renaissance because it shows little interest in ancient Greco-Roman art and does not portray man so heroically in scale, proportions, and action as does the painting of fifteenth-century Italy. Northern painting does intensify the late Gothic study of nature by adding deeper space, more convincing illusion of mass, more flesh-and-blood anatomy, and precise details and textures. Nevertheless, body proportions and drapery effects are conventional. The persistently thin bodies, large heads, narrow shoulders, angular drapery lines, and crowded landscape or architectural settings give

much Northern painting of the fifteenth century the total effect of a miniature, no matter how large the actual work (see Plate 1). The intricate physical detail was frequently given spiritual meaning by the elaborate symbolism inherited from the Middle Ages. Painters obtained transparent color through the increased use of oil glazes employed alone or in combination with the more traditional egg tempera.

Robert Campin, probably identical with the **Master of Flé-malle** (Flanders, 1378?–1444). Campin, one of the first painters to use oil paint extensively, had his studio in Tournai. The new realism of his style combines deep space created by means of exaggerated linear perspective, crowded objects, the typically rich color and angular drapery of fifteenth-century Northern art, and both private and conventional Medieval symbolism. His *Virgin and Child Before a Fire Screen* (Fig. 14-1), one of the earliest paintings to show a city view outside the window, presents the Madonna in a comfortable contemporary Flemish house. The fire screen suggests the shape of a halo behind her head, and the chalice (probably a later addition) by her elbow suggests the celebration of the Mass and hints at the future sacrifice of Christ.

Jan van Eyck (Flanders, *c.* 1390–1441). This pioneer in Northern painting worked for Count John of Holland and Philip the Good of Burgundy and finally died in Bruges. He was honored by the rulers and sent on a diplomatic mission to Portugal. *Arnolfini and His Bride* (Plate 1) has typically Northern features, such as the fragile bodies, angular drapery, miniature quality, and pervasive symbolism (see p. 26). The converging lines of the architecture effectively establish depth; but they are instinctive rather than systematic, for they meet at several different horizon levels. Two natural light sources admit a crossing light that shortens the shadows cast so that even the grain of the floorboards at Arnolfini's feet is not hidden. Although the woman's face has the smooth, wide, oval form and tiny mouth found in much Northern painting of the period, the striking individuality of Arnolfini's face is undeniable. The entire painting demonstrates remarkably careful observation, from the stubble on Arnolfini's chin to the transparent beads on the wall. The round mirror reveals the artist's interest in optical problems: It shows a wide-angle view of the room, the backs of the couple, and two spectators (perhaps including the artist) in the doorway. The mir-

14-1 ROBERT CAMPIN, *Virgin and Child Before a Fire Screen, c.* 1425. Panel, 24″ x 19¼″. Courtesy of the Trustees of the National Gallery, London.

ror frame contains tiny round scenes of Christ's Passion. The most famous work by Van Eyck is the *Ghent Altarpiece* (1432, St. Bavo, Ghent), which carries the names of Jan and his brother Hubert. There is uncertainty about which parts were done by each and whether or not we have any other paintings by Hubert.

Rogier van der Weyden (Flanders, *c*, 1400–64). Rogier probably studied under Robert Campin at Tournai before becoming the official painter of Brussels. About 1450, he traveled through Italy. Whereas Van Eyck's compositions lead our attention smoothly from foreground to background, Rogier's paintings tend to locate the major figures in a shallow foreground space, and the background serves only as a backdrop. Moreover, the faces in Rogier's paintings convey greater emotional intensity than do the faces painted by Van Eyck. These characteristics are evident in *The Descent from the Cross* (Fig. 14-2), an early work. Other major works attributed to Van der Weyden include *Christ Appearing to His Mother* (*c*. 1440–45, Metropolitan Museum of Art, New York) and the *Portrait of Lionello (or Francesco?) d'Este* (*c*. 1450, Metropolitan Museum of Art, New York).

14-2 ROGIER VAN DER WEYDEN, *The Descent from the Cross*, *c*. 1435. Tempera on wood panel, approx. 7'3" x 8'7". Prado, Madrid.

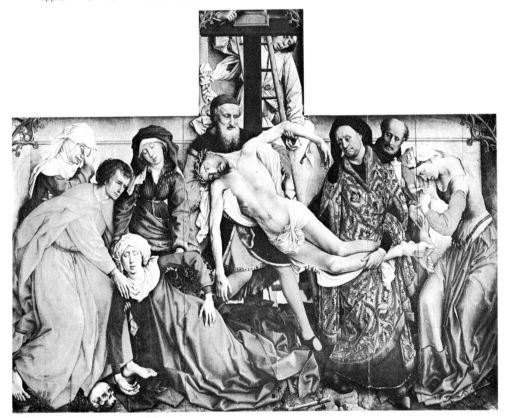

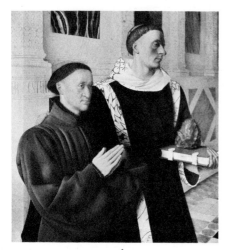

14-3 JEAN FOUQUET, *Étienne Chevalier and St. Stephen, c.* 1450. 36½'' x 33½''. Staatliche Museen, Berlin.

Jean Fouquet (France, *c.* 1420–81). Fouquet was born at Tours, and it is thought that he may have attended the University of Paris, since Parisian buildings often appear in his later book illustrations. If so, he undoubtedly saw there the work of Flemish artists, but his paintings contain Italianate elements, which are best explained by a trip to Rome in 1445. After his return to France, he established himself in Tours, although his activity was not limited to this area. During the period between 1450 and 1460, Fouquet painted the *Portrait of Charles VII* (Louvre, Paris) and the *Pietà of Nouans* (Nouans). The portrait of Charles VII's minister of finance, Étienne Chevalier with his patron saint, Stephen (Fig. 14-3), originally formed the left wing of the *Diptych* (two-part altarpiece) *of Melun;* the two figures were presented as worshipers of the Madonna and Child depicted in the right wing, which is now in the Antwerp Musée Royal des Beaux-Arts. (The face of the Madonna is thought to be a portrait of Agnes Sorel, the mistress of Charles VII.) The left wing reveals Italian influence in the perspective of the architecture, the amplitude of the massive bodies, and the equivalent scale of man and saint—even though the saint's head is given a traditionally higher position than the head of the man. Having served the court of Charles VII, Fouquet, in 1475, was made court painter to the king by Charles' successor, Louis XI.

Hugo van der Goes (Flanders, 1440–82). Van der Goes died in a monastery near Brussels after having spent most of his life in Ghent. His work often has a strange tenseness derived from sharp contrasts in directional forces and between sparse and crowded areas, passive and active attitudes, and concentrated and distracted attention. His major work is the *Portinari Altarpiece* (1476), done for the Italian representative of the Medici banking interests in Bruges. The central panel of this *triptych* (three-part altarpiece) shows *The Adoration of the Shepherds* (Fig. 14-4). The disparity between the size of the Madonna and that of the angels echoes the Medieval lack of concern for physical reality, while the deep space and realistic detail are characteristically Renaissance. The perspective lines of the architecture converge toward a vanishing point behind the head of the Madonna and emphasize her importance. The foreground symbols include a cast-off shoe as a sign of a holy event, wheat as a reference to the bread of the Eucharist, scattered anemones as a symbol of sorrow and sacrifice, an iris (sword lily) as a symbol of the Madonna's suffering during the Passion of Christ, a lily

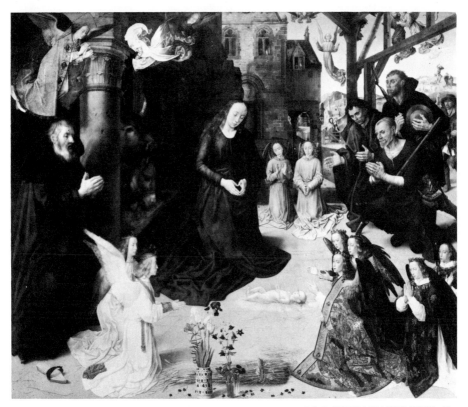

as a symbol of sacrifice and chastity, and columbine as a symbol of the Holy Ghost. On the basis of the Portinari painting, a number of other stylistically similar works have been attributed to Van der Goes.

Hieronymus Bosch (Holland, *c.* 1450–1516). The extraordinary fantasies of Bosch seem closer to the grotesqueries of the Middle Ages than to the rational order of the Renaissance; yet even the Greeks had their Dionysiac Mysteries, and Bosch painted his visions with a control of deep space that is one hallmark of the Renaissance. His religious scenes and representations of proverbs and fables, which often contain moral lessons, are portrayed through strange combinations of men, plants, and animals; and interpretation is sometimes difficult. Bosch is often cited as a precursor of twentieth-century Surrealism. The much-copied *Temptation of St. Anthony* (Fig. 14-5) is a perfect subject for his imagination. The creatures of hell swarm from earth, sky, and water to torment the saint, whose body is almost lost, even in the very center of the composition. His other works include *The Garden of Earthly Delights* (*c.* 1500, Prado, Madrid) and *The Hay Wain* (*c.* 1485–90, Prado, Madrid).

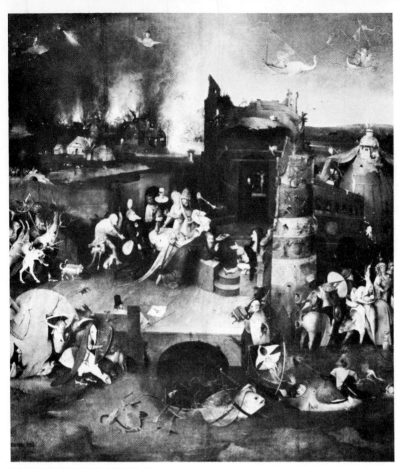

14-5 HIERONYMUS BOSCH, *The Temptation of St. Anthony, c.* 1500. Museu Nacional de Arte Antiga, Lisbon.

PAINTING IN ITALY

While conservative Italian painting continued the traditions of Byzantine and late Gothic art, the new painting was molded by the major Renaissance interests: individual man, nature, and ancient Greco-Roman art. The scattered remains of antique sculpture had encouraged the love of mass in Medieval Italian sculpture. It was Medieval sculpture that helped shape the art of Giotto, which in turn became a source for the new fifteenth-century painting (Figs. 1-10 and 1-26). Increased efforts were made to duplicate the visual experience of the physical world: Linear and aerial perspective were used to create space; natural light (from direct sources and from reflecting surfaces) was studied as a means of suggesting mass; land forms, plant life, and animal and human anatomy were observed in detail; and natural posture as well as convincingly natural movement became important to the new concept of what was "real." For all of this, clarity was considered to be essential,

but, at the same time, the attempt to achieve clarity led to conflicts. Clarity called for sharply outlined edges that contradicted the roundness of the form, and the insistence on mass sometimes made a painted face seem more like stone than flesh. Only late in the century were deep shadows allowed to obscure parts of the composition in the interests of strong focus (Fig. 1-26). Portraiture, nature study, Greco-Roman architecture and mythology, and traditional Christian subject matter were often mixed; an Adoration of the Christ Child might be depicted with ancient ruins or with Roman sarcophagi adorned with mythological reliefs, while portraits of the artist's contemporary patrons might be found among the Three Kings and their retinue. The confidence in the importance and capabilities of man was expressed by some artists in dignity of pose, emotional restraint, and boldness of masses (Fig. 1-10), all producing a kind of monumentality. Much fifteenth-century Italian painting has a breadth of form and a largeness of scale quite unlike the miniature quality of most Northern work. Flemish painting was admired by Italians, however, and its landscape backgrounds had some effect on Italian art. The major media for the period were fresco, tempera, and occasional oil glazing.

Fra Angelico (Florence, 1387–1455). Guido da Vicchio probably studied under Lorenzo Monaco before joining the Dominican Order and taking the name of Fra

14-6 FRA ANGELICO, *The Coronation of the Virgin*, c. 1430. Panel, 44⅛″ x 45″. Galleria degli Uffizi, Florence.

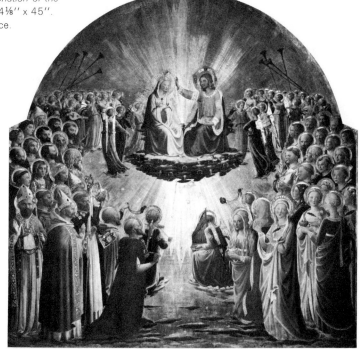

Angelico. His early style, which lasted from 1418 until the 1430's and is illustrated by such works as *The Coronation of the Virgin* (Fig. 14-6), was Gothic in its slender figures, delicate textile patterns, and paradisaical settings. From 1435 to 1445, in such works as the frescoes in San Marco in Florence, his figures became more solid and the settings more earthbound. His late paintings, such as those in the Nicholas Chapel (Vatican, Rome), have simpler, more massive bodies and deep perspective vistas framed by grand architecture.

Masaccio (Florence, 1401–28). *The Tribute Money* (Fig. 1-10) reveals Masaccio's use of aerial and linear perspective (see p. 6) and his modeling with light and shadow to create the illusion of mass. The linear perspective used systematically here was invented by his architect friend Filippo Brunelleschi, who was also an admirer of ancient Roman architecture. Brunelleschi probably encouraged Masaccio to use Roman architecture as a setting for his painting *The Trinity*. The massiveness of Masaccio's figures owes much to the painting of Giotto, and the poses indicate the influence of the sculptor Donatello. Masaccio's greatness lies in the gravity, poise, and depth—the monumentality—he gave to his humanistic vision of man. These qualities stem from his combination of eloquent but restrained facial expressions, a stately rhythmic accord between the lines of poses and drapery, and the suppression of detail where necessary to strengthen the masses. Certainly the grandeur of scale and mass in the ruins of Roman architecture and sculpture was a formative influence.

Piero della Francesca (central Italy, 1415/20–92). Piero was primarily a painter, but he was also a Renaissance humanist scholar who wrote on perspective and was active as a poet, cosmographer, mathematician, and architect. In painting, his major technical interest seems to have been the effect of light on color and three-dimensional form. His painting often has the quality of bright, diffused luminosity. He brought simple massive figures into alignment with their architectural settings to produce an architectonic stability that reinforces the dignity of the persons portrayed. He owed much to Masaccio's painting and to Donatello's sculpture. Piero's major fresco cycle depicts *The Legend of the Holy Cross* (from the thirteenth-century *Golden Legend* by Jacopo da Voragine) on the walls of San Francesco at Arezzo (*c.* 1458–66). *The Annunciation* (Fig. 14-7) from San Francesco shows Piero's subtle treatment of color

14-7
PIERO DELLA FRANCESCA, *The Annunciation,*
c. 1455. San Francesco, Arezzo.

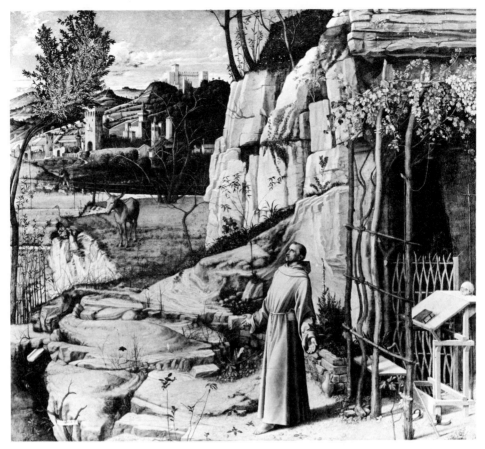

14-8 GIOVANNI BELLINI, *St. Francis Receiving the Stigmata,* c. 1480. Panel, 48¾" x 54". Frick Collection, New York.

and light in addition to typically Renaissance architecture, perspective, and three-dimensional forms. His fresco work includes *The Resurrection* (1460, Town Hall, Borgo San Sepolcro). His panel paintings of the Duke and Duchess of Urbino (1465, Uffizi Gallery, Florence) are fine examples of fifteenth-century profile portraiture stressing individual features and meticulous detail.

Giovanni Bellini (Venice, 1430?–1516). Probably the most significant fifteenth-century Venetian painter, Giovanni was one of three famous painters bearing the Bellini name. He received his early training from his father, Jacopo, and from Andrea Mantegna. His early style is represented by *St. Francis Receiving the Stigmata* (Fig. 14-8). Sharp, intricate details reveal a kind of microscopic appreciation of nature. Later, his style changed to one using softer light, subordination of detail to large masses, and more emphasis on a general color effect rather than on local color. His late style, which established the characteristic elements of sixteenth-century Venetian painting, is evident in the *Madonna and Saints* (1505, San Zaccaria, Venice).

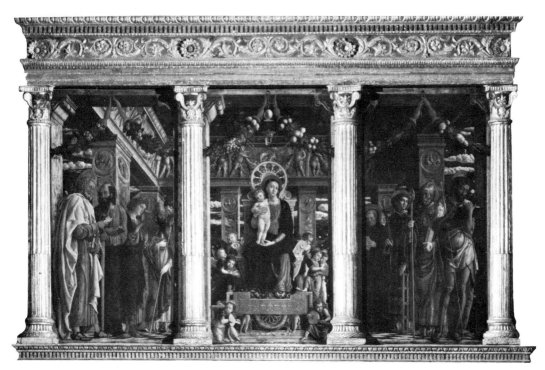

14-9 ANDREA MANTEGNA, *San Zeno Altarpiece*, 1456–59. San Zeno, Verona.

Andrea Mantegna (northern Italy, 1431–1506). Mantegna was apprenticed to Francesco Squarcione in Padua, but it was Donatello's sculpture in Padua that influenced Mantegna's love of statuesque figures with brittle, clinging drapery and highlights of stony or metallic character. Precise detail and settings with architectural reliefs and deep rocky landscapes are typical. In 1459, Mantegna became court painter to the Gonzaga family at Mantua, where he painted wall and ceiling frescoes in the palace. In the *San Zeno Altarpiece* (Fig. 14-9), the traditional triptych format acquires an architectural frame inspired by Roman work. This actual architecture is continued by the illusionistically painted architecture within the panels, architecture covered with reliefs that recall the sculpture of Donatello. The figures of the Madonna and saints reveal the painter's interest in three-dimensional form. *The Dead Christ* (c. 1501, Brera Gallery, Milan) is a dramatic example of Mantegna's interest in spatial illusion; the body is daringly *foreshortened* (the effect of spatial recession obtained by drawing the object as a series of overlapping or successive masses). Mantegna's statuesque figures, his use of Roman architecture and sculpture, and his interest in illusionistic space had wide influence in northern Italy.

Sandro Botticelli (Florence, 1444–1510). Under the influence of his teacher Fra Filippo Lippi, Botticelli developed a style of knobby, jointed figures and rippling, linear drapery folds. He was patronized by the Medici family, and his *Adoration of the Magi* (1476–78, Uffizi Gallery, Florence) portrays members of the family as the Magi and their followers. His best-known paintings are *The Birth of Spring* (c. 1478) and *The Birth of Venus* (Fig. 14-10), both in the Uffizi Gallery. Both paintings exhibit Botticelli's use of sweeping linear curves and convolutions, his preference for lean figures with enlarged joints, and his use of repetition and variation in richly ornate patterns. In 1481, Botticelli was called to Rome to do one of the frescoes on the walls of the Sistine Chapel, the *Moses and the Daughters of Jethro*. In his later work, Botticelli turned increasingly to religious subject matter, and it is thought that his work was influenced by the emotional preaching of Savonarola. The *Pietà* (c. 1496, Alte Pinakothek, Munich) has only traces of his former delicacy of line, now imprisoned within harsh angular forms, and the expressions of the participants convey desperation and anguish.

Pietro Vannucci, called **Perugino** (central Italy, 1445?–1523). Perugino worked in Perugia in the region of Umbria except for his trip to Rome in the 1480's to

14-10 SANDRO BOTTICELLI, *The Birth of Venus*, c. 1480. Tempera on canvas, approx. 5'8" x 9'11". Galleria degli Uffizi, Florence.

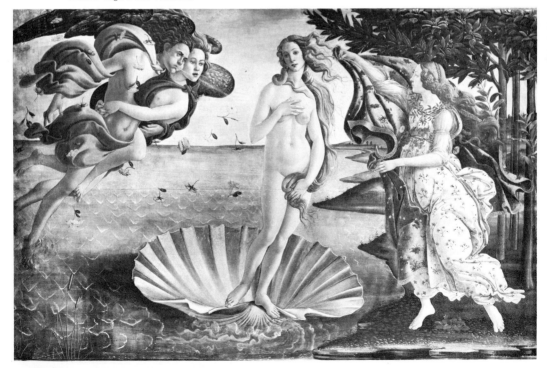

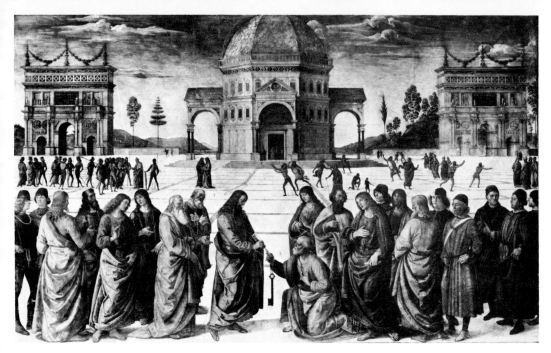

14-11 PERUGINO, *The Handing of the Keys to St. Peter,* 1481–83. Fresco. Sistine Chapel, the Vatican, Rome.

paint *The Handing of the Keys to St. Peter* (Fig. 14-11) in the Sistine Chapel. He simplified the parts and the action in his compositions, employing serene landscapes, figures and drapery with gently curving rhythmic lines, and passive faces with small, buttonlike eyes and delicate mouths. Typical works are the *Crucifixion* fresco in Santa Maria Maddalena dei Pazzi in Florence and the *Pietà* panel painting (Uffizi Gallery, Florence), both done in the 1490's. Perugino was the teacher of Raphael.

Leonardo da Vinci (Florence, Milan, and Amboise, 1452–1519). Leonardo was born near Florence and sent at an early age to be trained in the studio of Andrea del Verrocchio. Leonardo's wide interests ranged from engineering to botany, and his notebooks are famous as records of a many-sided genius. *The Madonna of the Rocks* (Fig. 1-26) reveals not only his interest in anatomy, geology, and botany, but qualities that forecast the sixteenth century: a conscious effort to perfect nature through concepts of ideal form and a desire to go beyond surface appearances to express the working of the mind or a condition of the spirit. While Leonardo was not the first to have these concerns, he faced them more deliberately than his contemporaries did and went further in seeking pictorial means for their expression. Sixteenth-century painting was influenced by his triangular figure groupings and his ideal facial type—the

softly modeled oval with slender nose and delicately curved mouth. Unlike most fifteenth-century painters, he no longer felt the need for clarity in all parts. In *The Madonna of the Rocks* (Louvre version), he subordinated local colors to a total color effect and used strong chiaroscuro, leaving parts of the painting in obscurity but providing powerful focus. The highlighted fingers of the Madonna's outstretched hand create a startling illusion of depth; they hover over the head of Jesus and suggest a halo or a crown of thorns. The angel's hand points to the other child, who will become John the Baptist and recognize Jesus as the Christ. The tense concentration of attention between the two children is softened by the meditative gaze of the Madonna, while the angel seems more aware of the spectator. The jagged rocks and delicate plants do not seem to be included merely to demonstrate technical virtuosity or to establish physical reality, as they do in much fifteenth-century work. Instead, the powerful contrasts of light and shadow, of wild nature and soft flesh create the dramatic intensity of a mystery play or a sacred ritual. From 1483 to 1500, Leonardo worked in Milan for the Sforza family and painted, in addition to *The Madonna of the Rocks, The Last Supper* in Santa Maria delle Grazie, where again the total composition is expressive of mental drama. In Florence once more from 1503 to 1506, he painted the *Mona Lisa* (Louvre, Paris). After a trip to Rome in 1513 and more time in Milan, he accepted the invitation of Francis I to come to Amboise in France, where he remained until his death. The variety of Leonardo's interests and his tendency to leave projects unfinished have left us few paintings; his drawings and notebooks contain anatomical and botanical studies and inventions ranging from hydraulic engineering to flying machines. His late painting of John the Baptist (Louvre, Paris) has definite Manneristic traits (see p. 199) and influenced the Mannerist painter Parmigianino.

SCULPTURE IN ITALY

Florentine sculpture led the movement toward the consolidation of mass, contrapposto poses, studied anatomical detail, naturalistic drapery, and portraiture, all inspired by the growing interest in Roman art, the physical world, and man. The first freestanding nude figures since Roman times were produced, and relief sculpture exploited the illusion of depth. As in painting, the desire for clarity often resulted in a linear inscribing of detail on the masses. The range of sculpture widened

in subject matter and in function. Human heroes, both contemporary and Biblical, were frequently chosen as subjects, and Greco-Roman mythology and secular allegory appeared more often than before. Enthusiasm for small bronze antique statuettes led Renaissance sculptors to take up this art, often borrowing subjects from mythology. Sculptures of the Madonna and of saints acquired portraitlike individuality. Relief sculpture served to emphasize focal points in the church, such as pulpits, *cantorias* (galleries for singers), and bronze doors. The relief on *tabernacles* (devotional centers ranging in size from small plaques to large wall niches) employed striking single-point perspective views surrounded by elaborate architectural frames using variations of ancient Greco-Roman moldings (Fig. 9-8, p. 98). The Renaissance appreciation of the individual is evidenced in the increased number of portrait busts after the middle of the century. Like old Roman portraits, they contained much detail, yet the sculptor was capable of ennobling the subject by dignity of pose or alertness of expression. The ancient Roman equestrian statue of Marcus Aurelius in Rome inspired similar monuments for fifteenth-century Italians. The desire to perpetuate a name also asserted itself in the Renaissance wall tomb, built into the side of a church. The tombs present Roman pediments, columns, pilasters, moldings, and Roman figure types such as *putti* (Cupids or cherubs) and Greco-Roman winged victory goddesses.

Lorenzo Ghiberti (Florence, 1378?–1455). Ghiberti's two sets of bronze doors for the Florentine Baptistery show the transition from late Gothic to early Renaissance style. The *Sacrifice of Isaac* panel, done as an entry in the competition for the first set of doors (1401–02), is spatially shallow and crowded. The same subject done for the second set of doors (Fig. 14-12), the so-called *Gates of Paradise* (1425–52), is set in a spacious landscape with deep space created by a suggestion of linear perspective in the lines of trees and an effect of aerial perspective in the contrast of high relief in the foreground and faint relief in the background. Typical of the age are the drapery folds that emphasize the flexible poses of the bodies. Ghiberti's freestanding statue of St. Matthew (1420) for the Or San Michele adopts the mass, pose, and drapery forms of ancient Greco-Roman statues of orators. In his *Commentaries*, Ghiberti wrote about the lives of great artists and the theory of art, seeking in this way to establish his own place in the history of art.

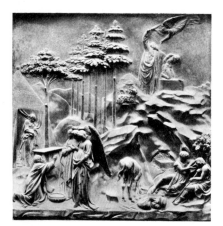

14-12
LORENZO GHIBERTI. *The Sacrifice of Isaac,* from the *"Gates of Paradise,"* 1425–52. Bronze, 21'' x 17½''. Baptistery, Florence Cathedral.

Donatello (Florence, 1386–1466). The most significant fifteenth-century Italian sculptor was Donatello, who learned bronze casting under Ghiberti and traveled to Rome with the architect Brunelleschi to study ancient art. Donatello worked in marble, bronze, and occasionally wood and *stucco* (a fine plaster or cement). His first bronze statue of David (1430–32, Bargello, Florence) appears to have been the first freestanding nude since Roman times. Donatello also did relief sculpture, advancing its illusionistic possibilities by suggesting deep space and a variety of spatial relationships without using high relief for the foreground. He often combined his subtle low relief, called *schiacciato*, with architectural settings in single-point perspective; the effect is much like that of a drawing. Poses are active, and drapery breaks into a complexity of nervously rippling linear folds. Major reliefs are those on the baptismal font at Siena (1423–34), the altar of Sant' Antonio in Padua (1444–53), the doors of the Old Sacristy at San Lorenzo in Florence (1430's), and the two pulpits in San Lorenzo (c. 1460–70). Donatello's art reflects the growing importance of the individual not only in the use of specific features and expressions but also in the choice of human heroes such as David, Judith, and "Gattamelata" (Erasmo da Narni, a Renaissance general) as frequent subjects. Most amazing is his ability to express convincingly a wide range of human emotions, from the brutal confidence of *Gattamelata* (1445–50, Padua) to the contemplative aloofness of *Young John the Baptist* (Fig. 14-13) or the tragic suffering of *Mary Magdalene* (c. 1454–55, Florentine Baptistery). Realism of the flesh is accompanied by the realism of bared feelings. Strangely enough, Donatello, unlike other sculptors, did not show great interest in the portrait bust.

Andrea del Verrocchio (Florence, 1435–88). Verrocchio was first trained as a goldsmith and then may have worked with Desiderio da Settignano. Only one painting, *The Baptism of Christ* (c. 1472, Uffizi Gallery, Florence) is attributed with certainty to Verrocchio; his main interest was sculpture. He worked in terra cotta, stone, and bronze, with subjects ranging from the *David* (Bargello, Florence) and the *Christ and St. Thomas* (c. 1465–83, Or San Michele, Florence) to the Tomb of Piero and Giovanni dé Medici (completed in 1472, San Lorenzo, Florence), the terra cotta busts of *Giuliano* and *Lorenzo de' Medici* (dates uncertain, National Gallery, Washington, D.C.), and the equestrian statue of Bar-

14-13 DONATELLO, *Young John the Baptist,* c. 1455. Marble, entire figure approx. 6' high. Museo Nazionale, Florence.

tolomeo Colleoni (Fig. 14-14). The *Colleoni*, a monument to a military leader, has much greater tension in both horse and rider than does its inspiration, Donatello's *Gattamelata*. Verrocchio's style is characterized by much hard-edged detail, bulbous anatomy, and distinct individuality in the faces. He taught Leonardo da Vinci.

ARCHITECTURE IN ITALY

The Renaissance man saw a sharp contrast between Gothic architecture, with its soaring verticals, irregular expansion, and complex geometric proportions veiled by lavish surface detail, and the remains of ancient Roman architecture. The Roman work, long since shorn of its decorative veneer, revealed a basic symmetry and a logical clarity in its proportioning that were simple enough to be quickly felt and comprehended, and the Renaissance scholar eagerly noted the static balance of vertical columns and horizontal architraves, the simple curve of the round arch, and the massive permanence of the walls that related to the rational structure of Greco-Roman literature and philosophy. Some fifteenth-century architects merely applied Roman pilasters, columns, and moldings in Gothic profusion, but the leaders sought to understand principles rather than to imitate details, and significant early Renaissance buildings, such as the Pazzi Chapel in Florence (Figs. 14-15–14-17) and Santa Maria delle Carceri in Prato (Figs. 1-16, 14-21, and 14-22) display a severe clarity of plan and elevation. The calculated simplicity and the linear outlining of each part call attention to the proportion of the parts to the whole, and the resulting diagrammatic effect is reminiscent of the insistence on linear clarity in much fifteenth-century Italian painting and sculpture. Studies of proportion in Roman architecture were intensified by the discovery, in a Swiss monastery in 1414, of the writings of Pollio Vitruvius, a Roman architectural theorist of the first century A.D., although difficulties in translating the work somewhat restricted its influence until the sixteenth century.

Florence sheltered the first early Renaissance architecture, the Foundlings' Hospital and the Pazzi Chapel. Other northern Italian cities, such as Rimini and Mantua, also became important. In Venice, the Renaissance came late and was mixed with strong Gothic and Byzantine traditions. Balconies and arcades kept walls light and open; Venetian politics were less violent than those of Florence, and the massive, fortresslike character of Florentine palaces was less necessary in Venice. Rome was also slow in developing the new style, partly

14-14
ANDREA VERROCCHIO, *Bartolomeo Colleoni*, c. 1483–88. Bronze, approx. 13' high. Campo dei Santi Giovanni e Paolo, Venice.

14-15 Pazzi Chapel.

14-17 Interior of Pazzi Chapel, Florence.

because few buildings were completed during the century. When Renaissance elements appear, as in the Cancelleria (begun in 1486), the most evident source of inspiration is the architecture of Leon Battista Alberti.

Filippo Brunelleschi (Florence, 1377–1446). Brunelleschi's aspirations as a sculptor may have been crushed by his loss to Ghiberti in the competition for the reliefs on the Florentine Baptistery doors. Brunelleschi turned to architecture and was the first to make accurate measurements of Roman ruins. He was the first to use the rediscovered Roman architectural motifs consistently and to combine them with a new sense of spatial unity based on mathematical proportions. For example, his Florentine Church of San Lorenzo (designed in 1418) used a bay in the side aisle as a module that, in different multiples, governs the proportions of all the other spaces in the plan. Although Gothic architecture was often based on mathematical proportions and multiples of a chosen unit of measurement, its complexity does not allow the spectator to sense the relationships of basic proportions as he does in Brunelleschi's buildings. Brunelleschi's design (1417) for a dome on the unfinished cathedral of Florence revealed his engineering genius. Brunelleschi's surviving buildings include the Foundlings' Hospital (designed in 1419), the Church of Santo Spirito (designed in 1436), and the Pazzi Chapel, all in Florence. In the small Pazzi Chapel (Figs. 14-15–14-17), the altar is set into a niche opposite the

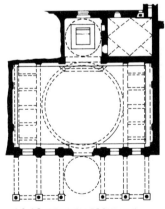

14-16 BRUNELLESCHI and GIULIANO DA MAIANO (?), plan of Pazzi Chapel, c. 1443–61. Dome, 1459. Porch, 1461.

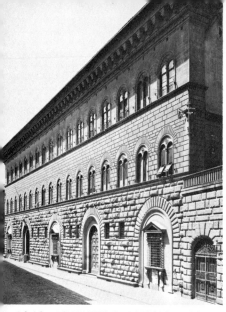

14-18 MICHELOZZO DI BARTOLOMMEO,
Medici-Riccardi Palace, Florence,
begun 1444.

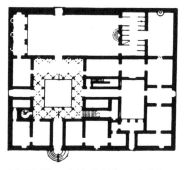

14-19 Plan of Medici-Riccardi Palace.

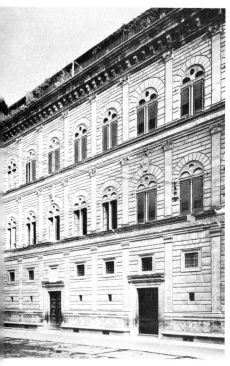

14-20 LEON BATTISTA ALBERTI, Rucellai
Palace, Florence, 1446–51.

entry and across the short axis of a simple rectangular plan. Walls and vaults are divided by dark stone pilasters and moldings into distinct geometric areas. The low relief of these details gives the effect of a linear diagram. A Roman dome covers the center of the space, and the unfinished porch employs the Corinthian order and a *broken architrave* (architrave interrupted by an arch) in the Roman manner. Roman moldings, pilasters, and columns organize mass, planes, and spaces with the self-contained stability and dignity that Renaissance men associated with ancient Roman architecture. Brunelleschi is credited with painting two panels that demonstrated, for the first time, a consistent system of linear perspective, a major step in the Renaissance search for pictorial means of conveying the experience of space.

Michelozzo di Bartolommeo (Florence, 1396–1472). To his contemporaries, Michelozzo was second only to Brunelleschi as a pioneer in the new architecture. Michelozzo became a favorite of Cosimo de' Medici, and the Medici-Riccardi Palace (Figs. 14-18 and 14-19) is the best-known work by the prolific architect. Roman details compose the arches, moldings, and *cornice* (terminating moldings that projects at the top of a wall or building), but the windows of the palace are connected by only a stringcourse, and no attempt was made to proportion the floors with vertical dividers in the form of pilasters or columns. The linear quality of the design is modified by heavy *rustication* (rough stonework) on the ground floor, which changes to boldly jointed but finished stone above and finally to smooth masonry in the top floor. The design is powerful but less subtle and less completely integrated in all its parts than works by Brunelleschi. Michelozzo did restoring and additional building for San Marco and the Palazzo Vecchio in Florence, and he designed the Medici Bank and probably did the drawings for the Portinari

Chapel (Sant' Eustorgio), both in Milan. After the death of Brunelleschi, Michelozzo was put in charge of the Cathedral Workshop in Florence. Although occasional use of Gothic arches links his work to the past, Michelozzo helped to spread the basic elements of early Renaissance architecture to Milan and even to Dalmatia.

Leon Battista Alberti (Florence, 1404–72). Alberti was born in Genoa to an exiled Florentine family and was educated at the universities of Padua and Bologna. He became a universal man of the Renaissance—a humanist scholar, painter, sculptor, mathematician, poet, and architect. His scholarly treatises on architecture, like those of Vitruvius, had wide influence, and he succeeded Brunelleschi as the leader in Renaissance architecture. For the Rucellai Palace (Fig. 14-20), Alberti used Roman arches and moldings and applied pilasters in sequence: a variation of Doric at ground level, a composite of Ionic and Corinthian on the next level, and Corinthian above that. As in much fifteenth-century architecture a linear effect comes from the way in which pilasters, stringcourses, and mortared joints are treated as though cut into the flatness of the wall. Other important buildings by Alberti are Sant' Andrea (1470, Mantua) and the remodeling of San Francesco (1446, Rimini). The latter church took its façade from the form of Roman triumphal arches.

Giuliano da Sangallo (Florence, 1445–1516). Giuliano came from a family of celebrated artists and was trained as sculptor, engineer, and architect. His sphere of activity extended from Naples to Milan and into southern France, where he served Cardinal Giuliano delle Rovere in Lyons. Giuliano's Santa Maria delle Carceri (Figs. 1-16, 14-21, and 14-22) came late in the fifteenth century; its central Greek cross plan accords with Alberti's argument that the four-sided symmetry of a central plan expressed divine reason in its unity and harmony. Both Sangallo and Alberti forecast the sixteenth-century interest in central plans. The dome over the crossing of Sangallo's church, the linear framing of dark against light, and the low relief of pilasters and moldings all reveal the influence of Brunelleschi. The pilasters and dark bands on the exterior emphasize the proportions and suggest structural framing without destroying the flatness of the wall surface, while the nature of the interior spaces is clearly revealed by the flatness and simplicity of the enclosing walls. Giuliano's career extended into the sixteenth century, and, in later life, he

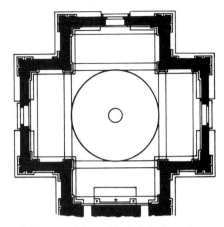

14-21 Plan of Santa Maria delle Carceri.

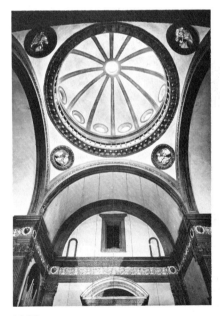

14-22
GIULIANO DA SANGALLO, interior of Santa Maria delle Carceri, Prato, 1485–92.

was appointed to serve with Fra Giaconda and Raphael in carrying on the construction of St. Peter's in Rome.

The Sixteenth Century

PAINTING IN ITALY

Italian painting of the High Renaissance period (1500–20) developed different aims from those of fifteenth-century art and should therefore not be thought of simply as a culmination of less successful fifteenth-century efforts. The earlier emphasis on the exploration of the physical world was superseded by a general effort to transform and transcend surface appearance without sacrificing its physical qualities. The artist sought to perfect nature according to preconceived ideal forms; faces were generalized to present types of humans rather than individuals, and there was less depiction of contemporary costume and more simplification of drapery folds for broad, sweeping, directional emphasis. The linear clarity of fifteenth-century work gave way to fuller masses; softer lighting and softer edges produced a dense atmospheric effect (called *sfumato*) that contrasted with the sharp airless space of much fifteenth-century painting. Individual actions conformed to a more flowing, all-inclusive, rhythmic harmony, and bold chiaroscuro provided dramatic focus. All this was part of a concept of the Grand Manner, by which the artist transformed nature and made it expressive of ideal form and inner experience, a concept possible only with the increased tendency to consider the artist as a divine genius rather than a mere craftsman. In the second half of the fifteenth century, many High Renaissance qualities had been developed in the art of Leonardo da Vinci. His work was a formative influence, and he is often considered a High Renaissance painter, even though most of his pioneering works were done in the fifteenth century. It is more helpful to see him as a bridge between the two centuries.

Florence must receive credit as the seedbed for High Renaissance painting, not only because of Leonardo's background there (although some of his major works were done in Milan) but because Raphael painted his first mature works in Florence. However, the blossoming occurred in Rome with the work of Raphael and Michelangelo. In northern Italy, Venetian painting moved away from the sharp detail of the early Renais-

sance toward softer light, fuller and less detailed masses, and the suppression of local colors for an over-all color effect (Plate 2). Soft atmospheric effects were easier to achieve with oil paint, and in the sixteenth century the technique of oil on canvas supplanted the traditional tempera on wood panels that had been used for easel paintings (portable works). Fresco techniques continued to be used for mural painting, although during the sixteenth century use was made of oil on canvas applied to the wall. Venetian painters used oil paint opaquely and in glazes for textural and color effects of great richness.

Italian painting in the Late Renaissance (1520–1600) manifested several stylistic trends, sometimes within the work of a single artist. While High Renaissance concepts continued to shape the art of some leaders, a second trend, known as *Mannerism*, rejected the clear underlying order of High Renaissance painting and replaced it with ambiguity in spatial relations, mood, and even subject matter. Elongated figures with narrow shoulders, wide hips, tapering hands and feet, and self-consciously affected gestures were composed with a lack of central focus and deliberately inconsistent scale in crowded spaces. A third trend may be called *Proto-Baroque* because it forecasts the violent activity, dramatic lighting, great complexity, and breathtaking illusionism that were to become important devices in seventeenth-century Baroque art.

Michelangelo Buonarroti (Florence and Rome, 1475–1564). As a youth, Michelangelo was taken from his birthplace, Caprese, to Florence, where he studied painting with Domenico Ghirlandaio and sculpture with Giovanni Bertoldo. Although his real love was sculpture, Michelangelo was forced by papal and financial pressures to do painting and architecture as well. The only easel painting that is known with certainty to be his is *The Holy Family* (1504–06, Uffizi Gallery, Florence); the rest of his painting is mural work done in fresco. One of the greatest monuments of the High Renaissance is his series of frescoes on the ceiling of the Sistine Chapel in the Vatican, done between 1508 and 1512 at the insistence of Pope Julius II. Between 1536 and 1541, he painted *The Last Judgment* on the end wall of the Sistine Chapel, and from 1542 until his death he worked in the Pauline Chapel in the Vatican. Michelangelo concentrated on the human figure, often to the near exclusion of setting, and his concept of ideal form led him to paint figures of awesome bulk and musculature

14-23 MICHELANGELO BUONARROTI, *The Creation of Adam*, detail from the ceiling of the Sistine Chapel, the Vatican, Rome, 1508–12.

in active or restless poses. The Sistine ceiling boils with writhing giants enacting the Creation of the World, the Creation and Fall of Man, the story of Noah, and numerous secondary stories and allegories, all organized within a painted architectural framework. One of the few relaxed figures is that of Adam as he receives life from the outstretched hand of God, whose body ripples with energy. Typically, *The Creation of Adam* (Fig. 14-23) is divided into only two large groupings: that of Adam with the vaguely suggested mound of earth, and that of God and surrounding angels framed by the billowing cloak. The two groupings focus on the almost-touching fingers of God and Adam. In many other scenes, the extraordinary physical power of the bodies is countered by expressions of mental attitudes ranging from contemplation to consternation and anguish. Michelangelo's art and poetry indicate an increasing disillusionment with the search for physical beauty. The overpowering scale and activity in his painting forecast the Baroque art of the seventeenth century.

Giorgione da Castelfranco (Venice, 1478–1510). The plague cut short the brilliant career of Giorgione, one of Titian's fellow apprentices in the studio of Giovanni Bellini. Scanty documentation has resulted in much discussion about the identification and dating of authentic paintings by Giorgione. Generally accepted works are the *Castelfranco Madonna* (Castelfranco), *The Tempest* or *The Soldier and the Gipsy* (Accademia,

Venice), *The Sleeping Venus* (Dresden Gallery), and *The Pastoral Concert*, although the latter has sometimes been questioned. In *The Pastoral Concert* (Plate 2) the nude women may personify the subject of the music played by the young men. The nude bodies are painted as heavy three-dimensional forms with soft edges, generalized anatomy, and delicate nuances of light and color. The foliage masses and the lavish costumes have equally full forms and subtle textures. The painting is organized in alternating areas of light and dark that move back step by step from foreground to background; and the colors become cooler and less saturated as they move from the red hat of the central youth into the distance. The forms complement each other in graceful consonance; for example, the tree trunk on the left flows into the vertical arm of the standing woman and also bends to meet the curve of her back, while the leaning position and the rounded forms of the seated woman are echoed in the foliage of the central tree. With his use of soft light, quiet, graceful masses, bold simplification of light and dark areas, and glowing color, Giorgione exemplifies the High Renaissance in Venice. His style may be seen as a bridge between the late work of Giovanni Bellini and the painting of Titian.

Tiziano Vecelli, called Titian (Venice, 1477/90–1576). As a pupil of Giovanni Bellini and an admirer of Giorgione, Titian acquired a love of soft, light, warm color effects, which subordinated local colors, and massive simplified forms. He enjoyed the lavish textiles and elegant costumes of the wealthy Venetian society and incorporated these into his painting. His ideal for the female figure is admirably presented in the Naples *Danaë* (Fig. 14-24). The breadth of the forms, the division of the composition into a few large parts, the subordination of details to large areas of light and dark, and the preference for spiral torsion in the poses probably owe something to

14-24
TITIAN, *Danaë, c.* 1545. Oil on canvas, approx. 4' x 6'. Museo di Capodimonte, Naples.

the art of Michelangelo, but Titian's color is richer and his forms are softer. Titian achieved depth and a variety of subtle textures by building up oil glazes of warm and cool colors along with areas of impasto. His preference for dynamic grouping and powerful chiaroscuro manifests itself in early works, such as *The Assumption of the Virgin* (1516–18) and *The Pesaro Madonna* (1519–26, both in Santa Maria dei Frari, Venice), where figures and areas of contrasting value are grouped as counterbalancing diagonals. His late work, such as the *Pietà* (1573–76, Accademia, Venice), developed even greater dramatic contrast in the chiaroscuro and heavier impasto. Titian's fame spread, and his energies were prodigious; in addition to religious subjects and mythological themes, he painted many portraits, including those of Pope Paul III and the Emperor Charles V.

Raphael Sanzio (Florence and Rome, 1483–1520). After studying with Perugino in Umbria and revealing his precocious talent in works such as *The Marriage of the Virgin* (1504, Brera Gallery, Milan), Raphael went to Florence (1504–08), where he painted portraits and Madonnas. The *Madonna of the Meadow* (Fig. 3-1) is typical. The feeling of gentle, sweet serenity is expressed not only through faces and gestures but through the whole compositional structure. The stable triangular group of figures works with the quiet landscape to form an obvious axial balance. The large triangle provides an effect of gradation and climax at the head of the Madonna, while the head of Jesus receives similar emphasis through the triangular shape formed by his body and the cross. The triangular groupings are softened by a modification of bodies and garments to produce variations on ovoid curves. Every part joins the gentle curvilinear harmony and fits into the underlying geometric structure. The face of the Madonna, the triangular grouping, and the sfumato effect owe much to Leonardo. In 1509, Pope Julius II called Raphael to Rome to fresco a series of rooms in the Vatican. *The School of Athens*, in the Stanza della Segnatura, combines Roman architecture on a vast scale, an ideal concept of human form, and individual portraits of the great minds of various ages. The many figures are organized in large, symmetrically balanced groups by geometric systems of sweeping curves, triangles, and vertical and horizontal lines. Restrained emotions, clear serene order, and exhilarating breadth dignify the grand symbolic program. We seem to witness the apotheosis of man. Some of the bodies in the Vatican paintings sug-

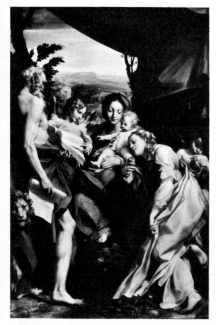

14-25 CORREGGIO, *Madonna of St. Jerome*, 1527–28. Galleria Nazionale, Parma.

gest the physique and poses of the figures in Michelangelo's contemporary frescoes in the Sistine Chapel. Raphael's earlier Vatican works are the epitome of High Renaissance art; the later ones reveal Manneristic qualities. Other important works from his Roman period are the frescoes in the Villa Farnesina, the *Portrait of Pope Leo X and His Nephews* (c. 1518, Uffizi Gallery, Florence), *The Alba Madonna* (c. 1509, National Gallery, Washington, D.C., *The Sistine Madonna* (c. 1514, Dresden Gallery), the cartoons for the *Vatican Tapestries* (1515–16, Victoria and Albert Museum, London), and *The Transfiguration* (1519–20, Vatican Gallery).

Antonio Allegri, called **Correggio** (Parma, 1494–1534). Correggio's art indicates an acquaintance with the painting of Leonardo, Michelangelo, and the Venetians. His *Madonna of St. Jerome* (Fig. 14-25), like his frescoes in Parma Cathedral (1526–30), has the spiral poses, fluttering drapery, bold dark and light contrasts, and avoidance of stable verticals and horizontals that forecast much seventeenth-century painting; yet Correggio held the activity within large areas, and the compositions do not figuratively break through their architectural frame. His late work, such as the *Virgin and Child with St. George* (1531, Dresden Gallery), combines saccharine smiles and sensual fleshiness with Manneristic poses.

Francesco Mazzola, called **Il Parmigianino** (Parma, 1503–40). Parmigianino, a leading representative of Mannerism, was influenced by Correggio before coming to Rome (1524–27), where he attempted to achieve the dramatic lighting effects of Leonardo, the restless poses of Michelangelo, the rhythmic grace of Raphael, and the sensuality of Correggio. Parmigianino's *Madonna del Collo Lungo* (*Madonna with the Long Neck*, Fig. 14-26) shows the sinuous elongation and the ambiguity in space, scale, and emotions that are typical of the Mannerist aesthetic.

Jacopo Robusti, called **Tintoretto** (Venice, 1518–94). Tintoretto, one of the giants of Venetian painting, was an admirer of Titian and Michelangelo. His paintings include scenes from the life of St. Mark done for the School of St. Mark (1547–66), scenes from the life of Christ done for the School of San Rocco (1560–87), and religious and mythological subjects for the Doge's Palace (1577–78), all in Venice. Tintoretto's series were often elaborate in concept and grand in scale. His

14-26
IL PARMIGIANINO, *Madonna del Collo Lungo* (*Madonna with the Long Neck*), c. 1535. Oil on canvas, approx. 85" x 52". Galleria degli Uffizi, Florence.

powers are summarized in the late painting of *The Last Supper* (Fig. 14-27), which makes a startling contrast with the same subject treated by Leonardo. Tintoretto grouped the active disciples along a table that pushes diagonally back into space. Halfway down the length of the table, the dazzling *nimbus* (glowing halo) around the head of Jesus provides the major light source in the dark room. Small nimbuses glow around the heads of all the disciples except Judas, who is placed on the opposite side of the table from the rest; a foreground lamp seems to radiate sparks, and transparent angels swoop down toward Jesus. This remarkably dramatic interpretation did much to inspire seventeenth-century art.

Paolo Veronese (Venice, 1528–88). At the age of twenty-seven, Veronese came from Verona to establish himself as a portrayer of the material wealth of Venice. His selection and interpretation of Biblical subjects was governed by his love of lavish costumes, ornate architecture, and elegant table settings. *The Feast in the House of Levi* (Fig. 14-28) is typical in its grand scale. Veronese's interest in decorative details sometimes weakens the expressive power of the figures, but his technical facility, his use of silvery color, and the exuberance of his composition compensate for his shortcomings.

14-27
TINTORETTO, *The Last Supper,*
1592–94. 12' x 18'8''.
San Giorgio Maggiore, Venice.

SCULPTURE IN ITALY

High Renaissance sculpture, like the painting of the period, sought ideal form, the Grand Manner that in-

14-28 PAOLO VERONESE, *The Feast in the House of Levi*, 1573. Oil on canvas, 18'2" x 42'. Galleria dell' Accademia, Venice.

volved nobility of action and scale, ideal shapes and proportions, and depth of feeling. Some sculptors employed the serene equilibrium and smooth transitions seen in much of Raphael's painting; others chose the twisting poses and more tense vitality of Michelangelo's painting and sculpture. Both these facets of High Renaissance style contributed to the Late Renaissance trends: Mannerism and the Proto-Baroque. The serpentine curves and self-conscious elegance of a Mannerist figure might be derived from Raphael's suave harmonies or might be a softened version of the torsion and heroic musculature in Michelangelo's art. The bold contrast, dramatic action, and powerful focus of Proto-Baroque sculpture were inspired particularly by Michelangelo.

Portrait sculpture tended throughout the sixteenth century to express social position and physical or mental types rather than the sharply individual traits seen in fifteenth-century works. Sixteenth-century wall tombs were often larger and more complex than their fifteenth-century forerunners. The architectural frame developed greater spatial variety in different planes of projecting and receding parts. High Renaissance tombs usually have a smooth integration of figures and architecture, while Late Renaissance tombs may combine Manneristic figures with the lavish materials and bold contrasts that forecast the Baroque. The love of contrast sometimes led the designer to set figures and architecture sharply apart through changes in values, colors, shapes, or scale. The most important source for Late Renaissance tombs was Michelangelo's design for the tombs of the Medici (Fig. 2-5). Only in the Late Renaissance was the fountain developed as a public monu-

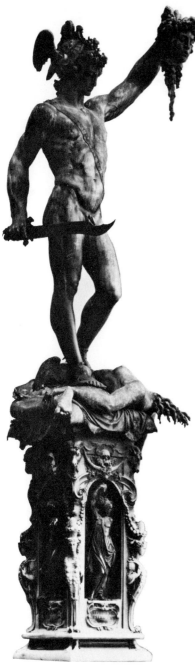

14-29
BENVENUTO CELLINI, *Perseus*, 1545–54.
Bronze, 10'6'' high without base. Loggia
dei Lanzi, Florence.

ment, one that could combine freestanding sculpture, relief sculpture, and water in movement. Fountains tended to become more complex, and relief sculpture gave way to more and more sculpture in the round (freestanding). Mass became more open, and dark and light contrasts became more extreme.

The major centers for the development of sixteenth-century sculptural style were Florence and Rome; Venice, Milan, and Naples were secondary. The sculptors, like the painters, often were active in several cities in the course of their careers.

Michelangelo Buonarroti. Michelangelo's early sculpture, such as *The Battle of the Centaurs*, done under the patronage of the Medici family in Florence, already showed the artist's preference for the nude, muscular body and active intertwining masses. His first major religious commission was the *Pietà* in St. Peter's (1498). Here cascades of deeply undercut drapery produce strong contrasts of light and shadow within the triangular group. The body of the Madonna is larger than that of her son so that she holds Jesus easily across her lap. Michelangelo's life was constantly upset by the conflicting demands of various patrons, and many of his sculptural projects remained unfinished or were finished in a compromise with original plans. This is the case with the tombs of Giuliano and Lorenzo de' Medici (Fig. 2-5), which underwent many changes and were left unfinished when Michelangelo departed for Rome. For the tomb of Giuliano, the wall emphasizes the climactic figure of Giuliano seated in a niche above the sarcophagus. Value contrasts stress the framing effect of the architecture, and the triangular grouping of the figures (Fig. 2-6, p. 24) integrates them with the geometry of the wall in spite of their restless poses and precarious positions; they were obviously designed to rest on horizontal surfaces. As in his painting, Michelangelo created muscular giants; he admitted that the central figure bore little resemblance to the face or body of Giuliano. Michelangelo saw his task not as the accurate portrayal of physical appearance but as the creation of a monument expressive of leadership. The female figure of Night and the unfinished male figure of Day seem to be grieving for Giuliano. The torso of *Day* reveals the influence of the *Belvedere Torso*, a fragment of a Roman copy of a Hellenistic Greek work that was known to Michelangelo. In view of his style, it is not hard to understand that Michelangelo's favorite ancient sculpture was the then newly discovered (1506) *Laocoön* (Fig. 9-30, p. 110), whose muscular power and dynamic

pose suggest the source of Michelangelo's concept of ideal form. The artist's grandest tomb design, that for Pope Julius II, suffered endless changes during forty years of struggle for funds and conflict with other projects. The result, in San Pietro in Vincoli, is a sadly heterogeneous collection of parts. Michelangelo's final sculptural work was an unfinished *Deposition* (Florence Cathedral) meant for his own tomb.

Benvenuto Cellini (Florence, Rome, and France, 1500–71). Cellini was trained as a goldsmith and worked mainly in Rome from 1519 to 1540 as a medalist, that is, doing metal medallions with portraits in low relief. His skill is evident in the gold *Saltcellar of Francis I* (Kunsthistorisches Museum, Vienna), finished during a sojourn in France from 1540 to 1545. It was then that Cellini produced his first large-scale sculpture, a bronze relief known as *The Nymph of Fontainebleau* (Louvre, Paris), using Mannerist proportions that suggest the influence of Francesco Primaticcio, Cellini's rival at the court of Francis I. Cellini's masterpiece was the *Perseus* (Fig. 14-29), done after his return to Florence. The body of Perseus is posed without twisting or violent action and shows more sympathy with Raphael than with Michelangelo. The intricate details reveal the goldsmith's art, and the only Manneristic elements are in the sculpture on the base. Cellini's autobiography is a fascinating sourcebook for the Renaissance.

Giovanni da Bologna (Florence, 1529–1608). Giovanni da Bologna grew up in Flanders, traveled to Rome, and settled in Florence about 1556. His *Medici Mercury* (1580, Museo Nazionale, Florence) and *Apollo* (1573–75, Palazzo Vecchio, Florence) are Manneristic in their soft anatomy and effeminate poses. The complex outline of the open forms, the intertwining organization, and the dramatic action forecast seventeenth-century art. Much of Giovanni's work, such as *The Rape of the Sabine Women* (Fig. 14-30), is more Proto-Baroque than Manneristic. He was the first sculptor since the fifteenth century to produce equestrian statues, but his work in this area is very restrained in style and close to its fifteenth-century prototypes. His activity was restricted to the area of Florence, but his influence was widespread.

ARCHITECTURE IN ITALY

The High Renaissance in Italy saw the creation of more effects derived specifically from Roman architecture.

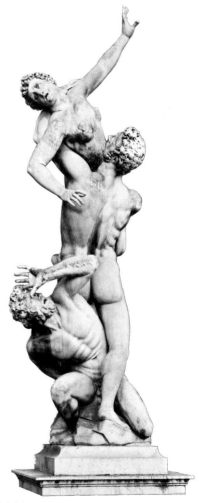

14-30
GIOVANNI DA BOLOGNA, *The Rape of the Sabine Women*, completed 1583. Marble, approx. 13'6" high. Loggia dei Lanzi, Florence.

Closer attention was paid to Roman proportions, and walls were treated more as sculpted mass, resulting in stronger contrasts of light and shadow. Further study of Roman art revealed a concern for shaping not only mass but space, and High Renaissance architects turned to the possibilities of using mass to shape space not only inside but outside, between buildings in a group, for more comprehensive schemes of order. Architecture, like painting, strove for the effects of equilibrium and monumental scale that were so evident in the ruins of Roman architecture. Details were used with restraint in order to stress the largeness of the forms.

Late Renaissance architecture is often characterized by features comparable to Mannerism in painting and sculpture: unexpected contrasts, deliberately crowded forms, fantastic shapes that suggest plants, animals, or men, and ambiguity in structural functions; a column might be robbed of its supporting role by undercutting its base, and an arch might be designed with its keystone slipping precariously out of place. Proto-Baroque tendencies also began to grow in architecture after 1520. Quiet equilibrium and clarity of parts were sacrificed for powerful focal effects, dramatic contrasts, and dynamic forms, such as concave-convex walls and expanding-contracting spaces. Surfaces were broken up with decorative elements in a great variety of depths.

Donato Bramante (Milan and Rome, 1444–1514). Bramante turned to architecture after beginning as a painter. His early buildings are in Milan and include the remodeling of Santa Maria presso San Satiro (begun c. 1479), where he used illusionistic perspective relief to make the choir seem deeper; and the choir and dome of Santa Maria delle Grazie (begun in 1492). The early work often shows a typically northern Italian tendency toward rich surface decoration, but there is already some subordination of details to large framing elements, the sign of bolder, grander systems of proportions. Bramante's mature style developed in Rome after 1500, where he was the leader of High Renaissance architecture. The Tempietto (Fig. 14-31) is based on the Greco-Roman tholos temple and typifies the High Renaissance interest in central buildings. The peristyle employs the Roman Doric order with triglyphs and metopes from the ancient Greeks (Figs. 9-5 and 9-6, p. 96), and the dome is a heightened version of the low Roman saucer dome seen on the Pantheon (Fig. 11-10). The wall was treated as a sculptural mass with projecting and receding parts; the light, delicate precision of earlier work has

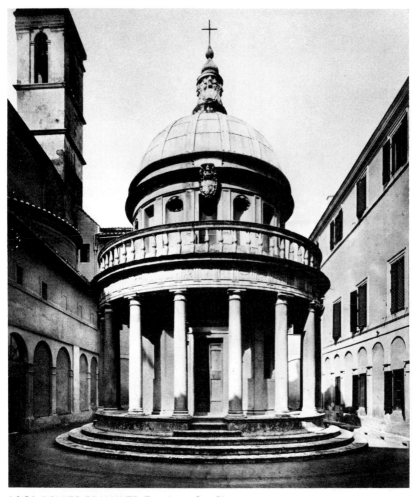

14-31 DONATO BRAMANTE, Tempietto, San Pietro in Montorio, Rome, c. 1502–03.

given way to a new monumentality. For the new church of St. Peter's, Bramante aimed at the magnificence of mass and space that still could be seen in the ruins of Roman baths. He turned back to the old Roman material, concrete, and drew a plan based on a Greek cross within a square. The arms of the cross were to terminate in apses and be roofed with barrel vaults. The crossing would be covered with a great dome inspired by the Pantheon. Bramante's death put the construction into the hands of a succession of architects, and the present church (Fig. 14-33) owes its form mainly to three men: Michelangelo, who planned a Greek cross as

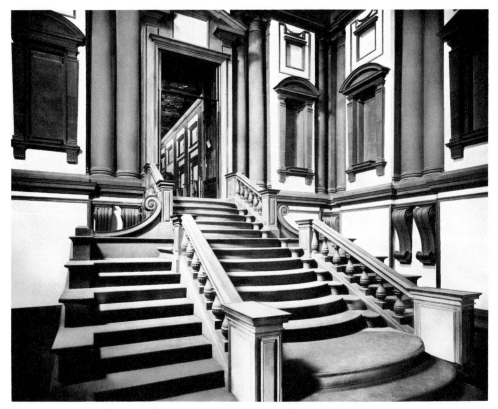

14-32 MICHELANGELO BUONARROTI, vestibule of the Laurentian Library, Florence, begun 1524. Stairway designed 1558–59.

Bramante had but made the masses bolder and more active; Carlo Maderna, who lengthened one arm to create a basilica plan and designed the façade; and Gianlorenzo Bernini, who planned the frontal square and its enclosing colonnades. Since Maderna and Bernini did their work in the seventeenth century, St. Peter's can hardly be considered simply as a Renaissance building. Bramante's plan for the Belvedere Court in the Vatican was realized somewhat more fully. Here he used massive walls and grand scale to mold the courtyard space into a focal apse. The boldness of mass, space, and scale set the key for High Renaissance architecture.

Michelangelo Buonarroti. Michelangelo's first major architectural design, the Laurentian Library in Florence (1524), sacrificed the quiet equilibrium and logical clarity favored by Bramante. In the vestibule of the library (Fig. 14-32), the pilasters have an inverted taper,

from small base to wide top, and engaged columns are denied their supporting role by being placed on console brackets extending from the wall. The pilasters, columns, and windows are crowded close together, and a staircase of expansive, curved steps dominates the room. This dramatic intensity disturbed some of Michelangelo's contemporaries, but it is considered today to be a Manneristic quality. In the 1530's, Michelangelo redesigned the Campidoglio (the Capitoline Hill) in Rome. A trapezoidal piazza flanked by two palaces focuses on the Palace of the Senators at the wide end. The piazza is filled by an oval pavement that radiates from the ancient equestrian statue of Marcus Aurelius. This dynamic space is enclosed by façades of strongly three-dimensional design, bold value contrasts, and *colossal orders* (columns or pilasters more than one floor high). Michelangelo's plan for St. Peter's provided walls of alternating angular and curved projections (Figs. 14-33a and 14-34), making the form complex to understand, somewhat restless in its movement, and powerful in value contrasts. To avoid weakening

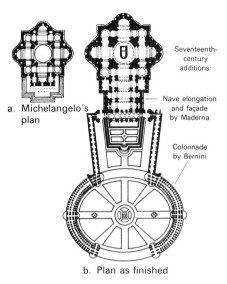

a. Michelangelo's plan

Seventeenth-century additions:

— Nave elongation and façade by Maderna

Colonnade by Bernini

b. Plan as finished

14-33 MICHELANGELO BUONARROTI, plan of St. Peter's, Rome.

14-34 MICHELANGELO BUONARROTI, south elevation of St. Peter's. (Engraving by Dupérac, *c.* 1569.)

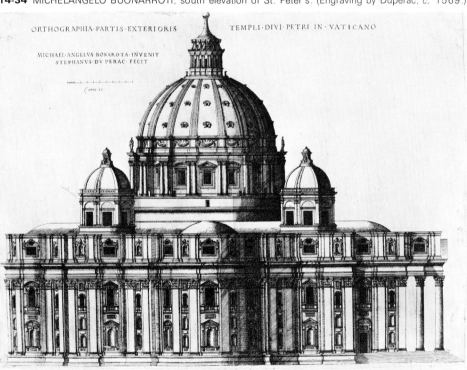

and cluttering the great masses of the building, Michelangelo used colossal orders to pull together the levels between base and attic. Such complexity, restlessness, and contrast may be considered Proto-Baroque.

Baldassare Peruzzi (Siena and Rome, 1481–1536). Peruzzi was trained as a painter in Siena, but after his arrival in Rome in 1503, he added architectural design to his activities. His reputation eventually gained him the chance to collaborate with Raphael, Jacopo Sansovino, and Michelangelo in planning the church of San Giovanni dei Fiorantini. After 1527, he served as city architect for Siena. Peruzzi's major work, however, is the Palazzo Massimi in Rome (Figs. 14-35 and 14-36), usually cited as an example of Manneristic architecture. The façade contains a number of sudden changes with no smooth transitions or connections between the parts. While the total effect is not disunified, it is strikingly dissonant. Peruzzi succeeded Raphael as architect of St. Peter's, but the plans of both men were superseded by others.

Andrea Palladio (Vicenza, 1518–80). The most influential architect of the second half of the century was Palladio, an admirer of Vitruvius as well as of Alberti, a student of Roman ruins, and a writer on architectural theory.

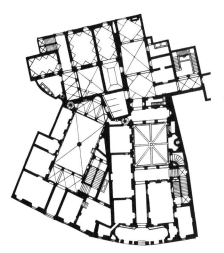

14-35 Plan of Palazzo Massimi.

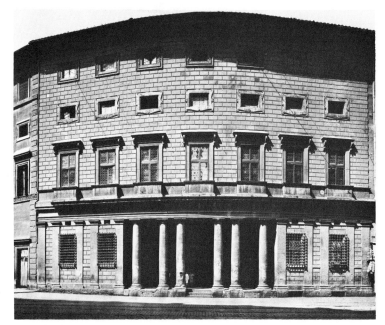

14-36
BALDASSARE PERUZZI,
Palazzo Massimi, Rome,
begun 1535.

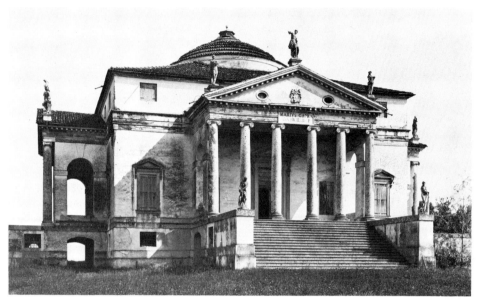

14-37 ANDREA PALLADIO, Villa Rotonda, Vicenza, begun 1550.

Palladio built in the region of his native Vicenza, but his influence was international, partly because of his *Four Books of Architecture* published in 1570. Many of Palladio's designs seem very conservative in comparison with those of Michelangelo or Peruzzi. A Roman dome and identical Ionic porches grace the simple square block of the Villa Rotonda (Figs. 14-37 and 14-38). From any one of the façades, designed in obvious axial balance, one quickly comprehends the whole exterior form. Each part has a beginning, a middle, and an end—that is, a base, a main part, and a termination. Minor parts, such as pediments over windows and doors, build toward focal points like the pediments on the porches. Proportions are clearly marked by simple moldings. Inside, an equally severe clarity is felt in the obvious central balance of the plan. Such design fits the concepts of High Renaissance architecture. Touches of Manneristic enigma are found in his Palazzo Thiene, however, where windows are framed by columns imprisoned in large blocks and topped by flat arches, the keystones of which break onto a pediment above. And his Loggia del Capitaniato bristles with crowded surfaces and complex three-dimensional variations, all heralding the Baroque age to come, as does the illusionistic architecture in his Olympic Theater, which makes the stage appear deeper than it actually is. One of Palladio's

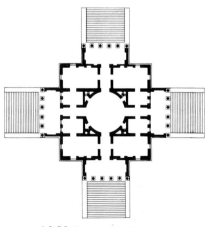

14-38 Plan of Villa Rotonda.

favorite devices, often called the *Palladian motif* (Fig. 14-39), was used frequently in seventeenth- and eighteenth-century architecture.

PAINTING IN THE NORTH

By 1520, Manneristic Italian elements had begun to appear in the work of many Northern artists. We find imaginative constructions of antique architecture, heroic proportions, broad, full masses, and the occasional use of chiaroscuro and sfumato. In Flanders, Antwerp became a prolific center for paintings in an exaggerated Michelangelesque style imported from Rome. The intricacy of fifteenth-century work was retained in another type of Antwerp painting, done for export to other European countries: small religious scenes containing weird combinations of Italianate architectural parts and elongated figures in self-conscious poses and fantastic costumes. The term *Antwerp Mannerism* is sometimes applied to both trends. Antwerp and Brussels were both important for landscape and *genre* (scenes from everyday life) painting. Landscapes were panoramic, with delicate detail and subtle color; genre subjects, often including still life, tended to have sharply defined shapes in complex compositions.

In Germany, Austria, and Switzerland, the Medieval love of intricate active line on the one hand, and flat patterns of clearly edged shapes on the other, modified the ideas that came from Italy. While religious, mythological, and portrait subjects predominated, landscape painting was developed by painters working in the vicinity of the Danube River. Their so-called *Danube Style* created visions of icy peaks, winding valleys, and feathery evergreens or clawlike branches, all in delicate detail.

Sixteenth-century French painting centered around the Palace of Fontainebleau, where Francis I, Henry II, and Henry IV gathered native and foreign artists. The leaders were Italian Mannerists.

In sixteenth-century England, portraiture was the major interest, and leadership came from foreigners such as Hans Eworth of Flanders and Hans Holbein the Younger of Switzerland. Typical stylistic features are brilliant detail in costume and accessories and containment of details within larger areas with sharply defined edges.

Matthias Neithardt-Gothardt, called **Grünewald** (Germany, *c.* 1470/80–1528). Grünewald may have been born in

Window

Opening

14-39 The Palladian motif.

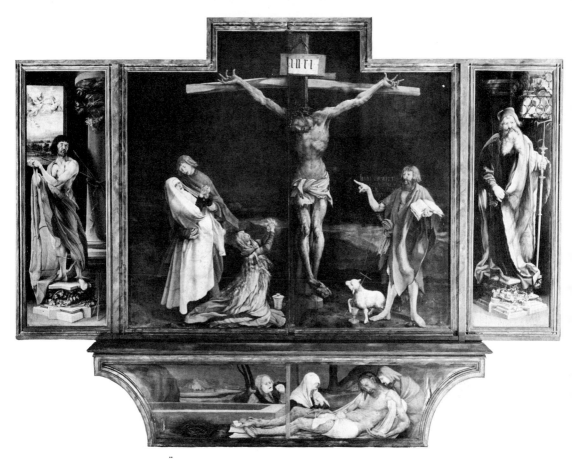

14-40 GRÜNEWALD, central panel of the *Isenheim Altarpiece, c.* 1510–15. Approx. 8'10'' x 10'1''. Musée Unterlinden, Colmar.

Würzburg; little is known of his life. Between 1508 and 1514, he was court painter to the Archbishop-Elector and then to the Elector of Mainz. Grünewald's major work is the large, many-paneled *Isenheim Altarpiece,* commissioned for a church at Isenheim. The central panel (Fig. 14-40) depicts the torn body of Jesus on the Cross, flanked by the Madonna, John, Mary Magdalene, and John the Baptist. Like many Germanic Medieval artists, Grünewald preferred harsh, jagged, and twisted forms. His sense of deep space and natural light, however, link him with the Renaissance.

Albrecht Dürer (Germany, 1471–1528). Dürer began training as a goldsmith in Nuremberg but turned to painting and studied under Michael Wohlgemuth, a painter of altarpieces in the late Gothic style. Yet Dürer's fame spread more because of his engravings and woodcuts than because of his paintings. The wood-

cut of *The Four Horsemen of the Apocalypse* (Fig. 14-41) rivals wood engraving in its detail and demonstrates Dürer's love of intricate, boiling line. In an eruption of seething activity, the Four Horsemen—War, Sickness, Famine, and Death—ride down their helpless victims. This print is part of Dürer's *Apocalypse* series, based on the Revelations of St. John. The artist also designed a series on the life of Mary (1504–05) and others on the Passion of Christ: the *Great Passion* in woodcuts (1500–10), the *Little Passion* in woodcuts (1509–10), and a *Passion* in prints from metal engravings (1508–12). For the woodcuts, Dürer did the drawings, and expert cutters prepared the wood blocks. The best-known of Dürer's individual metal engravings are *Adam and Eve; Knight, Death, and the Devil;* and *Melencolia I;* all done between 1504 and 1514 (prints are in the Metropolitan Museum of Art in New York and in the Museum of Fine Arts in Boston). Although he traveled to Italy and the Netherlands, most of Dürer's work retained the gnarled forms and intricate line characteristic of German Medieval art; but his landscape and anatomical studies, his observation of textures and of light effects, his use of aerial and linear perspective, and his interest in portraiture all link him to the Renaissance. In paintings

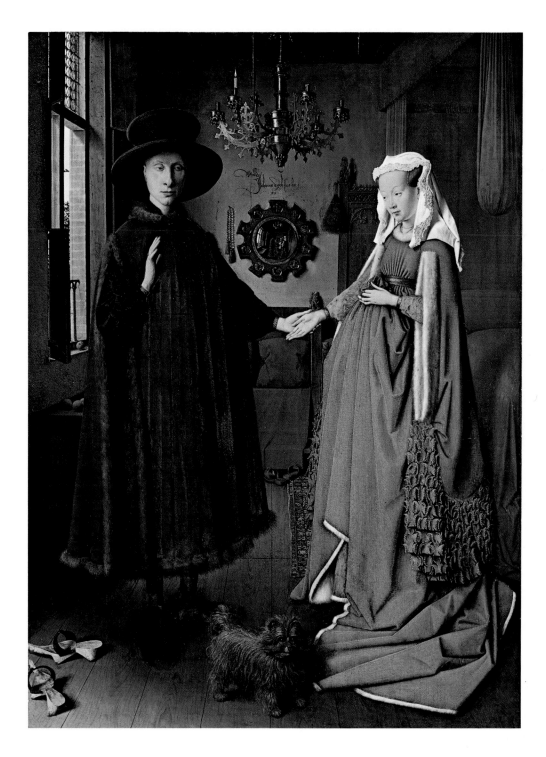

Plate 1

JAN VAN EYCK, *Arnolfini and His Bride*, 1434. Oil on wood panel, approx. 32″ x 22″. Courtesy of the Trustees of the National Gallery, London.

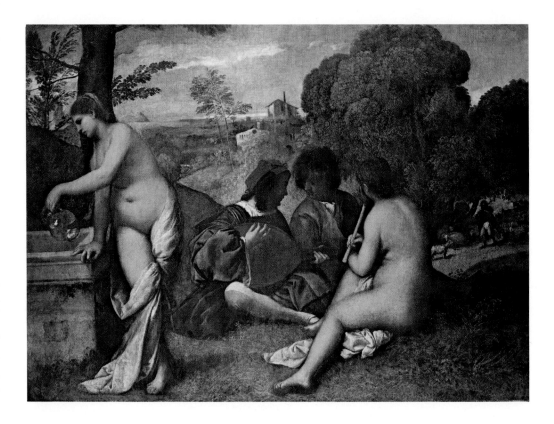

Plate 2

GIORGIONE DA CASTELFRANCO, *The Pastoral Concert, c.* 1508. Oil on canvas, approx. 43" x 54". Louvre, Paris.

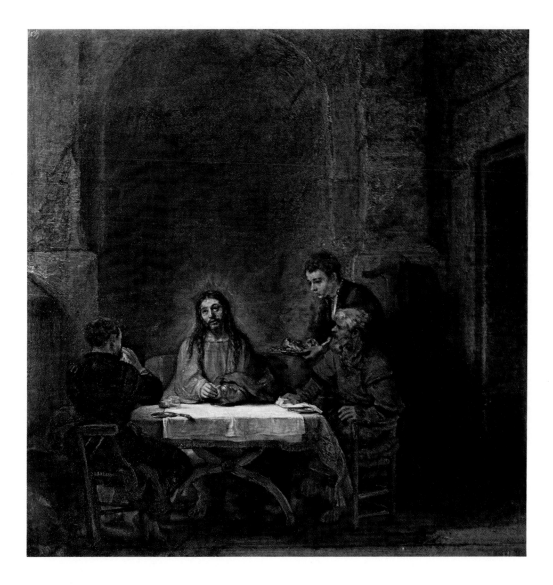

Plate 3

REMBRANDT VAN RIJN, *Supper at Emmaus, c.* 1648. Oil on panel, approx. 27" x 26". Louvre, Paris.

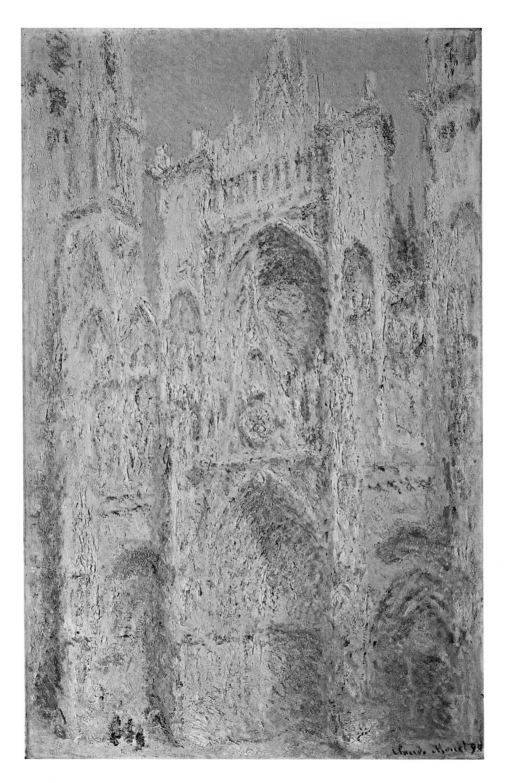

Plate 4

CLAUDE MONET, *Rouen Cathedral*, 1894. Oil on canvas, approx. 39¼″ x 25⅞″
National Gallery of Art, Washington, D.C.

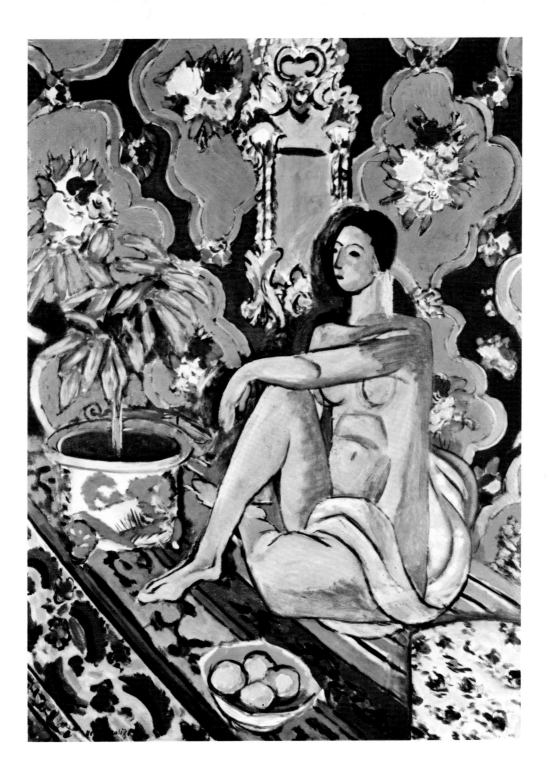

Plate 5

HENRI MATISSE, *Decorative Figure on an Ornamental Background,* 1927. Oil on canvas, approx. 48" x 36". Musée National d'Arte Moderne, Paris.

Plate 6

GEORGES ROUAULT, *The Old King*, 1916–38. Oil on canvas, approx. 30¼″ x 21¼″.
Collection, Museum of Art, Carnegie Institute, Pittsburgh (Patrons Art Fund).

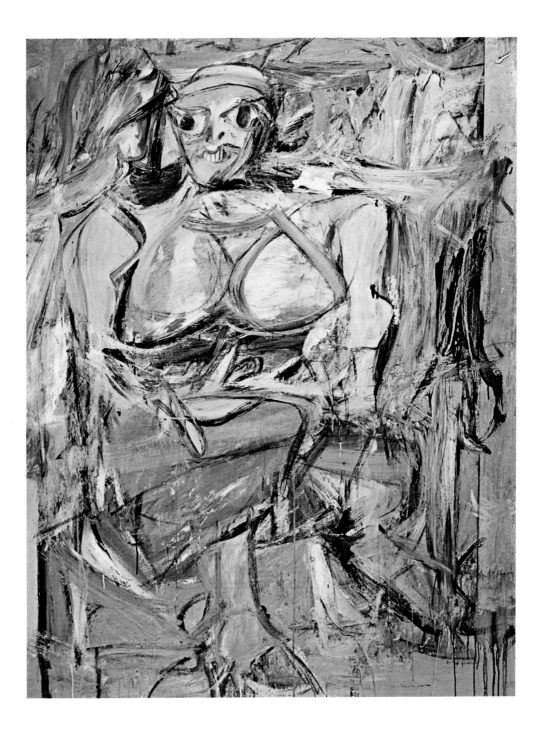

Plate 7

WILLEM DE KOONING, *Woman I*, 1952. Oil on canvas, 76" x 58". Museum of Modern Art, New York.

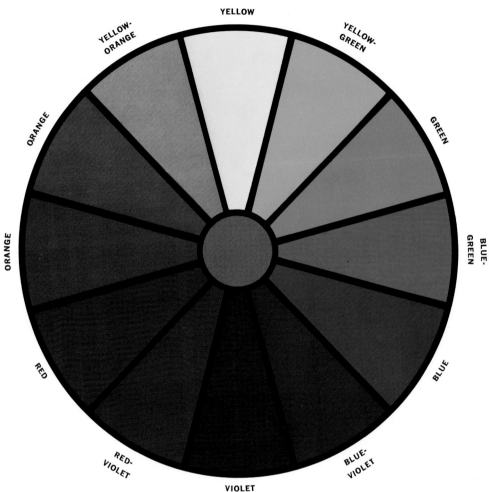

YELLOW

YELLOW-
GREEN

YELLOW-
ORANGE

ORANGE

GREEN

RED-
ORANGE

BLUE-
GREEN

RED

BLUE

RED-
VIOLET

BLUE-
VIOLET

VIOLET

Plate 8

By mixing the primary pigment colors red, yellow, and blue, we obtain the secondary colors: orange, green, and violet. Each secondary is placed between the primaries that produced it. Each secondary may then be mixed with adjacent primaries to produce a third set of hues. In the resulting color wheel, complementary colors are opposite one another. Complementaries may be mixed to lower their saturation, to produce browns, or to produce a neutral gray.

like the *Madonna of the Rose-Garlands* (1506, Prague Museum), Dürer used the chiaroscuro and sfumato that had been developed in Italy; and in the *Four Apostles* (1526, Alte Pinakothek, Munich), he employed simplified massive cascades of drapery that are reminiscent of Italian art.

Hans Holbein the Younger (Switzerland and England, 1497–1543). Holbein grew up in Augsburg and established himself in Basel as a wall painter, woodcut designer, and portraitist, but he found his greatest success as a portrait painter in England at the court of Henry VIII. In *The Ambassadors* (Fig. 14-42), Renaissance interests are apparent in the depiction of individual facial character and in the array of different forms and textures carefully situated in space and rendered in natural light. Like many Italian painters of the preceding century, he was not above using some illusionistic trickery to display his conquest of the physical world: When the long bony form in the foreground is viewed from the proper angle (hold the page against your face and sight along the length of the object), it becomes a skull. Like many of his contemporaries, Holbein was intrigued by the idea of death, and he designed woodcuts portraying the figure of Death coming to claim men of various social levels. His portrait of Henry VIII (1540, National Gallery, Rome) is a remarkably frank expression of luxury and crafty cupidity, yet underlying the bulk of the head and costume are the typically Medieval silhouetted shapes and flat backgrounds. The portrait of Erasmus (1523, Louvre, Paris) silhouettes the profile of cap and face against a close background of restrained textile pattern; the quiet concentration of the scholar's

14-42

HANS HOLBEIN THE YOUNGER, *The Ambassadors*, 1533. Oil and tempera on wood, approx. 7' x 7'. Courtesy of the Trustees of the National Gallery, London.

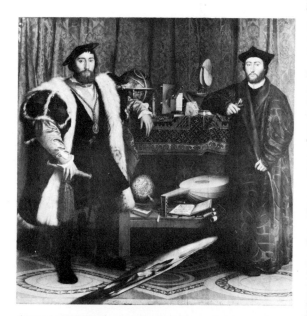

14-43 FRANÇOIS CLOUET, *Elizabeth of Austria*, 1571. Louvre, Paris.

personality is expressed along with his individual physical traits.

François Clouet (France, 1500?–72). François was trained by his father, Jean Clouet, and succeeded him as court painter to Francis I. François Clouet's earliest known portrait, *Pierre Quthe* (1562, Louvre, Paris) shows Italian influence in pose, setting, and massiveness. Later portraits, like *Charles IX* (1570, Kunsthistorisches Museum, Vienna), belong to an international portrait style of the second half of the sixteenth century, a style that owes much to Holbein as well as to Italian painting. Standard poses and accessories are combined with elaborate costume detail, which is treated rather flatly. Clouet's chalk portraits achieve some of Holbein's conciseness of characterization, and his portrait of Elizabeth of Austria (Fig. 14-43) reflects Holbein's ability to depict character as well as an orchestral range of textures.

Pieter Bruegel the Elder (Flanders, 1525–69). Although Bruegel may have been born in the Netherlands, his career is part of Flemish art. After registering with the painters' guild in Antwerp in 1551, he traveled in Italy and then returned to Antwerp to work as an engraver. After 1563, Bruegel lived in Brussels. An intellectual, he was a friend of leading humanists in his region. His paintings suggest his philosophical position and often are subtly satirical. *The Wedding Feast* (Fig. 14-44) exemplifies his leadership in genre painting. The rounded, knobby forms, small scale, and jerky movements of the countless little people are in jolting contrast to sixteenth-century Italian style, but they are a logical outgrowth of fifteenth-century Flemish art. Although the individual figures are rounded and the space is deep, the contrast of local colors and values gives the effect

14-44
PIETER BRUEGEL THE ELDER, *The Wedding Feast*, c. 1565. Panel, approx. 4' x 5'. Kunsthistorisches Museum, Vienna.

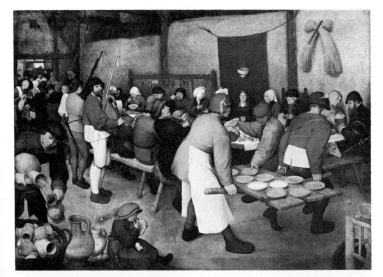

of a complex, richly varied patchwork of flat shapes. Bruegel's best-known works include the *Way to Calvary* (1563, Kunsthistorisches Museum, Vienna) and a series done in 1565 representing the seasons: *The Harvest* (Metropolitan Museum of Art, New York), *Hunters in the Snow, Dark Day,* and *The Return of the Cattle* (all in the Kunsthistorisches Museum, Vienna).

ARCHITECTURE IN THE NORTH

In northwestern Europe, the Gothic style lingered into the fifteenth and sixteenth centuries. Renaissance details slowly infiltrated Gothic detail until at last the basic structure changed and an integrated Renaissance style was formed. The change occurred first in France, the Renaissance influence coming from northern Italy in the early sixteenth century because of French military campaigns there. The importation of Roman moldings, pilasters, columns, arches, and floral ornament is evident in churches such as St. Eustache in Paris and in the châteaux of the Loire Valley, where Medieval forms are given Renaissance decorative details. The Palace of Francis I at Fontainebleau demonstrates various phases of Renaissance architecture during his reign and afterward. Of considerable influence were the writings of the Italian Serlio, who was called to France by Francis I in 1540. Typical sixteenth-century Northern features are steeply pitched roofs and ornate gables. As in painting, the northerners often applied Italian Renaissance motifs in a spirit of fantasy and profusion that suggests the Middle Ages.

Pierre Lescot (France, 1510/15–78). Lescot came from a wealthy family and received a broad education. His architectural style was formed before he traveled to

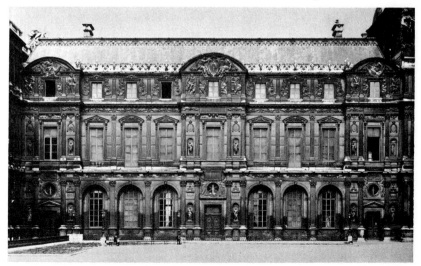

14-45 PIERRE LESCOT, square court of the Louvre, Paris, begun 1546.

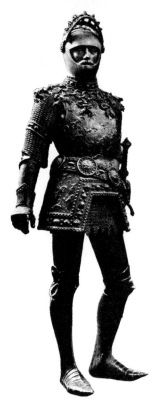

14-46
PETER VISCHER THE ELDER, *King Arthur*, 1513. Bronze, life size. Hofkirche. Innsbruck.

Italy, although he undoubtedly knew the standard sourcebooks for Renaissance and antique architecture. Most of Lescot's work has been changed or destroyed. The most complete remaining structure is the façade of the square court of the Louvre (Fig. 14-45), in which the major horizontal and vertical dividing lines are broken at intervals, and the small size of columns and pilasters, along with the ornamental breakup of the surfaces, creates richness rather than the monumental grandeur of Italian design.

SCULPTURE IN THE NORTH

In the North, sculpture, like painting and architecture, clung to the Gothic style until well into the sixteenth century. The fifteenth century had nurtured increasing portraiture in tomb sculpture, the use of standard types in faces portrayed in religious and mythological scenes, and both the smoothly flowing drapery common to late Gothic French art and the crackling angular drapery of the Lowlands and the Germanic areas. Sixteenth-century sculpture produced more portraiture, more anatomical detail, and more interest in landscape and deep space in relief compositions. Countries with the tradition of angular drapery and thin figures turned to fuller masses and curving forms. French sculpture was strongly affected by the Italian Mannerist sculptors serving Francis I, and Renaissance concepts were introduced to England after 1512 by the Italian sculptor Pietro Torrigiano.

Peter Vischer the Elder (Germany, *c.* 1460–1529). Vischer the Elder was one of a large family of Nuremberg sculptors and bronze casters. Although he did not travel to Italy, he would have known Italian art from drawings and engravings. The life-size bronzes of Theodoric and King Arthur (Fig. 14-46) from the Tomb of Maximilian are extraordinary displays of realistic armor.

Jean Goujon (France, ?–1567). Although Goujon was one of the major sculptors of his day, little is known of his life. By 1540, he had developed a Renaissance style based on a knowledge of both Italian and antique art. His *Pietà* from St. Germain l'Auxerrois (1544–45) reveals Manneristic poses and proportions. Both the *Pietà* and the relief panels of nymphs from the Fontaine des Innocents (Fig. 14-47) have a delicate flowing harmony in the thin linear drapery folds that seems peculiar to Goujon's style.

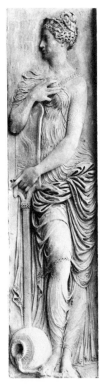

14-47 JEAN GOUJON, nymphs from the Fontaine des Innocents, Paris, 1548–49.

Suggestions for Further Study

Benesch, Otto. *The Art of the Renaissance in Northern Europe: Its Relation to the Contemporary Spiritual and Intellectual Movements,* rev. ed. London: Phaidon Press, 1965.

Blunt, Anthony. *Art and Architecture in France: 1500–1700* (Pelican History of Art). Baltimore: Penguin Books, 1953.

————. *Artistic Theory in Italy: 1450–1600.* New York: Oxford University Press, 1956.

Clements, Robert J. *Michelangelo's Theory of Art.* New York: New York University Press, 1961.

Cuttler, Charles D. *Northern Painting from Pucelle to Bruegel.* New York: Holt, Rinehart and Winston, 1968.

De Tolnay, Charles. *Michelangelo.* 5 vols. Princeton, N.J.: Princeton University Press, 1943–60.

Freedberg, Sydney J. *Painting of the High Renaissance in Rome and Florence.* 2 vols. Cambridge, Mass.: Harvard University Press, 1961.

Gombrich, Ernst Hans Josef. *Norm and Form: Studies in the Art of the Renaissance.* London: Phaidon Press, 1966.

Hartt, Frederick. *History of Italian Renaissance Art: Painting, Sculpture, and Architecture.* New York: Abrams, 1969.

Krautheimer, R., and Trude Krautheimer-Hess. *Lorenzo Ghiberti.* Princeton, N.J.: Princeton University Press, 1956.

Lassaigne, Jacques. *Flemish Painting.* 2 vols. Translated by Stuart Gilbert. New York: Skira, 1957.

Müller, Theodor. *Sculpture in the Netherlands, Germany, France, and Spain: 1400–1500.* (Pelican History of Art). Baltimore: Penguin Books, 1966.

Murray, Peter. *The Architecture of the Italian Renaissance.* New York: Schocken Books, 1963.

Osten, Gert von der, and Horst Vey. *Painting and Sculpture in Germany and the Netherlands: 1500–1600* (Pelican History of Art). Baltimore: Penguin Books, 1969.

Panofsky, Erwin. *Early Netherlandish Painting: Its Origins and Character.* 2 vols. Cambridge, Mass.: Harvard University Press, 1953.

————. *Renaissance and Renascences in Western Art.* Stockholm: Almqvist and Wiksell, 1960.

Pope-Hennessy, John. *An Introduction to Italian Sculpture.* 3 vols. New York and London: Phaidon Press, 1955–62.

Seymour, Charles, Jr. *Sculpture in Italy, 1400–1500* (Pelican History of Art). Baltimore: Penguin Books, 1966.

Stechow, Wolfgang. *Northern Renaissance Art, 1400–1600: Sources and Documents.* Englewood Cliffs, N.J.: Prentice-Hall, 1966.

Vasari, Giorgio. *The Lives of the Painters, Sculptors, and Architects.* Edited by Betty Burroughs. New York: Simon and Schuster, 1959.

Wittkower, Rudolf. *Architectural Principles in the Age of Humanism,* 3rd rev. ed. London: Alec Tiranti, 1962.

Wolf, Robert Erich, and Ronald Millen. *Renaissance and Mannerist Art.* New York: Abrams, 1968.

Chapter 15

Baroque Art:

1600–1700

The term *Baroque* has dual sources and has been used with varied meanings. The Italian word *barocco* grew out of the language of Medieval logic and by the seventeenth and eighteenth centuries had come to mean any system of thought that was contorted, irrational, or untrue; in Portugal, the word *barroco* referred to a rough, imperfect pearl. Both words seem to have been sources for the French word *baroque*, which originally meant an imperfect pearl and by extension something irregular or bizarre, and hence was applied to an artistic style that did not conform to accepted rules of proportions but rather to individual whim. "*Baroque*" was used by eighteenth-century writers as a disparaging term for such artists as Giovanni Lorenzo Bernini, Francesco Borromini, and Pietro da Cortona and for writers who showed an appetite for novelty or untraditional forms. In the nineteenth century, "*Baroque*" was used more objectively to denote a historical period and certain stylistic characteristics. In the narrowest sense, the period was the seventeenth century, but many writers today prefer the broader dates of 1600 to 1750. However, since Baroque qualities persevere in many important works until the end of the eighteenth century, we will use the even broader dating of 1600 to 1800 and treat each century in a separate chapter.

This period developed a wider variety of styles than we have seen in earlier centuries, and it is necessary to consider a broad range of characteristics under the concept of Baroque styles. Complexity, contrasts, bold effects of gradation and climax, overwhelming vastness or unexpected intimacy in scale, deliberate lack of clarity, illusionistic effects, and calculated surprise were used together or in various combinations. The roots of this art are found in the work of Michelangelo, in Mannerism, and especially in the Proto-Baroque.

The seventeenth century was one of bold contrasts within and between ideological systems: The parliamentary system developed in England while absolutism developed on the Continent, particularly in France; Catholicism struggled with Protestantism, and religious truth had to be reconciled with newly discovered scientific truths. Seventeenth-century science replaced the old concept of a finite and fixed universe with the more awesome vision of infinite space and ceaseless motion. The new view was paralleled in art by a preference for vast spaces and the effect of constant movement in much of the architecture, painting, and sculpture of the seventeenth and early eighteenth centuries.

In art, the prevailing system of values was promulgated by the French Royal Academy, established in the

seventeenth century to provide acceptable standards. Effective at first, the Academy later became dogmatically restrictive, and many artists rebelled against it.

PAINTING IN ITALY AND SPAIN

Rome was the international center where the major stylistic tendencies of seventeenth-century painting were formed. Early seventeenth-century Italian painting reveals three major currents: a continuation of sixteenth-century Mannerism, a reappraisal, led by Annibale Carracci, of High Renaissance styles, and a pioneering trend led by Michelangelo da Caravaggio. The attitude of Carracci and his followers was conservative in that it sought to incorporate selected qualities from certain High Renaissance and Late Renaissance paintings. Clarity in parts, in expressive gestures, and in focus was joined to strong compositional structure and massively solid, ideal human form. The Carracci group was the strongest camp in Rome at the beginning of the century, and its stylistic character— sometimes called *Restrained Baroque* or *Baroque Classicism*—was influential during the remainder of the century. The Caravaggio trend sacrificed clarity for dramatic light effects and complex natural detail. As the seventeenth century unfolded, all three trends contributed to full Baroque painting, which exploited illusionistic effects on a grand scale, dramatic value contrasts, active, irregular forms suggesting constant change rather than stability, compositions with a minimum of stabilizing vertical and horizontal lines and a maximum of diagonals or undulating curves, and ideal figures of heroic proportions. It attempted to break through the limits of the frame, making the painted scene a more overwhelming experience because it appears to be a part of the spectator's real world.

The seventeenth century produced a distinct division of painting into different types of subject matter with greater specialization by many artists. During the early seventeenth century, landscape painting in Rome was led by German and Flemish painters and tended to ally itself with either the Carracci or the Caravaggio group. Later, it was dominated by two French expatriates, Nicolas Poussin and Claude Lorrain, both in the Carracci camp. Genre painting gained popularity with private patrons. The genre painters, called *Bamboccianti*, were led by Dutchmen living in Rome and were scorned by the critics of the Carracci persuasion, partly because of the commonness of genre subjects and partly because

many genre painters rejected ideal form for the realistic detail and bold lighting of Caravaggio. Still-life painting was indebted to Dutch and Flemish art for its intense study of details and textures and to Caravaggio for its lighting.

Several other cities in addition to Rome were important for seventeenth-century painting. Venice continued in the tradition of its sixteenth-century masters, and Venetian color was a significant influence throughout the century. In Milan, a tradition of sixteenth-century Mannerism was modified by influences from the art of the Flemish painters Rubens and Van Dyck, both of whom, in turn, owed much to the art of Caravaggio. Genoa enjoyed the stimulus of numerous foreign visitors; the Flemish, especially Rubens, were leaders, and both the Caravaggio and the Carracci trends were represented. Bologna was the stronghold of the Carracci Academy, established before Annibale Carracci went to Rome. Florence, however, played a relatively minor role in seventeenth-century Italian painting.

In Spain, Seville and Madrid were the important centers. Early seventeenth-century painting there shows a strong Caravaggesque influence, and painting of the latter part of the century is marked by the soft fleshiness, undulating forms, and dramatic light of Rubens and Van Dyck.

Domenikos Theotocopoulos, called **El Greco** (Spain, 1541–1614). El Greco came from Crete to Spain by way of Italy, working first in Venice, where he was impressed by the chiaroscuro of Titian and the active compositions of Tintoretto, and then briefly in Rome, where he became acquainted with the art of Michelangelo. He settled in Toledo in 1576 or 1577. There he received numerous commissions for portraits and religious subjects. The Prado *Crucifixion* (Fig. 15-1) is typical in the bold value contrasts, the jagged highlights, and the elongated figures with undulating contours. The crackling, flame-like energy of the stormy sky, the billowing garments, and the hovering weightless figures all express ecstatic religious experience. His famous landscape, the *View of Toledo* (1604–14, Metropolitan Museum of Art, New York), acquires the same electric intensity and the same tendency of forms to glow as though illuminated from within. Even El Greco's portraits seem to transcend the physical world; the bodies, the garments, and the large eyes seem to shimmer like a mirage. In style as in actual chronology, El Greco holds a position between Late Renaissance Mannerism and the seventeenth-century Baroque.

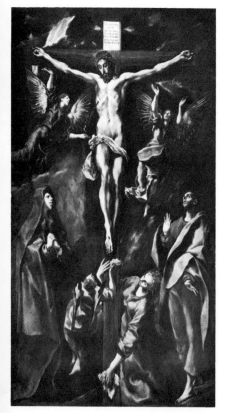

15-1 EL GRECO, *The Crucifixion,* 1584–90. Oil on canvas. approx. 10′ x 6′. Prado. Madrid.

Annibale Carracci (Bologna and Rome, 1560–1609). Carracci began his career as a Mannerist but turned more and more to High Renaissance and Proto-Baroque characteristics. His famous frescoes in the Farnese Gallery in Rome, of which *The Triumph of Bacchus and Ariadne* (Fig. 15-2) is the center, depict the loves of the classical gods and employ the heavy muscular figures seen in the art of Michelangelo and in the late work of Raphael. Carracci used an ideal facial type with full cheeks, straight, flat-planed nose, and broad forehead; his work often has strong value contrasts and compressed compositional activity. For color, his idols were first Correggio and later Titian. Annibale Carracci, his brother Agostino, and their cousin Ludovico opened an art school in Bologna before Annibale went to Rome in the 1590's. The teaching was eclectic, urging a combination of the best qualities from various masters.

Michelangelo da Caravaggio (Rome and Naples, 1573–1610). While Annibale Carracci and his followers led the conservative tendency in early Baroque painting, Caravaggio represented the more innovative spirit. He went from Milan to Rome about 1590 and, at first, earned a precarious living by painting still lifes with one or two half-length figures, such as the *Bacchus* (Uffizi Gallery, Florence). These works have remarkably precise details and distinct local colors. About 1597, he received his first commission for a church (Contarelli Chapel, San Luigi de' Francesi), and from then on his subjects were usually religious. The style that made Caravaggio well known is evident in his *Conversion of St. Paul* (Fig. 15-3). All the traditional accessory figures have been omitted. We see an armored man lying on his back with arms outstretched, while his nervous

15-2 ANNIBALE CARRACCI, *The Triumph of Bacchus and Ariadne,* central composition on the ceiling of the Farnese Gallery, Rome, 1597–1604.

15-3 MICHELANGELO DA CARAVAGGIO, *The Conversion of St. Paul,* 1601–02. 90½" x 69". Cerasi Chapel, Santa Maria del Popolo, Rome.

horse and mystified companion look on. The scene is pushed into the immediate foreground so that we have a startlingly close view. A flesh-and-blood reality is stressed by precise physical detail, yet there seems to be something extraordinary about the event. The strong spotlight that illuminates the objects against the dark background can hardly be natural light. Its source is outside the picture and remains a mystery to us, but its effect is to dramatize rather than to clarify. The few forms are broken into many parts by the light and shadow, making the composition complex and hard to comprehend immediately. This use of chiaroscuro to transcend physical reality is typical of Caravaggio's mature style and forecasts later Baroque painting. Caravaggio was forced to flee Rome in 1606 after he had killed a man, and he sojourned in Naples, Malta, Syracuse, and Messina before his tempestuous career was cut short by malaria.

Pietro da Cortona (Florence and Rome, 1596–1669). Pietro was one of the major seventeenth-century artists in both painting and architecture. He represented the

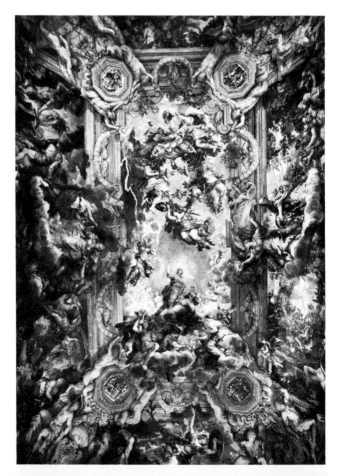

15-4
PIETRO DA CORTONA, *Glorification of Pope Urban VIII's Reign,* central composition on the ceiling of the Gran Salone, Barberini Palace, Rome, 1633–39.

15-5
DIEGO VELÁZQUEZ, *The Maids of Honor*,
1656. Oil on canvas, approx. 10′5″ x 9′.
Prado, Madrid.

full Baroque rather than the conservatism of the Car-
racci school. His best-known painting, the *Glorification
of Pope Urban VIII's Reign* (Fig. 15-4), contains boiling
masses of clouds and figures soaring up through an
illusion of an architectural frame that seems to surround
an opening into the sky. Light and shadow play over
the forms, breaking them into complex parts. There is
a strong focus on the central figure, Divine Providence,
who points to a group of bees, a symbol taken from
the Barberini coat of arms. The allegorical-mythological
scenes at the sides refer to the piety, justice, and
prudence of the Barberini Pope. The elaborate program
of symbolism was worked out not by Pietro but by a
poet in the Pope's circle. Pietro's dazzling production
included frescoes in the Pitti Palace in Florence, in Santa
Maria in Vallicella in Rome, and in the Palazzo Pamphili
in the Piazza Navona in Rome. Unlike some of his
contemporaries, Pietro restrained his illusionism to the
extent of maintaining a clear division between painted
areas and the stucco architectural framework. In his late
easel paintings, he stabilized the compositions with
firmer vertical and horizontal lines and contained the
figures in more rigid groupings, thus rejecting his earlier
dynamism.

Diego Velázquez (Seville and Madrid, 1599–1660). Seville
was a center of Caravaggesque influence in Spain.
Velázquez's early work, such as *The Water Carrier of*

Seville (c. 1619, Wellington Museum, London), sparkles with the brilliant detail and bold value contrasts loved by Caravaggio. At the age of twenty-three, Velázquez was appointed painter to the court of Philip IV, and he retained this position for the remainder of his life. His mature style exploits glazing and impasto to produce rich color and textural effects. *The Maids of Honor* (Fig. 15-5) demonstrates his interest in the play of direct and reflected light on a variety of textures. Close observation reveals that details have been softened by brushwork that is much freer than in his early painting, and light bathes the forms like a palpable liquid, suggesting a source of nineteenth-century Impressionism. *The Maids of Honor* presents an enigma in compositional arrangement. Velázquez and the Infanta look out toward the spectator, who can see the faces of the king and queen in a mirror on the back wall. Either the spectator is placed in the position of the royal couple or the mirror is reflecting part of the picture the artist is painting.

SCULPTURE IN ITALY

At the beginning of the seventeenth century, sculpture in Italy was dominated by the style of Giovanni da Bologna, with its Mannerist poses and its Proto-Baroque irregularity and openness of form. Full Baroque sculpture developed after 1618, when the expression of greatest vitality was sought in poses, multiple and overlapping planes were employed, and deep undercutting produced dramatic shadows planned to provide gradation and climax from a fixed point of view. The sculpture of this period often breaks through the boundaries of its architectural frame or extends beyond the private spatial environment suggested by the base, so that the composition seems to inhabit the spectator's world of space and action. Such efforts to overwhelm the spectator or to draw him into the work of art are analogous to the illusionistic mural and ceiling compositions or to the intimate views found in the painting of the period. Full Baroque sculpture, like painting, used realistic details, complex parts, and lavish color. Varieties of colored stone were combined with bronze, but the leading sculptors did not use colored materials merely to counterfeit nature. Polychrome backgrounds and frames were used for contrast with figures in white stone or bronze. Special lighting, sometimes from hidden windows of colored glass, often intensified dramatic effects. As in painting, there were both full Baroque and conservative trends in sculpture, but the distinction

is less clear because the influence of Bernini's full Baroque was so pervasive. After Bernini's death in 1680, the many French sculptors who had come to Rome after the founding of the French Academy in Rome in 1666 made French leadership a significant force in Roman sculpture.

Gianlorenzo Bernini (Rome, 1598–1680). Bernini, the greatest genius of the Italian Baroque, considered himself to be primarily a sculptor, but he was also architect, painter, and poet. His prodigious abilities as sculptor were demonstrated by an early series of statues done for Cardinal Scipione Borghese between 1618 and 1625. The series included *The Rape of Proserpina*, *David*, and *Apollo and Daphne*, all in the Borghese Gallery in Rome. The open twisting poses, the complex silhouettes, and the realistic detail make the works intensely alive. Although the Baroque is the antithesis of the serenity of much Greek sculpture, Bernini's admiration for Greek art is evident in such features as the modified Greek profiles used for Apollo and Daphne. From Bernini's middle years came the Tomb of Urban VIII (1628–47, St. Peter's), with its exuberant forms in various marbles and in bronze. In the same period, he did the Cornaro Chapel, which contains *The Ecstasy of St. Teresa* (Fig. 15-6), in Santa Maria della

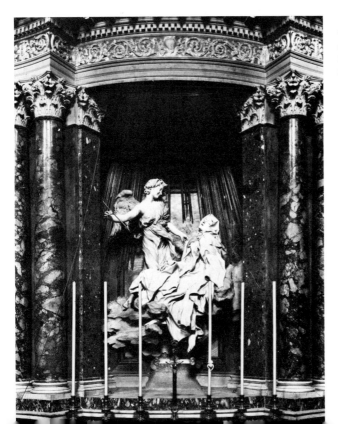

15-6
GIANLORENZO BERNINI, *The Ecstasy of St. Teresa*, 1645–52. Marble, life size. Cornaro Chapel, Santa Maria della Vittoria, Rome.

Vittoria. The members of the Cornaro family are sculpted as spectators in boxes on the side walls of the chapel, and the space between the walls belongs both to the world of the spectator and to the architectural-sculptural composition, deliberately blurring the boundaries of the work of art. Multicolored marble and lavish architectural details lead to the climactic group within an undulating, concave-convex frame. White marble figures with rippling garments and lively, open silhouettes are suspended in space behind the frame and in front of a dark background. A hidden yellow glass window lights the group from above. Bernini's abilities as an organizer enabled him to assemble a large studio with many helpers to develop his ideas for the commissions that were showered on him, and it is often hard to distinguish between works executed by Bernini and those executed by assistants.

ARCHITECTURE IN ITALY AND SPAIN

Baroque architecture ran the gamut from restrained composition to dynamic complexity. Full Baroque architecture tended to exploit painting and sculpture as well as materials of different colors for a compelling total effect with strong focal emphasis. Masses were composed in complex parts and in many layers of depth; the effect of movement was obtained not only by receding and projecting parts, with their concomitant value contrasts, but also by wall surfaces of concave-convex alternations and by rhythmic variations of spaces, walls, piers, columns, and pilasters. Each layer of a multilayered wall may have a rhythmic scheme of its own, giving a fuguelike complexity to the total effect. Accordingly, architectural space was molded to express dynamic rather than static form. Converging streets, façades, or walls focus on the façade of a major building. Interiors reveal a preference for oval plans rather than the more static circular plan, and alternations of expanding and contracting spaces urge the spectator to change position constantly in order to experience the architecture completely. Characteristically, neither the masses nor the spaces have easily or simply perceived limits. Light was manipulated for focus; it often alternates with darkened areas or spaces to create movement or gradation and climax.

In Spain, a special style called the *Churrigueresque*, after a family of designers, developed in the second half of the seventeenth century; it is characterized by an extraordinary richness of decoration.

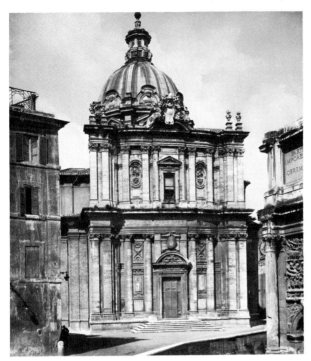

15-7
PIETRO DA CORTONA, San Martina
e Luca, Rome, 1635–50.

Pietro da Cortona. Pietro's art exemplifies the Baroque tendency to fuse painting, sculpture, and architecture for a powerful total effect. His first major commission in architecture was the church of San Martina e Luca, which came in 1635 while he was working on the Barbarini frescoes. He gave movement to the façade (Fig. 15-7) in two ways: first, by using a convex center that seems to bulge out in response to the pressure of projecting wings at the sides; and second, by creating an elaborate play of light and shadow through the use of many layers of pilasters, engaged columns, and panels. While the exterior uses the Ionic order below and Corinthian above, the interior (Fig. 15-8) is re-

15-8
Interior of San Martina e Luca.

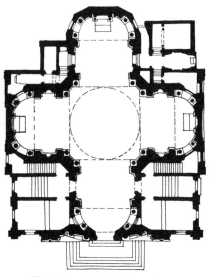

15-9 Plan of San Martina e Luca.

stricted to the Ionic. The Greek cross plan (Fig. 15-9) is opened up and given flexibility by the interior walls, which are built up in layers of panels, pilasters, and columns that create a rhythm of projecting and receding elements; the wall is transformed into undulating systems of supports. In the vaults and dome, Pietro used a great deal of architectural ornament. A strong unifying feature of the interior is the unusual restriction of color to white. His other church designs include Santa Maria della Pace and Santa Maria in Via Lata, both of which exploit deep porches or balconies for dramatic shadows and bold focus. Broken pediments—pediments whose frames have been opened up or cut into projecting and receding parts—are important features of Pietro's architecture and of the Baroque period in general.

Gianlorenzo Bernini. Bernini's activity as an architect began earlier than Pietro da Cortona's. In 1624, Bernini designed the façade of Santa Bibiana in Rome. He opened the ground floor with a three-arched porch and gave climactic emphasis to the upper story with a deep niche and broken pediment. Although the façade

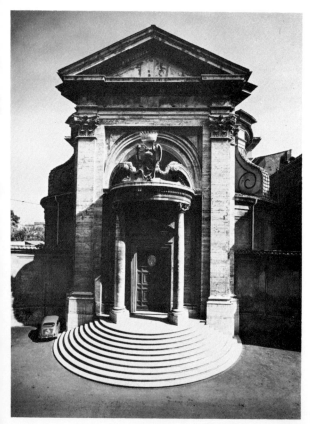

15-10
GIANLORENZO BERNINI, Sant' Andrea al Quirinale, Rome, 1658–70.

is composed of simple elements and many plain sur-
faces, it is developed in layers of superimposed pilasters
that add to the sculptural effect and to the deep shadows
of the porch. Soon Bernini turned to more complex
composition. His tabernacle for St. Peter's, the canopy
shelter over the tomb of St. Peter, done between 1624
and 1633, fuses architecture and sculpture to produce
a focal center for the vast interior. Over twisted, vine-
covered columns, he placed a canopy of sweeping scroll
curves flanked by restless angels and topped by an
active receding and projecting entablature. Bernini also
designed the keyhole-shaped piazza in front of St.
Peter's. The enclosing colonnades shape the piazza into
an expanding and contracting space that demonstrates
the preference for active spaces in Baroque art. Between
1658 and 1670, Bernini designed the small church of
Sant' Andrea al Quirinale in Rome (Figs. 15-10–15-12).
Concave walls focus upon the convex porch with its
rounded broken pediment and ornate coat of arms.
Behind the porch, actively curving scroll buttresses
support the drum, which, in turn, supports the dome.
From the entrance, one looks across the width of the
oval interior to the high altar set deeply within an
architectural frame with a concave, rounded, and broken
pediment. In the opening of the pediment, the twisting
figure of Sant' Andrea is shown ascending into heaven,
the irregular white shape of the saint contrasting boldly

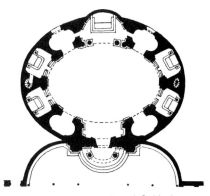

15-12 Plan of Sant' Andrea al Quirinale.

15-11 Interior of Sant' Andrea al Quirinale.

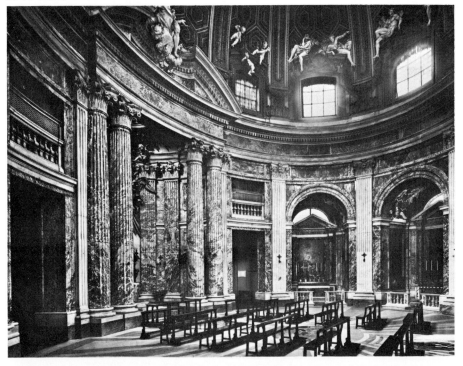

with its surroundings and creating a powerful focal point. Below, the set-in altar receives dramatic illumination from a hidden window. Elsewhere, the walls are opened to form deep niches and secondary altar spaces that enrich the lighting and the spatial effect of the interior. Exuberant architectural ornament and multicolored marble complicate the wall surfaces, while the dome achieves its effect through a contrast of white and gold. Bernini's fame led to an invitation from Louis XIV in 1665 to come to Paris to suggest plans for the completion of the Louvre Palace, but the more restrained taste of the French and the jealousy of French architects led to the rejection of all of Bernini's proposals. His architecture did, however, influence the work of French architects.

Francesco Borromini (Rome, 1599–1667). From a carver of architectural ornament, Borromini moved to the position of architectural draftsman for Maderna and Bernini and finally became an architect after 1633. His first major work was the dormitory, refectory, and cloisters for the monastery of San Carlo alle Quattro Fontane (Figs. 15-13, 14, 15). He planned the church itself, using undulating walls and a complex rhythmic spacing of wall panels, niches, and engaged columns for the interior. The entablature has projecting and receding parts that accentuate the active design of the wall and tie together the various parts. Overhead, pendentives support an oval dome cut into deep hexagonal, octagonal, and cross shapes. The exterior façade was added by Borromini much later (1665–82) and presents an undulating multilayered composition. In the bottom half, engaged columns connect two floors, divide the façade into concave and convex areas, and support an entablature that unifies the verticals and emphasizes the movement of the whole. Above, the third floor and attic are grouped by columns, the center area becomes an oval *pavilion* (part of a building projecting from the main part and often emphasized with ornament) to provide a transition from the convex area below, and the entablature is broken to embrace a medallion that becomes the climax of the upper section. The moldings, balustrades, sculpture, and niches with small framing columns all add richness and value contrast. The tower and the lantern over the dome repeat the in-and-out movements of the façade. Borromini's other works include Sant' Ivo della Sapienza (begun in 1642, Rome) and much of Sant' Agnese in Piazza Navona (1653–63, Rome), a church that had been started by Girolamo Rainaldi and his son Carlo. Borromini frequently used

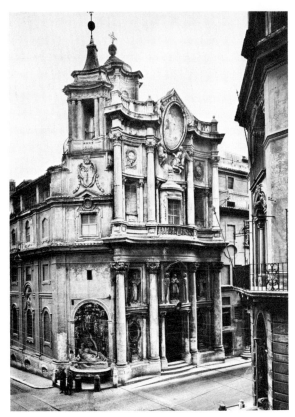

15-13 FRANCESCO BORROMINI, San Carlo alle Quattro
Fontane, Rome, 1635–67.

15-14 Interior of San Carlo alle Quattro Fontane (view toward
altar), approx. 53′ x 34′.

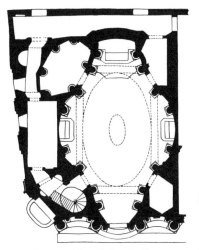

15-15 Plan of San Carlo alle Quattro
Fontane.

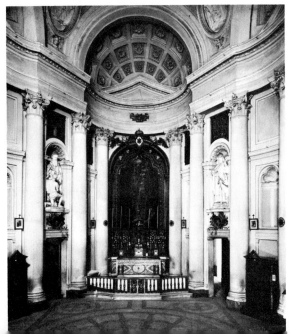

surprising combinations of curves and angles to produce directional forces. His inventive and unorthodox approach led him to squeeze proportions and thereby produce tensions, to create sudden contrasts in shapes and directions, and to provide rapid variations on thematic forms. The source of some of these tendencies is found in Mannerist architecture of the preceding century. Bernini and his followers felt that Borromini went too far, and there was antagonism between these two leaders in full Baroque architecture.

PAINTING IN THE NORTH

Seventeenth-century painting in the North was influenced by Italian art, since many Northern artists studied in Italy. For French painting, Caravaggesque lighting and the realism of Bamboccianti subject matter were important during the first half of the century. A restrained style, derived from the Carracci, but emboldened by Caravaggesque lighting, was brought to France when the Frenchman Simon Vouet returned to Paris from Rome in 1627 and acquired a large following. One of his pupils, Charles Lebrun, became director of the French Royal Academy of Painting and Sculpture in 1663. The records of the Academy meetings reveal a conflict between advocates of the restrained Baroque and those of the full Baroque; as in Italy, the hero of the conservative attitude was Poussin, while the idol of the full Baroque was Rubens.

In Holland, the prevalence of Protestantism limited the demand for religious subjects, but the merchant class provided a market for portraits, landscapes, cityscapes, interiors, genre painting, and still lifes. A number of Dutchmen returned from Rome to Utrecht and created a center of Caravaggesque painting that reached its height about 1620. In the 1640's, more Caravaggesque influence in the form of Bamboccianti painting emanated from Haarlem. There were both Italianate and Flemish strains in seventeenth-century Dutch landscape painting; the first stemmed from Annibale Carracci, Claude Lorrain, and the German Adam Elsheimer; the second came from the tradition of the Flemish painters Joachim Patinir and Pieter Bruegel. Low horizons and vast, cloudy skies are typical of Dutch landscape painting. Still life tends toward lavish displays of colors, textures, and detail in foods and utensils or toward prodigious bouquets of flowers. Sensory experience is dramatized in such work by the intensity and luxury of shapes, colors, textures, and light effects. Flanders also developed outstanding still-life

and genre painting, but the prevailing Roman Catholic religion encouraged religious subjects. In Holland, the major painter of the century was Rembrandt; in Flanders, Rubens dominated.

English seventeenth-century painting was dominated by foreigners, particularly Rubens and his pupil, Van Dyck. German and Austrian painting of the period reveals no school of real national character; there was considerable dependence on Italy and Flanders.

Peter Paul Rubens (Flanders, 1577–1640). Rubens, the leading Flemish painter of the seventeenth century, received a broad classical education and was accepted as master painter by the Antwerp Guild in 1598. In 1600, he traveled to Italy and for eight years served the Duke of Mantua as both painter and diplomat. In this capacity, he brought gifts—including many of his own paintings—to King Philip III of Spain. Spanish painting was widely influenced by the Rubens paintings that became part of the royal collections. Rubens was also active in Florence and in Rome, where he copied works by Michelangelo, Caravaggio, and others. By 1608, he was reestablished in Antwerp and was soon appointed court painter to Archduke Albert and the Archduchess Isabella. Rubens' early painting, particularly before 1620, included some relatively quiet compositions, but the majority of his work shows a remarkable assimilation of the violent action and dazzling light of Tintoretto, the massive figures of Michelangelo, the spotlighting of Caravaggio, and the warm color of Venetian painting. The *Coup de Lance* (Fig. 1-23) employs the heroic proportions, the fleshy figures, the dynamic opposition of diagonal forces, the activity, and the intimate view that are characteristic of his Baroque style. Contours tend to twist and undulate; faces tend to have large eyes, delicate flaring nostrils, and small Cupid's-bow mouths; hands and feet are small and tapering. As his style developed, Rubens used loose, fluid brushwork and paint textures ranging from heavy impasto to delicate transparent glazes. His international renown brought him many students and a number of large commissions, including the series of allegorical compositions depicting the life of Marie de' Medici (1620's, Louvre, Paris). Many assistants were necessary, but Rubens' letters to patrons indicate clearly which paintings of a given group were done by his own hand and which were done mainly by helpers. His well-organized workshop made possible an enormous productivity in spite of Rubens' time-consuming but historically important diplomatic missions to England and to Spain.

15-16
FRANS HALS, *Malle Babbe (Mad Babbe)*,
c. 1650. Approx. 30″ x 25″. Staatliches
Museen, Berlin.

Frans Hals (Holland, 1580–1666). Hals was born in Antwerp but is thought of as Dutch because he made his career as a portrait painter in Haarlem. His bohemian life and huge family made him the subject of constant lawsuits for debt and, in his later years, a recipient of assistance from the paupers' fund. From vigorous local colors and a detailed execution, Hals's style changed slowly toward grays and blacks rendered in freer brushwork. *The Banquet of the Officers of St. George* (1616, Frans Hals Museum, Haarlem) exemplifies his early work. Its casual grouping, active poses, and sweeping diagonal forms helped to loosen up the traditionally rigid compositions of Dutch group portraits and prepare the way for Rembrandt's *Night Watch.* Unlike Rembrandt, Hals took care to give almost equal illumination to each face. The *Malle Babbe (Mad Babbe)* (Fig. 15-16) reveals the dazzling impasto brushwork of his late style. The even later *Women Guardians of the Almshouse* (1664, Frans Hals Museum, Haarlem) uses somewhat more restrained execution to express a more contemplative mood. Hals's late painting was less popular than his early work; old age brought him increasing troubles and fewer commissions.

Nicolas Poussin (France and Rome, 1593/4–1665). From a peasant village in Normandy, Poussin traveled to Rouen and then to Paris, seeking instruction in art. In 1624, he carried a Mannerist style with him to Rome, where he worked in the studio of Domenichino, one of the chief pupils of the Carracci. Poussin apparently disliked the large scale required by most major commissions; his paintings are relatively small, and he depended on a small group of private patrons. His subjects are usually religious, allegorical, or mythological, but the landscape settings often dwarf the subject matter. His early works, such as *The Inspiration of the Poet* (*c.* 1628–29, Louvre, Paris), reveal the influence of Titian and Veronese. Later, his composition became more formal, with a stable structure of vertical and horizontal elements and an alignment of the main objects with the picture plane. For example, in his *Orpheus and Eurydice* (Fig. 15-17), the groups of trees, the hills, the buildings, and the river are all parallel to each other and to the surface of the painting. Gradation and climax are provided by lighting and by bright color in the foreground figures. Poussin believed that the spectator should read the gestures and symbols in the painting and that the content should be expressed logically and clearly by effective gestures and composition. Painting was to appeal to the mind more than to the senses.

Poussin's method consisted in making a rough sketch of the subject and then setting up the composition with little wax figures and linen drapery in a stagelike box in which lighting could easily be controlled. Changes were made with the figures and lighting until the composition was decided on. Poussin said that he did not paint directly from live models because he wanted to preserve idealism in the forms. The sources for his concepts of ideal form were Raphael, Raphael's follower Giulio Romano, Annibale Carracci, and Greek and Roman sculpture. With the exception of a sojourn in Paris between 1640 and 1642, Poussin made his career in Rome. His work exemplifies the conservative Baroque that started with the Carracci School. His painting was an important source for artistic theory as taught in the French Royal Academy from the mid-seventeenth century until the French Revolution.

Claude Lorrain (France and Rome, 1600–82). Claude of Lorraine or Claude Gellée is often linked with Poussin, not only because they were contemporary French expatriates in Italy, but also because they both represent the conservative Baroque. By 1627, Claude had established himself permanently in Rome. His style owed much to German and Flemish landscape painters who had settled there. Landscapes and seascapes provided the real subjects for his paintings; their Christian or mythological subjects were, even more than in Poussin's painting, merely *staffage*—that is, an intellectual or

15-17
NICOLAS POUSSIN, *Orpheus and Eurydice*, 1659. Oil on canvas, approx. 4' x 7'. Louvre, Paris.

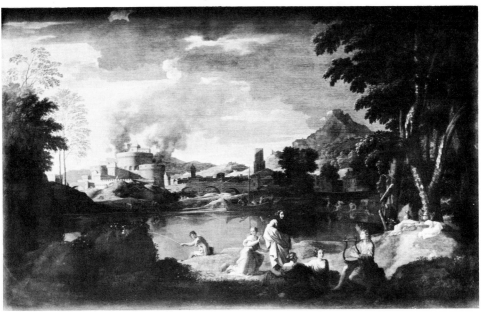

15-18 CLAUDE LORRAIN, *A Pastoral, c.* 1650.
Copper, 15⅞'' x 21⅝''. Yale University
Art Gallery, New Haven, Connecticut.

literary excuse for the landscape and a means of estab-
lishing scale or providing nostalgia for the past. Claude's
major interest was in the poetic qualities of landscapes
or seaports seen in late afternoon light. Unlike Poussin's
horizontally anchored planes with sharp edges and clear
spatial relations, Claude's landscapes suggest no such
flat stage-platform base but glide easily along rolling
hills and meadows, while the trees shimmer in the
breeze and present soft lacy silhouettes against the light.
A composition like *A Pastoral* (Fig. 15-18) is less closed
in depth than those of Poussin; the vistas give the ef-
fect of infinite space. The seaport scenes, such as *The
Embarkation of St. Ursula* (1641, National Gallery,
London), often have the spectator looking directly into
a setting sun that dissolves the details of architecture
and ships on either side. The great demand for Claude's
work encouraged forgery, and he was obliged to make
a book of drawings, the *Liber Veritatis*, that recorded
all his authentic paintings.

Rembrandt van Rijn (Holland, 1606–69). Rembrandt, the
son of a Leiden miller, studied in Leiden and Amster-
dam with minor masters. Although he admired Italian
art and eventually collected a number of Italian works,
he never traveled to Italy. His early style, exemplified
in *The Blinding of Samson* (1636, Staedel Institute,
Frankfurt), reveals the influence of Caravaggio's lighting,
perhaps by way of the Utrecht painters. He broke with
the conventionally even lighting and formal grouping
of Dutch group portraits; his celebrated *Night Watch*
(1642, Rijksmuseum, Amsterdam) subordinates some of
the company of Captain Frans Banning Cocq to shad-

owed areas. The dramatic value contrasts, the glowing color, the subtle organization of the active figures into the form of an "M" extending into depth, and the rich variety of personality all help make this painting the outstanding Baroque group portrait in the North. From the 1640's on, Rembrandt's art acquired a deeper gentleness; the drama became less physical and more psychological. The *Supper at Emmaus* (Plate 3) has the deeper chiaroscuro, the softer light, the suppression of local color, the reduction of physical movement, and the portrayal of intense human relationships that characterize his later work. Detail has been sacrificed to the fluidity of heavy impasto in the lighted areas and deep glazes in the shadows. Rembrandt produced many of his major etchings between 1650 and 1669. The velvet-rich blacks—often reinforced with drypoint—and the quick, telling character of the lines have made these works masterpieces in the history of printmaking. Although portraits were an important source of income for him, he painted an unusually large number of religious subjects, many of them done, like his self-portraits, for his own satisfaction. Like Caravaggio, but unlike Rubens, Rembrandt visualized Biblical events in terms of common people with unheroic proportions and individual features, although he did occasionally use exotic costumes for accessories. Rembrandt's landscape paintings make striking use of stormy skies, areas of luminous foliage, dramatic cloud shadows, and architectural ruins. Rembrandt acquired several students and some wealth, but the death of his wife in 1642 marked the beginning of a period of poor financial management that finally drove him to bankruptcy. His last years were probably unhappy ones, for his fame had been eclipsed in his own country by the successes of younger men.

Jan Vermeer (Holland, 1632–75). Little is known about the life of the greatest of the Dutch painters of interiors. He made a precarious living as painter and a picture dealer and left his widow with a large family and numerous debts. Only thirty-six paintings are now attributed to him, but his limited output seems to have found a ready market. Although Vermeer was a genre painter, he is more readily thought of as a painter of interiors because the quiet human activity in his pictures is usually subordinated to the structure of the composition and to the play of light on colors and textures. As in Poussin's landscapes, most of the larger objects in Vermeer's interiors are parallel to the picture plane, and we experience the picture space in a measured progression from one parallel to another. Occasionally, diago-

15-19

JAN VERMEER, *Young Woman with a Water Jug, c.* 1665. Oil on canvas, approx. 18″ x 16″. Metropolitan Museum of Art, New York (gift of Henry G. Marquand, 1889).

nal forms accelerate the transitions between the parts. The shapes also build a system of interlocking rectangles whose sides are often aligned with the sides of the painting, further emphasizing the static serenity of an all-pervasive order. In such works as *Young Woman with a Water Jug* (Fig. 15-19), the underlying geometry is given relief by the curves and irregular forms of people and drapery. Light and shadow are used to group objects and to subordinate large areas of a composition in order to focus on others; light seems to wash the spaces and reveal textures and colors with gentle softness. This effect comes from minute pearl-like globules of paint and from the softening of the shadow areas with reflected light.

SCULPTURE IN THE NORTH

France was the major center of seventeenth-century sculpture in the North. During the first half of the century, however, France was represented by men of competence rather than genius. Style in portraiture tended toward much heavy detail, while allegorical, mythological, and religious subjects received some idealization of form. Objects were clearly defined, and drapery was simpler and less active than in Italian full Baroque work. Essentially, the French sculptors were conservative. The second half of the century saw more

inspired sculpture, much of it done under the auspices of the French Royal Academy for the enormous palace at Versailles. Bernini was a major influence, but the restraint of French sculptors tempered their borrowings from Italy.

François Girardon (France, 1628–1715). Girardon subscribed to the taste and theory of the French Academy, worked closely with the director Lebrun, and established his career with the commissions for Versailles. Girardon was very interested in ancient sculpture; his famous *Apollo Tended by the Nymphs* (Fig. 15-20) shows the influence of Greek art in the profiles of the faces, the serene poses, and the relatively calm drapery. The original arrangement of the statues was more symmetrical than the present one. Similarly quiet contours and smooth transitions from part to part can be seen in Girardon's tomb of Richelieu (1675–77, Sorbonne, Paris). Girardon represents the restrained Baroque attitude that was shared by such artists as Poussin.

ARCHITECTURE IN THE NORTH

France, like Italy, developed city planning as an adjunct to seventeenth-century architecture. Parisian squares and circular places utilized converging avenues for focal emphasis on a special building. The triumph of the age was Versailles, the court palace of Louis XIV, where vast gardens and enormous buildings collaborate in an all-encompassing geometric plan. French churches of the period show the restraint, as well as the Italian

15-20 FRANÇOIS GIRARDON, *Apollo Tended by the Nymphs, c.* 1668. Marble. Park of Versailles.

influence, seen in French sculpture. A distinctly French town house evolved in the *hôtel particulier*, a central structure that had side wings embracing a court with an entry gate facing the street.

English architecture had imported Renaissance details in the sixteenth century, but not until the seventeenth century did the total effect of plan, structure, and detail become Renaissance in attitude, largely through the influence of the sixteenth-century Italian Andrea Palladio. The great fire of London in 1666 allowed a fresh start to be made in city planning and architecture. More squares were created, helping to open up the dense city. The rebuilding of churches provided England's first Baroque architecture; the style was influenced mainly by Italy but showed considerable restraint.

In the Low Countries, Holland was inspired by Palladio, but Flanders produced an architecture of strident Italianate Baroque with a special Flemish insistence on fantastically ornate gables.

In German and Austrian architecture, Italy provided the models for churches, while Versailles was the model for palaces. Italian architects were frequently employed, and on several occasions German and Austrian architects were sent to Paris to have their plans approved by leading French architects.

Inigo Jones (England, 1573–1652). We know little of Jones's background, but he traveled in Italy, gained a reputation in England as a designer of stage sets, accompanied the Earl of Arundel on a European trip, and was appointed to the highest architectural office in England—Surveyor of the King's Works. It was Jones who finally brought to England a classical attitude in the total design of a building. The austere formality of his Queen's House (Fig. 15-21) depends on stark simplicity of plan and elevation, precise symmetry, and a crystalline clarity in all the parts. The rigid equilibrium of quiet, unbroken lines and plain wall surfaces suggests the work of Palladio, Jones's major inspiration. Jones's best-known building, the banqueting hall at Whitehall Palace (1619–22, London), has slightly more activity in its three-dimensional variation and in decorative elements. His first ecclesiastical building was the Queen's Chapel, St. James Palace (1623–27, London), where the flat wall surfaces of a rectangular box are broken only by severely simple window frames and limited by sharply defined *quoins* (especially bold stonework used to emphasize the corners of a building), corbeled cornices, and a corbeled pediment. A Palladian

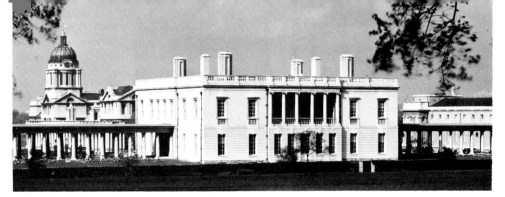

window is used at the east end. Jones's architecture inspired a number of followers and was the major source for the eighteenth-century architectural trend in England called the Palladian movement.

François Mansart (France, 1598–1666). Mansart was one of the most competent French architects of the seventeenth century, but his independence and his difficult disposition apparently limited the number of his commissions. Just as Inigo Jones set the key for the general conservatism of English architecture, so Mansart represents the restraint of French designers. His new wing for the Château at Blois (1635–38) has a court façade with very restricted decoration and modest variation in

15-22 FRANÇOIS MANSART and JACQUES LEMERCIER, Val-de-Grâce, Paris, 1645–66. 133' high.

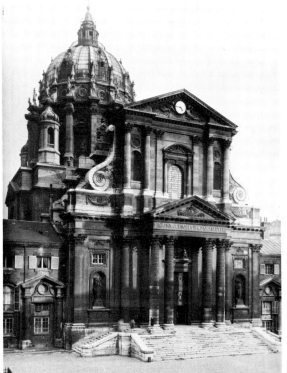

15-23 Interior of Val-de-Grâce.

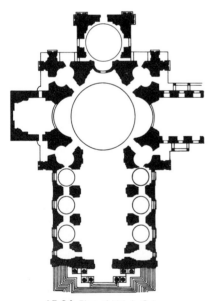

15-24 Plan of Val-de-Grâce.

depth, but the powerful focus on the entrance is typical of the Baroque. Curving colonnades fill in the corners and lead our attention to the pavilion, where pilasters, engaged columns, a decorated pediment, a shield, and breaks in the cornice and in the roof levels all provide an effect of gradation and climax for the entrance. He used the classic succession of orders, from Doric below to Corinthian above. The most complete surviving work by Mansart is the Château of Maisons (1642–51), which consists of a rectangular main structure flanked by two freestanding wings at the sides. The main building, like the wing at Blois, has very clear vertical and horizontal lines and a relatively shallow buildup of layered masses around the frontispiece. As at Blois, the classic succession of orders was used. Inside, the crisply carved ornament is unified by the exclusive use of white stone, without color or gilt paint. Mansart also planned the Val-de-Grâce in Paris (Figs. 15-22–15-24) and was responsible for construction up to the second story of the façade and up to the vaults of the nave. The second story, the vaults, and the dome were completed by Jacques Lemercier. The plan is that of a Latin cross basilica with a chapel added to the rear of the apse,

all quite simple and stable compared with plans by an Italian like Borromini. The nave is divided from the side aisles by Roman arches and piers with Corinthian pilasters; the entablature is simple, and the richest ornamentation is saved for the vaulting. On the exterior, the façade employs the Corinthian order. On the first level, the façade moves from corner pilasters to engaged columns and then to the freestanding columns of the porch. Above, Lemercier reversed the effect by making the engaged columns at the sides come forward while the center pulls back, taking the horizontal molding of the upper pediment with it. The large scroll buttresses at the sides of the upper level are indebted to Italian architecture.

Sir Christopher Wren (England, 1632–1723). Wren started his remarkable career as an astronomer and inventor of practical devices of all kinds. His first architectural work of significance was the Sheldonian Theater at Oxford (1662–63), a design inspired by the Roman Theater of Marcellus as described in one of Serlio's books. In 1665, Wren traveled in France and visited many major works of architecture. His great opportunity came the following year when the London fire destroyed eighty-seven parish churches. As one of the

15-25
SIR CHRISTOPHER WREN,
St. Paul's Cathedral, London,
1666–1717.

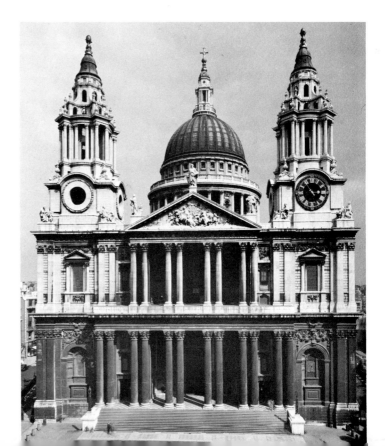

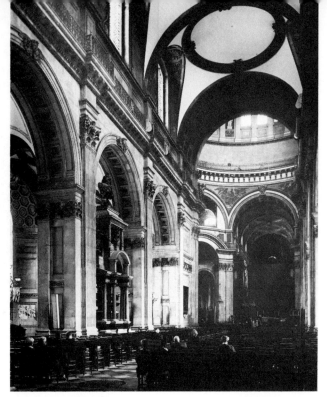

15-26 Interior of St. Paul's.

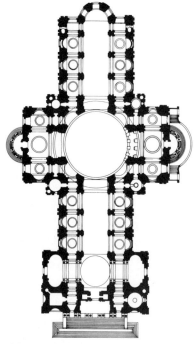

15-27 Plan of St. Paul's.

Commissioners for Rebuilding the City of London, and as Surveyor-General of the Royal Works, Wren designed many of the new churches. Like many of the architects of his day, Wren learned much from the designs of the ancient Roman Vitruvius and was aware of seventeenth-century Italian architecture. Nevertheless, the London churches show considerable originality. Their most Baroque qualities are found in the steeples. The best-known example of Wren's work is St. Paul's Cathedral (Figs. 15-25–15-27), which developed from an early design in central form to a Latin cross basilica with Baroque complexity in the many-layered façades. The west façade employs deep porches for dramatic shadow and lavishly ornamented towers that recall Borromini's Sant' Agnese in Piazza Navona. A deep colonnade provides sharp value contrasts at the base of the drum from which the great dome springs. Inside, colors and materials are varied, but the basic form of the interior space is relatively simple. This most Baroque of Wren's churches seems conservative in comparison with full Baroque design in Italy. Wren's Royal Hospital at Chelsea (1682–89) and his designs for Hampton Court Palace (1682–89) reveal even more clearly his essential reserve.

Suggestions for Further Study

Bergström, Ingvar. *Dutch Still-Life Painting in the Seventeenth Century.* Translated by Christina Hedström and Gerald Taylor. New York: Thomas Yoseloff, 1956.

Blunt, Anthony. *Art and Architecture in France: 1500–1700* (Pelican History of Art). Baltimore: Penguin Books, 1953.

Châtelet, Albert, and Jacques Thuiller. *French Painting from Fouquet to Poussin.* Translated by Stuart Gilbert. Geneva: Skira, 1963.

Downes, Kerry. *English Baroque Architecture.* London: Zwemmer, 1966.

Friedländer, Walter. *Nicolas Poussin: A New Approach.* New York: Abrams, 1964.

Gerson, Horst, and Engelbert H. ter Kuile. *Art and Architecture in Belgium: 1600–1800* (Pelican History of Art). Translated by Oliver Renier. Baltimore: Penguin Books, 1960.

Haak, Bob. *Rembrandt: His Life, His Work, His Time.* New York: Abrams, 1969.

Hempel, Eberhard. *Baroque Art and Architecture in Central Europe: Germany, Austria, Switzerland, Hungary, Czechoslovakia, Poland* (Pelican History of Art). Baltimore: Penguin Books, 1965.

Kaufmann, Emil. *Architecture in the Age of Reason: Baroque and Post-Baroque in England, Italy, and France.* Hamden, Conn.: Archon Books, 1966.

Pope-Hennessy, John. *Italian High Renaissance Sculpture, Part III: An Introduction to Italian Sculpture.* 3 vols. New York and London: Phaidon Press, 1963.

Rosenberg, Jakob. *Rembrandt.* 2 vols. Cambridge, Mass.: Harvard University Press, 1948.

———; Seymour Slive; and E. H. ter Kuile. *Dutch Art and Architecture, 1600–1800* (Pelican History of Art). Baltimore: Penguin Books, 1966.

Rothlisberger, Marcel. *Claude Lorrain: The Paintings.* 2 vols. New Haven, Conn.: Yale University Press, 1961.

Summerson, John. *Architecture in Britain: 1530–1830* (Pelican History of Art). Baltimore: Penguin Books, 1953.

Swillens, P. *Johannes Vermeer: Painter of Delft, 1632–1675.* Translated by C. M. Breuning-Williamson. Utrecht: Spectrum, 1950.

Trapier, Elizabeth du Gué. *Velázquez.* New York: Hispanic Society of America, 1948.

Waterhouse, Ellis. *Painting in Britain, 1530–1790* (Pelican History of Art). Baltimore: Penguin Books, 1953.

Whinney, Margaret. *Sculpture in Britain, 1530–1830* (Pelican History of Art). Baltimore: Penguin Books, 1964.

White, Christopher. *Rubens and His World.* New York: Viking Press, 1968.

Wittkower, Rudolf. *Art and Architecture in Italy, 1600–1750* (Pelican History of Art). Baltimore: Penguin Books, 1958.

———. *Gian Lorenzo Bernini: The Sculptor of the Roman Baroque.* London: Phaidon Press, 1955.

Chapter 16

Later Baroque, Rococo, and Neoclassic Art:

1700–1800

Baroque stylistic tendencies continued in much eighteenth-century art; however, two other major trends developed and acquired labels. *Rococo* art retained the complexity of the Baroque but sacrificed power for refined elegance and a delicate, light profusion of forms. *Neoclassicism* was, in part, a reaction against Baroque and Rococo characteristics. Neoclassic theory, promulgated by the German archaeologist and art historian Johann J. Winckelmann, was stimulated by the discovery and excavation of two Roman cities that had been buried by a volcanic eruption in 79 A.D.: Herculaneum and Pompeii. The increasing importance of Neoclassic art after 1750 has led some scholars to consider that date as the end of the Baroque period. One aspect of the Baroque that developed during the eighteenth century was an aesthetic concept called the *sublime*. This was presented in works like Edmund Burke's essay "The Sublime and Beautiful" (1756), which distinguished between the beautiful and the sublime in that the latter could include the ugly. While much eighteenth-century effort sought to unravel the systematic order of nature and bring it under man's control, the lovers of the sublime gloried in the mysterious power of nature over man. The sublime could be frightening, painful, or astonishing; it stimulated the emotions and the imagination. The concept of the sublime was fostered by Goethe and the *Sturm und Drang* movement, which emphasized the struggle of the individual against the world. It was the interest in the sublime that provided a basis for the broad nineteenth-century attitude called *Romanticism*.

The eighteenth century saw French art assume the position of leadership that Italian art had enjoyed previously; and French institutions, such as the Royal Academy, were imitated by other countries.

The late seventeenth and the eighteenth centuries are often called the *Age of Enlightenment*. Major scientific discoveries were made, but the term refers especially to a spirit of rationalism, empiricism, and skepticism in social and political thought. Locke, Voltaire, Rousseau, and Diderot criticized existing society and spread ideas about human rights that laid the basis for the American and French revolutions. Also basic to these revolutions was the rise of the bourgeoisie to a position of power from which it could challenge the aristocracy. Bourgeois power, like the concepts of mercantilism and colonial expansion, developed as a result of accelerating growth of commerce and industry. This environment affected, directly or indirectly, much of the art of the period.

French painting continued to be dominated by the Royal Academy until the time of the Revolution. The older Academy of St. Luke, which had grown out of the guild system, was held down to a secondary role. No painter could paint and sell pictures unless he was a member of one of these academies. The Royal Academy acquired a virtual monopoly on exhibitions; its *Salon*, a periodic exhibition named for its location (after 1725) in the Salon Carré of the Louvre, had royal sanction. Until 1748, all members could exhibit in the Salon; after that time, a jury of academicians screened submitted works. Academic teaching used various methods, from apprenticeship under a master to copying accepted masterpieces from sixteenth-, seventeenth-, and eighteenth-century painters, drawing from plaster casts of Greek and Roman sculpture, and drawing from live models. Prizes were given for the best work in anatomy, perspective, facial expression, and other categories. The most important prize was the *Prix de Rome*, which since its establishment in the seventeenth century has given selected students the opportunity to study at the French Academy in Rome. Leading academicians gave periodic discourses on theory and principle. In the seventeenth century, a hierarchy was established for subject matter; history painting—religious, historical, allegorical, or mythological subjects—was the highest category, and only painters of history could become professors. Following history painting came portraiture, genre painting, landscape (including seascapes and city views), animal painting, and still life. Early in the century, another category, that of the *fête galante* (an elegant outdoor entertainment), was added to sanction the popularity of Watteau's work. The style of history painting owed much to Rubens and to sixteenth- and seventeenth-century Italian masters. The conflict between *Poussinistes* and *Rubénistes* in the Academy was won by the *Rubénistes* early in the century, but the full Baroque styles gave way increasingly to the lighter colors and playful intricacy of the Rococo. Mythological subjects became more intimate than heroic, more gay than dignified. Genre painting gained in popularity during the period of Louis XV and often shows Rococo characteristics. Portraiture became more casual and livelier in pose and expression. Pastel portraits enjoyed great vogue. Landscape was often combined with battle scenes or with ruins, the style varying from repetitive formulas to the freshness of direct observation from nature. The major source for landscape, animal painting,

and still life was seventeenth-century Dutch, Flemish, and Italian painting. The reign of Louis XVI and the revolutionary period that followed reemphasized history painting and introduced the Neoclassic style. Simplicity in accessories, clarity of contours, and rigid organization supplanted the billowing power of the Baroque and the tinkling delicacy of the Rococo. The French leader of Neoclassicism was the painter Jacques Louis David, who will be considered at length in the following chapter.

In England, a royal academy was not founded until 1768. Although its first president, Sir Joshua Reynolds, stressed in his famous discourses the superiority of history painting, he and other English painters found portraiture to be more rewarding financially. The glory of eighteenth-century English painting is its portraiture, ranging from heroic poses, idealized faces, and pompous settings to casual poses, candidly recorded faces, and unassuming environments. Genre painting and satire were also significant in England, and style ran the gamut from caricature to tentative and humble faithfulness to natural detail. Although seventeenth-century Dutch landscape and seventeenth- and eighteenth-century Italian landscape were popular with English collectors, English landscape painters were not given great encouragement at home. Despite this situation, Englishmen produced some outstanding landscape painting that varied from the delicate detail of John Crome's watercolors to the broadly brushed, sparkling watercolors of Alexander Cozens, and from the deliberate rendering of Richard Wilson's ideal landscape to the filmy brushwork of Gainsborough. In the realm of animal painting, George Stubb's carefully rendered horses appealed to a major interest of the aristocracy. Neither Rococo nor Neoclassic stylistic qualities were developed in England as fully as on the Continent.

In German regions during the eighteenth century, the northern areas were influenced by Holland and France; southern areas were inspired by Italy. Imported painters strengthened such influence, but a vigorous native Rococo style developed in the religious paintings of the German C. D. Asam and in the work of the Austrian Franz Anton Maulbertsch. German painters living abroad, such as Anton Raffael Mengs and Asmus Carstens, were leaders in developing Neoclassic art.

Antoine Watteau (France, 1684–1721). Of the three major eighteenth-century French painters whose art represents the Rococo style, Watteau is the earliest. He came from the Franco-Flemish city of Valenciennes to

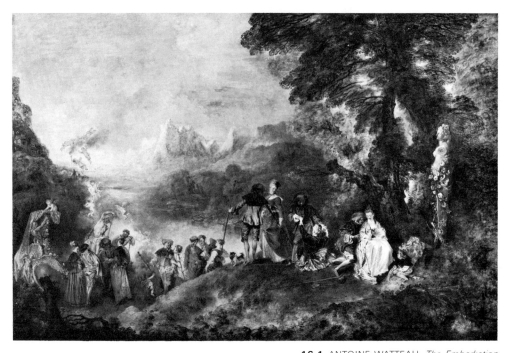

16-1 ANTOINE WATTEAU, *The Embarkation for Cythera*, 1717. Oil on canvas, approx. 4' x 6'. Louvre, Paris.

Paris, where he found an international market for his work, partly through the help of several wealthy patrons. His painting was so successful that in order to accommodate it the French Academy created a new category of subject matter: the *fête galante*. Although Watteau painted religious works, portraits, and scenes with soldiers, the majority of his works depict characters or scenes from theatrical comedy or from the French aristocracy at leisure. His procedure was to paint directly on the canvas without elaborate preparatory drawings, but he composed by selecting figures from a large collection of sketches made from life. Thus his compositions are not so much records of a particular event as they are imaginative constructions. The famous *Embarkation for Cythera* (Fig. 16-1) is derived from a play and depicts a gay company about to sail for the legendary island of love. The painting is typical of Watteau in its soft, dreamlike landscape, luxurious costumes, dainty slender figures, and rich silvery colors. Its seeming casualness in composition and its softness in form contrast sharply with the paintings of Poussin. Indeed, the French Academy's acceptance of Watteau in 1717 represents one of the triumphs of the *Rubénistes*. Watteau's idol was Rubens; the delicate pointed noses, small mouths, and tapering hands of Rubens' people reappear with slender bodies and more restrained sensuality in the art of the Frenchman. Watteau also learned from the Rubenesque painters in Paris and from the

art of sixteenth-century Venice. He chose not to portray important historical actions; instead he depended on the spectator's associations or emotional responses to lyrical variations on the themes of theatrical entertainment and a leisurely aristocracy in natural settings. Sometimes it is difficult to distinguish between actor and aristocrat, between theater and *fête galante.*

William Hogarth (England, 1697–1764). The famous eighteenth-century satirist began as an apprentice to a silver-plate engraver but soon turned to painting and produced a number of *conversation pieces*—group portraits posed as an informal gathering with a suggestion of typical activity or anecdote. In 1731, Hogarth painted six works that were engraved and distributed the following year under the general title of *The Harlot's Progress.* The moralizing story of the downfall of a young woman in the big city was immediately successful and inspired a number of unauthorized copies. Hogarth then promoted the Copyright Act for Engravers (1735) to secure his market and proceeded to make engravings of a similar series, *The Rake's Progress,* eight scenes portraying the dissolution of a young man. (The third scene is shown in Figure 16-2.) Such work was far more lucrative than the history painting that was Hogarth's ambition; yet the artist did occasional history paintings and continued with portraiture while he produced paintings for the engravings that were both moralizing and satirical. His satire was aimed at all classes, striking sometimes at topical events, sometimes

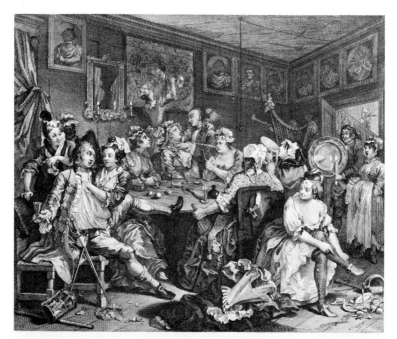

16-2
WILLIAM HOGARTH, *The Orgy,* Scene III from *The Rake's Progress.* Metropolitan Museum of Art, New York.

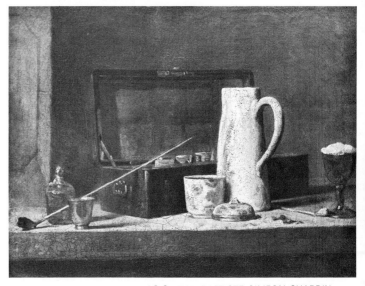

16-3 JEAN-BAPTISTE SIMEON CHARDIN, *Clay Pipes and Earthenware Jug.* Louvre, Paris.

at specific facets of British society, and sometimes at universal human weaknesses. His remarkable visual memory was aided by a mnemonic system that he devised for remembering the positions and gestures of principal characters in a witnessed event. Hogarth formed his own St. Martin's Lane Academy for teaching art and became a governor of the Foundling Hospital, where he arranged for picture exhibitions; he also found time to write a theoretical treatise, *The Analysis of Beauty* (1753), urging the aesthetic values of asymmetry, intricacy, and the serpentine line. Although the proportions, intricacy, and frequent intimacy of his paintings link him with the Rococo, he was indebted to seventeenth-century Dutch genre painting and to the fifteenth- and sixteenth-century art of Bosch and of Bruegel the Elder. Hogarth was the predecessor of such satirical artists as Goya and Daumier.

Jean-Baptiste Siméon Chardin (France, 1699–1779). After working as an assistant to the painter Noël Coypel, Chardin was accepted by the Royal Academy in 1728 as a "genre painter of animals and fruit." In the tradition of seventeenth-century Dutch genre and still life, he painted works such as *The Mother's Advice* (1739, Collection of the Prince of Liechtenstein) and *Clay Pipes and Earthenware Jug* (Fig. 16-3). His art is outstanding in its subtlety of color, light, and texture. By 1740, Chardin enjoyed critical acclaim and an international demand for his paintings as well as for the engravings done after them. He spent considerable time copying his own works to satisfy collectors. By 1755, he was treasurer of the Academy and in charge of

hanging exhibits. In his later years, when public favor had shifted from his still-life painting to the more moralizing and anecdotal art of others, Chardin turned to portraiture in pastels, where the crosshatching of color used in his oils is amplified.

Fançois Boucher (France, 1703–70). Boucher was the second major representative of French Rococo art. He was admitted to the Academy in 1734 and became first painter to King Louis XV in 1765. As a favorite of Madame de Pompadour, the mistress of the king, Boucher received many commissions, was made director of the Gobelins Tapestry Works, and designed tapestries as well as figures for the Royal Porcelain Factory at Sèvres. Boucher's subjects ranged from the religious to landscape, but the most frequent are allegory and mythology presented with dainty sensual figures in powder-puff landscapes that suggest stage settings. A typical example is *The Captive Cupid* (Fig. 16-4). The pretty faces, coy poses, sweet colors, delicate accessories, and lilting lines all relate Boucher to the Rococo decorations of his early master, François Lemoyne. To appreciate such art, we must not demand depth or monumentality; Boucher's graceful facility was employed to create a pleasant, carefree world that ignores the problems of real life.

Thomas Gainsborough (England, 1727–88). Gainsborough started as an assistant to an engraver who had studied under Boucher. As a restorer of seventeenth-century Dutch landscape paintings, Gainsborough acquired a love for landscape but found portraiture more profitable. His landscapes vary from the earthy Dutch details of *Gainsborough's Forest* (c. 1748, National Gallery, London) to the soft, airy forms of *Mountain Landscape with Sheep* (c. 1783, Collection of the Duke of Sutherland, Sutton Place, Surrey). Gainsborough's portraiture moved from the solid detailed style of *Mr. and Mrs. Andrews* (c. 1749, Collection of G. W. Andrews, Redhill, Surrey) to light, freely brushed backgrounds, rather insubstantial bodies, and fairly solid heads, as in *The Morning Walk* (Fig. 16-5). The gauzelike background and the fluffy forms recall Watteau, whose works Gainsborough had copied. Although the full-blown Rococo never found a footing in England, Gainsborough began what has been called English Rococo portraiture. Late in life, he also developed what he called "fancy pictures," genre scenes combining pretty, unsophisticated children and rustic nature. From 1761 on, Gainsborough exhibited with the

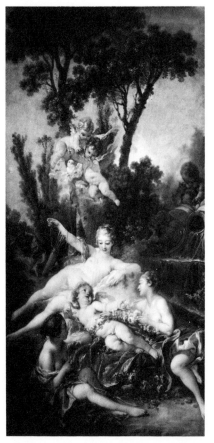

16-4
FRANÇOIS BOUCHER, *The Captive Cupid,* 1754. Wallace Collection, London.

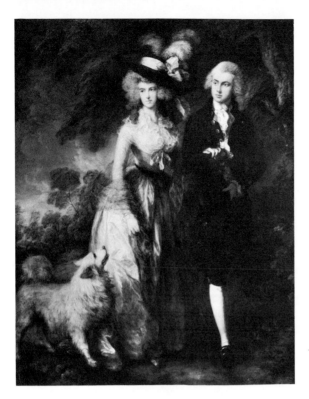

16-5
THOMAS GAINSBOROUGH, *The Morning Walk*, 1785. Lent by Lord Rothschild to the Birmingham Art Gallery.

London Society of Artists, and he was one of the original members of the British Royal Academy at its founding in 1768.

Jean-Honoré Fragonard (France, 1732–1806). The third major representative of the Rococo lived through the French Revolution and beyond his own era. Fragonard left Chardin's instruction for the studio of Boucher, where the student copied the master so skillfully that it is sometimes difficult to distinguish between their works. In 1752, Fragonard won the Prix de Rome and, during his stay in Italy, was deeply impressed by the work of Pietro da Cortona and Giovanni Battista Tiepolo. His other idols were Rubens and Rembrandt. Although Fragonard offered a history painting as his acceptance work for the Academy, he chose as his role the development of the subjects and the Rococo style of Watteau and Boucher. Fragonard's dazzling technical facility is evident in *The Marionettes* (c. 1770, A. Veil-Picard Collection, Paris), in which the *fête galante* has acquired glowing pools of light and color and contrasts of impasto with glazes. One thinks of Rembrandt, but Fragonard's lightness of touch, the dainty proportions of the figures, the breaking up of the forms, and the fluttery, rippling line are all thoroughly Rococo. Like Boucher, Fragonard often painted panels to be used as

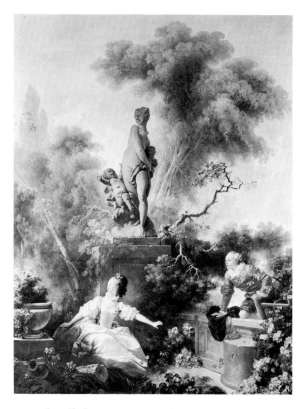

16-6 JEAN-HONORÉ FRAGONARD,
The Rendezvous, 1773.
Frick Collection, New York.

part of wall decorations in Louis XV interiors. Well-
known examples are the panels on the theme of love
(Fig. 16-6), which Fragonard executed for Madame du
Barry, the lady who succeeded Madame de Pompadour
as the mistress of Louis XV.

SCULPTURE IN THE NORTH

As in painting, the three general trends in sculpture
were (1) a continuation of the seventeenth-century
Baroque, ranging from stereotyped forms to a robust
naturalism; (2) a Rococo style, emphasizing lilting,
playful curves, intricate details in accessories, and slen-
der proportions; and (3) a Neoclassic tendency toward
simplification, quiet equilibrium, and long sweeping
curves. Neoclassicism was especially important in the
second half of the century. France was the most prolific
producer of sculpture, but after the death of Louis XIV
in 1715 the number of commissions for Versailles de-
clined. The nobles were less attached to the court; they
built town houses in Paris and furnished them with
small sculptures in the Rococo style. Statuettes of por-
celain and terra cotta were produced at the Sèvres
workshops, a special interest of Louis XV's favorite,
Madame de Pompadour. Baroque and Neoclassic styles

were preferred for public monuments and other large works. Some sculptors modified their style to suit the commission.

In German areas, demand was greater for small sculpture than for monumental works. Meissen porcelain inspired the manufacture of France's Sèvres; but northern Germany imported French sculptors and French influence, while southern Germany and Austria were influenced by Italian sculpture, particularly in the stucco sculpture for their ornate Rococo churches.

Sculpture was meager in eighteenth-century England. French Baroque influence was brought to England by the sculptor Louis François Roubillac. Italian influence came from several leading Englishmen who studied in Italy. John Flaxman, for example, sent designs and sculpture from Italy to Wedgwood in England. The resulting Wedgwood ware is Neoclassic in the manner of Robert Adam decoration, that is, with a touch of Rococo delicacy. Otherwise, the Rococo did not take root in English sculpture.

Cosmas Damian and **Egid Quirin Asam** (Bavaria, 1686–1739 and 1692–1750). The Asam brothers were trained by their father, Hans G. Asam, and had the benefit of a year in Rome (1712), where they were impressed by the works of Giovanni Lorenzo Bernini, Giovanni Battista Gaulli, Andrea Pozzo, and Pietro da Cortona. The brothers formed a partnership but also worked separately. Cosmas Damian specialized in fresco painting and Egid Quirin in stucco ornament and sculpture. Their early collaborations include *The Assumption of the Virgin* (Fig. 1-27) above the high altar in the monastery church at Rohr, near Regensburg. In this overwhelming demonstration of Baroque dramatics, the sculpted figures of the gesticulating Apostles are gathered around the sarcophagus, while Mary ascends toward sculpted clouds and metallic rays that partially eclipse the architecture. The highly colored sculpture of the Madonna and the supporting angels presents a light, active, irregular group that contrasts with a darker curtain suspended in the background. The avoidance of framing and the concentrated lighting from above and from the sides are typically Baroque. The complexity, activity, and richness of the forms indicate a continuation of seventeenth-century sculptural-architectural combinations. The more delicate forms of the Rococo had not yet sapped the boisterous strength of Baroque composition. The later work of the brothers, however, became more Rococo.

16-7 JEAN ANTOINE HOUDON, *Voltaire*, 1781. Comédie Française, Paris.

Jean Antoine Houdon (France, 1741–1828). Houdon studied under the Baroque sculptors Jean-Baptiste Pigalle and Michel-Ange Slodtz, won prizes as a youth at the Academy, and spent the years from 1764 to 1768 at the French Academy in Rome. His thorough study of anatomy was demonstrated in the *Écorché* (c. 1766, École des Beaux Arts, Paris), a statue of a man without skin. Copies of this work served as study aids for anatomy classes in art schools. However, Houdon decided early on portraiture as a specialty and received many commissions from the nobility. His portrait style was one of keen characterization and precise detail. He used neither the delicate forms of the Rococo nor the generalization of the Neoclassic. Between 1771 and 1789, Houdon undertook a series of portraits of great men, including Voltaire (Fig. 16-7). His fame spread, and the esteem of Benjamin Franklin and Thomas Jefferson led to the commission for the full-length statue of George Washington (1785) in the State Capitol of Virginia, at Richmond. Houdon adopted a more Neoclassic style in a number of lesser-known works with mythological or allegorical subjects. He lived beyond the Revolution and continued to receive commissions, although he did not enjoy the favor of David, the leader of the Neoclassicists, or the patronage of Napoleon.

ARCHITECTURE IN THE NORTH

Eighteenth-century French architecture displayed a very restrained Baroque stylistic tendency that continued through most of the century and received the official sanction of the Academy. During the reign of Louis XV, the Rococo style was popular for interiors; bold surface projections were flattened, and pilasters and engaged columns were replaced by encrustations of dainty floral ornament and fluttering ribbons that break through any restraining geometric frames. Curves obscure, soften, and complicate the straight structural lines. Large halls gave way to small apartments and intimate rooms. Occasionally the Rococo was used for an exterior. The discovery of the buried Roman cities of Herculaneum (found in 1719) and Pompeii (found in 1748) provided inspiration for Neoclassicism, which developed in several directions after 1750. Simpler interiors with uninterrupted lines, rectangular rigidity, and more dependence on Roman ornament appeared in the work of Jacques-Germain Soufflot. With architects like Charles Nicolas Ledoux, however, simplicity and Greco-Roman elements were combined with jolting contrasts, grandiose scale, and surprisingly imaginative forms. The Rev-

olution slowed building but strengthened the preference for the Neoclassic, partly because it was associated with the republican governments of certain periods in Greek and Roman history.

German eighteenth-century architecture developed a variety of styles within the general trends of Baroque, Rococo, and Neoclassicism. Some of the leading architects studied in Italy and France, and designers from these countries were brought to Germany. Churches of the early eighteenth century show the influence of the Italian Baroque. By mid-century, southern Germany and Austria were creating churches with rich Rococo interiors. Palaces were inspired by both Italian and French examples. Exteriors are often quite reserved, with decoration in low relief that does not obscure the basic masses; interiors could be lavishly Rococo. Winckelmann's influence was important in the second half of the century, and Neoclassicism waxed strong, particularly in Berlin. Neoclassic interiors often resemble those by Adam in England and suggest faint echoes of the delicacy of the Rococo.

The eighteenth century in England opened with the reserved Baroque that had developed in the previous century. After 1710, this tendency was challenged by the *Palladian Revival,* a movement espousing a return to the simpler Roman forms of the sixteenth-century Italian Palladio. A third tendency is evidenced by the occasional designs in Romanesque or Gothic styles. The ruins of Medieval architecture could be appreciated, as could Roman ruins, for their *picturesque* qualities of rough, irregular, and varied forms, and for their *sublime* qualities, which evoked nostalgic enjoyment of man's smallness and of the transitory character of his achievements in the face of nature's vastness and power. Furthermore, Gothic ornament could be appreciated for having some Rococo qualities. Neoclassic architecture developed in the second half of the century under the leadership of Robert Adam, Sir William Chambers, and Sir John Soane. It is notable that a given architect might work in several of these four trends.

Johann Bernhard Fischer von Erlach (Austria, 1656–1723). After his training in Rome, Fischer von Erlach returned to Vienna, where he became a leader in seventeenth- and eighteenth-century Austrian architecture. His church of St. Charles Borromaeus (Figs. 16-8–16-10) provides a strong focus on the main altar, which is placed in an extension at one end of an elliptical interior space. At the opposite end, a wide narthex is placed at a right angle to the elliptical center section. The

16-8
JOHANN BERNHARD FISCHER VON ERLACH,
St. Charles Borromaeus, Vienna, 1716–37.

exterior façade of this narthex consists of a Corinthian porch connected by two concave wings to towers at the sides. Within the concave areas at each side of the porch stand two tall columns with spiral reliefs in the manner of the ancient column of Trajan in Rome. Above the impressive façade looms a high dome set over the elliptical interior. The total effect both inside and out is one of dramatic contrasts between parts, but there is greater restraint in ornament than in many Italian Baroque churches.

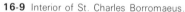
16-9 Interior of St. Charles Borromaeus.

16-10 Plan of St. Charles Borromaeus.

Balthasar Neumann (Germany, 1687–1753). Neumann was trained by the Würzburg bronze caster Sebald Kopp, and in addition gained considerable experience as a military engineer-architect. In 1720, he was given responsibility for the building of the Episcopal Residence at Würzburg and, in 1723, was sent to Paris to study French architecture. The Residence, like so many other eighteenth-century palaces, owes much to Versailles. French influences were important in the development of Neumann's Rococo style, which left a strong imprint on the architecture of southern Germany. Of his many buildings, the most celebrated church is that of Vierzehnheiligen (The Fourteen Saints, Figs. 16-11–16-13). Here, the façade pushes forward in a convex center framed by engaged columns and broken pediments; the twin towers become more complex and bolder in value contrasts as they rise. Rococo touches can be seen in the lilting curves of pediments and window frames, but the real drama is in the interior. Neumann's basilica plan was based on ovals and circles, producing even more restless wall planes than those of Borromini's San Carlo alle Quattro Fontane. The activity of the walls is intensified by the profusion of vinelike, irregular ornament that seems to crawl over the surfaces. The lavish colors, the delicate details, and the amazing effervescence of the interior make it an outstanding example of German Rococo.

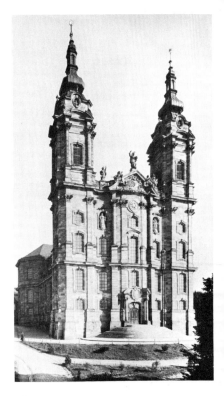

16-11
BALTHASAR NEUMANN, Vierzehnheiligen (The Fourteen Saints), near Banz, 1743–72.

16-12 Interior of Vierzehnheiligen.

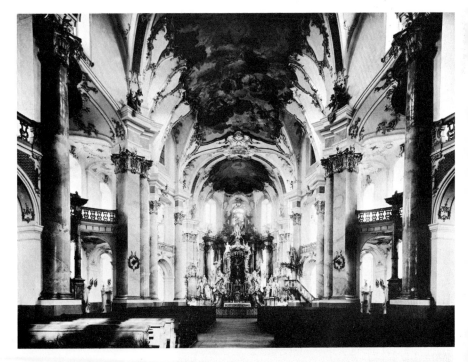

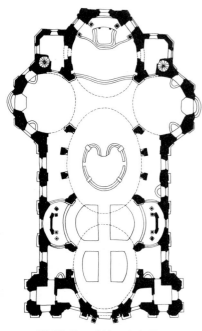

16-13 Plan of Vierzehnheiligen.

Anges-Jacques Gabriel (France, 1699–1782). Gabriel came from a family of architects and studied with his father. As architect for Louis XV, he produced both independent buildings and large building groups. His Military School in Paris (1751) presents an elevation that is simple at the sides but strongly focused on the center, where a bold colonnaded pavilion is surmounted by a pediment, a four-sided dome, and extensive sculpture. Gabriel's typical reserve is better demonstrated in the pair of palaces in the Place de la Concorde (1761–1771), formerly the Place Louis XV. Rusticated and arcaded bases support colossal Corinthian orders that carry an entablature, balustrades, and corner pediments. Although the seventeenth-century east front of the Louvre inspired Gabriel's design, he used more three-dimensional variation and value contrast in the base. The simplest of his buildings is the Petit Trianon at Versailles (Fig. 16-14), an almost square structure with a symmetrical arrangement of interior spaces. While the interior has some traces of Rococo decoration, the exterior is remarkably austere. Three façades use slightly projecting pavilions marked by columns or pilasters framing the tall windows of the main floor and the square windows of the attic. The blocky form is topped by an entablature and a balustrade. It has been claimed that Gabriel was influenced by the publication, in 1758, of J. D. LeRoy's *Ruins of the Most Beautiful Monuments of Greece*, but the natural reserve of Gabriel's style came basically from the traditional restraint of French architecture in the preceding two centuries.

Robert Adam (England, 1728–92). Robert Adam was born in Scotland and attended the University of Edinburgh. From 1754 to 1758 he toured Italy, joined the artist's Academy of St. Luke in Rome, became a friend of Piranesi, and measured and drew the ruins of the palace of the Roman Emperor Diocletian at Spalato.

16-14
ANGES-JACQUES GABRIEL, Petit Trianon, Versailles (façade on the Jardin Français), 1762–68.

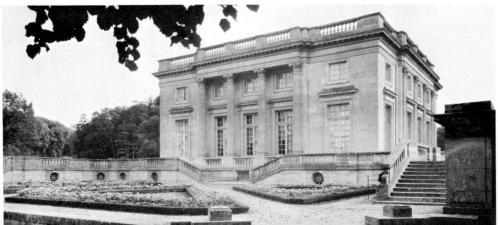

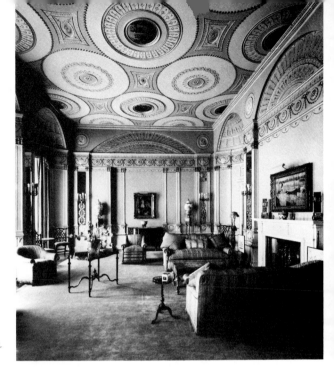

16-15
ROBERT ADAM, music room of No. 20,
Portman Square, London, 1777.

Upon his return to England, he formed an architectural
office with his brothers James and William. In 1761,
Robert Adam was appointed one of the two Architects
of the King's Works. He and his brothers designed
whole houses, reconstructions, interiors, and furnish-
ings. Stylistically, their work was among the most sig-
nificant done in the England of the 1760's and 1770's,
and their influence was international. The Adam style
may be called, with qualification, Neoclassical. Floor
plans such as that of Syon House, Middlesex, have
balanced symmetry and were inspired by specific
Roman or Greek buildings. Façades range from the mas-
sive stately south front of Kedleston Hall, Derbyshire,
with its Roman triumphal arch motif, to the delicate,
crisp, miniature character of the Adelphi Houses in
London. The Adams' greatest influence was on interiors.
Their preference was for slender pilasters, Grecian urns,
and architectural moldings borrowed from Rome and
Greece and used with rich profusion in very slight relief
with sharp contrasts in value or color. The result has
some of the delicacy of the Rococo but much more rigid
geometric structure, as shown in No. 20, Portman
Square (Fig. 16-15). In speaking of architecture, Robert
Adam emphasized "movement," the rise and fall, the
advance and recession of parts that is a facet of the
Baroque love of strong gradation and climax.

PAINTING IN ITALY

Major centers for eighteenth-century Italian painting were Naples, Bologna, Rome, and Venice; many Italian painters also found employment in other countries. As elsewhere, there was increased specialization in subject matter. Style in history painting was based on the work of the Carracci, Pietro da Cortona, Rubens, Titian, Tintoretto, and Veronese. The shimmering color of Veronese can be seen as one source for Italian Rococo, which was developed independently by Giovanni Battista Tiepolo. Loose brushwork and ragged, fluttering shapes created light, spacious compositions that maintain more breadth and grandeur of scale than French Rococo. Foreign painters were responsible for Neoclassic work in Italy. Portraiture was abundant in both the Baroque and the Rococo styles. Paintings of city views, ruins, landscapes, and imaginative combinations of all three found a wide international market. Not only were many north Italian palaces decorated with such subjects, but travelers collected them as souvenirs. Style varied from precise, dry detail, natural light, and documentary accuracy to fluid brushwork, dramatic lighting, and exaggerated scale. Genre painting followed the traditions of the Bamboccianti and that of the upper-class interiors from seventeenth-century Dutch painting.

Giovanni Battista Tiepolo (Venice, Lombardy, Würzburg, and Madrid, 1696–1770). Tiepolo's rise to fame began during his study under a secondary master in Venice. Commissions for wall and ceiling frescoes eventually led him from one city to another. The heavy forms and powerful value contrasts of his early work, like *The Sacrifice of Abraham* (1715-16, Church of the Ospedaletto, Venice), show the influence of Titian and of Tintoretto, but Tiepolo then turned to lighter and more open composition. In the Church of the Gesuati in Venice, he did the ceiling painting of *St. Dominic Instituting the Rosary* (1737–39), a composition that recalls the illusionistic architecture in Veronese's *Triumph of Venice*. Yet Tiepolo reduced the proportion of heavy solids and increased the proportion of sky. The thin, fluffy clouds, the fluttering airborne figures, and the light colors and shadow areas produce a buoyant effect. Between 1750 and 1753, he decorated the Episcopal Residence at Würzburg. The ceiling painting of the throne room depicts *Apollo Conducting Beatrice of Burgundy to Barbarossa* (Fig. 16-16) and goes further than earlier work in lightening and opening the composition. Architecture is reduced to a small structure

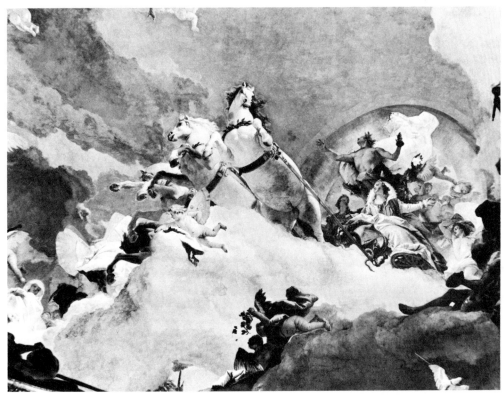

GIOVANNI BATTISTA TIEPOLO, *Apollo Conducting Beatrice of Burgundy to Barbarossa*, ceiling of the throne room of the Episcopal Residence, Würzburg, 1750–53.

in the lower left, and the figure groups present fluttering irregular shapes like leaves blown in the wind. The sweeping clouds are thin overlapping veils with delicately scalloped edges. Around the painting, a gilded stucco frame consists of compound curves and lacy edges, broken in several places by painted forms that seem to spill over it in typical Baroque illusionistic fashion. From 1762 until 1770, Tiepolo worked in Spain, decorating the Royal Palace at Madrid. The jealousy of rivals and the growing preference for Neoclassicism led to a decline in his popularity and may have hastened his death. Tiepolo's painting presents the fullest expression of the Rococo in Italian art.

Giovanni Antonio Canal, called Canaletto (Venice, Rome, and London, 1697–1768). Canaletto studied first with his father, a painter of theatrical scenery. In 1719, the young artist traveled to Rome, where he saw Giovanni Paolo Pannini's paintings of ruins and the Bamboccianti paintings of everyday life in the city. After his return to Venice, Canaletto became a specialist in painting views of the city and obtained numerous commissions from Englishmen making the grand tour of the Continent and wishing to take home souvenirs. Canaletto painted Venice in sharp linear detail, sweeping spaces, and vast

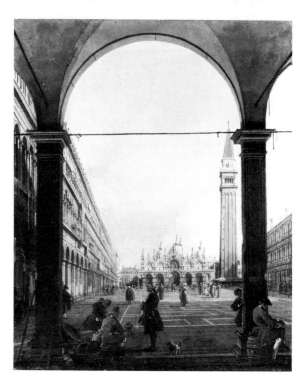

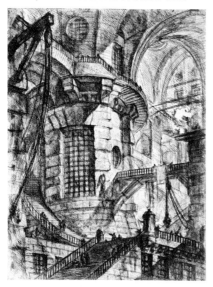

gentle skies, as in the *Piazza San Marco* (Fig. 16-17).
The popularity of his art led to the publication of a
series of engravings of his paintings that was used as
a catalogue by his clients and an aid by his imitators.
It is probable that he visited Rome again in 1740. Be-
tween 1742 and 1743, he painted a series of scenes
depicting Roman ruins. Canaletto did not always limit
himself to documenting particular spots; he occa-
sionally created imaginary scenes, sometimes containing
well-known buildings. Much of the period from 1745
to 1755 was spent in England, where his reputation was
already well established. The visit was a great success,
although the English collectors were, at first, discon-
certed by the *caprices*—imaginary scenes—that the
painter produced along with many views of London.
Commissions were so plentiful that Canaletto employed
assistants. Cityscapes and landscapes were considered
inferior subject matter by academic standards, however,
and in spite of his international success Canaletto was
not accepted into the Venetian Academy until 1763.

Giovanni Battista Piranesi (Rome, 1720–78). Piranesi's
engravings and etchings demonstrate the growing
eighteenth-century interest in Greco-Roman art and the
appreciation of the picturesque. Piranesi began his ca-
reer in Venice as a student of architecture but estab-
lished himself in Rome in 1740. There he turned to

engraving and etching prints of the ruins of Roman architecture. His etching of the Great Hall of the Baths of Caracalla indicates his love of grand scale, often exaggerated by depicting tiny human figures next to ragged, crumbling architecture eaten away by time and vegetation. Etching needles of different sizes made for rich diversity of line. Piranesi's best prints show a wide variation of grays and deep blacks. He documented and interpreted ancient Rome in his views of that city, but the range of his imagination is shown in his *Carceri* series (Fig. 16-18), imaginary interiors of prisons in fantastic scale and structural elaboration based vaguely on Roman architecture. A comparison of the art of Piranesi with that of David indicates the wide range of style that could be inspired by intense interest in ancient Greco-Roman art. In an effort to describe Piranesi's particular attitude and style, some writers have used the rather awkward term *Romantic Classicism.*

Suggestions for Further Study

Downes, Kerry. *English Baroque Architecture.* London: Zwemmer, 1966.

Fosca, François (pseudonym for Georges de Traz). *The Eighteenth Century: Watteau to Tiepolo* (Great Centuries of Painting). Translated by Stuart Gilbert. Geneva: Skira, 1952.

Gerson, Horst, and Engelbert H. ter Kuile. *Art and Architecture in Belgium: 1600–1800* (Pelican History of Art). Translated by Olive Renier. Baltimore: Penguin Books, 1960.

Hempel, Eberhard. *Baroque Art and Architecture in Central Europe: Germany, Austria, Switzerland, Hungary, Czechoslovakia, Poland* (Pelican History of Art). Baltimore: Penguin Books, 1965.

Irwin, David. *English Neo-Classical Art.* London: Faber and Faber, 1966.

Kaufmann, Emil. *Architecture in the Age of Reason: Baroque and Post-Baroque in England, Italy, and France.* Hamden, Conn.: Archon Books, 1966.

Mayor, Alpheus H. *Giovanni Battista Piranesi.* New York: Bittner, 1952.

Morassi, Antonio. *Tiepolo: His Life and Work.* New York: Phaidon Press, 1955.

Rosenberg, Jakob; Seymour Slive; and E. H. ter Kuile. *Dutch Art and Architecture, 1600–1800* (Pelican History of Art). Baltimore: Penguin Books, 1966.

Summerson, John. *Architecture in Britain: 1530–1830* (Pelican History of Art). Baltimore: Penguin Books, 1953.

Waterhouse, Ellis. *Painting in Britain, 1530–1790* (Pelican History of Art). Baltimore: Penguin Books, 1953.

Whinney, Margaret. *Sculpture in Britain, 1530–1830* (Pelican History of Art). Baltimore: Penguin Books, 1964.

Wittkower, Rudolf. *Art and Architecture in Italy, 1600–1750* (Pelican History of Art). Baltimore: Penguin Books, 1958.

Chapter 17

Neoclassic Through Post-Impressionist Art:

1800–1900

Modern art is often dated from David's rebellion against the Baroque and Rococo styles in the late eighteenth century (see p. 252). Rebellion against tradition, even an immediately preceding one, and the rapid change of form and content are important characteristics of modern art. With these characteristics in mind, we can consider the nineteenth century to be the first major period in the history of modern art. The development of archaeology and art history as disciplines seems to have led to greater self-consciousness about individual style and to an increased awareness of stylistic movements and group identities. For some artists, however, the interest in these disciplines led to more precise borrowing from the art of the past. These divergent tendencies, along with changing ideas in philosophy and science, help to explain why different concepts of artistic "truth" are implicit in the different styles in art and in the writings of art critics during the nineteenth century.

The most important geographical area for developments in painting and sculpture was France. In architecture, England played a significant role, especially since her leadership in the Industrial Revolution encouraged pioneering in the use of iron and glass as building materials.

During the first half of the nineteenth century, the various styles tended to express one of two major attitudes, Neoclassicism or Romanticism. The distinction between the two is not always sharp since there were considerable overlapping and mutual influence. Nineteenth-century Neoclassicists borrowed more specifically from Greek and Roman art than did their eighteenth-century predecessors. Underlying the many Neoclassic styles is the search for an absolute beauty based on the perfection of nature and in accordance with preconceived ideal types. Clarity of parts, stable equilibrium, and proportions inspired by Greek and Roman art are basic to Neoclassic work. The attitude called Romanticism produced such a wide range of styles that it is more difficult to characterize; generally there is an insistence on the freedom of the individual and the importance of individual experience. Individual characteristics—the unique form rather than the ideal type—are stressed, and restrictive traditions are rejected. In the famous preface to his play *Cromwell* (1827), Victor Hugo provided a manifesto for Romanticism. He attacked academic dogma and argued that the Christian concept of the worth of the individual makes possible a new kind of pity, *melancholy.* He stated that the

individual, indeed all of nature, contains the ugly as well as the beautiful, evil as well as good. Art should therefore dramatize the dual nature of reality, stress the worth of the individual, and evoke the profound sentiment of melancholy. Romantic artists found subject matter in the works of Lord Byron and Sir Walter Scott and inspiration in the appeal to emotional and mystical experience by writers like François René de Chateaubriand and Wilhelm H. Wackenroder. Christian pietism frequently reinforced the Romantic attitude and created an interest in the Middle Ages; the Romantic could turn to any period in the past, however, since he appreciated the exotic and the remote in time or place.

After the middle of the nineteenth century, the Neoclassic and Romantic attitudes gave way to tendencies that have been described as a *positivistic reaction* and that are reflected in some of the pioneering literature, painting, and sculpture of the period. The continuing desire to upset conventional ideas was joined by an interest in treating all aspects of everyday life in styles that were labeled *Realistic* or *Naturalistic*. Such art was linked with the growing enthusiasm for science, and artists began to investigate even the chaotic incidental nature of human events and the impressionistic character of our experience of the physical world. Toward the end of the century, however, the realization grew that science and progress would not solve all the ills and mysteries of the world. The *Symbolist movement* in literature and art emphasized the enigma of existence and the subjective nature of reality. In the 1890's, a stylistic trend called *Art Nouveau* in France and *Jugendstil* in Germany spread across Europe and America, bringing into art and product design a preference for flat shapes and undulating, plantlike contours.

PAINTING

In France, the late eighteenth and early nineteenth centuries saw the triumph of Neoclassicism under the leadership of Jacques Louis David. During the early years of the nineteenth century, however, Neoclassic stylistic qualities were temporarily supplanted, in the work of many artists by more irregular masses, deliberate merging and obscuring of some compositional parts, more individualistic details in anatomy, and more specific and contemporary details in accessories. These features, some of which recall seventeenth-century Baroque art, were particularly evident in the painting of Napoleonic history and were further developed,

during the years after the fall of Napoleon, in much of the painting that has been called Romantic. The immediate ancestry of Romantic art can be found in the eighteenth-century enjoyment of the picturesque and in the sentimentality of such eighteenth-century painters as the Frenchman Jean Baptiste Greuze. Delacroix was considered to be the leader of Romanticism, while Ingres led academic art in the search for the ideal truth of Neoclassicism. The Salon of 1824 provided a confrontation of works by the two leaders, and it is from this date that the conflicting and overlapping attitudes of Neoclassicism and Romanticism assume major importance in French art.

Academically approved "classic landscape" painting, exemplified by Poussin's work, was superseded during the first half of the century by the art of certain French painters who turned to more direct experiences of nature. These *Barbizon painters* did much painting outdoors, in the forest of Fontainebleau near the village of Barbizon. Although the works were usually finished in the studio, they retained the freshness of firsthand experience in more casual, varied, and free compositions than those of academic landscape. The Barbizon painters made their debuts around 1830 but were not widely accepted until the second half of the century. Their delight in sensitive interpretation of the moods of nature, ranging from lyrical reverie to dramatic storm, links them with Romanticism, and their ancestry may be found in seventeenth-century Dutch landscape painting.

The mid-century was marked not only by political revolution but also by a new movement in French painting, *Realism*, which treated all facets of daily life in a style that showed frank enjoyment of the natural shapes, textures, and colors of things and a delight in the manipulation of the paint itself. In comparison with Realist work, the painting of the Barbizon artists and the exotic subjects, grand passions, glowing colors, and dashing brushwork of Delacroix became much more acceptable to conservative critics, and Realism succeeded Romanticism as the rebel of the period. The leader of the Realists, Gustave Courbet, was rebuked for the vulgarity in form and subject matter in his work.

The hegemony of the French Academy suffered a blow in 1863 when the outcry against the severity of the Salon jury caused the emperor to order an exhibition of rejected works, called the *Salon des Refusés*. Although the public tended to agree with the jury's decisions, the artist's right to exhibit outside the Salon was taken more seriously than before.

After about 1860, certain French artists, notably Édouard Manet, began to intensify their pictorial images by using patches of color relatively unbroken by internal modeling. An important inspiration for this trend was the Japanese woodblock print. The intensification of vision assumed another form in the stylistic movement called *Impressionism*, which made its formal debut in the exhibit of the *Société anonyme des artistes, peintres, sculpteurs, graveurs, etc.* in 1874. The momentary visual impression of a world of light and color in constant change became the major interest of Impressionist leaders like Claude Monet and Auguste Renoir, who went one step further than the Barbizon painters by finishing their paintings outdoors, working directly from the subject. Their patient study of the effects of light and color has been linked with the scientific study of optical phenomena, but they intensified the effects of shimmering light, reflected colors, and simultaneous contrasts, re-forming the visual world into a luminous matrix of small strokes of rich color. Their scientific objectivity seems to have been qualified by sensuous enjoyment of visual experience. By the 1890's, Impressionist work was grudgingly accepted by academic juries and even awarded occasional prizes.

Meanwhile, attitudes in academic painting had undergone changes. The fall of Napoleon had not stopped Napoleonic history painting, and the taste for specific details and local color that had been inspired by Napoleonic history was strengthened by an interest in the developing scientific methods in archaeology and history and by the exactitude of photography. Neoclassic painting was continued by some painters, but after mid-century, academic painters turned increasingly to precise, carefully researched details, and the truth of Neoclassic ideal form was supplanted in academic work by this documentary or archaeological truth.

In the 1880's and 1890's, a number of pioneering young painters who had tried Impressionist painting early in their careers came to feel that Impressionism sacrificed too much solidity of form and compositional structure for the sake of color and light. They therefore turned to very different styles in their mature painting. The most important of these men were Seurat, Van Gogh, Cézanne, and Gauguin. They have been called *Post-Impressionists*, and their styles forecast significant directions in the painting of the twentieth century.

German painting at the beginning of the nineteenth century was molded by the doctrines of Winckelmann and the influence of the Frenchman David. Rome was the training ground for many of the leading German

painters, just as it had been for David (see p. 276). A group known as the *Nazarenes* sought new purity of religious content through a self-consciously simple, linear style inspired by Italian Renaissance art like that of Perugino and Raphael. Members of the Nazarene group later obtained positions of leadership in German academies at Düsseldorf, Munich, and Berlin. German Romanticism was expressed in styles that incorporated more precise detail than did those in France; evocations of nostalgia about the brevity of man's existence, the mysterious forces of nature, and the secret life of the individual recur frequently in paintings by Philipp O. Runge and by Caspar David Friedrich. Realism developed in the work of several Germans and was inspired either by Courbet or by the concept of documentary truth. Impressionism had a belated emergence in Germany.

In Italy, as in France and Germany, the major academies were dedicated to Neoclassicism in the early part of the century. A Romanticism that rejected Neoclassic ideal form for individualistic details made its appearance in Milan. By mid-century, a group of Roman painters called the *Macchiaiuoli* ("painters of spots") were employing bold patterns of color patches that forecast the style of Manet in France several years later. Documentary history painting became important in the second half of the century.

In England, the opening years of the nineteenth century were dominated by several of the great eighteenth-century portrait painters. As the century unfolded, genre painting found a wide market. Landscape painting was led by Constable, whose free brushwork influenced Delacroix, and by Turner, who exploited dramatic effects of light and color in both real and imaginary landscapes. In 1848, the *Brotherhood of Pre-Raphaelites* united several precocious young painters whose moralizing zeal was combined with a yearning for mystical experience, a love of involved literary symbolism and feverishly bright detail, and a desire to return to the style of art before Raphael. Carefully staged and precisely rendered history painting came from the brushes of academicians. Impressionism did not develop in England as it did in France. The American expatriate James McNeill Whistler was fascinated by Oriental art, and his muted, misty riverscapes of scenes along the Thames combine the broad patterns of Manet's art with Impressionistic interest in atmospheric effects. Whistler's English student, Walter Sickert, used more broken color, but his heavy, earthy style is quite unlike French Impressionism.

During the nineteenth century in the United States, patrons became increasingly more sophisticated and developed interests in a wider range of subject matter and style. Portraiture remained the type of painting in greatest demand, and style ranged from the facile brushwork of Thomas Sully to the sparkling detail of Thomas Eakins. Genre and landscape painting expressed a patriotic enthusiasm for the local customs and natural beauty of a rapidly growing America. The *Hudson River School*, a group of landscape painters dedicated to depicting Arcadian river views, might be compared with the Barbizon painters in France. During the second half of the century, a romantic nostalgia for grandeur and overpowering scale is evident in some landscape paintings. The mystery of nature was expressed in the glowing, somber landscapes and seascapes of Albert P. Ryder; the Impressionistic interest in natural light and color came only in the last decade of the century.

Francisco Goya (Spain, 1746–1828). While Goya's love of fantasy has led some historians to consider him a Romantic, his expository portrayal of human personality has inspired the term Realist. The latter designation seems more accurate in that even his imaginative work stresses the realistic acceptance of the role of the irrational in human experience; yet Goya's art is far different from that of the French Realists of the mid-nineteenth century. Goya's teachers were minor masters, who had less influence on his art than did the paintings of Tiepolo and Velázquez. In his mature work, Goya used a dazzling variety of textures; his style ranges

17-1

FRANCISCO GOYA, *May Third, 1808,* 1814–15. Oil on canvas, approx. 9' x 11'. Prado, Madrid.

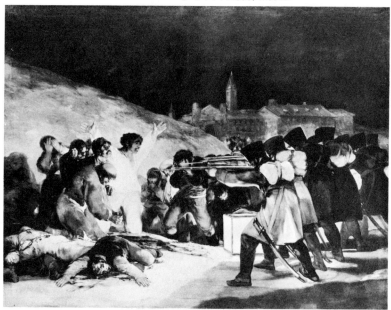

from harsh light and simplified forms to soft light and the effect of mass and detail seen through dense air. In *May Third, 1808* (Fig. 17-1), which shows Spanish citizens being shot by French soldiers, a harsh style underscores the painting's social comment. The grouping of shapes into simple areas of light and dark intensifies the gestures of the subjects and the total impact of the composition; Goya here forecasts the art of Manet. Social commentary is implicit in some of Goya's portraits as well. *The Family of Charles IV* (1800, Prado, Madrid) candidly reveals the homeliness or viciousness of the different personalities and contrasts these with the luxurious costumes. Goya's frankness makes his official success surprising, for he became painter to the king and president of the Spanish Royal Academy. His strongest social commentary and his most unrestrained fantasy are found in his prints. *The Caprices*, a series of eighty-two aquatint etchings, depict man as unreasonable, petty, self-indulgent, and sadistic. *The Disparates*, a set of twenty-two aquatint etchings, reveal Goya's extraordinary imagination in a sequence of grotesque visions; they are frequently ambiguous in meaning, but the total effect is one of fascination and horror in the observation of man. Inhumanity and viciousness are the essence of *The Disasters of War*, a series of eighty-three aquatint etchings presenting a catalogue of barbaric cruelties.

Jacques Louis David (France, 1748–1825). David lived through some of the most violent periods in French history, and his art spearheads one of the most drastic stylistic changes in French painting. As a student at the Paris Academy, David won a Prix de Rome in 1774 with a history painting done in the Baroque manner. During his sojourn at the French Academy in Rome, he changed his style to such an extent that the *Oath of the Horatii* (1784, Louvre, Paris) and other works caused great excitement in Rome and Paris. The stylistic change is also evident in *The Death of Socrates* (Fig. 17-2). This composition is starkly simple; the figures form triangular or rectangular groupings, and the main elements are aligned with stable verticals and horizontals as well as with the picture plane. While the light is dramatic, it does not obscure the rigid structure of the painting. There is no softening effect of sfumato in the sharp contours of the forms. David's inspiration came from certain Greek and Roman works, from his teacher Joseph Vien, and from the theories of Johann J. Winckelmann, who praised the noble simplicity and calm grandeur of ancient Greek art. David's style, in

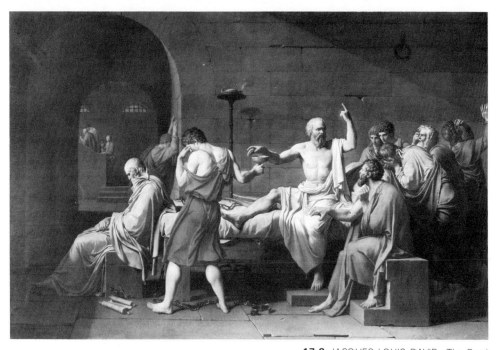

17-2 JACQUES LOUIS DAVID, *The Death of Socrates*, 1787. Oil on canvas, approx. 5' x 7'. Metropolitan Museum of Art, New York (Wolfe Fund, 1931).

its simplicity and strength, seemed the very antithesis of the aristocratic art of the Rococo, and David was adopted as the artist of the developing Revolution. Not only the style but also the subject of *The Death of Socrates* easily acquired political meaning. Socrates gave his life for the principles of reason and truth, principles that the antiroyalists were citing in 1787 as arguments for liberty, equality, and fraternity. After the Revolution, David became a veritable dictator of the arts. His Neoclassical style was the order of the day, and he was powerful enough to have the Royal Academy abolished. However, David's painting changed in the early years of the nineteenth century. David and others were inspired by Napoleonic history, and Greco-Roman subjects gave way to dramatic contemporary events. The austere rigidity of David's early style softened to suggest more dramatic movement and more detailed accessories. For example, the *Bonaparte Crossing the Alps* (1800, Kunsthistorisches Museum, Vienna) employs unsupported contrasting diagonal forms quite unlike the stable triangular arrangements in David's earlier works. The search for timeless ideal human form changed to an interest in topical detail, as demonstrated by *The Coronation of Napoleon* (1805, Louvre, Paris). After the fall of Napoleon, David went into exile in Belgium, where he continued to produce portraits and also painted mythological subjects, which he treated in a lighter, less dramatic manner than that of his earlier style.

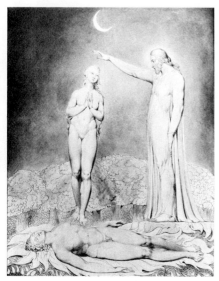

17-3 WILLIAM BLAKE, *The Creation of Eve*, from the *Paradise Lost* series, 1808. Watercolor. Museum of Fine Arts, Boston.

17-4 CASPAR DAVID FRIEDRICH, *Cloister Graveyard in the Snow*, 1810. Approx. 47'' x 70''. Staatliche Museen, Berlin. (Now lost.)

William Blake (England, 1757–1827). Blake was an engraver, painter, poet, and visionary. He illustrated his own poems with hand-colored engravings. *The Creation of Eve* (Fig. 17-3), from Milton's *Paradise Lost*, is a watercolor incorporating typically linear, ideal, Neoclassic figures into a very personal vision. A flaming nimbus surrounds the body of Adam, and the light figures are set against a delicate foliage pattern, a black sky, and a crescent moon. His most famous works include twenty-one illustrations for *The Book of Job* (1820-26) and 102 illustrations for Dante's *Divine Comedy*. Blake's late style became more extraordinary in imagination, more extreme in figure proportions, and less clear in spatial relations. He drew inspiration from Medieval and Renaissance art. Some of his work was based on a mythology of his own, infused with personal mysticism. His art provides a link between Neoclassic form and the subjective dream world of many Romantics in the following generations. Blake also influenced Art Nouveau (see p. 271).

Caspar David Friedrich (Germany, 1774–1840). Friedrich studied at the Academy of Copenhagen and moved to Dresden in 1798, where he joined a circle that included the Romantic writers Ludwig Tieck and Novalis and the painters Philipp Runge and Ferdinand von Olivier. In 1805, Friedrich's sepia drawings won a prize in a competition judged by Goethe. Friedrich's subjects tend to show a single person or a small group dwarfed by the vastness of nature. He loved grand scale, sweeping vistas, effects of sunrise or moonlight, and a mood of

solitude, meditation, or melancholy. He is identified with Romanticism in Germany, as was Delacroix in France, but there are wide differences between the styles of the two men. Friedrich loved precise detail and patterns formed by delicate silhouettes. His *Cloister Graveyard in the Snow* (Fig. 17-4) is typical. The painting evokes a powerful mood of melancholy. Although it has none of the vigorous brushwork and apparent spontaneity of Delacroix's art, it contains a similar suggestion of man's tragic and ephemeral existence.

Joseph Mallord William Turner (England, 1775–1851). Turner was first a watercolorist, adding color washes to drawings by Thomas Girtin, but in the 1790's he began painting landscapes in oil, his major sources of influence being seventeenth-century Dutch landscape, Claude Lorrain, and Nicolas Poussin. During walking tours of England and France, he made thousands of drawings that became the bases for many of his paintings. Turner worked in two styles: One recorded nature in faithful detail and was the basis for his acceptance by a part of his public; the other, thought of today as the typical Turner, intensified the vast scale of nature and the effects of light and atmosphere. Solid forms dissolve in a shimmer of mist, glowing light, and iridescent color. *Rain, Steam, and Speed* (Fig. 17-5) exploits a combination of rain and the steam of a locomotive for these effects. Sunrise, sunset, storm, and the clearing after a storm were favorite moments for Turner. He

frequently added mythological elements or sentimental subject matter, as in *Ulysses Deriding Polyphemus* (1829, National Gallery, London) and *The Fighting Téméraire* (1838–39, National Gallery, London). Because many of his works sacrifice detail for effects of light and color, Turner has been considered a source of French Impressionism, which developed in the latter half of the century. But Turner's more imaginative paintings are visions that magnify the mystery and grandeur of nature; in this respect, they reflect the Romantic attitude.

John Constable (England, 1776–1837). Constable began life as the son of a country miller but in 1799 was admitted as a student to the Royal Academy in London. His mature style was considered to be crude and unfinished by some critics. *The Hay Wain* (Fig. 17-6), one of his best-known landscapes, was exhibited in 1821. Although considerably more detailed than a full-sized oil sketch of the subject (Victoria and Albert Museum, London), the final work has sparkling color and buttery paint application that create an effect of dewy freshness. The composition reflects the influence of Constable's idols, Claude Lorrain and Thomas Gainsborough, as well as of seventeenth-century Dutch landscape painting. *The Hay Wain* was exhibited in the Paris Salon of 1824. French critics, like the English, had mixed responses, but painters were impressed by the vigor and

17-6

JOHN CONSTABLE, *The Hay Wain*, 1821. Oil on canvas, approx. 4' x 6'. Courtesy of the Trustees of the National Gallery, London.

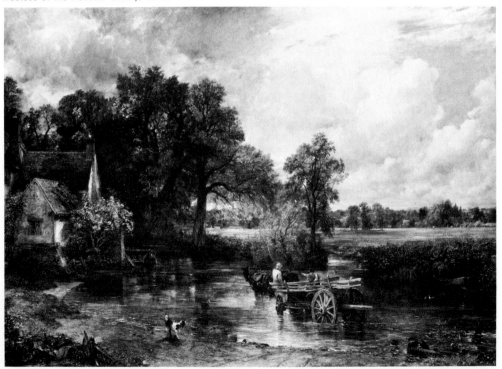

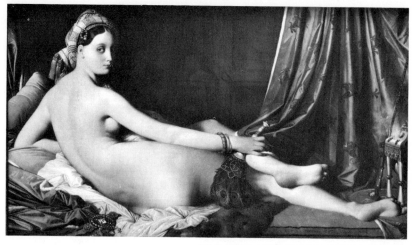

17-7 JEAN AUGUSTE DOMINIQUE INGRES, *Grande Odalisque,* 1814. Oil on canvas. approx. 35″ x 64″ Louvre, Paris.

freedom of the execution. Delacroix is said to have repainted the background of his *Massacre de Scio* after having seen Constable's painting. Along with Turner, Constable helped to open the way for the freer interpretation of landscape later in the nineteenth century.

Jean Auguste Dominique Ingres (France, 1780–1867). David's replacement as leader of academic Neoclassicism did not emerge immediately. The early work of Ingres, a pupil of David, was criticized for the distortions of anatomy and complexities of drapery that the young artist created in the interests of rhythmic line. Ingres was happy, therefore, having won a Prix de Rome with a carefully constructed academic exercise, to leave France in 1806 for Florence and Rome. This first sojourn lasted eighteen years. The *Grande Odalisque* (Fig. 17-7) reveals Ingres's Neoclassic training, his love of Raphaelesque ovoid forms, his use of arbitrary human proportions, his contrast of smooth flesh with complex drapery, and his highly finished paint surfaces. In 1824, however, his Salon contribution, *The Vow of Louis XIII,* was so successful that he returned to Paris as the leader of academic painting and became president of the École des Beaux-Arts. *The Apotheosis of Homer* (1827, Louvre, Paris) exemplifies the most official, rather than the most personal, aspects of his style. Academic teaching under Ingres's leadership was very dogmatic; he insisted that drawing was the basis of art, and he stressed sharply defined contours and smooth finish. He was considered to be the leader of Neoclassicism and the foe of Romanticism; at the Paris International Exposition of 1855, the most lavish representation in the exhibit of French painting was accorded the paintings of Ingres and Delacroix.

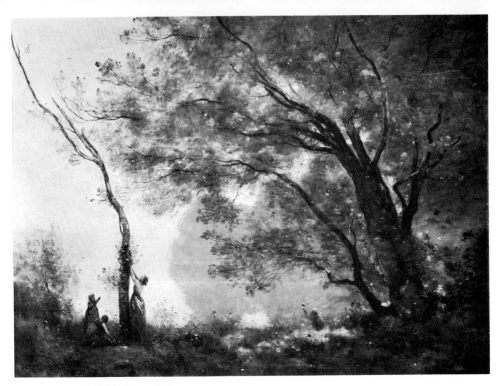

17-8 CAMILLE COROT, *Souvenir de Mortefontaine*, 1864. Oil on canvas, 25¼" x 34½". Louvre, Paris.

Camille Corot (France, 1796–1875). Corot was born in Paris and trained by painters of classic landscape in the tradition of Poussin. During a sojourn in Italy in the 1820's, Corot painted landscapes with bold masses and simplified areas of light and dark, usually grouped around a horizontal or vertical axis. In his later landscape painting he developed the silvery, cloudlike foliage and poetic delicacy typified by *Souvenir de Mortefontaine* (Fig. 17-8). Small flecks of light-colored flowers float against deep shadows; light filters through the leaves, and hazy banks of foliage step back into space. Although Corot occasionally peopled his landscapes with Grecian nymphs, his scenes are more earthbound than those of Turner. Corot's landscapes are based on a lifetime of outdoor drawing and painting; he was associated with the Barbizon painters. Until the twentieth century, Corot's figure paintings were less appreciated than his landscapes. Most are portraits of anonymous people whom Corot painted in subtle colors and solid forms and with quiet dignity, using some of the broad simple areas of value and color that are typical of his early work. Corot was awarded the Legion of Honor in 1846 and lived to see his works forged to meet a growing demand by collectors.

Eugène Delacroix (France, 1798–1863). For Delacroix, the most important qualities in painting were vitality and the sensuous appeal of color. Although his teacher was the academic painter Guerin, his real inspiration was the art of Michelangelo and Rubens; Delacroix was a descendant of the *Rubénistes*. While his subjects usually came from literature, as did those of Ingres, Delacroix's painting seemed violent, crude, and unfinished to Ingres and his followers. *The Lion Hunt* (Fig. 17-9) recalls similar subjects by Rubens and reveals Delacroix's love of dramatic action and exotic settings; a trip to Morocco in 1832 and the reading of Byron's *Childe Harold* had fired his enthusiasm for the Near East. The writhing entanglement of hunters, horses, and lions suggests the eternal struggle between man and his environment, a theme dear to Delacroix and to Romantic art and literature. The explosive energy of the composition is organized within an oval of light. The blurred edges, the *lost and found* (discontinuous) outlines, rapid brush strokes, vigorous paint texture, and touches of bold color all make the action more convincing. Delacroix did not seek the timeless ideal form and precise sleek finish of Ingres's painting, nor did he employ the heroic proportions of Rubens' figures. The sense of immediate, everyday reality in Delacroix's treatment of literary themes comes in part from his use of ordinary human proportions, like those of the people in the paintings of Rembrandt. It is not surprising that

17-9
EUGÈNE DELACROIX, *The Lion Hunt*, 1861. Oil on canvas, 30½'' x 38¾''. Potter Palmer Collection, Art Institute of Chicago.

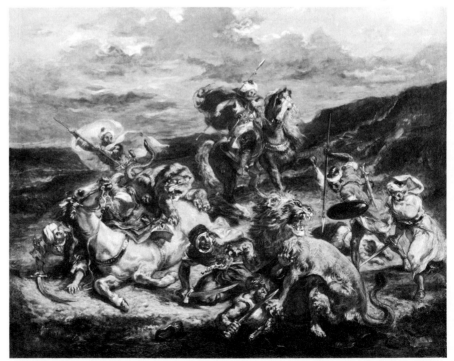

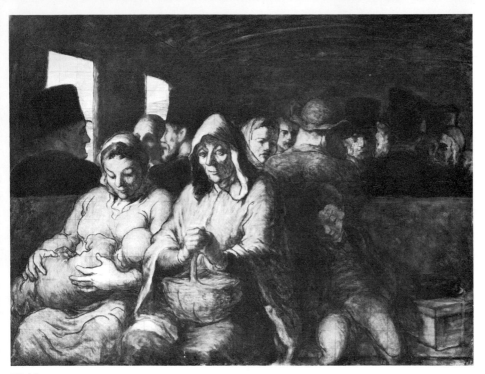

17-10
HONORÉ DAUMIER, *The Third-Class
Carriage,* c. 1865. Oil on canvas,
25¾" × 35½". Havemeyer Collection,
Metropolitan Museum of Art, New York
(bequest of Mrs. H. O. Havemeyer, 1929).

Delacroix's painting is often described as emotional and
that of Ingres as intellectual; yet Delacroix's *Journals*
indicate that he had a calculating nature, while Ingres's
emotional nature was well known. The apparent free-
dom and spontaneity of Delacroix's canvases were
achieved with deliberation and method. He learned
much from the dynamic compositions of his fellow
student Théodore Géricault and from the English
painter Constable, who often placed colors side by side
rather than blending them smoothly together. Dela-
croix's use of complementary colors to obtain liveliness
within shadow areas forecasts the practices of the Im-
pressionists. In spite of official opposition to his work,
Delacroix received a number of important mural com-
missions and was finally granted membership in the
Academy in 1857.

Honoré Daumier (Paris, 1808–79). Daumier's keen
powers of observation and his remarkable ability as a
draftsman compensated for his lack of formal training.
He earned a meager living as a cartoonist, using wood-
cuts for book illustrations and lithography for political
journals like *La Caricature* and *Le Charivari.* The
bourgeoisie, the law courts, and the government all
provided material for Daumier, but his main protests
were against the shortcomings of human nature on all

social levels. His work ranges from brutal caricature to gentle humor and warm appreciation of life. Daumier was essentially an optimist endowed with the grace of liking people in spite of their failings. Unlike Goya, he was realistic without being bitter. Daumier's oil paintings were relatively unknown until his first exhibition, which was in 1878, the year before his death. While the prints rely on line reduced to its most essential and expressive gesture, the paintings depend on starkly simple masses modeled in strong chiaroscuro. *The Third-Class Carriage* (Fig. 17-10) retains the sensitive line characteristic of his lithography; yet the use of light and mass is typical of his oils.

Gustave Courbet (France, 1819–77). While various aspects of realism are basic to the art of Goya and of Daumier, the artist who chose the term Realism for his battle standard was Courbet. He came from a farm to Paris and had several of his early works accepted by the Salon. His notoriety and his leadership in French painting began with the Salon of 1850, where his *Rock Breakers* (Fig. 17-11) and *Funeral at Ornans* (Louvre, Paris) were attacked as unartistic, crude, and socialistic. His early works had been admitted to the Salon because

17-11 GUSTAVE COURBET, *The Rock Breakers*, 1849. Formerly in the Staatliche Kunstsammlungen, Dresden (painting lost during Second World War).

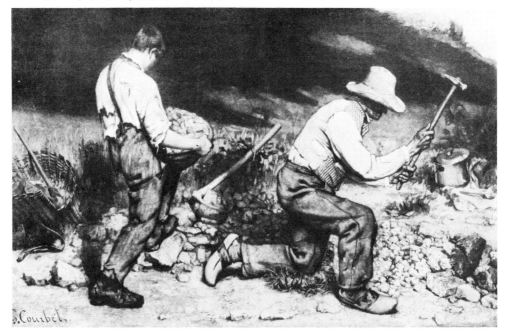

their moody chiaroscuro fitted the now acceptable qualities of much Romantic painting. His mature work stresses the physical reality of the everyday world and the artist's enjoyment of paint textures. Neither the polite veil of acceptable ideal form of Ingres nor the exotic dramatic subject matter of Delacroix appealed to Courbet, who preferred subjects from his own experience and painted them with an obvious enjoyment of the texture of the paint itself, which he applied with brush and palette knife. The epithet "socialistic" came partly from the combination of style and subject that made *The Rock Breakers* look like ragged workers doing a miserable task—the wrong kind of content for a bourgeoisie still frightened by the socialist uprising that occurred after the Revolution of 1848—and partly from the perennial tendency of some critics to ascribe any deviation from conventional standards in the arts to the latest unpopular political movement. Courbet was adopted as a standard-bearer by the socialist philosopher Proudhon, but his painting continued to be a fresh appreciation of the people and the landscape around him. During the International Expositions of 1855 and 1867 in Paris, Courbet built his own pavilions of Realism and held private showings of his work, thus helping to establish the artist's right to have privately organized exhibitions.

Édouard Manet (France, 1832–83). The most shocking painting in the Salon des Refusés of 1863 was the *Luncheon on the Grass* (*Déjeuner sur l'Herbe*, Fig. 17-12) by Manet. Earlier work by the painter had been accepted; Manet had come from a wealthy family and had studied under the academic painter Couture. His *Spanish Guitar Player* (Metropolitan Museum of Art, New York) had even won an honorable mention in the Salon of 1861, probably because of the popularity of Spanish culture at that time. Neither the subject nor the style of the *Luncheon on the Grass*, however, was considered proper by the public or by many critics. Manet had taken the basic idea from Giorgione (Plate 2) and had borrowed the poses of the main figure group from an engraving of a Raphael painting of the *Judgment of Paris*, but he had omitted the mythological context and shown a nude woman in the company of two well-dressed contemporary Frenchmen. Further, the forms are reduced to large simple areas of color and value; few highlights or shadows break up the shapes. The brushwork is bold and rejoices in the texture of the paint. Frans Hals and Rembrandt, not to mention Delacroix, had used bold brushwork, but without such

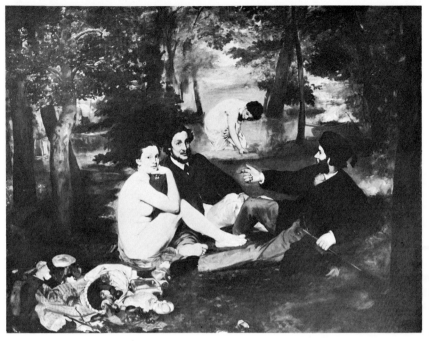

17-12
ÉDOUARD MANET, *Luncheon on the Grass*
(*Déjeuner sur l'Herbe*), 1863. Oil on canvas,
approx. 7' × 9'. Galerie du Jeu de Paume,
Paris.

drastic simplification of form. After 1874, Manet's style changed; the large forms were broken more and more into small areas of bright color, and he increasingly depicted outdoor scenes and effects of light. His late work is represented by *The Bar at the Folies-Bergère* (1881, Courtauld Collection, London). Here the intensity of vision is different from that in the early work. The shimmering light and color partially fuses the forms and suggests a momentary glimpse during an ebb and flow of constant change. Manet owed this vision to the young Impressionists.

Edgar Degas (France, 1834–1917). Manet's friend Degas also came from a family of means. Degas admired Delacroix but idolized Ingres and studied under one of Ingres' pupils. Line was the most natural medium of expression for Degas, but he was not interested in adopting the ideal forms of Neoclassicism. He found his favorite subjects in the streets of Paris, the cafes, race tracks, and theaters. The *Foyer de la Danse* (Fig. 17-13) is typical of Degas' unconventional composition and reflects the influence of Japanese prints. An irregular, diamond-shaped spatial disposition is made by the dancer on the far left, the background dancers, the group around the ballet master, and the foreground chair. Architecture supports the figure arrangement through the placement of the arch, the corner of the room, the open door on the left, and the practice bar. The center of the composition contains only the psy-

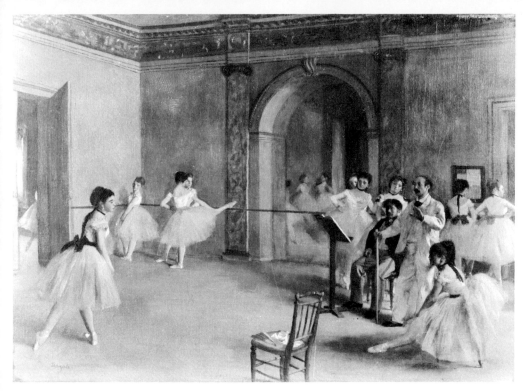

17-13 EDGAR DEGAS, *Foyer de la Danse*, 1872. 12½" x 18⅛". Camondo Collection, Louvre, Paris.

chological tension between the ballet master's group and the dancer receiving his correction. Such focus of attention helps the lone figure on the left counterbalance the greater weight of objects on the right. Unlike Manet, Degas often chose to depict the marginal event, the wings of the stage, as though the essential meaning could best be seen in those watching or waiting to perform. It is this "keyhole" vision, inspired partly by Japanese prints, that gives the impression of a momentary glimpse in Degas' particular kind of Impressionism, which differed sharply from that of the Impressionist leader Claude Monet. Degas did not subscribe to the soft form and vague edges in Monet's work until late in his career. While Monet saw human forms merely as objects reflecting light and color, Degas showed strong interest in the character of individuals. In his later work, Degas abandoned oil for pastels; soft light and glowing, broken colors are combined with firm anatomical structure and the softened but ever-present contour. His relatively traditional use of line enabled Degas to exhibit frequently at the Salon. Although he disliked the term Impressionism, he participated in most of the eight Impressionist exhibits. Degas modeled wax and clay statuettes of dancers and horses, many of

which have expressive poses and rough surfaces that produce multiple highlights, making the sculptures comparable to some of his drawings and paintings.

Winslow Homer (United States, 1836–1910). Homer's early work in magazine illustration emphasized bold massing of values and incisive characterization. He made a sensational debut as an oil painter with his *Prisoners from the Front* (1866, Metropolitan Museum of Art, New York). His paintings of genre scenes show a keen interest in outdoor light and atmospheric effects. He turned increasingly to elemental subjects of man and nature: the lone hunter, the struggle of boats in rapids, and the violence of the sea. His watercolors range in technique from broad sweeping brush strokes with sparkling transparent washes to small areas of overlapping washes and careful detail. Both in watercolors and in oils Homer subordinated detail to large areas of contrasting values that strengthen the visual impact of the composition. This aspect of his style is exemplified in *The Artist's Studio in an Afternoon Fog* (Fig. 17-14), an oil study in browns that has satisfying variation in its simple proportions. Certain angles in the roof echo the powerful middle-ground diagonal plane, which seems to express the conflict of land and sea; this darkest area is set against the small patch of water and foam that receives the brightest highlights in the painting and outshines the veiled sun. Homer's

17-14
WINSLOW HOMER, *The Artist's Studio in an Afternoon Fog*, 1894. Rochester Memorial Gallery, University of Rochester.

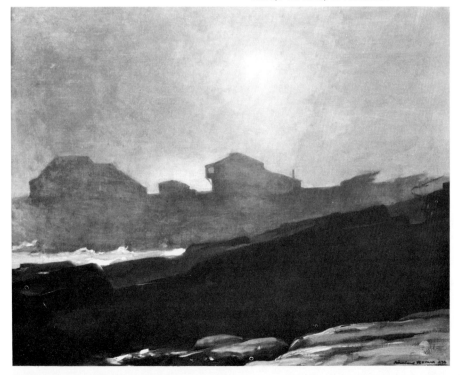

method of working was apparently instinctive, for he denied that he modified nature for the sake of art.

Paul Cézanne (France, 1839–1906). One of the most celebrated of the Post-Impressionist painters was Cézanne, who came from Aix-en-Provence to Paris and studied at the Académie Suisse, an unusual institution that provided models and working space but no instruction. The young artist admired Delacroix and Courbet but also several of the academic painters. Cézanne's early work is characterized by dark values, bold awkward forms, and thick paint handled in such a way as to suggest powerful feelings. In the 1870's, he turned to Impressionist painting and exhibited the *House of the Hanged Man* (1873, Louvre, Paris) in the first Impressionist show in 1874. He came to feel, however, that Impressionism sacrificed too much solidity and structure, and in the 1880's he changed to the style for which he is well known today. Cézanne's portraits, still lifes, and landscapes all reduce objects to basic planes and masses that are brought into subtle complementary relationships on the canvas. The *Mt. Ste.-Victoire from Bibemus Quarry* (Fig. 17-15) is typical in the small groups of parallel brush strokes that suggest massive form in mountain, in foliage, and even in sky. Lost and found outlines define the masses but allow them to flow into each other at various points, and the planes and angles of the forms are echoed and modulated throughout the canvas. All the forms acquire a

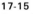

17-15
PAUL CÉZANNE, *Mt. Ste.-Victoire from Bibemus Quarry*, c. 1898. Oil on canvas, 25½'' x 32''. Cone Collection, Baltimore Museum of Art.

structural unity—a family resemblance—in this way. Roundness is achieved not only with light and shadow but also with advancing and receding colors. Yet all forms are obviously constructed with paint, and there is a paradoxical suggestion of mass and depth and at the same time of a flat painted surface. In contrast to Impressionist painting, Cézanne's mature work emphasizes a static structure that largely excludes motion or the changing effects of light and weather. His link with the past can be found in the art of Poussin. Cézanne's importance for the future was summed up in his advice to a young painter to paint nature in terms of the cylinder, the sphere, and the cone—that is, the basic geometric forms. This is generally what was done in Cubist art, which began in 1907, a year after Cézanne's death and the same year as his first large retrospective exhibition.

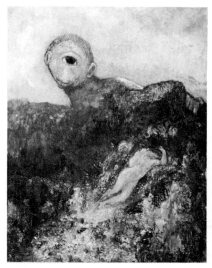

17-16
ODILON REDON, *The Cyclops*, 1900–05. 25¼″ x 20″. Rijksmuseum Kröller-Müller, Otterlo.

Odilon Redon (France, 1840–1916). Redon came from Bordeaux to Paris in 1864. He devoted much of his time to charcoal drawings and albums of lithographs, but he also worked in oils and pastels. His titles, referring to dreams, the works of Edgar Allan Poe and Goya, the Temptation of St. Anthony, and Baudelaire's *Fleurs du Mal*, indicate Redon's concern with fantasy. *The Cyclops* (Fig. 17-16) reveals a dream world of iridescent color and floating forms. His monsters, spiders, and ghostly faces seem more playful or melancholy than frightening. Many of his flower paintings are simply delicate, ethereal bouquets; others contain apparitions of faces. His gentle, mysterious work was discovered by the French Symbolist writers in the 1880's, and Redon was labeled a Symbolist and admired by the painters known as the *Nabis* (see p. 294).

Claude Monet (France, 1840–1926). Monet came from Le Havre to Paris and studied at the Académie Suisse and in the studio of the academic painter Gleyre, where he met Renoir and several other young men who would later participate in the Impressionist movement. In Le Havre, Monet early acquired a love of painting outdoors, partly through the example of his older friends Eugène Boudin and Johan Jongkind. His early style was bold in color and vigorous in brushwork. Large unbroken areas recall the art of Manet; yet the Salons of 1865 and 1866 accepted some seascapes and a portrait by Monet and praised him as a "naturalist." However, as he went further in his studies of the effects of light on color and as his forms became less clearly defined, Monet was continually rejected by juries. In 1874, his

Impression: Sunrise (1872, Musée Marmottan, Paris) caused the label "Impressionism" to be attached to the exhibition by critics. The smoldering light of the rising sun coming through mist and shimmering on the surface of the water is rendered in loose brush strokes and vague forms, a technique meant to distill the total visual impression of a particular moment. For many critics this appeared to be sheer incompetence. Seeking more subtle distinctions in changing light and color, Monet sometimes worked in series, painting the same subject—a haystack, a railway station, or the cathedral of Rouen—in various kinds of light. *Rouen Cathedral* (Plate 4) employs the complementary colors blue and orange in separate brushstrokes to create a vibrating mirage-like image that sacrifices solid form for intensity of visual experience. Had the blues and oranges been blended by the brush, they would have neutralized rather than intensified one another. Where the brush strokes are small enough to allow the spectator's eyes to "mix" the complementary colors when viewing the painting at a distance (*optical mixing*), the effects range from intense color to lively grays. The Impressionist process of applying colors separately in order to expolit their effects on each other is called the technique of *broken color.* By the 1890's, Monet's series paintings had met with considerable success; his approach could be appreciated as scientific, although scientific interest is not a satisfactory explanation of his work. There is an intensification or exaggeration of natural color and light effects—typified in Plate 4—that comes from the artist's sensuous enjoyment of such phenomena. The subject of Monet's last great series, spread over the latter years of his life, was a pond with water lilies. Here the imaginative quality of his art grew more evident, and the paintings became increasingly abstract.

Auguste Renoir (France, 1841–1919). Renoir, Monet's friend and fellow Impressionist, began as an apprentice to a porcelain decorator and then studied with the academic painter Gleyre. His early work consists of rather tightly detailed landscapes and earthy, solidly painted nudes that show the influence of Courbet. Renoir was accepted by the Salon in the 1860's and occasionally thereafter. Like Monet, he turned increasingly to broken color and the evanescent effects of light. The *Nude in the Sunlight* (Fig. 17-17) treats the subject neutrally as an object dappled by light and color reflections rather than as an individual human body expressing personality, although there is some of the sensual

quality that characterizes his many paintings of bathers. Renoir managed to obtain a number of portrait commissions, and these were usually executed with more detail than his other subjects. During his travels in the 1880's, his encounter with Raphael's paintings in Italy led him to return temporarily to sharper outlines and curved forms in flowing, rhythmical relationships. The major painting done during this Raphaelesque phase is *The Bathers* (1884–87, Tyson Collection, Philadelphia Museum of Art). In the work that followed, the interest in curving forms remained, but contours were softened. Woman is the main subject, and Renoir gave her his personal concept of ideal form: soft, ponderous masses of flesh in delicate, luminous colors. The impersonal treatment of the human figure in earlier work here gives way to a mystical reverence for woman as a symbol for the fecundity and glory of nature.

Thomas Eakins (United States, 1844–1916). Eakins first studied at the Pennsylvania Academy of Fine Arts in Philadelphia and then went to Paris in 1866, right after the stormy Salon des Refusés and during Manet's notoriety. Eakins studied with the French academic painter Jean L. Gérôme, however, and his art shows little influence of the young French painters of the day.

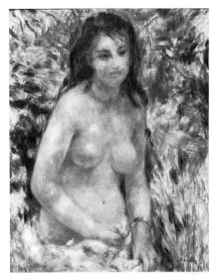

17-17
AUGUSTE RENOIR, *Nude in the Sunlight,* 1876. Galerie du Jeu de Paume, Paris.

17-18 THOMAS EAKINS. *Max Schmitt in a Single Shell,* 1871. 32¼" x 46½". Metropolitan Museum of Art, New York (Alfred N. Punnett Fund and gift of George D. Pratt, 1934).

He seems to have been more sympathetic to the art of Velázquez and Ribera, which he saw during a trip to Spain. Upon his return, Eakins settled in Philadelphia and spent the rest of his career painting the people and the life around him. His major interests were the individual character of a human face, the anatomical structure of the body, and the rich variety of textures and details in all things. *Max Schmitt in a Single Shell* (Fig. 17-18) shows the principal figure looking over his shoulder as he pauses in his rowing. The diamond-bright detail suggests a photograph with equally sharp focus from foreground to background. The careful compositional structure keeps the details from weakening the whole and provides a satisfying unity of parts.

Paul Gauguin (France, 1848–1903). As a young man, Gauguin developed a promising career in a brokerage firm, collected Impressionist paintings, and painted as a hobby. This hobby eventually led him to leave his secure situation and seek a career as a full-time painter. Partly to live less expensively and partly because he was fascinated by primitive societies, he went to Brittany (first to Pont-Aven and then to Le Pouldu). His early work there was Impressionistic; but under the influence of Cézanne, Manet, Japanese prints, and the young painter Bernard's use of flat shapes, Gauguin slowly turned away from broken color and began to use outlines around areas of closely modulated color. The color areas became more closed, suggesting flat textile patterns, and color contrasts became bolder. Several young men joined Gauguin in Brittany and accepted him as their leader. These Pont-Aven artists chose the word *synthesism* to describe their painting. Later the term *symbolist-synthesist* was used frequently as Gauguin became acquainted with some of the Symbolist writers. Two of the Pont-Aven painters joined the *Nabis* (Hebrew for prophets), a group that derived some of its symbolism from the mysticism of Theosophy, but Gauguin maintained an independent attitude. His symbolism expresses the mystery and the imaginative life of primitive peoples. In 1891 he traveled to Tahiti, where he produced such works as *The Spirit of the Dead Watching* (Fig. 17-19). Here resonant hues of yellows, purples, oranges, and blues join the flat patterns that set off the ponderous, solid body of the frightened girl lying on a bed. The spirits of the dead, represented by small flashes of light, and a ghost, represented by a woman in profile, watch from above and behind. Gauguin returned to Paris for a short time

17-19 PAUL GAUGUIN, *The Spirit of the Dead Watching*, 1892. Oil on canvas, approx. 39″ x 36″. A. Conger Goodyear Collection, Albright-Knox Art Gallery, Buffalo.

(1893–95) and rapidly spent a small inheritance. He was soon back in Tahiti, where his health began to fail. His last two years were spent in the Marquesas Islands.

Vincent Van Gogh (Holland and France, 1853–90). Van Gogh was a Dutchman, but most of his painting was done in France during the last four years of a short but intense life. After abortive attempts at working for art dealers (in The Hague, London, and Paris), studying theology, and preaching evangelism among coal miners, Van Gogh turned to painting in 1880. Millet, Daumier, and Rembrandt were the idols of his early period; in works like *The Potato Eaters* (1885, Collection of V. W. Van Gogh, Laren, Holland), poverty-stricken workers are compassionately portrayed with heavy blunt forms and dark brownish color. In 1886, Van Gogh settled in Paris with his brother Theo. Study with the academic painter Cormon soon gave way to enthusiasm for the Impressionists. Under the encouragement of Camille Pissarro, Van Gogh's colors became brighter and lighter, and he began to use broken color; yet his brush strokes have a writhing liveliness unlike those in most Impressionist work. While in Paris, Van Gogh became acquainted with Japanese prints, such as those shown in the background of his portrait of *Père Tanguy* (1887–88, Collection of Stavros Niarchos, Athens). In 1888, Van Gogh left Paris for Arles in southern France. His compositions began to employ more powerful colors, often clashing complementaries; thick paint textures that seem to be sculpted with the brush or the palette knife; and shapes

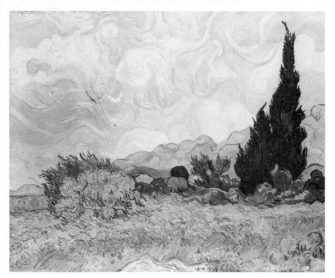

17-20 VINCENT VAN GOGH, *Wheat Field with Cypresses*, 1889. Oil on canvas, 28½'' x 36''. Courtesy of the Trustees of the National Gallery, London.

whose abruptly changing contours express a convulsive energy. Van Gogh was subject to occasional epileptoid seizures, and these led to a year's residence in the asylum at Saint-Rémy. *Wheat Field with Cypresses* (Fig. 17-20) is a work typical of this period in its glowing colors and in the dancing, twitching rhythm that activates earth and sky. Paint is applied in short, choppy strokes that seem to sculpt edges and surfaces. From Saint-Rémy, Van Gogh went to Auvers, near Paris, to receive treatment from Dr. Gachet, a friend of Pissarro, and it was at the small village of Auvers that he committed suicide. His imaginative use of color, his expressive distortion of natural forms, and the emotional force of his art made him an important source for many trends in twentieth-century painting, particularly Fauvism and Expressionism.

Georges Seurat (France, 1859–91). The last Impressionist exhibition, in 1886, was marked by dissension; Monet and Renoir were both absent. A central problem was the new approach represented by Seurat and his followers. Their works were displayed in a separate room and their style, generally subsumed under the label of Post-Impressionism, came to be called *Neo-Impressionism*. The intensity of light and color in Impressionist work appealed to Seurat, but he felt—as did Cézanne—that mass and compositional structure had been unduly sacrificed; so he set out to systematize the broken color of Impressionism and to clarify its forms. On the basis of the color theories of Michel Chevreul and Charles Henry, Seurat applied colors in uniformly small dots in specific quantities to create particular effects when the spectator experienced optical mixing.

Seurat's technique was called *pointillism* in regard to the paint application and *divisionism* in regard to the systematically broken color. The suggestion of constant change and movement found in much Impressionist work was replaced, in Seurat's painting, by more rigid organization and static form. In his *Sunday Afternoon on the Island of La Grande Jatte* (Fig. 17-21) the shadows, trees, and figures form static horizontals and verticals; the clearly edged and simplified forms become standard rather than individual objects; and there is a quality of geometric order, of inflexible balance, and of calculated method. In 1884 Seurat became one of the founders of the *Salon des Indépendants*, which provided exhibition opportunities without jury selection and thus answered one of the basic needs that had inspired the Impressionist exhibitions between 1874 and 1886.

James Ensor (Belgium, 1860–1949). After studying at Ostend and Brussels, Ensor became a painter and printmaker; he worked with still-life, landscape, marine, religious, and mythological subjects, ranging from everyday scenes to frightening grotesqueries involving men, animals, and monsters. His early art employed gentle lighting and subtle colors, although the paint was often applied vigorously with a palette knife. In the course of the 1880's, fantasy invaded his subject matter, and paint application became increasingly nervous and complex. *Masks Confronting Death* (Fig. 17–22) is typical in its combination of delicate color and grotesque subject. It recalls late Medieval prints depicting the Dance of Death. Ensor's etching *The Vengeance of the Hop Frog* (1898) combines cruelty with a Bosch-like

17-21
GEORGES SEURAT, *Sunday Afternoon on the Island of La Grande Jatte,* 1884–86. Oil on canvas, approx. 7' x 11'. Art Institute of Chicago.

17-22
JAMES ENSOR, *Masks Confronting Death*, 1888. Museum of Modern Art, New York, Mrs. Simon Guggenheim Fund.

imagination. In his most macabre works, Ensor mixed religious and scatological elements; yet at the same time, he continued to paint still-life, landscape, and marine subjects like those of the early period. While some of his more conventional paintings owe much to Impressionism, the highly imaginative compositions are more closely related to the Expressionist art of the late nineteenth and early twentieth centuries.

Gustav Klimt (Austria, 1862–1918). Klimt both studied and worked in Vienna. In 1897, he became the first president of the Vienna Secession, an organization of artists opposed to conservative art. In *Death and Life* (Fig. 17-23) Klimt used two-dimensional shapes, stressed undulating contours, and exploited intricate, abstract patterns based on geometric and plant motifs for symbolic purposes. His art can be seen as a sig-

17-23
GUSTAV KLIMT, *Death and Life, c.* 1908, reworked 1911. Oil on canvas, 70¼'' x 78''. Collection of Marietta Preleuthner, Vienna.

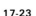

nificant contribution within the introspective and symbolic tendencies of the late nineteenth and early twentieth centuries and within the stylistic trend of Art Nouveau.

Edvard Munch (Norway, 1863–1944). A government grant for study in Paris from 1889 to 1892 and a controversial exhibition of his work in Berlin in 1892 were major events in the formation of Munch's style and his recognition as a leading figure in the modern movement. During the Paris sojourn, his style changed from a boldly painted, factual presentation modified by Impressionist light to stronger, simpler, and more arbitrary colors and shapes. Toulouse-Lautrec and Gauguin were major influences. The Berlin exhibit was closed as a result of pressure by conservatives, and Munch became a celebrity among young German painters and an important influence on the *Brücke* group (see p. 313). *The Cry* (Fig. 17-24) employs dissonant colors, undulating shapes, and violent perspective to express the tension and anxiety characteristic of Munch's art. He intended many of his works to be part of a *Frieze of Life*, a series that was never finished. One of the major works in the series is *The Dance of Life* (1899–1900, National Gallery, Oslo), depicting dancing couples and spectators on a moonlit beach. With flat, weightless shapes, serpentine contours, and dark colors, he depicts three phases of womanhood: innocence, sensuality, and disillusionment.

Henri de Toulouse-Lautrec (France, 1864–1901). The extreme dissoluteness of Toulouse-Lautrec's life, his aristocratic ancestry, and his dwarfed and crippled body have made dramatic material for biographies. In spite of the dissipated life he led, however, his short career was remarkably productive. After training in the studio of an academic painter and working in an Impressionistic vein, Toulouse-Lautrec formed a style closely related to that of Degas. His *At the Moulin Rouge* (Fig. 17-25) is a casual passing glimpse of the cabaret life that provided many of his subjects. The large areas of color function as bold patterns and reveal the influence of Japanese prints and the paintings of Degas. As in Degas' work, movement is expressed by the contours of active shapes, the sweeping asymmetrical diagonals, and the extension of major figures beyond the edges of the composition. Like Degas, but unlike many of the other Impressionists, Toulouse-Lautrec was interested in human personality. His depictions of Paris dandies and prostitutes show a sensitivity that neither condones nor

17-24 EDVARD MUNCH, *The Cry*, 1893. 33" x 26½". Nasjonalgalleriet, Oslo.

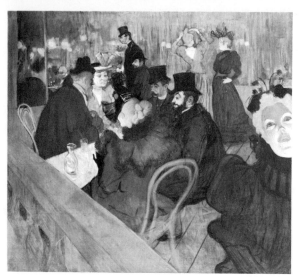

17-25
HENRI DE TOULOUSE-LAUTREC, *At the Moulin Rouge*, 1892. Oil on canvas, approx. 48⅜" x 55¼". Helen Birch Bartlett Memorial Collection, Art Institute of Chicago.

criticizes but mercilessly reveals the monotony, the frantic efforts to live fully, the cynicism, the lust, and the gaiety of a certain stratum of international society. His famous posters for several of the cabarets are brilliant demonstrations of lithography applied to advertising art. Toulouse-Lautrec never became a member of the Impressionist group; he belongs more properly with the Post-Impressionists.

SCULPTURE

Nineteenth-century sculpture was less inventive than painting, and stylistic trends are less distinct. After the Revolution, France gave preference to the clear sweeping lines and ideal forms of Neoclassic sculpture. Napoleon supported this preference and commissioned portraits from the Italian Neoclassicist Antonio Canova. The Romantic attitude in sculpture became apparent in the Salons of 1833 and 1834, when rough surfaces, individualized features, and entangled forms were used to accentuate active subjects, as in the work of Antoine Barye and François Rude. The second half of the century saw more precise anatomical and costume detail. The major figure in French sculpture of the late nineteenth and early twentieth centuries was Rodin, who combined an interest in lively, rippling surfaces with expressions of man's aspirations and of conflicts between mind and body.

During the first half of the century Italy was the center of Neoclassic sculpture, which was led by Antonio Canova. During the second half of the nineteenth century, the tendency toward increasingly naturalistic detail was international.

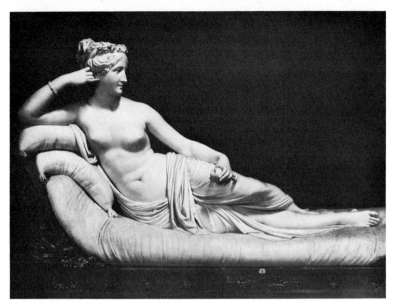

Antonio Canova (Italy, 1757–1822). Canova was trained in Venice and developed an early style that combined naturalistic detail with late Baroque composition. When he moved to Rome in 1779, however, and studied Roman ruins and ancient sculpture, his style changed to the simplified anatomy, long sweeping curves, and quiet compositions that became representative of the Neoclassic aesthetic. The *Pauline Borghese as Venus* (Fig. 17-26) presents an idealized figure in a serene pose with clear stately contours in a static alignment of vertical and horizontal elements. The composition seeks an absolute beauty outside the reach of motion, change, or time.

François Rude (France and Belgium, 1784–1855). Rude came to Paris in 1807 after studying in Dijon. A successful beginning was interrupted when the defeat of Napoleon forced Rude to accept exile in Belgium. Twelve years later, he returned to Paris. In the Salon of 1833, his *Neapolitan Fisherboy* (1831, Louvre, Paris) won him the Legion of Honor. Of his many commissions, the best known is *The Departure of the Volunteers of 1792* (Fig. 17-27), a 42-foot-high relief on the Arch of Triumph in Paris. This bristling composition depicts young and old warriors, allegorically dressed in an imaginative version of Roman armor, setting off for battle. Above them, the winged goddess of war surges forward. The frantic complexity of the group sets it apart from Neoclassic concepts, and Rude was linked with Romanticism.

17-27 FRANÇOIS RUDE, *The Departure of the Volunteers of 1792*, 1833–36. Approx. 42' x 26'. Arc de Triomphe, Paris.

17-28
AUGUSTE RODIN, *The Thinker,* 1889.
Bronze, 70½'' high including base.
Metropolitan Museum of Art, New York
(gift of Thomas F. Ryan, 1910).

Auguste Rodin (France, 1840–1917). The Frenchman Rodin dominated Western sculpture in the late nineteenth and early twentieth centuries. He was trained as a sculptor's helper and as a carver of architectural ornament. A voyage to Italy in 1875 opened his eyes to the expressive power of Donatello and Michelangelo; he was particularly impressed by the pulsating life suggested in the rough surfaces of Michelangelo's unfinished work. For his first Salon offering in 1875, Rodin chose *The Man with a Broken Nose* (Rodin Museum, Paris), a head that preserves in the bronze cast something of the rough flowing, easily shaped quality of clay, Rodin's favorite material. *The Age of Bronze* (1877, Rodin Museum, Paris) has the same breakup of surfaces into a flickering complexity of highlights. In 1879, Rodin began planning *The Gates of Hell* for the Museum of Decorative Arts in Paris. Although the project, which took its theme from Dante, was never finished, the constantly evolving plan for the work served as a source from which Rodin took figures for other sculptures. *The Thinker* (Fig. 17-28) was first conceived as part of the reliefs for *The Gates of Hell* but gained fame as an individual figure. The bronze presents a convincing muscular and skeletal structure, but details have been

omitted or softened, and the surfaces are both rough and lively. Like many of Michelangelo's figures, *The Thinker* implies that physical power does not hold the solution for man's most challenging problems. *The Burghers of Calais* (1884, Calais) is one of the most emotionally powerful of Rodin's works. Rough surfaces, distorted proportions, and conflicting directional forces express the fear and the strength of will required of these citizens who gave themselves up to the enemy during the Hundred Years' War in order to save their city. Because of such expressive distortions, Rodin's *Monument to Balzac* (1891, Rodin Museum, Paris) was refused by the society that had commissioned it. In 1898, however, *The Kiss* (1886, stone version in the Rodin Museum, Philadelphia) was purchased by the French government. Rodin's style is best seen in his bronzes, which catch the essence of the artist's work in clay; assistants did much of the stone carving. The effect of agitated surfaces in Rodin's work has caused him to be called an Impressionist in sculpture. Such a designation ignores the powerful emotional expression in his art, a quality not basic to Impressionism in painting but most important to French Fauvism and to German Expressionism.

ARCHITECTURE

Nineteenth-century architecture has been described as the "Battle of the Styles" because of the prevailing tendency to borrow forms from various periods of the past. This eclecticism had begun in the eighteenth century, especially in England, where the work of a single architect would frequently include buildings in the Greek, Roman, Romanesque, Gothic, and Renaissance styles. Eclecticism became international during the nineteenth century, and the word *revival* is often used to indicate the close dependence of a particular style on its historical prototype. Iron could be cast into different kinds of ornamental details, but it could also be used inventively for strikingly new architectural forms such as those of the Crystal Palace, built as an exhibition hall for the London International Exhibition of 1851. During the second half of the century, England developed the so-called *Victorian Gothic* (Italianate Gothic with polychrome stripes) and imported the Second Empire Style from France. The British arts and crafts movement urged efficient, practical design and was an indirect influence on twentieth-century art and theory.

France began the century with dreams of creating an empire rivaling that of ancient Rome. Napoleonic plans provided for vast Greco-Roman monuments, like the Arch of Triumph and the Church of the Madeleine, many of which were finished long after the Battle of Waterloo. Renaissance revival designs were also popular. The *Second Empire Style*, named for the empire of Napoleon III, is characterized by *mansard* roofs (steeply pitched roofs with a flat or almost flat platform at the top) and highly decorated dormer windows. Walls were treated with ornate sculptural richness, in a style often described as *Neo-Baroque*. French and Belgian architecture of the 1890's led in the international style called *Art Nouveau*, which turned away from eclecticism and exulted in a profusion of irregular, curving, linear ornament inspired by plant life.

Outside of France and England, the revival styles were equally current in Germany, Italy, and the United States. The reaction against eclecticism began with the work of Louis Sullivan and Frank Lloyd Wright. The steel-framed skyscraper developed first in the United States, partly because of the high cost of land but especially because of the availability and relative cheapness of steel.

Thomas Jefferson (United States, 1743–1826). One of the stylistic phases of postcolonial architecture in the eastern United States is often called the *Federal Style*. Thomas Jefferson's home, Monticello (Fig. 17-29), is a fine example of this Roman phase of the Neoclassic.

17-29 THOMAS JEFFERSON. Monticello, Charlottesville, Virginia, 1796–1808.

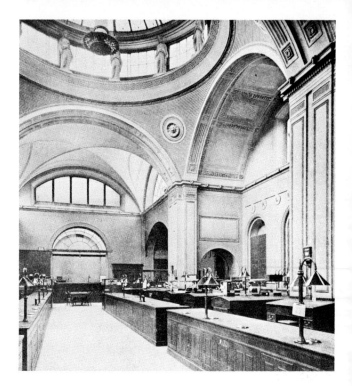

17-30
SIR JOHN SOANE, Consols Office
of the Bank of England, London,
1797.

Of the many amateur architects of his day, Jefferson
produced some of the most influential buildings, even
while he was engaged in a variety of other activities.
Monticello is based on Palladio's Renaissance inter-
pretation of Roman architecture. Jefferson used strict
symmetry, a pedimented porch with a semicircular
Roman window, Roman-inspired Tuscan columns, a low
Roman dome on an octagonal base, severely simple
ornament, and the single-story effect of a Roman tem-
ple. His designs for the Capitol Building at Richmond,
Virginia (1785–89), were based on the Maison Carrée
(Fig. 11-2). For the University of Virginia, he used the
example of the Pantheon (Fig. 11-10) for the library.
Jefferson's architecture, however, shows a flexibility and
inventiveness in the application of Roman forms that
is a refreshing contrast to the more imitative pedantry
of many Neoclassic designers.

Sir John Soane (England, 1753–1837). One of England's
most original Neoclassicists was Sir John Soane. During
a visit to Italy, he studied the antique world of Piranesi's
imaginative prints, actual Roman ruins, and Renaissance
buildings. In 1788, he was appointed architect for the
Bank of England. He used Roman domes and arches,
but instead of the ponderous mass of Roman work,
Soane used linear ornament. The total effect, as in the
Consols Office of the bank (Fig. 17-30), is one of crisp

17-31 KARL FRIEDRICH VON SCHINKEL, Old Berlin Museum, 1824–28.

17-32 SIR CHARLES BARRY and A. WELBY PUGIN, Houses of Parliament, London, begun 1835.

precision with thin, taut surfaces. His own house in London—No. 12, Lincoln's Inn Fields—provided more opportunity for experiment. Canopylike cross-vaulted ceilings cover spaces that continue over screening walls which stop short of the ceiling. From low dark spaces, one is drawn toward high, brightly lighted areas. Mirrors help to convey light and to emphasize the continuity of space. The variety of spaces and light effects and the variety of Soane's collection of art objects lead one to expect surprises around every corner. It is here, rather than in the austerely simple surfaces and restrained linear ornament of his larger buildings, that we see Soane's kinship with Piranesi.

Karl Friedrich von Schinkel (Germany, 1781–1841). Germany's leading architect in the first half of the nineteenth century began, like Inigo Jones, as a designer of stage sets; but his architecture began as Greek revival and eventually employed Roman domes and arches. A good example of his early work is the New Guardhouse in Berlin (1816–18), with an authentically proportioned Doric order and the severe simplicity of parts that is characteristic of much Greek revival architecture. His Old Berlin Museum (Fig. 17-31) masks the two-story interior with a huge Ionic stoa and hides the interior Roman dome behind a simple rectangular attic.

Sir Charles Barry (England, 1795–1860). Barry's career demonstrates the various enthusiasms of nineteenth-century architects and their patrons. Barry began by designing Gothic revival churches but turned to Renaissance revival as his major interest. In 1836 he won the competition for the new Houses of Parliament (Fig. 17-32) with a Gothic design, forecasting the wide popularity of Gothic in the Victorian period. In the same year, A. Welby Pugin's book *Contrasts* appeared, arguing that the Gothic style should be used exclusively. It was Pugin who designed the details for the Houses of Parliament; late Gothic was used because its more complex ornament was considered to be richer and more picturesque for a skyline as prominent as that of Parliament.

Henri Labrouste (France, 1801–75). Labrouste's masterpiece is the Bibliothèque Sainte-Geneviève in Paris (Fig. 17-33), a design based on Italian Renaissance palaces but handled with sensitivity in its proportions and inventiveness in the application of iron in the interior. The reading room (Fig. 17-34) gains spaciousness from

17-33 HENRI LABROUSTE, Bibliothèque Sainte-Geneviève, Paris, 1843–50.

the slender iron columns, which support a ceiling of plaster panels between round arches of perforated iron. Labrouste added a reading room to the Bibliothèque Nationale in Paris (1862–68), where he again used thin iron columns, this time supporting light terra cotta domes. The book-stack areas that he designed for the same building are of iron and glass. With respect to both design and materials, Labrouste was an important leader in mid-nineteenth century French architecture.

17-34 Reading room of the Bibliothèque Sainte-Geneviève.

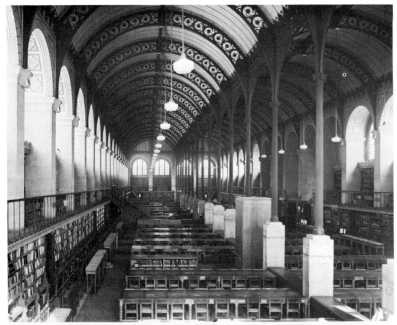

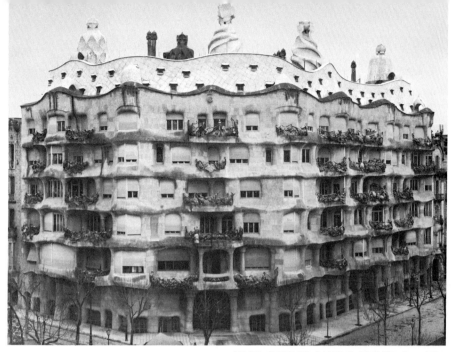

17-35 ANTONIO GAUDI Y CORNET, Casa Milá, Barcelona, 1907.

Antonio Gaudi y Cornet (Spain, 1852–1926). After studying architecture in Barcelona, Gaudi made his career there, aided by many commissions from the industrialist Güell. Gaudi's inventive mind utilized Medieval masonry vaults, Moorish forms, and contrasting materials to develop a unique style related to Art Nouveau in its irregular, constantly curving surfaces. His thin, laminated vaults of tile and mortar, his warped surfaces—such as hyperbolic parabolids (see p. 46) —and his inclined supports all forecast later twentieth-century architecture. The Casa Milá (Fig. 17-35) presents a constantly undulating wall surface of hammered stone. Windows and doors suggest grotto openings, and balcony railings are explosions of foliagelike ironwork. The irregular rise and fall of the roof line and the twisting forms of certain chimneys and ventilators offer a bizarre silhouette. Interior rooms are irregular, with curving walls and spaces that seem flexible and flowing. The building was originally intended to be a base for an enormous statue of the Virgin.

Louis Sullivan (United States, 1856–1924). America's most pioneering architect in the late nineteenth century was Louis Sullivan, who was trained at the Massachusetts Institute of Technology and at the École des Beaux-Arts in Paris. At a time when architecture was deriving inspiration from the past, Sullivan insisted on a fresh approach to form and decoration. His concept

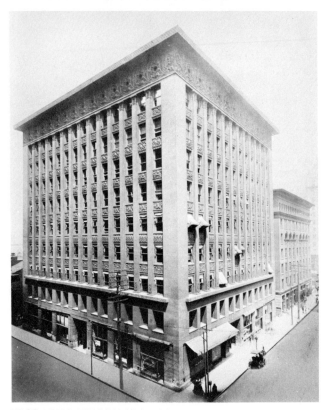

17-36 LOUIS SULLIVAN, Wainwright
Building, St. Louis, 1890–91.

that *form follows function* (suggested earlier in the cen-
tury by Horatio Greenough) argued that design should
express the use, structure, and materials of a building.
Sullivan, a Bostonian, came to Chicago in 1873, and from
1881 to 1895 he worked in partnership with Dankmar
Adler. Sullivan's early work is represented by the
Chicago Auditorium Building (1886–89). In the lower
floors, the granite masonry is handled with bold rough-
ness and deep shadows, emphasizing the base and
creating an effect of vast scale and strength. Above, the
smooth stone façade is unified by tall arches with
groups of windows that decrease in size as they ap-
proach the final cornice. Sullivan here shows the influ-
ence of Henry Hobson Richardson, an older architect
noted for his sensitive interpretation of Romanesque
forms. Other Chicago architects were more advanced
than Sullivan in exploring new structural methods and
materials, particulary the steel frame, but these new
techniques were hidden behind facings of columns and
pilasters. It was only in 1890 and 1891 in St. Louis that
Sullivan used the steel frame in a design independent
of past styles. In his Wainwright Building (Fig. 17-36)
the idea of form following function resulted in large-
windowed shops at the base, a central section of offices
treated as a framed area, and a crowning band of floral

ornament beneath the projecting cornice. The steel frame is expressed in the large windows and slender brick-covered piers; it is obvious that the steel skeleton, not the wall, supports the building. Sullivan believed that a tall building should look tall, so he made the vertical piers rise through the contrasting horizontal floors with their panels of rich ornament. The ornament is composed of geometric and plant forms in intricate profusion. Though there is no direct reference to past styles, the total effect recalls Celtic art or the looser, more asymmetrical Art Nouveau in Europe. Sullivan's commissions for large buildings declined as eclecticism increased in commercial architecture during the late nineteenth and early twentieth centuries. His ideals gained fuller acceptance after his death, when they were carried on in the work of his former employee, Frank Lloyd Wright.

Suggestions for Further Study

Badt, Kurt. *The Art of Cézanne.* Translated by Sheila Ann Ogilvie. Berkeley: University of California Press, 1965.

Courthion, Pierre. *Edouard Manet* (The Library of Great Painters). New York: Abrams, n.d.

Dowd, David L. *Pageant-Master of the Republic: Jacques Louis David and the French Revolution.* Lincoln: University of Nebraska Press, 1948.

Elsen, Albert. *Rodin.* New York: Museum of Modern Art, 1963.

Fernier, Robert. *Gustave Courbet.* Translated by Marcus Bullock. New York: Praeger, 1969.

Hamilton, George Heard. *Nineteenth and Twentieth Century Art.* New York: Abrams, 1971.

Hitchcock, Henry Russell. *Architecture: Nineteenth and Twentieth Centuries* (Pelican History of Art). Baltimore: Penguin Books, 1958.

Huyghe, René. *Delacroix.* Translated by Jonathan Griffan. New York: Abrams, 1963.

Licht, Fred. *Sculpture, Nineteenth and Twentieth Centuries* (History of Western Sculpture). Greenwich, Conn.: New York Graphic Society, 1967.

Rewald, John. *The History of Impressionism.* New York: Museum of Modern Art, 1946.

————. *Post-Impressionism from Van Gogh to Gauguin.* New York: Museum of Modern Art, 1956.

Rosenblum, Robert. *Jean-Auguste-Dominique Ingres* (The Library of Great Painters). New York: Abrams, 1967.

Sloan, Joseph C. *French Painting Between the Past and the Present.* Princeton, N.J.: Princeton University Press, 1951.

Sullivan, Louis. *Kindergarten Chats and Other Writings.* Edited by Isabella Athey, rev. 1918. New York: Wittenborn, 1947.

Chapter 18

Modern Art: 1900 to the Present

The twentieth century, even more than the nineteenth, has been characterized by international and individual rather than regional styles and by a diversity that makes generalization difficult. Not only new materials and techniques but a rapidly changing world view have influenced art. The increasing importance of the machine seems to be reflected in some styles and reacted against in others, and psychology and physics have reshaped the artist's conceptions of man and the physical world. The complex interaction of factors that form the artist's style, however, does not encourage simple or easy explanations, especially since many artists have moved through a number of stylistic trends.

One widespread tendency in twentieth-century art has been to place the highest value on purely formal qualities—for example, the coherence, variety, subtlety, and uniqueness of forms—rather than to stress the interpretation of subject matter. This tendency accompanied perforce the rise of abstract and nonobjective art, but it has since affected attitudes toward representational art as well. Most artists and critics have used the language of pure form to evaluate the cityscapes of Hopper as well as the personal revelations of De Kooning and the calculated structures of Mondrian.

Sometimes allied with and sometimes opposed to the emphasis on formal qualities has been a tendency to stress subjectivity, the individual's reaction to his world, his exploration of the realm of fantasy, or his creation of new worlds without familiar objects.

More pervasive than either of the above has been the tendency to attack conventional ideas about the nature and value of art, even when such ideas have only recently played a revolutionary role themselves. For example, the emphasis on formal values has been challenged as being too limited in its concept of art as good taste embodied in a precious object. The challenge appeared as early as 1913, with Duchamp's exhibition of factory-produced articles as art and was continued by Pop Art, which blurs the division between art and mass media images or mass-produced objects; by Conceptual Art, which presents idea as art; and by those Minimal artists who claim to present objects liberated from formal relationships. The concern with subjective experience and personal style has been challenged by Pop Art and Minimal Art, which are sometimes mass produced, and by team-produced art. The traditional concept of art as a precious object to be merchandised and collected has been further attacked through sculpture that destroys itself in a dramatic performance, through some earth works, and through *Happenings*,

artist-directed performances employing crudely made properties and improvised action.

Geographically, the United States has become much more important since the Second World War; New York now rivals Paris as a creative center, although in very recent years art has tended toward decentralization, with new developments taking place in San Francisco, Tokyo, and London.

PAINTING

The first major event in twentieth-century painting occurred at the Paris Salon d'Automne in 1905, when a number of French painters, including Derain, Vlaminck, Marquet, Rouault, and Matisse, exhibited paintings with such intense color, free brushwork, and expansive shapes that a critic called the painters *Fauves* (wild beasts). *Fauvism* was a short-lived movement, lasting only about three years and never formally organized; while its influence was widespread in later twentieth-century painting, only a few of its members, notably Matisse, continued to paint in the style. The immediate sources of Fauvism were Van Gogh and Gauguin, and its bursting vitality and instinctive spontaneity give it an expressionistic quality.

The year 1905 also marked the first exhibition of a group of German painters that called itself *Die Brücke* (The Bridge). The group, centered about Karl Schmidt-Rottluff, Emile Nolde, Ernst Ludwig Kirchner, Erich Heckel, and Max Pechstein, lasted from 1905 until 1913. These men, whose headquarters were in Dresden, were inspired by the paintings of the Fauves and the Norwegian painter Munch and by Medieval German woodcuts. They used harsh, brutally simplified forms and strong, often clashing colors in a heavy, expressionistic manner. Some of the Bridge group were absorbed by *Der Blaue Reiter* (The Blue Rider), a group formed in Munich in 1911 by Vassily Kandinsky that encompassed a variety of styles ranging from Kandinsky's gay, buoyant, nonobjective paintings to the moody, geometric abstractions of Franz Marc. The Bridge and Blue Rider groups provided the basis for the broad trend known as *German Expressionism*, which is still evident today.

Meanwhile, *Cubism* developed in France during the period from 1907 to 1914 under the leadership of Pablo Picasso and Georges Braque. Its early phase, often called *Analytical Cubism*, sought to reduce nature to its basic geometric shapes while viewing objects from several sides simultaneously. This simultaneity of vision im-

plies a summation of visual experience from different moments and different positions in space and suggests an intriguing parallel to the theories of relativity that Einstein was proposing in the same period. Analytical Cubism employed restrained colors, limited space, and a limited repertoire of geometric shapes; it may be understood partly as a reaction to the spontaneous freedom and lively color of Fauvism. The second phase of Cubism has been called *Synthetic*, because it is a more imaginative reconstruction of or improvisation on the forms of natural objects. Color and space are less limited, and shapes are less restricted to basic geometry. Synthetic Cubism employed *collage*, the pasting of actual objects, such as pieces of newspaper, to the surface of the painting.

French Cubism inspired the Russian painter Kasimir Malevich, who proclaimed a movement called *Suprematism* in 1915. Malevich's geometric compositions evolved from Cubism to nonobjectivism. A broader movement, which embraced both painting and sculpture, was *Constructivism*, the manifesto of which was drawn up in Moscow in 1920 by the brothers Antoine Pevsner and Naum Gabo. Constructivist painting employed precise geometric forms in generally nonobjective compositions. French Cubism also inspired the Dutchman Mondrian to seek even greater austerity in compositions of rectangles and primary colors. In Holland, Mondrian helped form a group in 1917 that is generally known by the name of its magazine, *De Stijl*. The influence of Cubism may be seen in the Italian movement called *Futurism* (c. 1909–15), which used multiple contours, diagonal lines, and swirling curves to express the dynamism of the machine age.

The tendency to apply a severe geometric system of order to an objective or a nonobjective world has been widespread in twentieth-century painting and has produced a wide variety of styles. A very different tendency has developed concurrently since 1916, when *Dada* was founded in Zurich, Switzerland. Dadaism was a nihilistic rejection of rationality and order. Arising from the disillusionment of the First World War, Dada sought to destroy through ridicule the old ideas about the character, aims, and standards of art and to build a new standard with an appreciation of fantasy and the irrational. Dadaists used sculpture, painting, and photomontage to present extraordinary combinations of ordinary objects, thereby destroying the conventional meaning of the objects and opening the way for new interpretations by the spectator. Dadaism reflected the growing appreciation of the role of the irrational as

revealed by psychiatry. It spread quickly to Cologne, Berlin, Paris, and New York. Its organized life was short (1916–22), but its influence can be seen in much contemporary painting and sculpture. Many Dadaists joined the *Surrealist* movement, which announced its aims in a Paris manifesto in 1924 and which continues as one influence on painting today. Some Surrealist work, like that of Salvador Dali, attempts to depict hallucinatory or dream experiences, where recognizable and unrecognizable forms appear in surprising combinations and vast scale. Other Surrealists, like Joan Miró, produce compositions with lighter, more humorous fantasies. A major source of both Dada and Surrealism was the Italian Giorgio de Chirico, who was painting haunting, dreamlike landscapes as early as 1910.

In the 1920's and 1930's, while Surrealism, Expressionism, and various kinds of geometric abstraction developed, there was also much painting with social commentary being done in Europe and the Americas. The cynicism that grew out of the First World War encouraged not only the Dada movement but also a trend that in Germany was called *The New Objectivity (Die Neue Sachlichkeit)*. Here realistic detail was used more specifically than in Dadaism to point out the horrors and corruption of men and society. There were counterparts to the New Objectivity in other countries. In the United States, the vigorous life of crowded cities, particularly that of the slum areas, provided subject matter for the so-called *Ash Can School* or *The Eight*, which played an avant-garde role from 1908 until 1913. After the 1913 New York Armory Show, which jolted Americans into awareness of advanced trends in European art, American patrons became more sympathetic to abstract art. A generation of American artists, many of whom had studied in Paris during the crucial years of Fauvism and Cubism, had become pioneers in American abstract painting. However, in the late 1920's there was a tendency to move away from abstraction and toward painting the American scene. The Depression of the 1930's encouraged such art to depict not only the face of America but also the tragedy and suffering caused by economic crisis. In Russia after 1921, the Communist government forced into exile those artists who would not turn to a propagandistic realism in support of its political ideas. Mexico produced three of the most powerful artists of social commentary in the 1920's and 1930's, Orozco, Rivera, and Siqueiros, whose mural paintings protest the viciousness of humanity and the oppression of the weak by the strong.

Since the Second World War an international trend toward abstract and nonobjective art has been dominant. Many European artists were driven by the war to the United States, bringing with them quantities of talent and new ideas. It was in New York, under the leadership of Jackson Pollock, Franz Kline, and Willem de Kooning, that the first major movement in postwar painting developed—*Abstract Expressionism.* This painting is sometimes abstract and sometimes nonobjective, but it is usually explosive in the activity of its forms. The quality of expressed activity—often cathartic in its violence—led American critics to describe much Abstract Expressionist art as *action painting.* It has its ancestry in Fauvism, German Expressionism, and the Surrealist emphasis on instinct and fantasy. Although the term Abstract Expressionism was applied first to American painting of this type during the 1940's, similar work has been done in other countries.

In the 1960's, the dominance of Abstract Expressionism was challenged by variations of three international trends: *Pop Art, Op (Optical) Art,* and *Minimal Art.* Pop Art developed first in England and then in America and France. The images of the mass media advertising and comic strips are presented in bizarre combinations, distortions, or exaggerated size, blurring the distinctions between commercial art, fine art, and real life. Although the term *Neo-Dada* has been used in connection with Pop Art, satirical intent is often less evident than enthusiasm for the daily images and objects of our culture. Op Art is a development within the broad category of geometric abstraction; it employs precise shapes and optical illusion for effects of movement and ceaseless change. Op Art sometimes overlaps Minimal Art, a drive toward reduction to few or single shapes and colors. Certain Pop, Op, and Minimal artists have been outspoken in expressing appreciation of forms that seem mechanical, conventional, or impersonal.

Vassily Kandinsky (Russia, Germany, and France, 1866–1944). Kandinsky was born in Moscow but settled in Munich; he became the leader of the Blue Rider group in 1911. Earlier he had abandoned a career in law and had turned to Fauvist painting and, eventually, to increasingly abstract forms. It may have been as early as 1910, depending on the disputed date of a watercolor, that he developed nonobjective art. His treatise *Concerning the Spiritual in Art,* published in 1912, urged that painting can approach the state of pure music—that is, that line, color, and form may be used like sounds to evoke emotional response without the help of subject

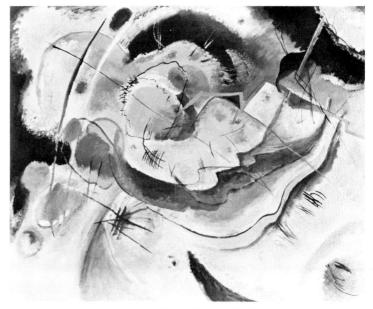

18-1 VASSILY KANDINSKY, *Improvisation,*
1914. Oil on canvas, 30¾" x 39⅞".
Louise and Walter Arensberg Collection,
Philadelphia Museum of Art.

matter. He often used titles such as "fugue" or "improvisation" to stress the correspondence with music. The *Improvisation* in Figure 18-1 is typical of his early nonobjective paintings. Cloudlike forms, angular and wavy lines, and rainbow colors expand spirally from a nucleus of smaller, brighter, denser, and more sharply contrasting parts. The activity is buoyant and spontaneous in effect but carefully controlled within the limits of the picture. From the 1920's on, Kandinsky also composed with rigid, precise, geometric shapes or combinations of geometric and freer forms. Occasionally, recognizable objects appear in his work. In 1934, Kandinsky settled in Paris, where he spent much of the remainder of his life. His art has been a major influence in twentieth-century painting.

Henri Matisse (France, 1869–1954). The study of law failed to satisfy the young Matisse, and his brief period as a student of the academic painter Adolphe Bouguereau was equally frustrating. After this, he studied with the lenient Gustave Moreau. An early interest in Impressionism is evident in *La Desserte* (1897, Collection of Stavros Niarchos, Athens). Matisse then became enthusiastic about the work of Cézanne and Gauguin. By 1905, Matisse's art had developed large areas of relatively unbroken color, often chosen quite independently of nature, and shapes manipulated to intensify their directional forces. In the Salon d'Automne of 1905, Matisse was seen as the leader of the Fauve group. *The Green Line* (1905, State Museum, Copen-

Painting / 317

hagen), a portrait of Madame Matisse, indicates by its title the artist's concern with color. Vibrating complementaries—greens and reds, yellows and violets—achieve a dynamic equilibrium and a life of their own. Such gymnastics with color continued to be typical of Matisse's style, but in his later works he tended to use thinner paint and to create looser forms. *Decorative Figure on an Ornamental Background* (Plate 5) is one of the more tightly constructed works from the 1920's, yet the solid rigidity of the figure contrasts with the exuberance of the patterns and colors. The exhilarating effect of ease and spontaneity masks the continual repainting and the deliberation that went into Matisse's painting. In *Notes of a Painter*, published in 1908, Matisse describes his dream of an art of balance, purity, and serenity devoid of troubling or depressing subject matter. No elaborate theories guided him; he relied on his instinct as he worked and reworked a composition according to his conviction that everything—shapes, spaces between shapes, colors, and lines—should contribute to the total expression.

Georges Rouault (France, 1871–1958). Rouault's training consisted of an apprenticeship to a maker of stained glass and the study of painting with Gustave Moreau. By 1905, Rouault was painting with the slashing brushwork and urgent scumblings seen in *The Head of Christ* (Collection of Walter P. Chrysler, Jr., New York). Although his works were not exhibited in the same room with those of the Fauves during the Salon of 1905, he was Fauvist in the expressive violence of his forms. Rouault's content, however, which deals more with the pathos, tragedy, and corruption of man, links him with German Expressionism. Frequent subjects are prostitutes, sorrowful clowns, evil judges, and heads of Christ. His deep religious convictions owed much to the writings of Léon Bloy; his sense of social justice recalls the art of Daumier. As Rouault's style matured, contours became rigid containers for islands of thick glowing color. *The Old King* (Plate 6) has the radiance of a stained glass window or a Byzantine icon. His genius as a printmaker is revealed in the lithography and intaglio prints that he executed as book illustrations under the patronage of his dealer, Ambrose Vollard, from 1916 to 1927, and which he eventually published as the *Miserere*.

Piet Mondrian (Holland, 1872–1944). Mondrian, even more than Kandinsky, was the exponent of nonobjective painting. Mondrian studied at the Amsterdam Academy

and began as a painter of landscapes in bright Fauvist colors, exemplified by *The Woods near Œle* (1907, City Museum, The Hague). After moving to Paris in 1912, his style was strongly influenced by Cubism and became increasingly abstract. *Composition No. 7 (Façade)* (Nieuwenhuizen Segaar Gallery, The Hague) indicates that by 1914 he was reducing subject matter to intricate flat rectangular systems limited to a few colors. Mondrian returned to Holland in 1914 and remained there during the First World War. In 1917, he and a circle of friends founded the magazine *De Stijl*, whose name was subsequently attached to their group, in spite of Mondrian's choice of the term *Neo-Plasticism*. He remained the major spokesman for the group and the only faithful follower of the strict principles he enunciated. He stated that the new plastic idea would seek universal harmonies, using the pure forms of straight lines and primary colors. He saw subject matter as an impurity that limited the universality of the painting by tying it to a particular time and place. *Composition with Blue and Yellow* (Fig. 3-3) exemplifies Mondrian's mature style; a certain intensity of warm yellow and a certain intensity of cool blue are adjusted in quantity to form an equilibrium within the simple gridwork of black lines. This search for absolute order makes an interesting parallel with the Neoclassic artist's effort to find an absolute beauty that would last through the changes of time and place. In 1919, Mondrian returned to Paris and stayed there until 1938, when the Second World War forced him to move to London for two years and then to New York. His art has had a wide influence on painting, sculpture, architecture, and commercial design.

Kasimir Malevich (Russia, 1878–1935). The Kiev School of Art and the Moscow Academy of Fine Arts provided Malevich with his formal training. By the time of his first exhibition, in 1909, his art revealed the influence of Vuillard, Bonnard, and Matisse. Between 1911 and 1913, he came under the spell of Cubism and Futurism. The desire to purify and reduce painting to essential elements led him, in 1913, to paint a *Black Square* (Russian Museum, Leningrad) in the center of a white canvas. This was followed by other geometric compositions, sometimes in one or more colors, with simple shapes floating against white backgrounds. Only in 1915 did Malevich announce a name and a program for this kind of painting: Suprematism. *White on White* (Fig. 18-2) reached an ultimate in his search for purity; the white square can be distinguished from its white back-

18-2
KASIMIR MALEVICH, *White on White*,
1918. Oil on canvas, 31¼" x 31¼". Museum
of Modern Art, New York.

18-3
PAUL KLEE, *The Twittering Machine*, 1922.
Watercolor and pen-and-ink, approx.
16¼" x 12". Museum of Modern Art,
New York.

ground only through faint value differences. Suprematism paved the way for the broader movement of Constructivism.

Paul Klee (Switzerland and Germany, 1879–1940). Klee grew up in Bern, Switzerland, but studied in the Academy at Munich. After traveling in Italy, he painted and did etchings in Bern until 1906, when he moved back to Munich. In 1912, he participated in the second Blue Rider exhibit there. Although his studies included a firm academic grounding in life drawing and perspective, Klee early developed a preference for abstractions done in small scale with subtle color and delicate line. His intellectual attitude was very sophisticated, but his writings show a desire to join adult understanding and experience with the freshness of vision and the delightful fantasy usually left behind with childhood. *The Landscape with Blue Birds* (1919, Philadelphia Museum of Art) is typical of many of his landscapes of the 1920's in its delicate rectangles of color and the softly emerging shapes of trees and birds. The quality of intimate personal fantasy is all-pervasive. Klee's sly sense of humor and sensitivity of line are evident in works like *The Twittering Machine* (Fig. 18-3). During the 1930's, the shapes tend to become bolder, the line heavier, and the colors more opaque, as in the *Diana* (1931, Bernoudy Collection, St. Louis) and the *Park near L[ucerne]* (1938, Klee Foundation, Bern). From 1925 to 1930, Klee taught at the Bauhaus, the pioneering German school of design. During these years, he published many of his ideas in the *Pedagogical Sketchbook*. After teaching at the Dusseldorf Academy from 1931 to 1933, Klee was dis-

18-4
ERNST LUDWIG KIRCHNER, *The Street*, 1913.
47½' x 35⅞''. Museum of Modern Art,
New York.

missed by the Nazi government; he returned to Bern, where he worked until his death.

Ernst Ludwig Kirchner (Germany, 1880–1938). In Dresden in 1905, Kirchner and Nolde, along with several others, founded *Die Brücke*, a group dedicated to the "renewal of German art." The dating of Kirchner's early paintings and prints is uncertain, but they seem to reflect the character of Art Nouveau and the influence of Munch. Under the influence of Medieval German woodcuts and African and Oceanic art, Kirchner's work became more abrupt, angular, and dissonant. Color became more brilliant and clashing, and distortions became more extreme. In 1911, Kirchner moved to Berlin, where the life of the city provided a theme for a series of paintings and woodcuts. Some of the latter were used in the avant-garde publication *Der Sturm*. *The Street* (Fig. 18-4), one of the paintings in the series, demonstrates the conflict of angles, the splintered forms, and the spatial tensions common to Kirchner's work before 1920. From the time of his military service (from 1914 to 1915) and concomitant nervous disorders, Kirchner's style slowly changed. In the 1920's, shapes began to be more clearly separated and to contain less active brushwork. Kirchner went to Switzerland, where he spent the remainder of his life, and took much of his subject matter from the Swiss Alps.

Pablo Picasso (Spain and France, 1881–). After a triumph as a precocious academic student, Picasso went from Spain to Paris and quickly began experimenting with the revolutionary styles of the recent past. From early attempts at Impressionism, he moved to the first of many personal stylistic developments: his Blue Period (1901–04), during which he used blues and grays to depict people who seem spiritually and physically exhausted, as in *The Old Guitarist* (1903, Art Institute of Chicago). In 1905 and 1906, he turned to warm tans and reds; circus subjects were frequent. Slowly the forms stiffened to become masklike in works like the *Portrait of Gertrude Stein* (1906, Metropolitan Museum of Art, New York); Picasso had become interested in the primitive formal power of African Negro and ancient Spanish sculpture. A major milestone is *Les Demoiselles d'Avignon* (1907, Museum of Modern Art, New York), in which five female figures with masklike faces and flat, angular body forms become part of a sequence of splintered planes with lost and found edges. The painting is often seen as the starting point for Cubism. An example of Analytic Cubism is Picasso's *Girl with a Mandolin* (1910, Nelson Rockefeller Collection, New York), while Synthetic Cubism is exemplified by *The Three Musicians* (Fig. 1-14). Here, the effect of collage is produced with paint, and the liveliness of the composition is achieved within a more severe discipline than is found in Fauvist work. The drawing of Dr. Claribel Cone (Fig. 1-1), done in the same period, presents an entirely different stylistic discipline. It employs the massive simplified forms seen in many of Picasso's paintings done during the 1920's. These works have been called Neoclassical because they have some of the qualities of Greek sculpture. From the next decade, the best-known work is the *Guernica* mural, done for the Spanish government building at the Paris World's Fair of 1937. The painting is a violent but controlled expression of the horror evoked by the bombing of the town of Guernica during the Spanish Civil War. Interest in dissonant forms—shapes with much internal conflict in their directional forces—had been building in his work before *Guernica* and has since been prevalent in his art. The stylistic variety continues, however, and ranges from precise portraits to ebullient patterns in strident colors.

Georges Braque (France, 1882–1963). Braque went from Le Havre to Paris and, by 1906, was painting Fauvist works. In the following year, he became enthusiastic about the art of Cézanne, and some of Braque's offerings

18-5 GEORGES BRAQUE, *The Portuguese*, 1911.
Oeffentliche Kunstmuseum, Basel.

to the Salon d'Automne of 1908 were refused because
of his startling use of lively geometric form applied to
landscape subjects. The critic Louis Vauxcelles wrote
of "Cubism" in describing Braque's work, thus naming
for the first time one of the most important movements
in twentieth-century art. Picasso had already initiated
this trend in 1907, and he continued to provide the
inventiveness and drive for Cubism, while Braque went
through fewer drastic changes of style and worked more
methodically in exploring stylistic possibilities within
a limited range. The shallow depth, restrained color,
and many-faceted order of Analytical Cubism are evi-
dent in Braque's *The Portuguese* (Fig. 18-5). After his
service in the First World War, Braque worked in the
realm of Synthetic Cubism but employed unique, low-
keyed, sonorous color harmonies like those of *Café-Bar*
(1919, Basel Kunstmuseum). In the 1920's, he painted
a number of nudes with delicate wavering outlines, thin
washes of paint, and monumental proportions like those
in some of Picasso's figure compositions from this
period. At the same time, Braque continued to work
out the sensitive modulations of shape, texture, and
color in still-life paintings such as *The Round Table*
(1929, Phillips Gallery, Washington, D.C.). More playful
arabesque curves and lighter colors appear in some of
the work done during the 1930's, and the 1940's saw
a series of compositions on the theme of the *atelier*
(studio). These paintings reach a new height in com-

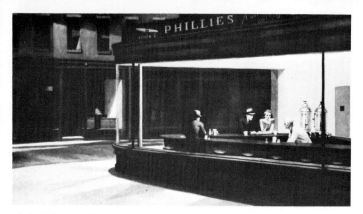

18-6 EDWARD HOPPER, *Night Hawks*, 1942.
Art Institute of Chicago.

plexity and control; textures, textile patterns, and transparent and opaque shapes move back and forth within labyrinthine spatial relationships.

Edward Hopper (United States, 1882–1967). Commercial art provided Hopper's living for years while he studied painting with Robert Henri and absorbed European art in museums and on trips abroad. From 1908 until his death, he lived in New York and spent summers in Maine. Hopper's subjects include New England houses and coast scenes, but he is best known for paintings of the city. Works like *Early Sunday Morning* (1930, Whitney Museum of American Art, New York) and *Night Hawks* (Fig. 18-6) utilize bold patterns of light, shadow, and color to distill the character of buildings and to express the monotony and the drama of daily life. A poignant loneliness frequently haunts the mute façades. Hopper's paintings of the American scene help us find significance in the commonplace; one senses the isolation of the individual within the group, the ageless cycle of life and death, and buildings as the expressive evidence of man's condition.

Umberto Boccioni (Italy, 1882–1916). Boccioni's painting drew from Seurat's divisionism but employed featherlike brush strokes that evoke forms in violent motion. In *The City Rises* (1910–11, Museum of Modern Art, New York), for example, objects sacrifice much of their solidity and take on the appearance of colorful whirlwinds. Boccioni was one of the authors of the *Technical Manifesto* of Futurist painting in 1910, which stressed the destruction of material bodies by movement and light and called for painting that expressed universal dynamism and metamorphosis. These convictions are powerfully conveyed by *The Dynamism of a Soccer Player* (Fig. 18-7). Boccioni's sculpture, like his painting, evokes a sense of violent motion and interpenetration of mass and space.

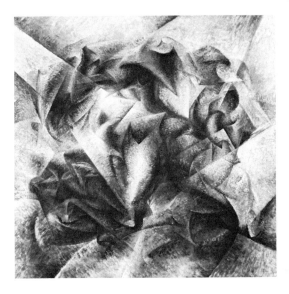

18-7
UMBERTO BOCCIONI, *The Dynamism of a Soccer Player,* 1913. 6'5'' x 6'7''. Collection of Mr. and Mrs. Sidney Janis, New York.

José Orozco (Mexico, 1883–1949). After training in the Academy of San Carlos in Mexico City, Orozco painted murals depicting themes of revolution, pillage, suffering, and cruelty in huge, massive forms. At the New School for Social Research in New York, he painted the revolution of the proletariat; and, in the Baker Library at Dartmouth College, he interpreted American history. The Dartmouth paintings include one of the most overwhelming of Orozco's compositions: *Christ Destroying His Cross* (Fig. 18-8). Having lost patience with man, Christ has repudiated his sacrifice, chopped down the Cross, and stands facing us with ax in one hand and the other hand raised in a clenched fist. Christ's wrath is awesome as he stands with enlarged eyes, blue-shadowed face, reddish beard and hair, a torso of blue, orange, green, gray, and purple, and partially flayed legs. In 1934, Orozco returned to Mexico to paint his

18-8
JOSÉ OROZCO, *Christ Destroying His Cross,* 1932–34. Fresco. Dartmouth College, Hanover, New Hampshire.

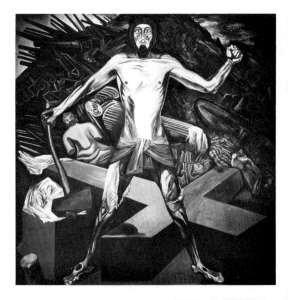

most furious condemnations of war in murals for the Palace of Fine Arts in Mexico City and for the University, the Government Palace, and the Hospicio Cabañas in Guadalajara.

Max Beckmann (Germany and the United States, 1884–1950). The Weimar Art School provided training for the young Beckmann, whose early style was a boldly brushed Impressionism. During military service in the ambulance corps in the First World War, he developed compositions of greater dissonance and intensity, like that of his *Self-Portrait with Graver* (Fig. 1-2). As a leader in the German New Objectivity movement, he depicted the poverty, corruption, and hopelessness of his era. *The Departure* (Fig. 18-9) assumes the traditional triptych format of an altarpiece. The harsh angles, the pinched and twisted forms, the conflict between two-dimensional and three-dimensional forms, and the spatial compression are found, to some extent, in much of his work. The side panels depict scenes of torture and of burden-bearing or constraint; the center is relatively tranquil. At one time, Beckmann said that the woman bound with a man, on the right, symbolized the individual searching his way through life but tied to the burden of his past failures; that the center depicts triumph over the tortures of life and attainment of freedom; and that the title referred to departure from the illusions of life. However, he also said that each spectator must understand the painting in his own way. Unlike Medieval symbolism, Beckmann's symbols, like many in twentieth-century art, are personal, enigmatic, and demand completion by each spectator. Beckmann

18-9

MAX BECKMANN, *The Departure*, triptych, 1932–35. Oil on canvas, central panel 84¾" x 45⅜". Collection, Museum of Modern Art, New York (given anonymously).

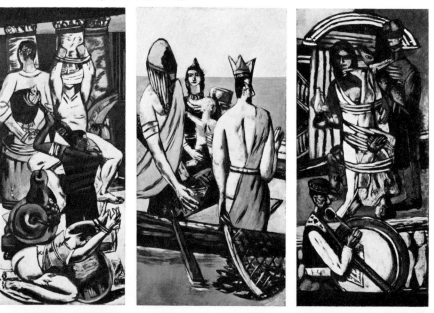

18-10
OSKAR KOKOSCHKA, *The Tempest*, 1914.
Oil on panel, 40¼″ x 75¼″. Oeffentliche
Kunstmuseum, Basel.

left Germany for Amsterdam during the Second World
War. In 1947, he moved to the United States, where he
taught painting in St. Louis and in New York. His art
is one of the most powerful expressions of concern for
the anguish and suffering of twentieth-century man.

Oskar Kokoschka (Austria, England, and Switzerland,
1886–). African art, Oceanic art, and Japanese
woodcuts fascinated Kokoschka even before his training
at the Vienna School of Arts and Crafts. His early paint-
ings (*c.* 1908–10), such as *The Marquis* (1909–10, Na-
tional Museum, Stockholm), were made by scraping or
rubbing a thin layer of paint onto the canvas and then
scratching lines into the paint with the brush handle.
The worried paint surface, the delicate color, and the
gauntness of the figures all suggest a hypersensitive,
fragile, anxious world. In 1910, Kokoschka moved toward
thicker, darker, and more iridescent paint; lines were
painted rather than scratched. By 1914, in *The Tempest*
(Fig. 18-10), an expression of the painter's passion for
Alma Mahler, the brush strokes are sweeping, and the
forms are conceived as active forces. By this time,
Kokoschka had sojourned in Berlin, done art work for
Der Sturm, and influenced some of the Brücke painters
there. Between 1938 and 1947, he stayed in England;
since 1947 he has lived in Switzerland. His style since
1924 has tended to combine active line and brushwork
with luminous color. Kokoschka is one of the leading
painters within the many-faceted trend called Expres-
sionism.

18-11

MARCEL DUCHAMP, *The Large Glass or the Bride Stripped Bare by Her Bachelors, Even,* 1915–23. Oil and wire on glass, 34¾″ x 21½″. Philadelphia Museum of Art.

Marcel Duchamp (France and the United States, 1887–1968). Duchamp has been one of the most publicized exponents of the irrational in art. He studied at the Académie Julian in Paris and painted under the influence first of Cézanne and then of the Fauves. By 1912, he had formed a personal style and painted the *Nude Descending a Staircase* (Arensberg Collection, Philadelphia Museum of Art) that became the focus of attention in the New York Armory Show of 1913. The concern with motion and its expression through multiple contours or repeated shapes suggests the influence of Cubism, photography, and the Italian Futurist movement. The same year, Marcel produced the first of his "ready-mades," a bicycle wheel mounted upside down on a stool. By exhibiting a common, machine-made article as art, he challenged traditional definitions and values. In 1915, he came to the United States, where he spent most of the remainder of his life. *The Large Glass or the Bride Stripped Bare by Her Bachelors, Even* (Fig. 18-11) has been the subject of much interpretation. Some critics have restricted their interpretation to a sexual one, based on the implications of the title; others view the work as an attack on the mechanization of modern man. The composition relates readily to Dada art, and Duchamp was, from 1915 on, the center of a New York group that was Dada in character and, eventually, in name. In the 1920's, his activities as an artist gave way to his interest in chess, although he did help to organize the 1942 Surrealist exhibition in New York.

Giorgio de Chirico (Italy and France, 1888–). The precursor of Surrealism, De Chirico was trained in Athens and in the Munich Academy, where he grew to admire the art of the Swiss painter Böcklin, the German painter Klinger, and the German philosopher Nietzsche. For De Chirico, Böcklin's fantasies, painted with realistic detail, may have expressed the reality underlying the physical world. *The Mystery and Melancholy of a Street* (Fig. 18-12) exemplifies the style that made De Chirico famous during his stay in Paris from 1911 to 1915. The empty arcades of two buildings, each seen from a different eye level, and a long human shadow provide a disquieting environment for the small girl playing with a hoop. Colors are somber and the paint is applied thinly. There is an almost hypnotic effect of loneliness and quiet. De Chirico's deserted cities, echoing arcades, and vast spaces suggest the world of dreams, and he was later appreciated by the Surrealists in Paris. After being called into the Italian army in 1915 and stationed in Ferrara, De Chirico found

18-12
GIORGIO DE CHIRICO, *The Mystery and Melancholy of a Street*, 1914. Oil on canvas, 34¼" x 28⅛". Collection of Mr. and Mrs. Stanley Resor, New Canaan, Connecticut.

time to paint. He and Carlo Carra, a former Futurist, established the *Scuola Metaphysica*, a small group of painters who were influenced by De Chirico's style. In 1918 De Chirico returned to Rome and changed his style slowly toward more conventional work in a Neoclassical vein. The Surrealists eventually attacked him for having deserted their camp; the critics lost interest in his work, and the unfortunate De Chirico was reduced, on occasion, to copying or imitating works in his earlier style.

Marc Chagall (Russia, the United States, and France, 1889–). Chagall's early style was formed during his residence in Paris from 1910 to 1914, when he was introduced to Cubism. Memories of his childhood in Vitebsk, Yiddish folklore, and Cubist geometry are freely combined without regard to time, space, or scale in *I and the Village* (1911, Museum of Modern Art, New York). Back in Russia between 1914 and 1923, Chagall served as Commissar of Fine Arts at Vitebsk and designed murals and stage sets for the Jewish State Theater in Moscow. The *Double Portrait with Wine Glass* (Fig. 18-13), from this period, portrays Chagall seated on his wife's shoulders drinking to the future while his young daughter hovers over his head. The monumental figures dwarf the cityscape beneath them, and bright colors combine with sudden angles, rippling curves, and anatomical transformations to provide an ecstatic vision. In the 1920's, geometric elements fade from his art, and softer, more sensuous shapes appear.

18-13
MARC CHAGALL, *Double Portrait with Wine Glass*, 1917. Oil on canvas, 91¾" x 53½". Musée National d'Arte Moderne, Paris.

Joan Miró (Spain and France, 1893–). Miró was born in Barcelona and trained in the La Lonja School of Fine Arts. His early work consisted of landscapes and portraits done in lively colors, patterns of repeated shapes, and occasional delicate detail. After 1919, Miró spent much of his time in Paris, and in 1924 he associated himself with the Surrealists. By that time, his work had developed a combination of reality and fantasy that evoked the quality of dream experience so interesting to the Surrealists. *The Harlequin Carnival* (Fig. 18-14) presents a preposterous collection of brightly colored objects. Balloon faces, butterflylike insects, snake forms with hands, musical notes, dolls, and fish all wriggle buoyantly in an architectural interior. Many of Miró's works are more abstract than this, but some identifiable objects are usually present. Frequently, the soft, undulating, amoebalike shapes change color where they overlap. Miró often dribbles or splashes paint onto a new canvas, employing accident to suggest the start of a composition. Renown has brought him a number of important mural commissions, such as that for the graduate center at Harvard University (1950–51). After devoting much time to ceramics between 1955 and 1959, he produced two ceramic murals for the UNESCO Buildings in Paris.

Stuart Davis (United States, 1894–1964). Davis received his early training in New York. The famous Armory Show of 1913 introduced him to Cubist and Fauve painting. During a year in Paris (1928–29), he produced a number of street scenes with delicate line and rectangular patterns. After returning to New York, his com-

18-14 JOAN MIRÓ, *The Harlequin Carnival,* 1924–25. Albright-Knox Art Gallery, Buffalo.

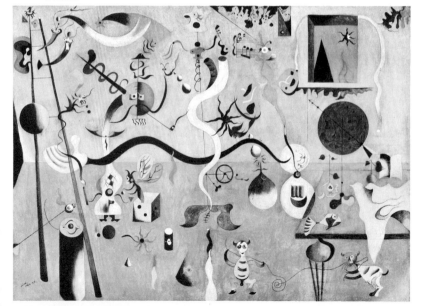

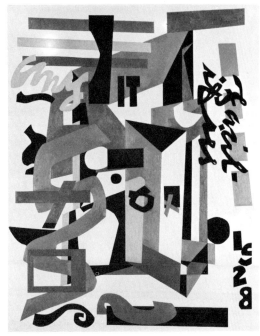

18-15
STUART DAVIS, *Something on the Eight Ball,* 1954.
Oil on canvas, approx. 5' x 4'. A. E. Gallatin
Collection, Philadelphia Museum of Art.

positions were still lifes, bustling city street scenes with garish advertising, or harbor scenes—all done with the aggressive shapes, jangling colors, and bits of letters or words that have come to characterize his mature style. *Something on the Eight Ball* (Fig. 18-15) is typical in the jerky curves and angles that weave a loose dynamic structure.

Salvador Dali (Spain and the United States, 1904–). Dali's studies at the School of Fine Arts in Madrid began in 1921 and were terminated by suspension in 1926; his behavior was too unconventional to be acceptable to the school. In his early work, Dali borrowed widely from artists ranging from Vermeer to Picasso and De Chirico, developing, by 1927, a mature style that combines recognizable and unrecognizable forms in vast spaces. In 1929, he settled in Paris and joined the Surrealists. *The Persistence of Memory* (Fig. 3-2) produces the effect of dream experience. Like other Surrealists, Dali is inspired by the ideas of Freud.

Willem de Kooning (Holland and the United States, 1904–). De Kooning worked at commercial art during the day and studied art in night classes, first at the Academy in Rotterdam, later in Belgium, and, after 1926, in New York. In 1935, he became a full-time painter, and during the 1940's he made his reputation in New York. His early style, in the 1920's and 1930's, often combined recognizable objects with geometric

shapes. Forms are solidly modeled in some parts and flattened in others, and there is a constant shifting from mass to plane and from flatness to depth. Colors develop around pinks, yellows, and light blues, sometimes in vibrating contrasts. In the 1940's, he produced a series of abstract and nonobjective works in black and white, with sprightly curving planes and active lines. Such painting composed the major part of his first one-man show in 1948, which immediately established his reputation. During the 1950's, color was added to the slashing brushwork and explosive energy of these works, as is evident in the series on Woman. Plate 7 is typical of this group; the work seems to have emerged from a violent encounter of artist and materials to become a record of action and spontaneous decision. In the late 1950's and early 1960's, he painted many nonobjective works; in the mid-1960's, he once more began painting the human figure, this time with more fluid brushwork than before.

Victor Vasarely (Hungary and France, 1908–). Vasarely came to Paris in 1930 after study in a Budapest school patterned after the German Bauhaus. For a time he worked as an advertising designer and did noncommercial designs in his free time. In 1944 he first exhibited his "free-graphics" and left commercial art. His early geometric abstractions occasionally used optical illusions of change and movement in patterns and colors, and after 1955 Vasarely became a pioneer in the exploitation of these kinetic effects, which he calls *cinétisme*. *Tlinko* (Fig. 18-16) demonstrates the vibrating and shifting effects that can be achieved with only black and white. The physiological basis for such illusions is retinal fatigue. Vasarely was a source of inspiration for such groups as *NTrc* (*Nouvelle Tendence recherche continuelle*) and *GRAV* (*Groupe de Recherche de l'Art Visuel*), which developed in the 1960's as part of the international spread of Kinetic and Op Art (see p. 316).

Franz Kline (United States, 1910–62). Kline, one of the leaders of the Abstract Expressionist movement, was born in Pennsylvania. He established himself in New York in 1938, teaching at Pratt Institute and doing commercial art to earn a living. During the 1930's and 1940's, he painted portraits, landscapes, and cityscapes. In 1950, the year of his first one-man show, he saw some of his small drawings enlarged by an opaque projector. The power of the forms thus magnified inspired Kline to turn to broad sweeping strokes in nonobjective compositions. For several years, he used only black and

18-16

VICTOR VASARELY, *Tlinko*, 1955. Approx. 76¾" × 51¼".

18-17
FRANZ KLINE, *LeGros*, 1961.
Oil on canvas, 41⅜" x 52⅝".
Sidney and Harriet Janis
Collection. Gift to the Museum
of Modern Art, New York.

white, but in the mid-1950's he began to employ color
again. Kline did brush drawings on newspapers and the
pages of telephone books. These sketches were then
framed with different-sized rectangles or cut into frag-
ments. Once the plan was established in this way, it
was enlarged on canvas and painted with large brushes.
Le Gros (Fig. 18-17) is typical in the slashing power
of the black strokes, which establish a horizontal shape
poised on a vertical one. Prolonged observation, how-
ever, calls into question the relationship between the
black figure and the white background, for the artist
dragged white paint over the black in certain areas to
keep the white from being simply empty. It takes little
effort to reverse the figure-ground relationship and see
the white shapes as positive forms in black space.

Jackson Pollock (United States, 1912–56). Pollock studied
in Los Angeles and New York and eventually settled
on Long Island. His painting became increasingly ab-

18-18
JACKSON POLLOCK, *Autumn Rhythm*,
1950. Oil on canvas, 105" x 207".
George A. Hearn Fund, Metropolitan
Museum of Art.

18-19
ELLSWORTH KELLY, *Blue-White*, 1962. 8'6" x 9'.
Rose Art Museum, Brandeis University, Waltham,
Massachusetts.

stract after 1940. From convulsive linear shapes that
sometimes acquire the character of humans, animals,
or cryptic symbols, as in the *Pasiphaë* (1943, Collection
of Lee Krasner Pollock, Long Island), he turned by 1948
to intricate, nonobjective networks of swirling, colored
line. *Autumn Rhythm* (Fig. 18-18) is typical of his late
works, sometimes called drip paintings because they
were done by dripping paints of different thicknesses
from cans onto canvas stretched flat on the floor.
Pollock's rise to fame was cut short by his death in a
car accident, but he has had a wide influence as a
leader of Abstract Expressionism and action painting.

Ellsworth Kelly (United States, 1923–). Kelly's paint-
ings in the early 1950's sought maximum visual impact
with stripes, grids, or panels in dazzling black and white
contrasts or in a few brilliant colors. By 1955, he had
begun to do painted reliefs and freestanding sculpture
of simple metal shapes painted in highly saturated
colors. In both painting and sculpture, a single intense
color often suffices to give one or two shapes great
energy. In *Blue-White* (Fig. 18-19), two swelling fields
of powerful blue meet in the center, cutting in two the
white buffer between them. Though he is linked with
the tradition of geometric abstraction, Kelly has been
a leader in Minimal Art.

Robert Rauschenberg (United States, 1925–). After try-
ing a variety of approaches, including blank white
canvases and compositions in black and white,
Rauschenberg turned to assemblages of found objects
and objects combined with vigorously brushed painting,
such as *The Bed* (1955, Collection of Mr. and Mrs. Leo
Castelli), which consisted of quilt, pillow, and paint.
By 1961, exhibits in New York and Paris had established

18-20
ROBERT RAUSCHENBERG, *Tracer*, 1962. Approx. 17'9" x 12'8". Collection of Mr. and Mrs. Frank Titelman, Altoona, Pennsylvania.

Rauschenberg as a daring and prolific talent. *Tracer* (Fig. 18-20) indicates a flattening tendency in that no actual objects are attached to the canvas surface. The work's photomontage profusion was obtained by commercial transfer of magazine images to silk screens that the artist then used to print on the canvas. The energy and scale of the brushwork links such a painting with Abstract Expressionism; the unexpected combinations of common objects recall Dada photomontage.

Andy Warhol (United States, 1931–). Warhol, one of the leaders of Pop Art, was raised in Pittsburgh and trained at the Carnegie Institute of Technology. He began a career in advertising art and window display and later employed the images of advertising in his paintings. Since 1961, his subjects have included cola bottles, soup cans, Brillo boxes, and the actress Marilyn Monroe. The Brillo boxes are plywood boxes on which labels have been silk-screened; they belong more to the realm of sculpture than do the other subjects, which are depicted on flat surfaces. Repetition is an important characteristic of Warhol's art. Frequently his compositions consist of one subject repeated many times, sometimes with slight variations. Figure 18-21 is one of a group of four Campbell's soup cans that differ from one another only in color. Warhol has verbally expressed a conviction that men's individual characteristics are on the wane; his art celebrates the impersonal nature of a machine-oriented culture.

18-21
ANDY WARHOL, *Campbell's Soup Can*, 1965. Oil and silk screen on canvas, 36" x 24". Museum of Modern Art, New York.

SCULPTURE

During the first half of the twentieth century, sculpture often reflected movements that occurred first in painting; since about 1950, however, sculpture has shown increasing vitality and inventiveness, greatly enhancing its importance in Western culture. As the twentieth century has unfolded, especially notable characteristics of sculpture have been: (1) a tendency to find inspiration in primitive art, (2) the rejection of mass by many sculptors, (3) the consideration of space as a positive compositional element, (4) the use of actual movement in sculptural compositions (kinetic sculpture), (5) the increasing use of welded metal and a variety of synthetic materials, and (6) the tendency to create sculpture by assembling objects that have been worn out or cast aside by our culture.

In the early years of the century, the mobile surfaces of Rodin's art were countered by the stable massiveness of Maillol's work. Revolutionary portents emerged in the simplified forms and aggressive three-dimensionality of sculpture done by the Fauve painter Matisse. Cubist sculpture, like Cubist painting, practiced disciplined analysis and free improvisation on natural forms. The Russian-instigated movement of Constructivism produced much nonobjective sculpture, created a pioneering example of kinetic sculpture, and provided a significant statement in the form of the *Realist Manifesto* (1920), which asserted the importance of space and time, rather than mass, as elements from which art should be built. The few pieces of sculpture created by Futurists are important three-dimensional expressions of the artists' obsession with speed and constant change. The Dada movement carried further the technique of *assemblage* that had been initiated by Cubist collage and first realized in sculpture by Picasso, with his *Glass of Absinthe* (1914, Philadelphia Museum of Art). Dada sculptures, sometimes called objects of non-art by their creators, were efforts to ridicule the world of convention and reason. The Dada blurring of distinctions between painting, sculpture, and commercially manufactured objects was portentous for later art. Surrealist sculpture has been more methodical in the effort to investigate the realm of the nonrational and to stimulate fantasy and free association by creating surprising combinations. Pop sculpture has ranged from garishly colored depictions of ice cream cones and other foodstuffs, sometimes enormous in scale, to plaster molds of human figures combined with actual furniture. Kinetic sculpture combines movement with forms

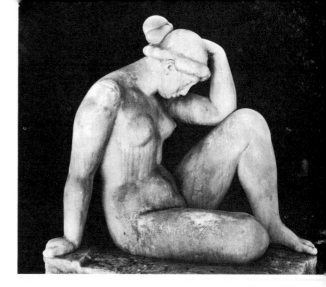

18-22
ARISTIDE MAILLOL, *The Mediterranean*,
1902–05. Bronze, 41" high, at base
45 x 29¼". Collection, The Museum of
Modern Art, New York. Gift of Stephen C.
Clark.

ranging from crisp geometry to bristling assemblages
of cast-off objects and has, in recent years, become
international in scope. The Swiss sculptor Tinguely has
designed kinetic sculpture that destroys itself through
fire and explosion in a predetermined sequence; the
sculpture becomes not only a unique temporary thing
but also a dramatic performance within time and space.
Some sculptors have used neon and fluorescent light;
others have marked the earth's surface with shaped
excavations, called *Earth Works*, in desert areas so
remote that only photographs are available to specta-
tors. In sculpture, as in painting, one major trend today
is Minimal Art.

Aristide Maillol (France, 1861–1944). Maillol and Rodin
were major sources of influence in early twentieth-
century sculpture. In the 1890's, Maillol developed a
mature style that remained essentially unchanged
throughout his career. Unlike Rodin, Maillol preferred
ponderous masses and broad simple surfaces; his poses
are usually static. In the *Mediterranean* (Fig. 18-22), the
back and the raised knee and arm create a large stable
triangle that is reinforced by the smaller triangular
forms of the raised leg and the arm supporting the head.
Geometric stability is strengthened by the simple, mas-
sive body forms, but the stony monumentality of the
work is softened by slight undulations in contour. This
sturdy female body appears throughout Maillol's work,
acquiring the blocky hardness of the *War Memorial
at Port-Vendres* (c. 1923) or the more active musculature
of *Action in Chains* (c. 1906, Metropolitan Museum of
Art, on extended loan to the Museum of Modern Art,
New York).

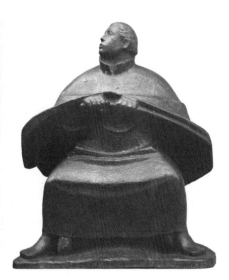

Ernst Barlach (Germany, 1870–1938). The key to Barlach's style may be found not so much in his studies in Hamburg and Dresden but in an early trip to Paris in 1895, where he saw and admired the massive peasants in Jean François Millet's paintings, the expressive force of Van Gogh's art, and the enduring strength of the workers sculpted by Constantin Meunier. From early work in clay, Barlach turned to wood as a favorite material. He reduced the human body and its costume to large simple masses, often unified by a common texture of gouge marks, emphasizing lines of force that express powerful feeling. His *Man Drawing a Sword* (Fig. 18-23) rises from the lines of tension in the skirt to the sweeping flare and bold shadows of the cape, which call attention to the hands drawing the sword. Tense urgency and vitality emanate from the simple forms.

18-23 ERNST BARLACH, *Man Drawing a Sword,* 1911. Wood, 29½'' high. Cranbrook Academy of Art, Bloomfield Hills, Michigan.

Constantin Brancusi (Rumania and France, 1876–1957). Brancusi studied at the Academy of Fine Arts in Bucharest and, after settling in Paris in 1904, at the École des Beaux-Arts. His first exhibit in 1906 revealed the influence of Rodin. By 1908, Brancusi was finding his way toward greatly simplified forms with slight but important surface variations. The *Girl's Head* (1907–08, Arensberg Collection, Philadelphia Museum of Art) gains monumentality from sweeping planes and the reduction of facial features to grooves and ridges. Such heads indicate Brancusi's debt to African sculpture and his influence on the sculpture and painting of Amedeo Modigliani. By 1910, Brancusi had pushed simplification still further in *The Sleeping Muse* (Fig. 18-24). The head is reduced to an egg shape, with slight ridges for nose, lips, and ear. This reduction to geometric forms must be distinguished from that of Cubism; Brancusi was not interested in a multiplicity of views or a plane-by-plane analysis. He sought form that would be both visually exhilarating in its absolute simplicity and significant in its symbolism. *The New-Born* (1915, Museum of Modern Art, New York) is a sleek bronze egg form that is

18-24
CONSTANTIN BRANCUSI, *The Sleeping Muse,* 1910. Bronze, 10¾'' long. Collection, The Metropolitan Museum of Art, New York, The Alfred Stieglitz Collection.

sliced by a plane and interrupted by a ridge. Where flat surface meets curved surface, the resulting edge gives a more precise idea of the nature of the curved surface. In addition to satisfying formal elegance, the work has subject matter that can be discerned with the help of its title. The egg not only refers to the beginning of life but also suggests the head of an infant, the anonymous face of a child whose personality is yet to be shaped by experience. Brancusi's preference for ovoid form is evident in the series of heads entitled *Mlle. Pogany*, done in many versions over a period of years, or in the versions of the *Fish* (one in the Museum of Modern Art, New York, done 1918–28), where the sleek, blade-shaped form is poised over a flat surface. Brancusi remained aloof from the various groups and movements in twentieth-century art, yet the influence and appreciation of his sculpture have been international.

Naum Gabo (Russia, Germany, France, England, and the United States, 1890–). Gabo's Russian parents sent him to study medicine in Munich, but his interests turned toward science and sculpture. Acquaintance with Kandinsky, travels in Italy, and visits with his brother Antoine Pevsner, then a painter in Paris, all strengthened Gabo's interest in art. He began to use wood, metal, and celluloid to create forms that were open spatial volumes rather than masses. In 1917, Gabo returned with his brother to Russia, and in 1920 they spoke for the Constructivist Group in publishing the *Realist Manifesto*, which called on art to express the new realities of space, time, and motion. Soon the Soviet government became hostile to abstract art, and Gabo and Pevsner were among the many artists to leave Russia. His *Linear Construction* (Fig. 18-25) is typical of his mature style. Nylon string and plastic sheets form gracefully curving planes that are subtly adjusted to the square edges of the composition and frame a central opening. Light and space permeate the transparent composition, and space participates as a positive element, providing the major theme in the form of the central opening. Gabo's work continues to embody most of the principles of the 1920 *Manifesto*. Using transparent planes, he imposes order on space. Time is organized by motion, but motion is expressed by flowing rhythmic continuity rather than by actual movement. Since his first experiment with motorized kinetic sculpture in 1920, Gabo has felt that expressed movement, rather than actual movement, is more effective for his sculpture.

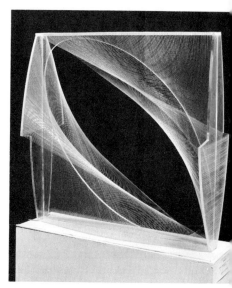

18-25

NAUM GABO, *Linear Construction*, 1942–43. Plexiglass, 24¼" x 24¼". Phillips Collection, Washington, D.C.

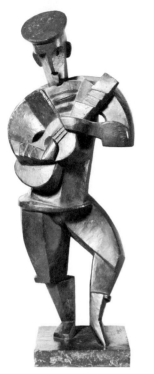

18-26 JACQUES LIPCHITZ, *Sailor with Guitar,*
1914. Philadelphia Museum of Art.

Jacques Lipchitz (Lithuania, France, and the United States,
1891–). Lipchitz left his Russian section of Lithu-
ania in 1909 and came to Paris. His early work, such
as *Woman and Gazelles* (1912, owned by the artist),
shows a tendency toward stolid equilibrium and heavy
simplified anatomy similar to that seen in the art of
Maillol. Soon, however, Lipchitz became involved with
the concepts of Cubism. The *Sailor with Guitar* (Fig.
18-26) has the cascading sequences of planes found in
Cubist painting, and the *Man with Guitar* (1916, Mu-
seum of Modern Art, New York) develops a more
abstract construction of geometric shapes with a hole
through the center; Lipchitz' art was to become still more
open in form. After doing a series of relief plaques in
a Cubist style, he moved toward freer-flowing curves.
A series of *transparencies,* as he called them, abandoned
the traditional mass of sculpture for thin perforated
planes, straps, and wiry forms. During the 1930's, the
forms regained some of their mass and became knotted
and muscular. In *Prometheus Strangling the Vulture II*
(Fig. 18-27), the forms become convulsive in their en-
ergy. Primarily a modeler, Lipchitz makes the malleable
clay burst with a life force. He has attempted to exploit
the spontaneity of accident by blindly forming a mass
of clay and then improvising with the result. He calls
such works *semi-automatics.* Although most of his sub-
jects can be recognized, their expressive and symbolic
character is not always easy to define; the forms seem
laden with suggestions of fecund plant and animal life,
of male and female elements, and of the mystery of
creation.

18-27
JACQUES LIPCHITZ, *Prometheus Strangling the
Vulture II,* 1949. Philadelphia Museum of Art.

ALEXANDER CALDER, *Under the White Sickle Moon,* 1963. Steel, approx. 4' x 5'. Perls Galleries, New York.

Alexander Calder (United States and France, 1898–). Although Gabo experimented with moving motor-driven sculpture, Calder is acknowledged internationally as the most important pioneer in kinetic sculpture. Calder was born in Philadelphia; he studied engineering before he became a student at the Art Students' League in New York. In Paris, in 1926 and 1927, he used wire to create toy circus performers and caricatures. From this, he turned to more abstract compositions of wire, metal shapes, or wood forms that were activated by electric motors or hand cranks. His acquaintance with the work of Mondrian led him to use color on some parts. Since 1932, he has felt that natural air currents are the best means of activating kinetic sculptures. *Under the White Sickle Moon* (Fig. 18-28) is typical in the lively curved metal shapes attached to the ends of delicately hinged and balanced wires. The flat metal pieces, like those of a weather vane, react to air currents, and the composition bobs and turns. Such sculpture renounces the traditional importance of mass; the open compositions participate actively in time and space. Calder has also done many *stabiles*, in which the motionless forms acquire liveliness from the directional forces within the cut-out sheet metal pieces.

Henry Moore (England, 1898–). England's most renowned twentieth-century sculptor studied sculpture at the Leeds School of Art and had his first one-man show in 1928. His early work is simple, massive, and blocky, reflecting an enthusiasm for ancient Mexican sculpture. *The Reclining Woman* (1929, Leeds Gallery, London) has ponderous monumentality in repose. By

18-29 HENRY MOORE, *Reclining Figure*,
1935. Wood. 19" x 35".
Albright-Knox Art Gallery. Buffalo.

1935, he was piercing the masses with openings treated as shaped spaces. The *Reclining Figure* in Figure 18-29 has such positive spaces; the female figure acquires the broad undulating hills and valleys of a landscape. As in so many of Moore's reclining figures, there is the suggested symbolism of the great earth mother, source of all life. During the 1930's, he did a number of string figures, in which string is threaded through the masses to form groups of lines that define spaces. Meanwhile, the reclining figures became increasingly open. During the bombings of London in the Second World War, Moore made drawings of Londoners sleeping in subway tunnels; war had driven men back into the womb of the earth. The cavernous openings within the figures suggest a relationship with their cavernous environment. It was also during the war that Moore began his series of *Helmet Heads*, helmetlike metal shells into which one of a number of bony core forms could be fitted. Although very abstract, the results produced the uncanny effect of a frightened being looking out of a sheltering helmet. In the 1950's he produced a number of sparse skeletal figures with a regal, if occult, bearing, and several mutilated warriors, timeless expressions of man's self-destruction. Moore's sculptures, like those of Lipchitz, rely not on precise conventional symbols but on forms that suggest partly hidden truths about the nature of man and his relation to his universe.

Alberto Giacometti (Switzerland and France, 1901–66). Giacometti settled in Paris in 1922. His early work was inspired by Cubism, but from 1929 until 1934 he was a member of the Surrealist group and produced such sculpture as *The Palace at 4 A.M.* (1932–33, Museum of Modern Art, New York), a cagelike structure in-

18-30 ALBERTO GIACOMETTI, *City Square,* 1948. Bronze, 8½" x 25¾". Museum of Modern Art, New York.

habited by skeletal forms. After 1934, he turned to more definite human figures, employing drastically elongated proportions. The fragile, isolated, phantom beings in the *City Square* (Fig. 18-30) suggest that human society offers no escape from man's alienation from his fellows.

David Smith (United States, 1906–65). Smith studied painting in Washington, D.C. and New York during the 1920's. In 1931, inspired partly by Picasso's welded sculpture, he began attaching found and shaped wooden objects to his paintings; and, in 1932, he began doing welded sculpture. Rough-edged geometric planes and masses were combined and painted in compositions like *Suspended Cube* (1938, Estate of David Smith). Social comment appears in the *Medals of Dishonor*, silver and bronze reliefs pointing out unjust or inhuman aspects of the Second World War. Smith's inventiveness ranged from such unlikely subjects as *Hudson River Landscape* (1951, Whitney Museum of American Art, New York) and *Banquet* (1952, private collection, New York), both linear, steel hieroglyphs in space, to a pure geometry of burnished or painted steel in the *Zig* and *Cubi* series. *Cubi XVIII* (Fig. 18-31) is a daring and "momentary" poise of shimering geometric solids, a visual statement with the authority of a trumpet call.

Theodore Roszak (United States, 1907–). Roszak was born in Poland and came to Chicago in 1909. He settled in New York in 1931 and created geometric nonobjective sculpture in the manner of the Constructivists. In 1945 came the stylistic change that led to his mature style, a bristling explosive combination of jagged torn forms and rough textures. The *Whaler of Nantucket* (Fig. 4-2) has the elusive symbolism of *Moby-Dick*. The welded

18-31
DAVID SMITH, *Cubi XVIII,* 1964. Steel, approx. 9'8" high. Museum of Fine Arts, Boston.

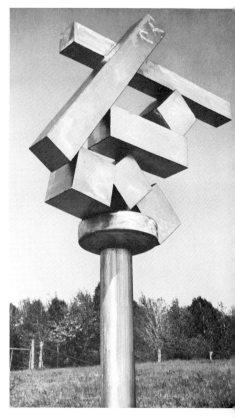

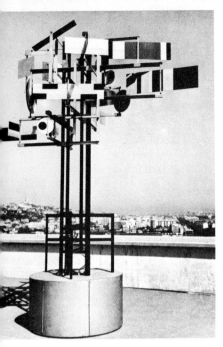

18-32
NICOLAS SCHÖFFER, *CYSP I*, 1956.
Steel and aluminum, 70⅞" x 63". Galerie
Denise René, Paris.

18-33
DONALD JUDD, untitled construction,
1965. Galvanized iron and aluminum,
33" x 11'9" x 30". Leo Castelli Gallery,
New York.

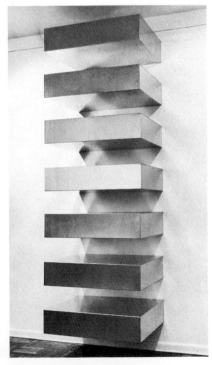

steel assumes threateningly violent forms that refer obliquely to the snout of a whale, the thrust of a harpoon, and the prow of a boat. Such active, powerful form links Roszak's art to Abstract Expressionist and action painting.

Nicolas Schöffer (Hungary and France, 1912–). Schöffer studied at the Budapest Art Academy before coming to Paris in 1936. At the time of his first one-man show, in 1948, he was still a painter; but in 1950, he presented an exhibition of kinetic sculpture. In 1954, with the financial and technical aid of the Phillips Corporation, he created his first spatiodynamic tower. The tower was an open metal frame with moving, colored, rectangular blades and loudspeakers emitting taped music composed of electronic and environmental sounds. Since then, other towers have combined sound, light, projected images, and motion, expressing Schöffer's belief that art should utilize the essential elements of space, time, light, and change. *CYSP I* (Fig. 18-32), whose name stands for Cybernetic-Spatiodynamic construction, was done in 1956, again with the help of the Phillips Corporation. The piece is mobile and sonic. Darkness and silence cause it to move and to produce loud sounds; brightness and noise cause it to become still and quiet; the presence of different colors produces varying degrees of reaction. A ballet was created by Maurice Béjart using *CYSP I*, dancers, and electronic music.

Donald Judd (United States, 1928–). Judd studied painting at the Art Students' League and at Columbia University before turning to three-dimensional form. In the early 1960's, he produced reliefs of painted wood and metal and made his first boxlike floor constructions of metal and plexiglass. Judd states that he wants to rid his art of illusions, compositional relationships, and rational implications; the work should be experienced as a single whole without reference to ideas beyond itself. This position has been taken by other Minimal artists and has been related to phenomenological philosophy. The untitled construction from 1965 (Fig. 18-33) is a series of identical masses and spaces whose reflecting surfaces and complex shadows produce effects of sensuous richness and severe order.

Claes Oldenburg (United States, 1929–). After studying English and art at Yale, Oldenburg enrolled at the Chicago Art Institute. His first one-man show, in New York, was in 1959 and consisted of assemblages of street

18-34
CLAES OLDENBURG, *The Soft Typewriter,*
"Ghost" version, 1963. Canvas, kapok,
wood, liquitex, 9" x 27½" x 26". Karl Stroher
Collection, Darmstadt.

materials painted only in gray, white, or black. In 1961,
he created an environment of store objects in a rented
storefront. After the exhibit closed, the store became
"The Ray Gun Theater," where Oldenburg produced
happenings. The Store was his first critical success; its
second version, in the Green Gallery in 1962, contained
an enormous hamburger and a slice of cake, both made
of brightly colored stuffed canvas. *The Soft Typewriter*
(Fig. 18-34), though modest in size, was produced during
this phase. A common object is presented with a change
in one basic characteristic, a change that makes the
viewer perceive the object in a new way. Pop Art, in
which Oldenburg is a leader, has tended to depict
objects or images from our consumer culture. In the
late 1960's, he planned large public monuments based
on such common objects as lipsticks. Unlike many Pop
artists, Oldenburg sometimes implies satire; he has said
that humor is a useful tool in a dissolving world.

ARCHITECTURE

Twentieth-century architecture has lost almost all ves-
tiges of regional style and has been characterized by
broad international trends. Eclecticism and Art Nouveau
continued as rival stylistic tendencies in the early years
of the century. The relatively new materials—steel and
reinforced concrete—were usually disguised by tradi-
tional forms in eclectic work; their structural potential
was demonstrated more clearly in the organic curves
of Art Nouveau. An architectural style that exploited
the advantages of reinforced concrete had its beginnings
in buildings by the Frenchman Auguste Perret. The
simplicity of Perret's work provided refreshing contrast
to the crowded surfaces and self-conscious ornament
of both eclecticism and Art Nouveau. Simplification was
carried further by several Viennese architects, notably

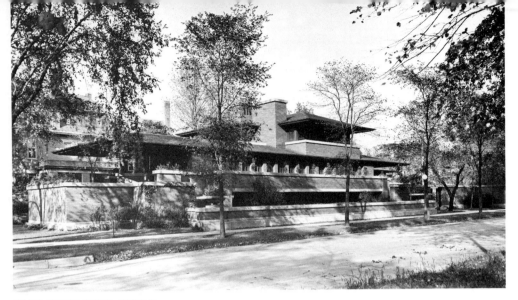

18-35 FRANK LLOYD WRIGHT,
Robie House, Chicago, 1909.

Adolf Loos. After 1910, the severe cubic forms of Loos's work were echoed in other countries and came to be known as the *International Modern Style.* The austere geometric buildings of this style were designed by Walter Ludwig Gropius, Mies van der Rohe, and other architects who worked at the *Bauhaus,* Germany's famous school of design during the 1920's, and by Le Corbusier in France. A secondary trend developed between 1910 and 1925 in Holland and Germany, where certain architects designed buildings with sudden curves or exaggerated streamlining. Effects ranged from playfulness and whimsy to overpowering animated or machinelike forms. The architecture has been described as expressionistic.

In the United States, Frank Lloyd Wright followed his master Sullivan in rejecting eclecticism, and Wright's use of uninterrupted interior spaces, asymmetrically expanding plans, long horizontal lines, and interlocking masses influenced the early work of Gropius, Mies van der Rohe, and several of the Dutch architects, all of whom learned of Wright's work through German publications. In place of severe geometric simplicity, however, Wright preferred proliferation of masses and the enrichment of surfaces with contrasting textures and colors. Wright has had great influence in residential design, while Gropius and Mies van der Rohe have shaped the prevailing styles in skyscraper design. Except for these tall buildings, the architecture of the 1950's and 1960's has revealed a general tendency away from simple cubic forms and toward more variety and complexity in mass and surface. Bold contrasts of projecting

and receding parts create dramatic light and shadow, and different materials vary texture and color, while reinforced concrete and glass provide hovering masses and exhilarating spatial vistas.

Frank Lloyd Wright (United States, 1867–1959). Wright, America's leading architect in the first half of the twentieth century had two years of engineering training at the University of Wisconsin before going to Chicago and joining the firm of Adler and Sullivan. Unlike Sullivan, Wright designed few large public buildings. He acquired from Sullivan a love of mass, a hatred of imitation, and the convictions that form should be determined by function and that decoration should emphasize structure. The low, widespread, asymmetrical ranch house has its ancestry in Wright's early *prairie houses*, the best known of which is the Robie House (Figs. 18-35 and 18-36). The asymmetrically arranged spaces are interrupted as little as possible and flow around the central chimney mass. Wright believed that walls should be opened up by large groups of windows to achieve the greatest sense of spaciousness, but he loved to contrast large window areas with unbroken masses of wall. He felt that the exterior should seem to be part of the building's site. The long low lines of the Robie House echo the flat earth plane and were originally punctuated by greenery in planters, so that the house seemed to be a part of nature. The wide overhanging eaves are typical expressions of Wright's conviction that the sheltering function of a roof should be emphasized. Concrete, brick, stone, and natural wood were used for contrasts of color and texture. Wright enjoyed elaborating on interlocking structures; throughout his work, the masses, spaces, and the smallest details interpenetrate to express the unity of the whole. Wright's favorite term for such unity of site, structure, and decoration was *organic architecture*. His designs are remarkably original, though he learned much from Japanese architecture and though some of his more massive buildings have a similarity to ancient Mayan architecture. His greatest technical triumph was the design of the Imperial Hotel in Tokyo (1915–22), which was planned to be earthquake-proof and was undamaged by the terrible earthquake of 1923. The houses of his later years sometimes employ a polygonal, circular, or triangular thematic shape as a unifying module for floor plans, for built-in furniture, and even for gardens. A circular module was the basis for the most controversial large building of his career, New York's Guggenheim Museum.

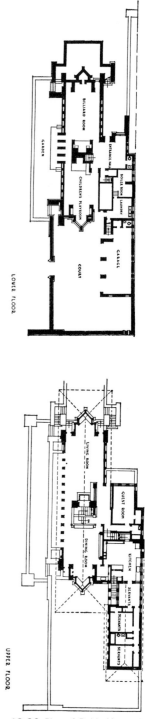

18-36 Plan of Robie House.

18-37
ADOLF LOOS, Steiner House, Vienna, 1910.

Adolf Loos (Austria and France, 1870–1933). Loos was one of the architects who rebelled against both eclecticism and ornament. He spent three years (1893–96) in the United States, and returned to Vienna to pursue a career in architecture, teaching, and writing. The Steiner House (Fig. 18-37) of 1910 illustrates his preference for starkly simple, boxlike geometric forms that rely completely on proportions for their aesthetic effect. Loos first acquired an international reputation through his writing, which was published in Vienna and then republished in Berlin and Paris. His most controversial essay was "Ornament and Crime" (1908), in which he equated ornament with crime and argued that culture advances as ornament decreases. Loos, like many of the International Style architects, was an avid admirer of engineers and machines. After 1923, he was active in Paris.

Auguste Perret (France, 1874–1954). Perret was trained as an architect in the École des Beaux-Arts. He is especially important as a pioneer in the use of reinforced concrete. For his Rue Franklin Apartments (1902–03, Paris) he used a ferroconcrete framework protected on the exterior by tile. The soaring vertical shafts of superimposed bays give the eight-story building impressive dignity. The thin members of the ferroconcrete frame are evident on the exterior; inside, large spaces are made possible by the widely spaced supports. Even more dramatic openness was arranged in the Garage Ponthieu (1905–06, Paris), where the stark concrete frame is filled in with glass. Perret's basilica church of Notre Dame Le Raincy (Figs. 18-38 and 18-39), has canopies of ferroconcrete vaults supported by slender columns.

18-38
AUGUSTE PERRET, Notre Dame
Le Raincy, 1922–23.

Since the walls are not needed to support the vaulting, they consist of concrete blocks perforated with designs and filled with stained glass. The buoyant, light-filled interior thus uses new means to achieve some of the qualities of Gothic architecture. Perret often mixed color aggregates with concrete in order to vary the color and minimize weather staining. His later works include the buildings of the Place de l'Hôtel de Ville at Le Havre (1948–54), whose carefully proportioned masses and openings are precisely framed with simple moldings and balconies. Discipline and reserved dignity are characteristic of Perret's designs.

Walter Gropius (Germany and the United States, 1883–1969). Mies van der Rohe, Le Corbusier, and Gropius were the major leaders in the trend toward austere simplicity from about 1920 until 1940. Of these, Gropius is the one whose theories have been most influential, through his architecture, his teaching, and his writing. In 1918, after several years of private practice as a Berlin architect, he was appointed Director of the Grand Ducal Saxon School of Applied Arts and the Grand Ducal Academy of Arts in Weimar. He united the two schools under the name *Staatliches Bauhaus* with the aim of joining the creative energies of artists and product designers. Like Loos, Gropius was enthusiastic about

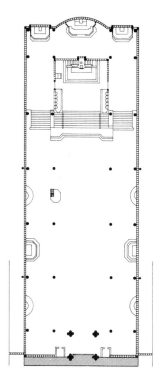

18-39 Plan of Notre Dame Le Raincy.

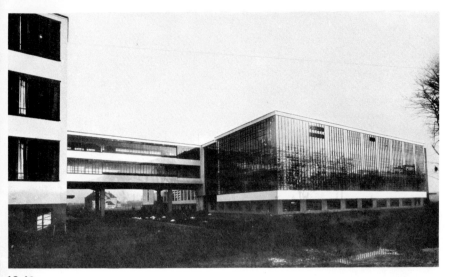

18-40
WALTER GROPIUS, Bauhaus shop, Dessau,
1925–26.

the possibilities of the Machine Age and deplored the use of applied ornament as a kind of cultural cake frosting. Gropius' buildings have been consistent with his theory. His first major work (in collaboration with Adolf Meyer), the Fagus Factory (1911, Alfeld an der Leine), employed steel supports, concrete floor slabs, and screen walls of glass. He used glass curtain walls again with dramatic effect in an office building for the Cologne Werkbund Exhibition in 1914 and in the new Bauhaus buildings at Dessau in 1926 (Fig. 18-40). In the Stuttgart Werkbund Housing Exhibition of 1927, where Le Corbusier and others demonstrated their advanced ideas, Gropius submitted a prefabricated house using a metal frame with asbestos and cork walls. In 1934, Gropius was forced by Nazi policies to leave Germany. He first went to England and then came to the United States, where he taught at Harvard and formed TAC (The Architects' Collaborative).

Ludwig Mies van der Rohe (Germany and the United States, 1886–1969). Like Gropius, Mies van der Rohe worked with the architect Peter Behrens before starting independent practice in Berlin. The extent of his vision was evidenced in his project for an office building for Friedrichstrasse in 1919. He proposed a steel frame with cantilevered floors and curtain walls of glass. His design for a brick country house (1923) has low spreading lines, grouped windows, and asymmetrical spaces that suggest the influence of Frank Lloyd Wright. Mies directed the Werkbund Exhibition of 1927 in Stuttgart; his apartments built for that occasion exploit the patterns of windows, balcony railings, and drainpipes to create a visually interesting design. Two years later, for the

German Pavilion at the International Exhibition at Barcelona, Mies produced one of the landmarks of twentieth-century architecture. The small building consisted of marble panels, steel supports, and glass walls. Spaces were defined without being isolated from each other or from the exterior. The spaciousness, the long low lines, the reflecting pools, and the steel, glass, and marble materials all created an effect of serene elegance. These stylistic features were incorporated in the famous Tugendhat House (1930, Brno, Czechoslovakia). The exterior of the house is starkly simple, employing blank walls and translucent glass on the street side and curtain walls of transparent glass on the garden side. Within, slender steel columns support the roof, and the minimal number of dividing walls creates a maximal sense of space. In 1933, Mies, who was then its director, closed the Bauhaus because of political pressure, and in 1938 he came to Chicago to direct the Armour Institute, which later became the Illinois Institute of Technology. The buildings that he designed for I.I.T. became Mies's manifesto in America. The simple rectangular forms were made of steel cages constructed on a 24-foot module and filled in with brick or glass. The Seagram Building (Fig. 18-41) was planned in 1956. The interior floor space gained by the height of the building enabled the architect to leave a large open area at the base for outdoor pools and gardens set into a pink granite platform, thus relieving the congestion at street level. The amber-gray glass and bronze tower that forms the main part of the building extends beyond the steel piers on which it is raised, emphasizing its lightness and openness. The vertical bronze beams, partly structural and partly decorative, stress the soaring height and provide a delicate linear pattern in relief.

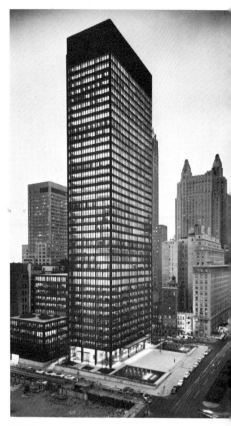

18-41
LUDWIG MIES VAN DER ROHE, Seagram Building, New York, 1956–58.

Charles Édouard Jeanneret, called **Le Corbusier** (Switzerland and France, 1888–1965). Charles Édouard Jeanneret, who took the name Le Corbusier to avoid confusion with his cousin, the architect Pierre Jeanneret, was born in Switzerland but made his career in France. He studied with Perret, learning about ferroconcrete and inheriting Perret's admiration for engineering and the efficiency of machines. Le Corbusier's Dom-ino multiple housing project, planned in 1914 and 1915 but never built, used ferroconcrete frames that reduced walls to weather screens having no weight-bearing function. The projects for the Citrohan House (1919–22) were a fuller exposition of his aims. Standardized parts were used wherever possible, and the severely simple boxlike form was of plain ferroconcrete, with no effort to vary texture. A

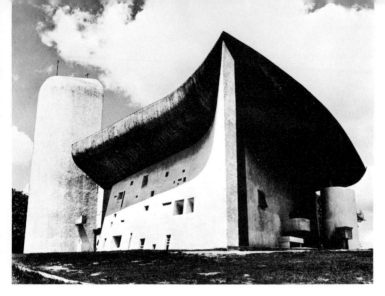

18-42
LE CORBUSIER,
Notre-Dame-du-Haut,
Ronchamp, 1950–55.

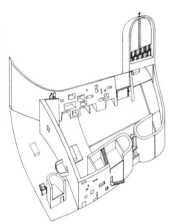

18-44 Plan of Notre-Dame-du-Haut.

wall of windows at one end illuminated a two-story-high living room; bedrooms were on a balcony and a third floor, and a recreation area was provided on the flat roof. A second version raised the whole house on concrete piers. Like Frank Lloyd Wright, Le Corbusier was a leader in opening up interior space with grouped windows and a minimum of partition walls. Although his houses were criticized as bleak machines, Le Corbusier often sacrificed the practical for the aesthetic—the huge window areas and two-story living rooms, for example, are very costly to heat. Le Corbusier's sense of the beautiful was inspired by machines, and his buildings have the look of machinelike efficiency, but they are designed to satisfy his love of spaciousness and light. Many of his projects were never built, but the Citrohan idea was realized in a special group of houses built for the Stuttgart Werkbund Exhibition of

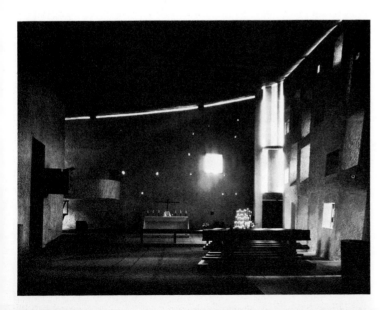

18-43
Interior of Notre-Dame-du-Haut.

1927. Only in the latter years of his career did Le Corbusier have the opportunity to realize his urban planning theories. The most notable design is that for Chandigarh, the new capital of Punjab. After 1940, Le Corbusier's architecture developed a very different character. The rigid boxlike forms gave way to irregular curves and deep openings in wall surfaces, producing a more sculptural effect. Notre-Dame-du-Haut at Ronchamp (Figs. 18-42–18-44) is an outstanding example and one of the most controversial church designs of our time. The billowing vitality of the roof, the sweeping curves of the walls punctuated by deep irregular windows, and the spotlighting effects on the interior dramatize the experience of worship.

Louis Kahn (United States, 1901–). Kahn received his degree from the Architecture School of the University of Pennsylvania in 1924 and worked as assistant to other architects until 1934. His early work, involving city planning and housing projects, revealed an admiration for Gropius in its flat-roofed, wide-windowed horizontality. In 1947, Kahn joined the architecture staff of Yale University and began to design more buildings that expressed his individual concepts rather than those of a team. The exterior of his Yale University Art Gallery (1951–53) uses glass and brick in a way that recalls the designs of Mies van der Rohe, while the rough concrete interior shows the influence of Le Corbusier. Kahn's work has emphasized revealed structure and spaces that are more separate than continuous. The Richards Medical Research Building (Fig. 18-45 and 18-46) clearly separates the massive service-utility towers from the glass-walled laboratories. Although the whole form is

18-45
Plan of Richards Medical Research Building.

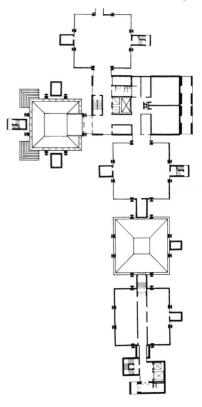

18-46
LOUIS KAHN, Richards Medical Research Building, University of Pennsylvania, Philadelphia, 1957–61.

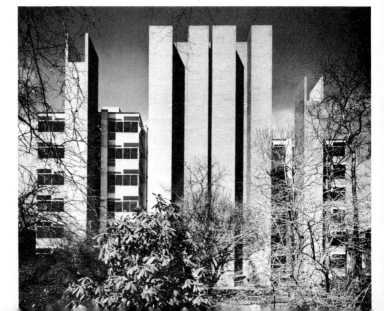

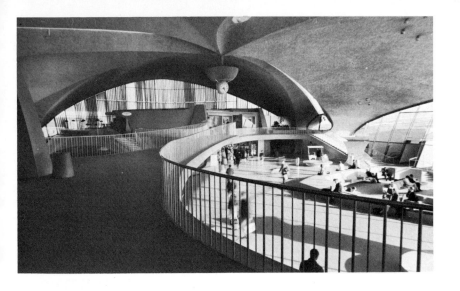

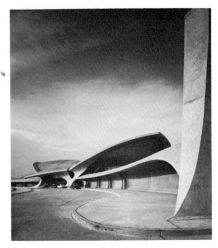

18-47 EERO SAARINEN, TWA Terminal, Kennedy Airport, New York, 1956.

complex, the stark simplicity of its individual parts and the bold contrast of upright and horizontal, transparency and opacity, projection and recession, give a total effect of variety and monumentality. Stylistically, this, and many other Kahn designs, may be included within a broad international trend that has been labeled the *New Brutalism.*

Eero Saarinen (Finland and the United States, 1910–61). After moving with his family to the United States in 1923, Eero studied in Paris and at Yale before joining the architectural firm of his father, Eliel Saarinen. The son's developing concept of architecture led to a separation from his father in 1948. Eero's firm designed the huge General Motors Technological Center near Detroit (1951-57), using a severely rectangular architecture influenced by Mies van der Rohe. Saarinen, unlike Mies, enlivened his forms with red, blue, yellow, and orange walls. From this colorful outgrowth of the International Modern Style, Saarinen, like Le Corbusier, turned to a more complex, animated style. In his Vassar College Dormitory (1954-58) and in the University of Chicago Law School (1956-60), he employed glass in vertical accordion pleats as deliberate embellishment. Although his former restraint occasionally returned, as in the IBM building in Yorktown, New York (1956), his late trend is strikingly exemplified in the TWA Terminal at Kennedy Airport (Fig. 18-47). Here the convoluted ferroconcrete forms are notable for their absence of stabilizing horizontal and vertical lines. The interior space is restlessly enveloped by ebbing and flowing masses; the exterior suggests a giant bird with lifted wings.

Suggestions for Further Study

Amaya, Mario. *Pop Art . . . And After.* New York: Viking Press, 1966.

Banham, Reyner. *The New Brutalism: Ethic or Aesthetic.* New York: Reinhold, 1966.

———. *Theory and Design in the First Machine Age.* New York: Praeger, 1960.

Battcock, Gregory, ed. *Minimal Art: A Critical Anthology.* New York: Dutton, 1968.

Blake, Peter. *The Master Builders.* New York: Knopf, 1960.

Boeck, Wilhelm, and Jaime Sabartés. *Picasso.* New York and Amsterdam: Abrams, 1955.

Crespelle, Jean Paul. *The Fauves.* Translated by Anita Brookner. Greenwich, Conn.: New York Graphic Society, 1962.

Gray, Camilla. *The Great Experiment: Russian Art, 1863–1922.* New York: Abrams, 1962.

Gropius, Walter. *Scope of Total Architecture* (World Perspectives). Edited by Ruth N. Anshen. New York: Harper & Row, 1955.

Haftmann, Werner. *Painting in the Twentieth Century.* 2 vols. Translated by Ralph Manheim. New York: Praeger, 1960.

Hamilton, George Heard. *Painting and Sculpture in Europe: 1880–1940* (Pelican History of Art). Baltimore: Penguin Books, 1967.

Jean, Marcel. *The History of Surrealist Painting.* Translated by Simon Watson Taylor. New York: Grove Press, 1960.

Jeanneret-Gris, Édouard. *Le Corbusier, 1910–1965.* Edited by W. Boesiger and H. Girsberger. New York: Praeger, 1967.

Martin, Marianne W. *Futurist Art and Theory: 1909–1915.* Oxford: Clarendon Press, 1968.

Neumann, Erich. *The Archetypal World of Henry Moore.* Translated by R. F. C. Hull. New York: Pantheon Books, 1957.

Norberg-Schulz, Christian. *Intentions in Architecture.* Cambridge: M.I.T. Press, 1965.

Popper, Frank. *Origins and Development of Kinetic Art.* Translated by Stephen Bann. Greenwich, Conn.: New York Graphic Society, 1968.

Read, Herbert and Leslie Martin. *Gabo: Constructions, Sculpture, Paintings, Drawings, and Engravings.* Cambridge, Mass.: Harvard University Press, 1957.

Richter, Hans. *Dada Art and Anti-Art.* New York and Toronto: McGraw-Hill, 1965.

Rickey, George. *Constructivism: Origins and Evolution.* New York: Braziller, 1967.

Rosenblum, Robert. *Cubism and Twentieth-Century Art.* New York: Abrams, 1960.

Seitz, William Chapin. *The Art of Assemblage.* New York: Museum of Modern Art, 1961.

Selz, Peter. *German Expressionist Painting.* Berkeley: University of California Press, 1957.

Seuphor, Michel (Ferdinand Louis Berckelaers). *The Sculpture of This Century.* Translated by Haakon Chevalier. New York: Braziller, 1960.

Venturi, Robert. *Complexity and Contradiction in Architecture.* New York: Museum of Modern Art, 1966.

Wright, Frank Lloyd. *An American Architecture.* Edited by Edgar Kaufmann. New York: Horizon Press, 1955.

Picture Credits

Scala; 14-8: The Frick Collection; 14-14: Anderson-Giraudon; 14-15, 14-17, 14-20, 14-31, 14-36: An-ARB; 14-18: Brogi-ARB; 14-24: Soprintendenza alle Gallerie della Campania, Naples; 14-34, 14-41: Met; 14-40: Musee d'Unterlinden, Colmar, France; 14-44: Kunsthistorisches Museum; 14-45: Giraudon; 14-46: Bildarchiv Osterrichishe; 14-47: Bulloz

Chapter 15 15-1: The Prado, Madrid; 15-2, 15-4, 15-10: Scala; 15-3: Alinari; 15-5, 15-13: An-ARB; 15-6, 15-14: Al-ARB; 15-7: Scala; 15-11: An-Scala; 15-16: Walter Steinkopf; 15-17, 15-20: Giraudon; 15-18: Yale University Art Gallery, Leonard C. Hanna Jr. Fund; 15-19: Met; 15-21: Crown Copyright, Department of the Environment, Hastings; 15-22, 15-23: Mar-ARB; 15-25: Crown Copyright, National Monuments Record; 15-26: Edwin Smith

Chapter 16 16-1, 16-8, 16-9: Scala; 16-2, 16-18: Met; 16-3: Louvre; 16-4: The Wallace Collection; 16-5: Birmingham Art Gallery; 16-6: The Frick Collection; 16-7: Giraudon; 16-11, 16-12: Mar-ARB; 16-14: Yvon, Arcueil, France; 16-15: Cortauld Institute of Art; 16-16: Hir; 16-17: National Gallery, London

Chapter 17 17-1: The Prado, Madrid; 17-2, 17-18, 17-28: Met; 17-3: MFA; 17-4: Staatliche Museen, Berlin; 17-5, 17-6: National Gallery, London; 17-7, 17-26: Al-ARB; 17-8, 17-13, 17-27: Giraudon; 17-9, 17-21, 17-25: Art Institute of Chicago; 17-10: Met; 17-11: F. Bruckmann, Munich; 17-12: Louvre; 17-14: Memorial Art Gallery, University of Rochester; 17-15: Baltimore Museum of Art; 17-16: Rijksmuseum Kröller-Müller, Otterlo; 17-17: Scala; 17-19: Albright-Knox Art Gallery, Buffalo, N. Y.; 17-20: National Gallery, London; 17-22: MOMA; 17-23: Galerie Welz, Salzburg, Courtesy of Marietta Preleuthner, Vienna; 17-24: Oslo Kommunes Kunstamlinger, Munch-museet; 17-29: Thomas Jefferson Memorial Foundation; 17-30: Radio Times Hulton Picture Library; 17-31, 17-34: Mar-ARB; 17-32: Louis H. Frohman; 17-33: Giraudon; 17-35: Foto Mas Barcelona; 17-36: Missouri Historical Society

Chapter 18 18-1, 18-11, 18-15, 18-26, 18-27: PMA; 18-2, 18-3, 18-4, 18-7, 18-9, 18-17, 18-21, 18-22, 18-30, 18-40: MOMA; 18-5: Oeffentliche Kunstmuseum, Basel; 18-6: Art Institute of Chicago; 18-8: Dartmouth College; 18-10: Kunst Museum, Basel; 18-12: MOMA, From the collection of Mr. & Mrs. Stanley Resor; 18-13: Scala; 18-14, 18-29: Albright-Knox Art Gallery, Buffalo, N.Y.; 18-16: Ann-Marie Desailly; 18-18, 18-24: Met; 18-19: Rose Art Museum, Brandeis University; 18-20: Collection of Mr. & Mrs. Frank Titelman, Altoona, Penna.; 18-23: Cranbrook Academy of Art, Bloomfield Hills, Michigan; 18-25: Philips Collection, Washington, D.C.; 18-28: Perls Galleries, New York; 18-31: MFA; 18-32: Galerie Denise René, Paris; 18-33: Leo Castelli; 18-34: Geoffrey Clements, Staten Island, N.Y.; 18-35: Chicago Architectural Photo Co.; 18-37: Photoatelier Gerlach, Wein; 18-38: Chevojon Frères, Paris; 18-41: Ezra Stoller Associates; 18-42: George Holton, PRI; 18-43: G. E. Kidder Smith; 18-46: Malcolm Smith Studio; 18-47: TWA

Color Section Plate I: National Gallery, London; Plate II: Scala; Plate III: Giraudon; Plate IV: N.G.A.; Plate V: Bulloz; Plate VI: Museum of Art, Carnegie Institute, Pittsburgh, Penna.; Plate VII: MOMA

Permission S.P.A.D.E.M. 1972 by French Reproduction Rights, Inc., for the following: Figs. 1-1, 1-14, 17-16, 17-28, 18-22, 18-42, 18-43, 18-44, Plates 4, 5, 6

Permission A.D.A.G.P. 1972 by French Reproduction Rights, Inc., for the following: Figs. 18-1 18-13, 18-28, 18-32

Illustration credits

6-1, 6-3, 6-7, 7-11 (from Banister Fletcher), 8-2, 8-3, 9-12, 9-15, 10-1, 11-14, 12-2, 12-13, 13-5, 13-7, 13-12, 13-17, 13-20, 13-28, 13-32: From Gardner's *Art Through the Ages*, 5th ed., revised by Horst de la Croix and Richard G. Tansey, © 1970 by Harcourt Brace Jovanovich, Inc. and reproduced with their permission.

6-6: From R. Ghirshman, Village perse-achéménide, Mem. de la Mission Archeologique d'argent à l'époque achéménide, Athéna, 1956.

7-11, 8-4, 14-19: From *A History of Architecture on the Comparative Method*, 17th ed., by Sir Banister Fletcher, rev. by R. A. Cordingly, 1961. Athlone Press of the University of London.

14-35: From *Art in the Western World*, by David M. Robb and J. J. Garrison. Harper & Row, 1963, p. 149.

15-9, 15-12: From *Art and Architecture in Italy*, by Rudolf Wittkower. Penguin Books Ltd., 1958.

15-27: From *Architecture in Britain*, by John Summerson. Penguin Books Ltd., 1963.

18-39: From *Nineteenth and Twentieth Century Architecture*, 2nd ed., by Henry R. Hitchcock. Penguin Books Ltd., 1963.

Drawings Felix Cooper, Vantage Art, Inc., Ira Grayboff

Index

Italicized numbers refer to illustrations.

binder, 36, 38, 72: synthetic, 38
Birth of Spring, The (Botticelli), 189
Birth of Venus, The (Botticelli), *189*
Bishop Bernward, 155–56, 161
Bison, 52
black-figure vase painting, 94, 95
Black Square (Malevich), 319
Blake, William, 278
blind arcades, 154, 157
Blinding of Samson, The (Rembrandt), 240
Blue Rider group, 313, 316, 320
Blue-White (Kelly), *334*
Boccioni, Umberto (bōt chyō′neh, ō̄om ber′tō), 324, 325
Bonaparte Crossing the Alps (David), 277
Book of Job, The (Blake), 278
Book of Kells, 152
Book of Pericopes of Henry II, 163
books, 136–37. *See also* manuscript illumination
Borromini, Francesco (bor ō mē′nē, frän ches′kō), 222, 234–36, 248
Bosch, Hieronymus (bosh; *Dutch* bos, hē ro′ni mus), 183, 184, 255
bottega, 179
Botticelli, Sandro (bot i chel′ē, sän′drō), 189
Boucher, François (bōō shä′, frän swä′), 256, 257
Boudin, Eugène (bōō′dan, eu zhen′), 291
Bouguereau, Adolphe (bōōgə-rō′), 317
Bramante, Donato (brə män′ teh, do nä′tō), 208–10
Brancusi, Constantin (bräng kōō′zē; *Rumanian* bräng kūsh′), 338–39
Braque, Georges (bräk, jorj; *French* zhorzh), 313, 322–24
Bridge group. *See* Die Brücke
British Royal Academy, 257
broken architrave, 196
broken color, 292, 294, 295

broken pediments, 232
bronze casting, 40–41, 161, 193, 220, 302–03
Brotherhood of Pre-Raphaelites, 274
Brücke. *See* Die Brücke
Bruegel, Pieter the Elder (broi′gəl; *Flemish* brü′gəl), 218–19, 236, 255
Brunelleschi, Filippo (brōōn əles′kē, fə lēp′pō), 186, 193, 195–96, 197
brush drawing, 33
Bull Games, 87–88
buon fresco, 38
Burghers of Calais, The (Rodin), 303
burial chamber, 68
burins, 34
Burke, Edmund, 250
burr, 35
buttressing, 43, 45–46
Byzantine architecture, 139–43
Byzantine mosaics, 143–45
Byzantine painting, 143–47
Byzantine sculpture, 147–49

C
Café-Bar (Braque), 328
Calder, Alexander, 341
Callicrates (kə lik′rə tēz), 98,99
campanili, 140
Campbell's Soup Can (Warhol), *335*
Campidoglio, 211
Campin, Robert (käm pən′), 180, 181
Canal, Giovanni Antonio. *See* Canaletto
Canaletto (kä nä lct′tō), 267–68
cancelation of prints, 33
Cancelleria, 195
Canova, Antonio, 300, 301
cantorias, 192
capitals, 63–64, 68: composite, 124
Capitol Building (Richmond, Va.), 305
caprices, 268

Caprices, The (Goya), 276
Captive Cupid, The (Boucher), 256
Caravaggesque lighting, 226, 236, 240
Caravaggio, Michelangelo Merisi da (kar ə vä′djyō; *Italian* kä rä väd′jō, mə rē′zē), 223, 224, 225–26, 228, 237
carbon 14 measurement, 53
Carceri series (Piranesi), *268, 269*
Carolingian architecture, 152–53
Carolingian painting, 151–52
Carra, Carlo, 329
Carracci, Agostino (kär rät′chē, ä go stē nō), 225
Carracci, Annibale (än nē′bä lä), 223–24, 225, 236, 238, 239
Carracci Academy, 224
Carracci School, 239
Carstens, Asmus, 252
cartoon, 32
carving: Egyptian, 73; ivory, 138, 139; techniques of, 41
caryatids, 99
Casa Milá, 309
casein paints, 38
cast stone, 41
Castelfranco Madonna (Giorgione), 200
Castiglione, Baldassare, 179
casting, 39–41
catacomb paintings, 134, 136, 137
cathedra, 151
Cathedral Workshop, 197
cathedrals, 44–45, 151: Baroque, 247–48; Gothic, 164–69; Romanesque, 159–60. *See also* churches
cave paintings, *52, 53*
cella, 56
Cellini, Benvenuto (chə lē′nē, ben və nōō′tō), 206, 207
Celtic painting, 151
Celto-Germanic architecture, 152–53
Celto-Germanic metalwork, 151
Celto-Germanic painting, 151–52
cemeteries, 113. *See also* tombs
centering, 43

merian period, 55–57
Mesopotamian painting: Assyrian period, 61–62; Sumerian period, 59
Mesopotamian sculpture: Achaemenian period, 64–65; Assyrian period, 60–61; Sumerian period, 57–59
metal cuts, 34
metal engraving, 35
metalwork, 151
metopes, 98, 103
Meunier, Constantin, (mü nyer'), 338
Mexican painting, 315, 325–26
Meyer, Adolf, 350
Michelangelo Buonarroti (mī kəl an'jə lō; *Italian* mē kel än' jeh lō, bwon ə rō'tē), 23, 24, 179, 198, 199–200, 202, 203, 205, 206–07, 209, 210–12, 222, 224, 225, 237, 302
Michelozzo di Bartolommeo (mē keh lot'tsō dē bär tō lōm meh'ō), 196–97
Middle Ages, 150
Middle Kingdom, 66, 73–75
Mies van der Rohe, Ludwig (mēz'van dər rō; *German* mē' əs fän dər rō'ə, lūd'vigkh), 346, 350–51
Military School (Paris), 264
Millet, Jean François (mē leh'), 295, 338
Minimal Art, 312, 316, 334, 337, 344
Minoan art. *See* Cretan art
Minoan Floral Style, 87
Minoan Marine Style, 87, 88
Minoan Palace Style, 87
Miró, Joan (mē rō', hō än'), 315, 330
Miserere (Rouault), 318
mixed media, 32
Mlle. Pogany (Brancusi), 339
Mnesicles (nes'ə klēz), 99
mobile sculpture. *See* kinetic sculpture
modeling, 12, 39–41
modern art. *See* Abstract Expressionism; Action paint-

ing; Analytical Cubism; Constructivism; Cubism; Fauvism; Futurism; geometric abstraction; German Expressionism; Minimal Art; nonobjectivism; Op Art; Pop Art; Surrealism; Synthetic Cubism
Modigliani, Amedeo (mō dē lēä'nē, ä me deh'ō), 338
modulated color, 294
modulation, 24, 32
moldings: Greek, 98; Roman, 125
Mona Lisa (Leonardo), 191
Monaco, Lorenzo, 185
Mondrian, Piet (mon'drē än), 30, 31, 312, 314, 318–19, 341
Monet, Claude (mō nā'), 16, 18, 273, 288, 291–92
monochrome landscapes, 131, 132
monotype process, 36
Monticello, 304–05
Monument to Balzac (Rodin), 303
Moore, Henry, 341–42
Moreau, Gustave (moh rō'), 317, 318
Morning Walk, The (Gainsborough), 256, 257
mortuary chapel, 68
mosaics: Byzantine, 143–45; early Christian, 135, 136, 137; Roman, 123
Moses and the Daughters of Jethro (Botticelli), 189
Mother's Advice, The (Chardin), 255
motion: in architecture, 265; in line, 6; in sculpture (*see* kinetic sculpture); in shapes, 10
mounds, 56
Mountain Landscape with Sheep (Gainsborough), 256
Mr. and Mrs. Andrews (Gainsborough), 256
Mt. Ste.-Victoire from Bibemus Quarry (Cézanne), 290
mud brick buildings, 55–56, 59
mud plaster painting, 59
multiple-point perspective system, 7

mummies, 133
Munch, Edvard (mūngkh), 299, 313, 321
Myron, 100, 102, 103

N
Nabis, 291, 294
Nahash Threatening the Jews at Jabesh, 175
narthex, 135
Naturalism, 258, 271, 291, 300
nave, 44
Nazarenes, 274
Neapolitan Fisherboy (Rude), 301
necropolises, 68, 113, 114
Nefertiti, 79
Neithardt-Gothardt, Matthias (nīt'härt goht'härt). *See* Grünewald
Neo-Baroque, 304
Neoclassicism, 49, 250, 252, 258, 259, 260, 261, 265, 266, 270, 271–74, 277, 278, 281, 300–01, 304, 305, 322
Neo-Dada, 316
Neo-Impressionism, 296
Neo-Plasticism, 319
Neumann, Balthasar, 263
New-Born, The (Brancusi), 338–39
New Brutalism, 354
New Guardhouse (Berlin), 307
New Kingdom, 66, 76–80
New Objectivity movement, 315, 326
Nicholas Chapel, 186
Night Hawks (Hopper), 324
Night Watch (Rembrandt), 238, 240–41
nike type sculpture, 110
nimbus, 204
No. 20, Portman Square, 265
Nolde, Emile (nōl'deh, ā'mēl), 313
nonobjectivism, 31, 314, 316, 318
Norman architecture, 158, 159
Norwegian painting, 299

Rape of the Sabine Women, The (Giovanni da Bologna), *207*
Raphael Sanzio (räf'ā əl, sän' tsyō), 26, 27, 48, 190, 198, 202–03, 205, 212, 225, 239, 274, 293
Rauschenberg, Robert, 334–35
"Ray Gun Theater, The," 345
ready-mades, 328
Realism, 271: Flemish, 180; French, 272, 275, 285, 286; Greek, 109; Italian, 193; Spanish, 275
Realist Manifesto, 336, 339
Reclining Figure (Moore), *342*
Reclining Woman, The (Moore), *341*
red-figure vase painting, 94, 104
Redon, Odilon (rə dōn', ō'də lon), 291
reflected light, 12
regional style, 53
registers, 63
registration, 34
Reichenau School of illumination, 163
Reims Cathedral, 165
Reims School of illumination, 152
reinforced concrete, 42, 43, 118, 345, 351
relativism, 50
relief processes, 34
relief sculpture, 39: Achaemenian, 63, 65; Assyrian, 60; Byzantine, 147; Egyptian, 70, 74; Florentine, 192, 193, 206; pre-Greek, 90; Roman, 120–21, 129–31; Sumerian, 57, 58
relieving arch, 86
religion: Achaemenian, 55; Aegean, 83; Assyrian, 55; Christian, 134; Egyptian, 66–67; Etruscan, 112; Greek, 92; Sumerian, 54, 57, 59
religious art, 26–29
reliquaries, 138, 147, 153
Rembrandt van Rijn (rem'brant; *Dutch* rem'bränt vän rīn'), 11, 12, 17, 25, 49, 237, 240–41, 295

Renaissance architecture, 194–98, 207–14, 219–20
Renaissance painting, 179–91, 198–204, 214–19
Renaissance sculpture, 191–94, 204–07, 220
Rendezvous, The (Fragonard), *258*
Renier of Huy (ren'yā hwē), 161
Renoir, Auguste (ren'wär), 273, 291, 292–93
repetition, 22, 24, 335
representational art, 31
resin, 35–36, 38
Restrained Baroque, 223
Resurrection, The (Piero), 187
Return of the Cattle, The (Bruegel), 219
revival, 303
Reynolds, Joshua, 252
rhythm, 20, 21
ribbed cross vaults, 44–45, 154, 158
ribs, 44
Richards Medical Research Building, *353*, 354
Richardson, Henry Hobson, 310
rinceau, 120
River Scenes (Hsia Kuei), 2
Rivera, Diego (rē veh'rä, dēä'gō), 315
Robie House, 13, 25, *346*, *347*
Robusti, Jacopo (roh bōōs'tē). See Tintoretto
Rock Breakers, The (Courbet), *285*, 286
rock-cut tombs, 73, 75
Rococo architecture, 260–64
Rococo painting, 251–54, 256, 257, 266–69
Rococo sculpture, 258–60
Rococo style, 250, 258
Rodin, Auguste (rō dan'), 300, 302–03, 336, 337
Roman arch order, 125
Roman arches, 118, 125, 154
Roman architecture, 118–20, 124–28
Roman mosaics, 123
Roman painting, 122–23, 131–33
Roman sculpture, 120–22, 128–31

Romanesque architecture, 154–60
Romanesque painting, 163–64
Romanesque sculpture, 160–63
Romano, Giulio, 239
Romantic Classicism, 269
Romanticism, 250, 270–71: English, 280; French, 272–73, 286, 301; German, 274, 279; Italian, 274; Spanish, 275–76
rose window, 165
rosettes, 162
Roszak, Theodore, 40, 41, 343–44
rotulus form, 136
Rouault, Georges (rōō ōlt'; *French* rü ō'), 313, 318
Rouen Cathedral, 16
Rouen Cathedral, 292, PLATE 4
round arch, 43
Round Table, The (Braque), 323
Royal Academy (London), 280
Royal Hospital at Chelsea, 248
Royal Palace at Madrid, 267
Rubènistes, 251, 253, 283
Rubens, Peter Paul, 11, 12, 49, 224, 236, 237, 251
Rucellai Palace, *196*, 197
Rude, François (rüd'), 300, 301
Rue Franklin Apartments, 340
Ruins of the Most Beautiful Monuments of Greece (Le Roy), 264
Rumanian sculpture, 338–39
Runge, Philipp O., 275, 278
Russian painting, 314, 316–17, 319–20, 329
Russian sculpture, 339
rustication, 196
Ryder, Albert P., 275

S
Saarinen, Eero (sär'ə nen, ā'rō), 354
Sacrifice of Abraham, The (Tiepolo), 266
Sacrifice of Isaac, The (Ghiberti), 39, *192*
Sailor with Guitar (Lipchitz), *340*

Sluter, Claus (slōōt'ər, klous), 172, 173
Smith, David, 343
Soane, John, 261, 305, 307
socialist painting, 285, 286
Société anonyme des artistes, 273
soft ground etching, 35
Soft Typewriter, The (Oldenburg), 345
Soldier and the Gipsy, The (Giorgione), 200
solidity: reflected light and, 12; three-dimensional, 10
Something on the Eight Ball (Davis), 11, *331*
sonic sculpture, 344
Souvenir de Mortefontaine (Corot), *282*
space: as compositional element, 336; line and, 5, 6–7; shape and, 10; texture and, 15–16; value and, 15
Spanish architecture, 230, 309
Spanish Guitar Player (Manet), 286
Spanish painting: Baroque, 223–24, 227–28, 237; nineteenth century, 275–76; twentieth century, 322, 330, 331
Spanish Royal Academy, 276
spatial illusion, 188. *See also* illusionism
spatiodynamic tower, 344
Spear-Bearer (Polyclitus), *103*
spiral torsion, 201
Spirit of the Dead Watching, The (Gauguin), 294, *295*
splayed openings, 154
Spoils from the Temple in Jerusalem, 129
springing, 43
squinch, 46, 139
Staatliches Bauhaus. *See* Bauhaus
stabiles, 341
staffage, 239
stained glass, 39, 164, 170, 173, 175
stamp seals, 89
Standing Youth, 94
Stanza della Segnatura, 202

star vault, 168
states of composition, 33
static balance, 24
static shape, 10
statue chamber, 68
statuettes from Tell Asmar, *58, 59*
steel frame construction, 310–11
Steiner House, *348*
steles, 57, 70
stencil processes, 36
step-pyramid of Zoser, *68*
still-life painting, 224, 225, 255: Dutch, 236; Flemish, 236–37
stoas, 104, 107
Stone Age, 52–53
stone carving, 41
stone maces, 57
stone sculpture, 40, 41
Store, The (Oldenburg), 345
Story of Jonah, The, 137
strapwork, 151
stratigraphy, 53
Street, The (Kirchner), *321*
stringcourse, 154
Stubb, George, 252
stucco, 42, 193
study, 32
Sturm und Drang movement, 250
style, concept of, 53
subject matter: conventional meaning in, 26–30; definition of, 26; degrees of, 31; factual meaning in, 26; subjective meaning in, 30; symbolism in, 26–30. *See also* symbolism
subjectivity, 50, 312
subjectless art, 30
"Sublime and Beautiful, The" (Burke), 250
sublime, concept of the, 250, 261
Sullivan, Louis, 309–11, 346, 347
Sully, Thomas, 275
Sumerian art, 54–59
Sunday Afternoon on the Island of La Grande Jatte (Seurat), 297
sunken relief, 74, 78
superposed orders, 124–25
Supper at Emmaus (Rembrandt), 11, 12, 17, 25, 241, PLATE 3

support, 37
Suprematism, 314, 319–20
Surrealism, 183, 315, 316, 328–29, 330, 331, 336
Surrealist sculpture, 336, 342
Suspended Cube (Smith), 343
Swiss architecture, 351–53
Swiss painting, 214, 217–18, 314, 320–21, 327
Swiss sculpture, 337, 342–43
symbolism: anthropomorphic, 144; Byzantine, 144, 147–48; early Christian, 138; Egyptian, 71, 72; Gothic, 165; Medieval, 180; religious, 27–29; Renaissance, 180, 182–83; Roman, 121; subjective, 30; twentieth century, 326, 342
Symbolist movement, 271
symbolist-synthesist, 294
Symbolists, 291, 294
symmetrical balance, 20, 22, 24
synesthesia, 19
synthesism, 294
Synthetic Cubism, 314, 322, 323
synthetic materials, 336
Syon House, 265

T
tabernacles, 192, 233
tablinium, 119
TAC, 350
Technical Manifesto (Boccioni), 324
tells, 56
Tellus Relief, *121*
tempera painting, 37, 136
Tempest, The (Giorgione), 200
Tempest, The (Kokoschka), *327*
Tempietto (Bramante), 208, *209*
Temple of Amen-Mut-Khôns, *76, 77*
Temple of Aphaia, *100*
Temple of Ceres, *97*
Temple of Hephaistos, *96*
Temple of Horus, *77, 78*
Temple of Zeus Olympios, 96, *102, 108*
temples: Assyrian, 59–60; Egyp-

C 2
D 3
E 4
F 5
G 6
H 7
I 8
J 9
0